A Century of Aerial Photography
NEW YORK

A Century of Aerial Photography
NEW YORK

TEXTS BY PETER SKINNER

PRESTEL

Munich · London · New York

Contents

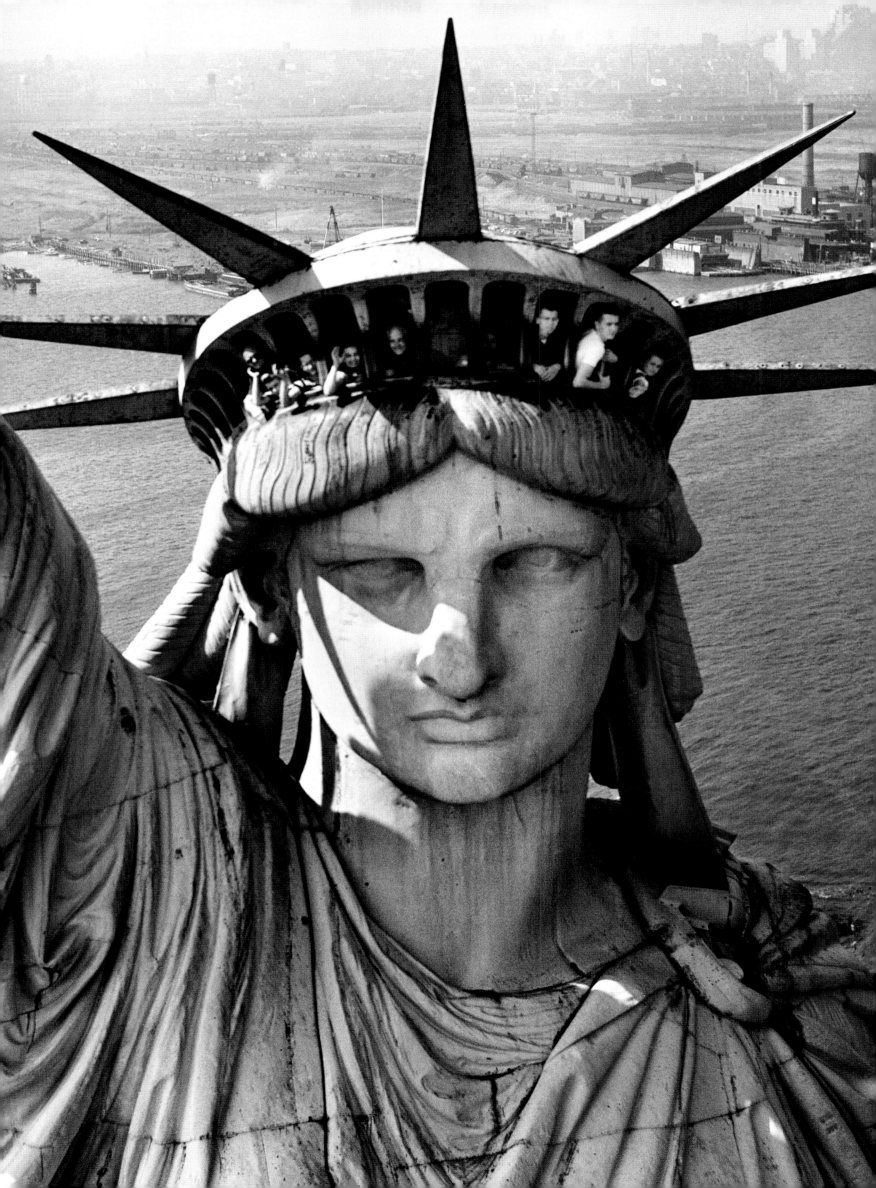

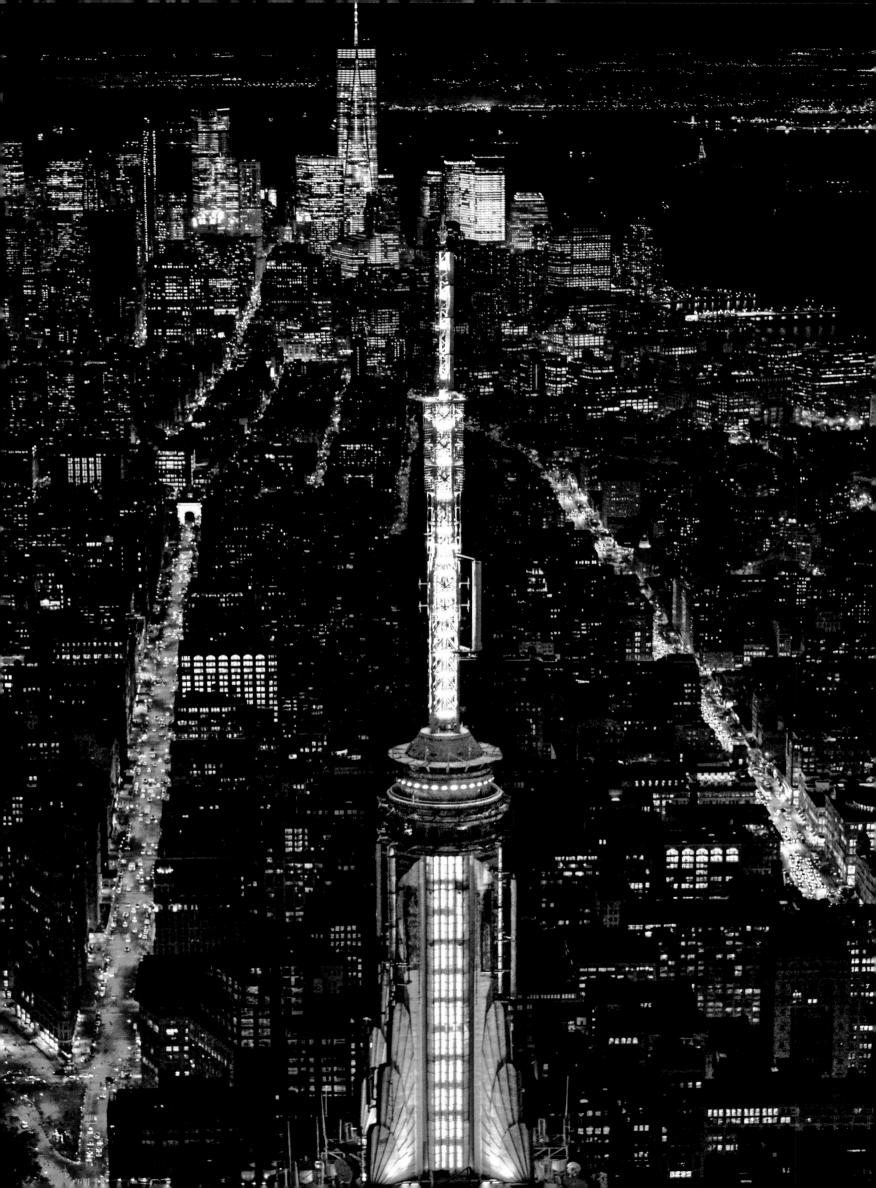

INTRODUCTION

All great cities attract the artist, the cartographer, and—more recently—the photographer. The successive practitioners of these crafts have variously captured the growth of cities over time. In earlier centuries, city walls, churches, and aristocratic palaces were strongly featured; they represented the security, the faith, and the strength of the people within the walls. Until the Middle Ages the task of recording was not too difficult; cities were small and developed only slowly; they had often grown in a valley or at a river crossing.

A valley location allowed for overviews from higher ground—and often a whole city could be captured in a single sketch. Castle towers and church domes or spires broke the upper horizon, and often the tiny figures of merchants or citizens could be perceived on the lower margin.

By the 1500s to 1600s, many cities had become too large for this type of overview treatment. Maps began to come in, depicting the entire extent of a city— far more than the eye could take in from any one vantage point. Gone were the artistic embellishments: perhaps gods breathing out winds or angels with trumpets overhead; perhaps savage animals or monsters patrolling the foreground; or perhaps orchards bearing bountiful fruit. Instead, inset panels might name numbered landmarks, particularly churches, colleges, or other major public buildings and streets.

At some time between the 1850s and 1900 or so, many capital cities and manufacturing cities had become too large for this convenient treatment; if maps were to have readable type, the sheets became too large for convenient use. One answer was sectional maps, with the viewer using only what was needed; another was to develop specialized maps providing only selected information: hence maps of churches, museums, theaters, colleges, and so on.

The modern age, the twentieth and twenty-first centuries, has intensified all the problems of "capturing" cities visually, but has also provided a superb new tool for ensuring capture. Aerial photography, which came in fitfully in the 1870s, soon became a very flexible tool that, in the hands of creative practitioners, has given rise to a distinguished and ever-growing body of work.

New York City—and Manhattan in particular—was in many ways an ideal subject for aerial photographers. The central city is both remarkably compact and also includes a remarkable variety of elements, facts not lost on early navigators. Once through the Narrows—the gateway to the Lower Bay—the southern tip of Manhattan Island stands at the head of the Upper Bay. Manhattan was in fact a perfect site upon which to found a colony, as the Dutch did in 1624. Fortunately, the narrow shape of Manhattan and the fact that it was an island of only moderate size (13.4 miles in length; 2.2 miles in breadth) greatly helped early artists and cartographers—and from the twentieth century on, this was an advantage to aerial photographers.

| WORKING SPIRES |

Though they may appear decorative, adding distinction to their structures, spires also serve electronic, communications, and related functions. In the case of the Empire State Building, initial plans called for a dirigible mooring station, soon abandoned as unmanageable—and potentially dangerous.

Early depictions of Manhattan clearly show a number of vital factors, among them fine access by water, compactness and defensibility, and a substantial tract of land to the northeast that would allow for future expansion. In terms of chronology, by the 1600s visual depictions and maps had left behind fanciful depictions and imaginative conceptions. Cartography had moved into the era of the accurate and the exact, where measurement had superseded estimation. One factor in this transition was that colonization meant investment—and investors were not prepared to commit their funds to a *terra incognita*, or to any unproven promise of gold in the mountains... Furs and skins were key items of trade—and if animal life was abundant, this could be confirmed as being so. Cartography shed its artistic patrimony and embraced its scientific future.

But the great revolution came about in the 1870s with the beginnings of aerial photography. The earliest examples (including shots of Boston at that time) were naturally not very impressive. Film stock quality could not be guaranteed, and many potential scenes were partly masked by the smoke of innumerable coal-burning fires—with manufacturing plants making a major contribution—and by the vibrations that endlessly disturbed smooth flight in early propeller-driven aircraft.

New York can be considered an ideal subject for photography from the air. The Narrows and the Upper and Lower Bays form a majestic foreground while the compactness of Lower Manhattan (the site of the Dutch and subsequent British colony) allows capture of both the old curvilinear street patterns and, to the north, the rectangular grid (begun in 1811) of parallel avenues extending northward and parallel streets running east and west, with Fifth Avenue (New York's central spine) marking the division between east and west. Many major cities, with London, Paris, Vienna, and Moscow notable among them, straddle a river. New York differs absolutely in that Manhattan Island is flanked on both sides by rivers, with a third river, the Harlem River, separating Manhattan's northern tip from the South Bronx. Given the comparative narrowness of Manhattan (2.2 miles at its broadest), many aerial photographs "frame" the island, bordered by the Hudson and East Rivers. From a greater height, the whole of Manhattan can be captured, with the Upper Bay to the south and the Harlem River to the north both helping frame the island.

The great interest that the continuing photography of New York from the air provides is the variety of scenes simultaneously captured, and the rapid change over time. Photographs in the late nineteenth century capture both the Brooklyn Bridge and the Statue of Liberty, and those up until the mid-twentieth century confirm the fact that New York was not only a great business city but also a thriving port, with sail-bearing and steam-driven ships crowding the Hudson and East River piers. Every viewer of photographs of New York becomes aware of how powerfully development rolled north, with the Chrysler Building opening in 1930, the Empire State Building in 1931, and Rockefeller Center throughout the 1930s. These were gigantic and near-simultaneous footprints, taking development far north of Lower Manhattan and, in the case of Rockefeller Center, deep into Midtown. Given that the Great Depression began in 1929, these buildings represented a supreme gesture of confidence in the future of the economy and of New York City.

Since that time, the construction of new high-rise towers appears to have been Manhattan's key enterprise. As this volume's images show, there has been a proliferation of building projects, continuing with ever-taller towers up until the present time. But these towers are not the only potent image of New York. The city's bridges are remarkable for their engineering boldness and their sophistication of design; they confirm that New York is a great business center, drawing on 1.5 million workers living beyond its rivers. But there is a far quieter New York, perhaps best exemplified by the 840-acre Central Park, though generously supplemented by Union Square, Chelsea Piers, Washington Square Park, and other places of recreation. Here the streets seem far away and the hum of activity is far less pronounced.

If the Empire State Building's 102nd-floor observation deck offers great urban views, then Central Park offers unrivaled green tranquility in which to recollect them. New York certainly has it all...

10 · 11 | WATERFRONT SCENES |

One World Trade Center, the Brooklyn Bridge, and the Manhattan Bridge (curiously shadowed in blue in the water) do much to define Lower Manhattan. Noteworthy is the intensive urbanization of Brooklyn and the New Jersey shorelines, both of which show much evidence of continuing maritime activity. The significant clustering of steel-and-glass towers in the Financial District forms a sharp contrast with low-rise Brooklyn and (to the right) Manhattan's Lower East Side.

12 · 13 | LACEWORK OF LIGHT |

In this image, the avenues are running from west to east, with Madison Square Garden at 7th Avenue and 33rd Street and, above it, the Empire State Building at Fifth Avenue and 34th Street. Moving left (northward), the huge cluster of high-rise buildings north of 34th Street becomes visible. Upper left is the Citigroup Center with its familiar sloping roof. Numbered avenues and streets make the task of finding destinations in New York much easier than anomalous street names.

14 · 15 | BIRD'S-EYE VIEW |

A seldom-seen view of Central Park showing the American Museum of Natural History outside the park, and the Metropolitan Museum of Art inside it. Game courts of various types show up as light brown, and the park's dense tree cover is very obvious. The north is to the left side, where Harlem Meer dominates the greensward. At the top of the image is the East River, the Queensboro Bridge, and Roosevelt Island; at the bottom is evidence of the Hudson River's bustling maritime activity.

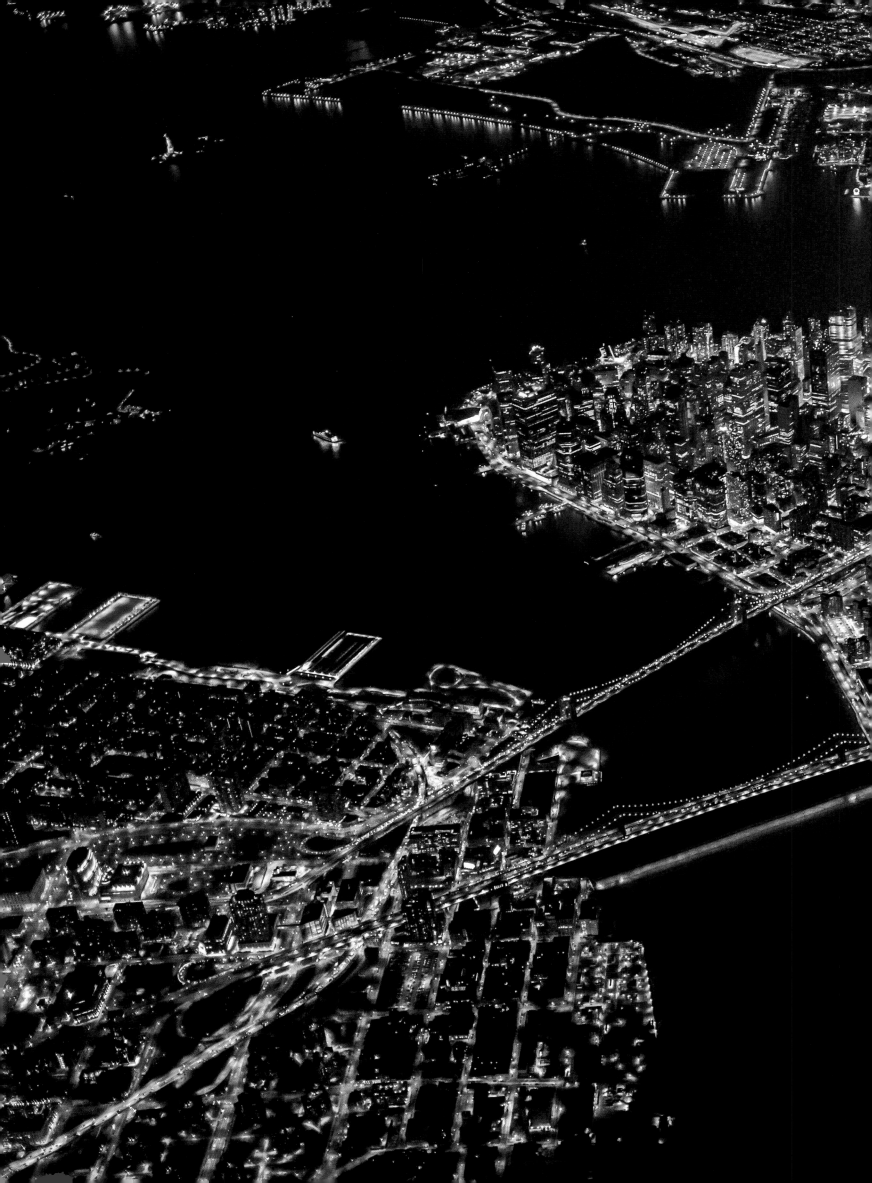

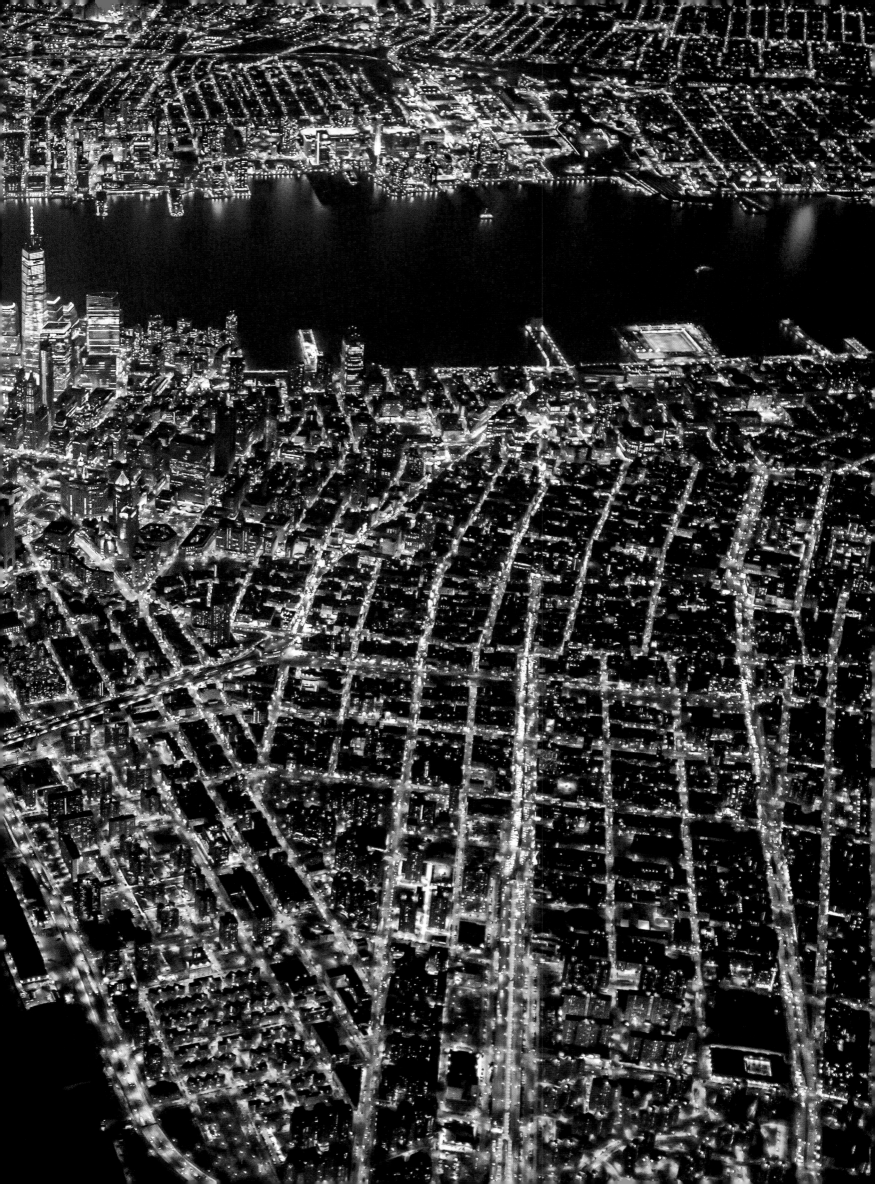

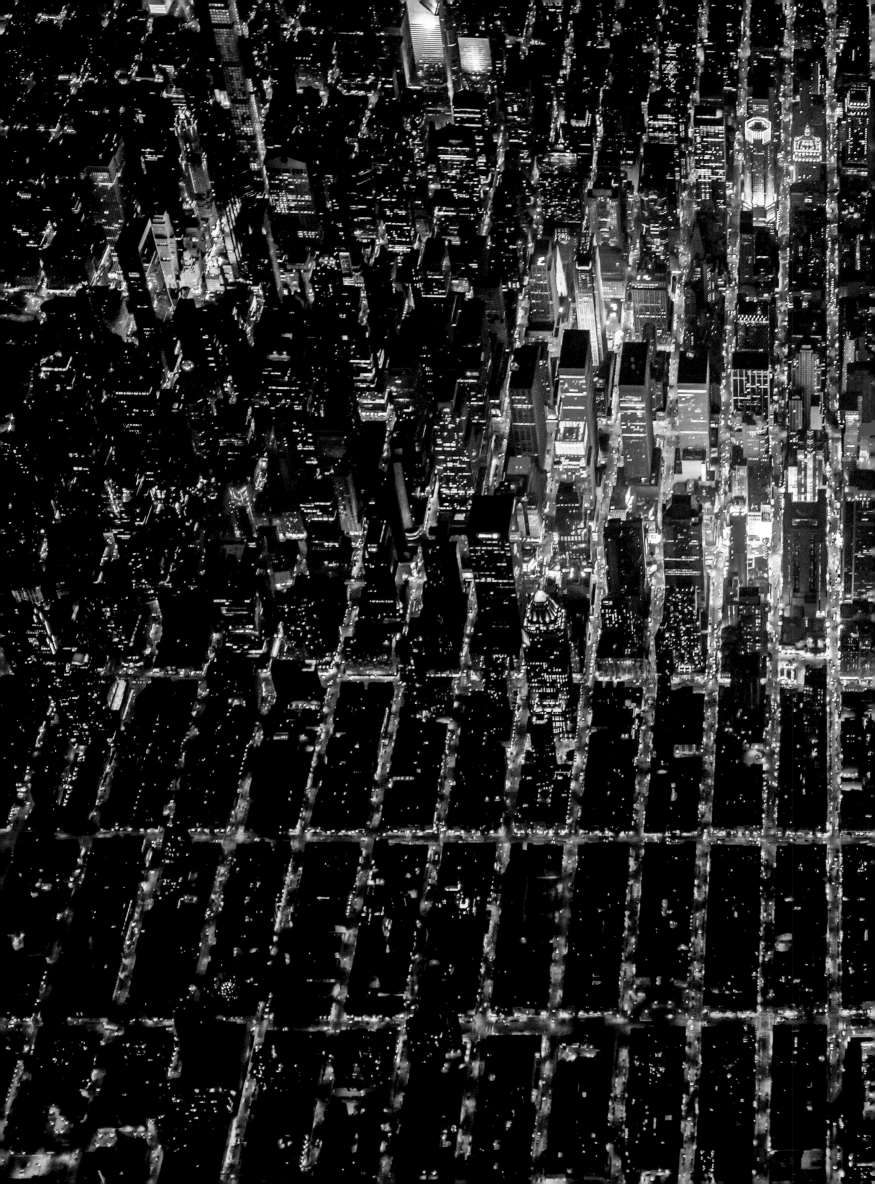

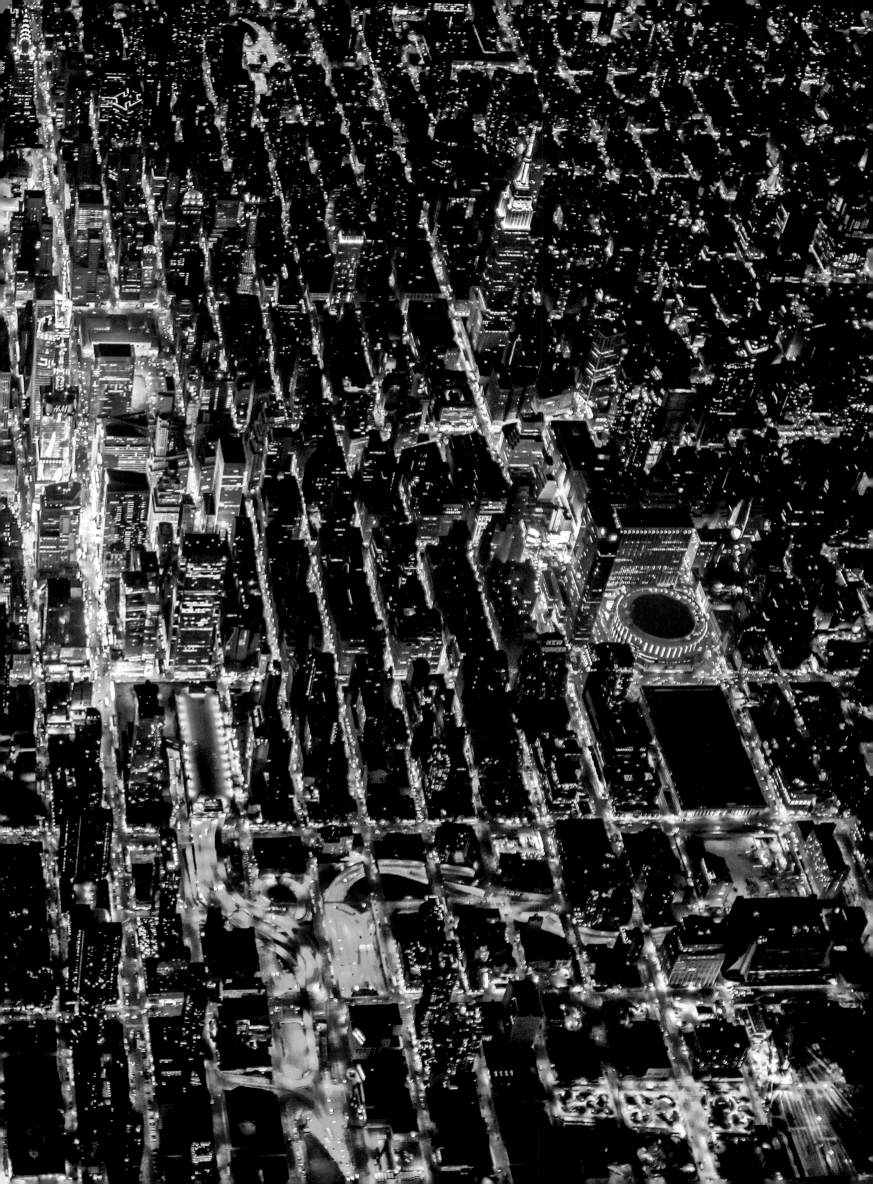

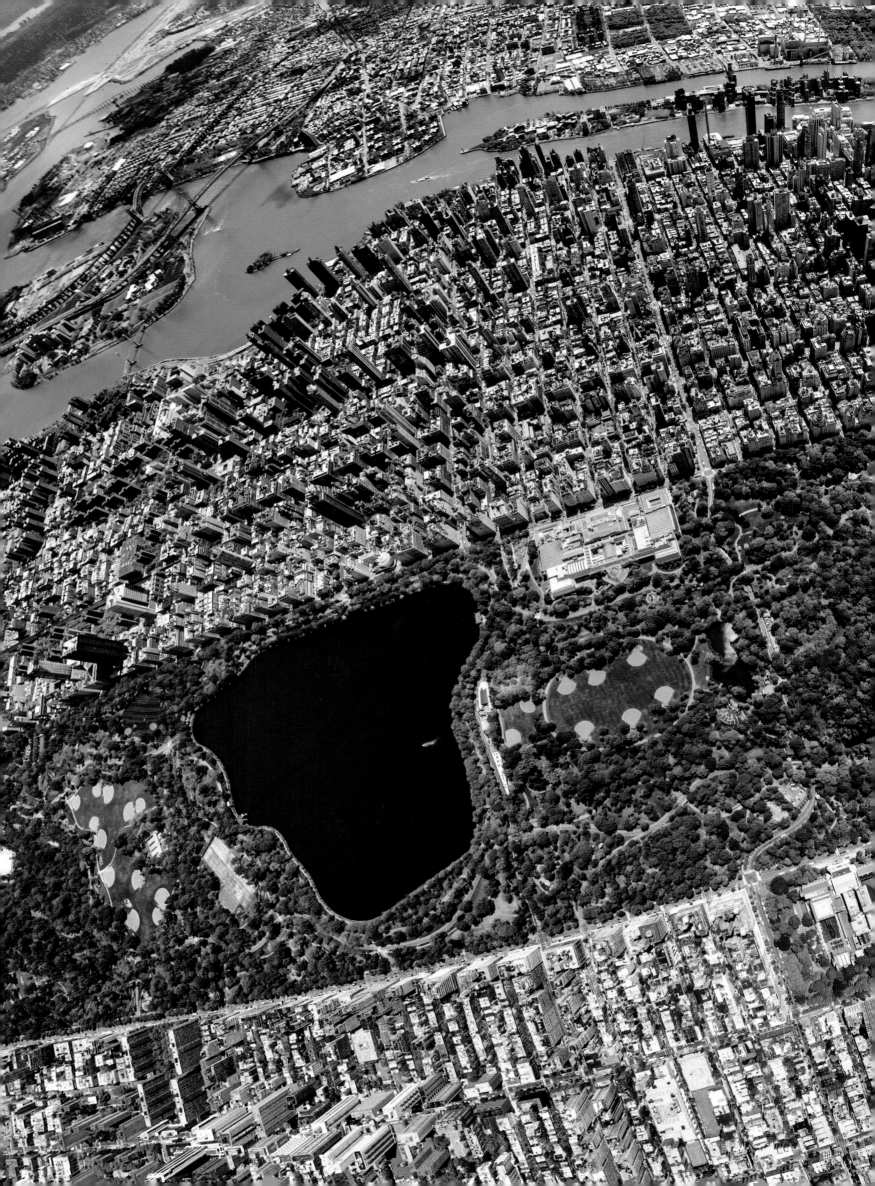

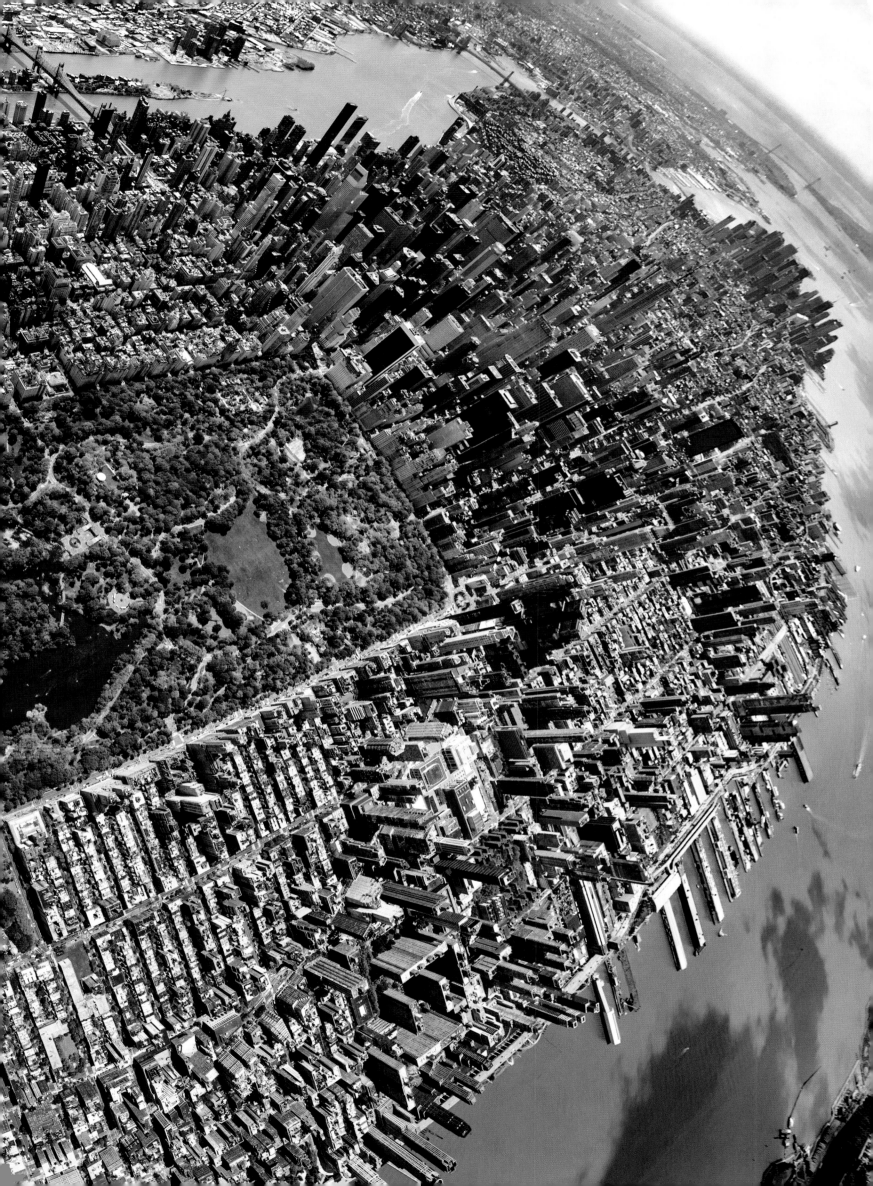

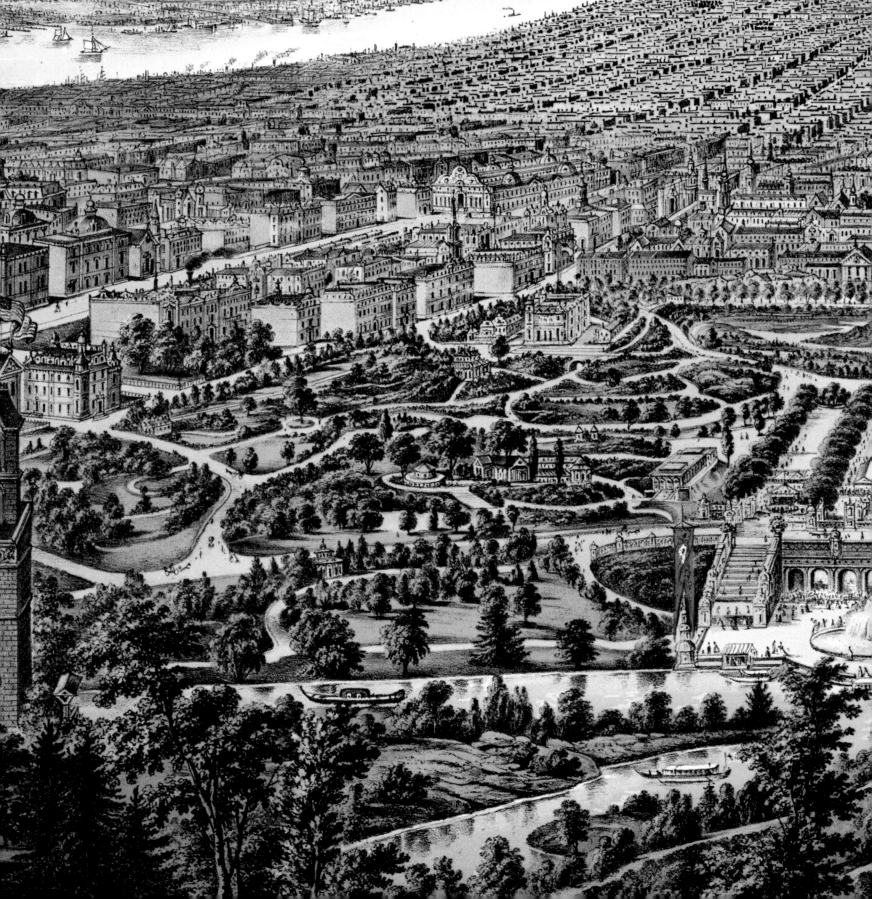

BEFORE AERIAL PHOTOGRAPHY

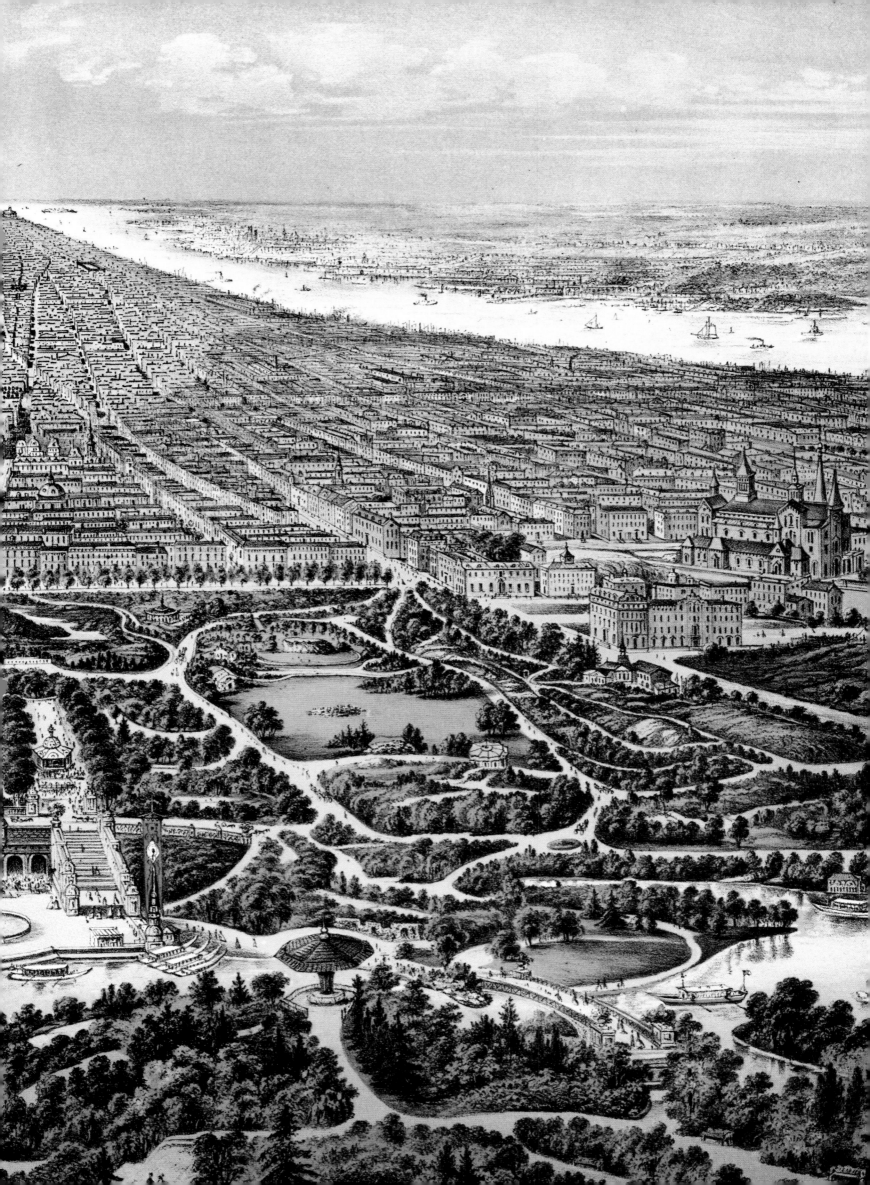

IMAGES OF NEW YORK FROM THE 1630s TO 1899

Viewed from above, the most striking feature about New York—or Manhattan as it can equally well be called—was its superb physical basis for steady and cohesive development. From a minute thumbtack of a settlement on its southern tip, urban development would naturally advance northward, swallowing outlying settlements, until reaching the island's northern tip. To any progressive thinker, New York's growth into a densely populated major city was eminently predictable.

Access and communications were first class. The bay that connects Manhattan to the Atlantic has a narrow and defensible mouth; the rivers that bound the island are easily navigable, with the Hudson serving as a huge artery to the northern hinterlands. Urban growth and development merely had to roll north over a terrain that offered no insuperable natural barriers.

Manhattan, an island some 13.4 miles long with a width ranging from 0.8 miles to 2.3 miles, encompassing an area of some 22.7 square miles, is composed largely of mica schist, an ideal foundation for manmade structures. The city commissioners' imposition of the grid plan in 1811, which called for easily traveled parallel avenues and cross streets for New York above 14th Street, ensured the orderly urban growth of the northern nine-tenths of the landmass. Farms and occasional clusters of homes and villages would eventually be swallowed up as New York expanded northward. The filling in of creeks, inlets, and small bays produced a very serviceable waterfront, home to an immense maritime trade. The engineering technologies of the nineteenth and early twentieth centuries made possible the bridges that linked a mighty metropolis to its fast-developing neighboring territories, and Manhattan, which became ever richer through trade and manufacturing, expanded relentlessly northward, creating one of the world's most iconic cities. However, for the first two centuries or so the pictorial record is modest, a complete contrast to the overwhelming photographic record of the twentieth and twenty-first centuries.

What does the pictorial—and later the photographic—record tell us? The first image of what is today's New York dates back to circa 1628, and depicts a small settlement at the southern tip of today's Manhattan. It was founded in 1624 by the Dutch West India Company, which was bent on anchoring its claims to a huge stretch of North America's shore and hinterlands. The company landed some 110 persons, some with wives and children, and named the settlement New Amsterdam, after the Netherlands' great port city. A year previously, the company had landed a group of settlers on a small island a half-mile to the south, an island that would later be called Governors Island, as it was reserved for use by the British royal governors. The aim in both locations was to create permanent and expanding trading posts, with beaver and other animal skins being a major commodity.

Though the Dutch were the first Europeans to settle on Manhattan—as the Native Americans called the island—they were not the first to see it. In April 1524, Giovanni da Verrazano looked out on New York's Lower Bay (the sea approach to Manhattan); in 1526, Estêvão Gomes of Portugal, employed by Spain, reached today's Hudson River; and in 1609, Henry Hudson of England sailed up the river now named for him. All noted the promise of the lands they saw, and their reports led Europe's maritime nations into a struggle for ownership and trade in the New York region.

From its birth, New Amsterdam was prepared for attack, as Britain, a rival power, had expansionist maritime aims. The fledgling New Amsterdam's largest building was the fortress at the southern tip guarding its cluster of homes, store-houses, windmill, and cargo ships against British or French attack, and a palisade to the north (Wall Street marks the line) as a defense against Native American marauders. The local Lenape tribe became less of a threat with Peter Minuit's purchase of Manhattan from them for trade goods worth 60 guilders, often valued as $24. The new settlement flourished, and in 1653, Governor Peter Stuyvesant incorporated New Amsterdam, though not yet the size of a town, as a city.

New Amsterdam was supposed to do more than fend for itself (and the windmill and the garden plots tell us something about early food sources); it was also required to enrich the mother city, "Old" Amsterdam, and the constant presence of ships in early representations of New Amsterdam bear witness to its involvement in trade, with the aforementioned animal skins being particularly prized.

A map of 1664 shows a very compact "city," dominated by its fort but with a lofty church and houses of substantial size. There was an expanding array of well-laid-out streets and gardens filling the area within the palisade, but with indications of enclosed farmlands beyond it. But any sense of quiet security was soon shattered. In that same year of 1664, the British were able to seize the settlement, the island, and its vast hinterlands, all to be renamed New York, as King Charles II's brother, James, the duke of York, had led the campaign. Within Europe and in the East Indies, the Netherlands and Great Britain had long been intermittently at war, each seeking to dominate the seas and secure the lion's share of trade. New York was indeed a valuable commercial prize.

The Dutch did not take the loss of New Amsterdam lightly, and with a masterful seaborne invasion regained possession in 1673, only to relinquish it in 1674, accepting a British-held spice island in the Dutch East Indies in its place. Under British rule, New York—with a population of over one thousand—grew

1630

steadily throughout the next century, expanding north beyond the natural "frontier" of today's Canal Street, which ran east-west, following a low-lying watercourse. During the next century, from the 1670s to the 1770s, New York steadily expanded and became an ever-busier port, growing in wealth and trade. But this peaceful evolution was soon to be interrupted, with the American Revolution pitting the colony of New York against the Motherland. A near decade of hostilities put an end to any possibility of a continuing untroubled existence.

Contention mounted in the early 1770s, with the English settlers in New York and North America protesting against the Crown's requirement to restrict their trade to supplying the mother country and to import needed goods only from her. The colonists also had to pay taxes to support defense and administration costs; as they could not send an elected representative of their own to Parliament, they saw no hope for securing remedies for any of their grievances. "No taxation without representation" became the colonists' rallying cry. They supported this with action, and made the rebellious decision to stop paying certain taxes. Negotiations between the Crown and the colonists broke down, and in 1776 the colonists declared their independence. Britain responded with military movements and occupied New York, which, given its 25,000 or so inhabitants, was a key strategic location. Within days of the British occupation of New York, in September 1776, a disastrous fire broke out, destroying some five hundred houses (many were now substantial, well-built homes with gardens and access to the water) and damaging about a third of the city, mainly on the western side. Military operations in the ensuing years caused much additional damage to both buildings and crops in the fields adjoining the city. Then, In November 1783, with British defeats in North America mounting, the war wound down, and George Washington led the victorious "Americans" into the city.

Historic events now happened in rapid sequence. For the three years from 1785 to 1788, New York served as the capital of the newly emerging nation, and thereafter, in 1789, as capital of the formally constituted United States, until 1791, when the largely unbuilt but envisioned Washington, in the newly created district of Columbia, was designated as the nation's capital. Unfettered from the burden of being a capital city, New York continued to grow as a great trade entrepôt, with a constantly burgeoning number of immigrants, for a total population of 90,000. Trade, manufacturing, agriculture, and the population's housing and transportation needs led to a subtle physical reshaping of New York's profile, with landfills smoothing out the shore line and with streams and riverlets being paved over and building projects advanced.

1899

As a now rich city and port, New York naturally began to invest more heavily in its own future and in public and civic amenities. Many nineteenth-century pictorial representations of New York began to show the city's new attractions and landmark structures. In the early 1800s, Battery Park, on the southern tip with the circular Castle Clinton (the old square Dutch fort of 1628 was long gone) had become a popular, breezy gathering place with spectacular views toward the mouth of the Lower Bay and the Atlantic. North of the square, at 14th Street, the grid plan began, shaping the city's development. The plan called for a "central park" occupying the land between Manhattan's central spine of Fifth Avenue and over westward to Eighth Avenue, running from 59th to 110th Street, an area of 843 acres. The surrounding land, though mapped, was by no means fully developed. Central Park was completed in 1853, one of the world's earliest and finest urban parks, with an unsurpassed mix of meadow, woodland, and water. The park's magnificent centerpiece Mall is still treasured for its welcoming colonnades and elegant walkways.

While providing a treasured "lung" and an escape into greenery uptown, New York was bursting at the seams downtown. Horse-drawn trams and private carriages brought manufacturers, merchants, lawyers, clerks, and retail works from uptown to downtown and fleets of ferries endlessly plied the harbor's waters, bearing people and goods to and from Brooklyn, just a few hundred yards distant across the East River. Brooklyn dated back to the mid-1640s when Dutch settlers had built settlements on the southern tip of Long Island; it had been founded with the Dutch name of Breuckelen. It was now a thriving city, whose name had become Anglicized to Brooklyn, and the new name came to denote the entire southern end of Long Island, which later became a borough of New York.

1630

A bridge from Manhattan to Brooklyn was desperately needed. The long process of building one took from 1870 to 1883 to complete. It was recognized as an engineering triumph of the day, and the main span, which measured 1,596 feet, carried elevated trains and streetcars as well as motor vehicles. Later the train and streetcar traffic was discontinued and today the bridge carries six lanes of motor traffic, and also provides pedestrian and bicycle lanes. The massive link was not formally named the Brooklyn Bridge until designation as such by the city council in 1915.

1899

The only rival to the Brooklyn Bridge as New York's most widely known historic icon is the Statue of Liberty, conceived by the French sculptor Frédéric Auguste Bartholdi and built by Gustave Eiffel—a gift from the French nation to the United States, honoring both nations' belief in liberty and enlightenment. The copper-sheet statue, rising 151 feet from its base to the goddess Libertas's torch, was shipped in sections from France and assembled in New York on its island site in the Upper Bay. A cost crisis occurred during construction; it was met with 120,000 Americans making small contributions. The statue was dedicated on October 28, 1886, and was seen by twentieth-century seaborne immigrants—and even by today's airborne visitors—as a symbol of welcome.

The infinitely detailed panoramas of nineteenth-century New York and its adjacent counties are of endless fascination to historians. However, the long views, drawn from an only moderately elevated viewpoint (most often from "above" Battery Park on Manhattan's southern tip) depict the nearer areas better than the farther ones, and such identifiers as church steeples are seldom depicted strongly enough to fully serve this purpose. What we miss are the specific buildings and systems that are within the panoramas but are not presented from directly above; they lose definition. Yet neighborhood streets, churches, meeting halls, and green spaces are a vital part of New York's development and, in many cases, of its architectural heritage. As the brief survey that follows will confirm, they cannot be presented—or viewed—from directly above.

Columbia University (founded in 1754) is a good example. It left its downtown site on Madison Avenue in 1896 and reestablished itself on Morningside Heights, at 116th Street. Its immense campus—which is still expanding—has a spaciousness and cohesion that impresses both students and visitors alike. Also impressive is the High Bridge at 173rd Street in Upper Manhattan, built in 1848, that carried the Croton Aqueduct's water tunnel over the East River, to continue down to a reservoir at Fifth Avenue and 42nd Street. Demolished in the 1890s, the reservoir's site is now Bryant Park, on which New York Public Library was later built. Also lost in panoramic views is Grand Central Terminal.

A further great milestone in New York's history deserves mention: in 1898, the Borough of Brooklyn legally became an integral part of New York—with New York City serving as the formal title of the five-borough entity: Manhattan, Brooklyn, Queens, the Bronx, and Staten Island.

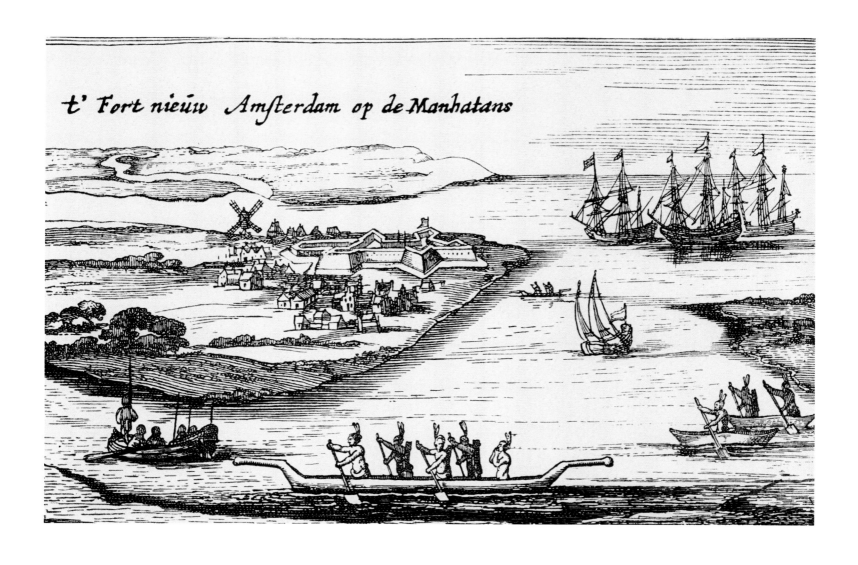

t' Fort nieúw Amsterdam op de Manhatans

| 1628 | JOOST HARTGERS' MAP OF NEW AMSTERDAM |

Known as "Hartgers' View," this is the earliest recorded view of the infant Dutch settlement of New Amsterdam. The fortress, the northern wall, and the southern harbor dominate New York (Manhattan to the Native Americans) in the mid-1600s. Trade—the purpose of the colony—required security from Native American or English attacks. For the colonists, gardens provided essential supplements to their diet; the windmill was essential for grinding imported or locally grown grain into flour.

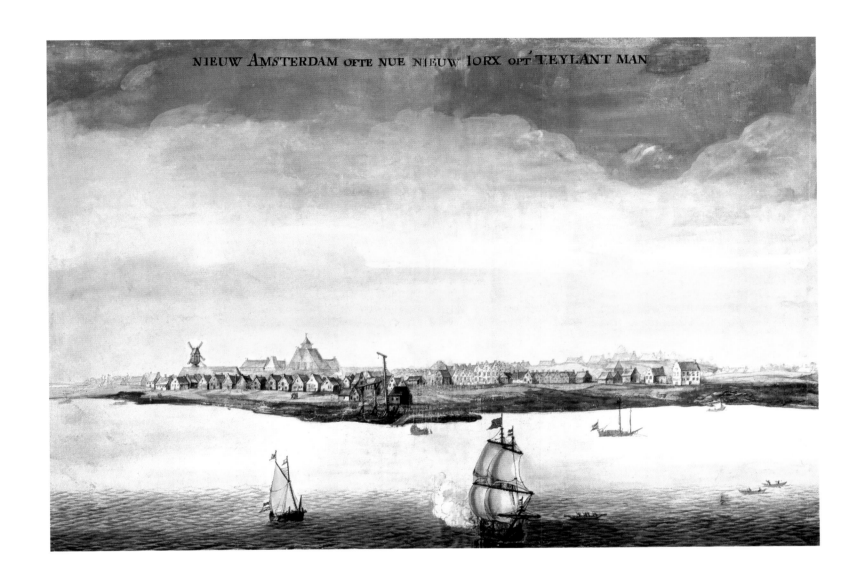

NIEUW AMSTERDAM OFTE NUE NIEUW IORX OPT TEYLANT MAN

| 1664 | DUTCH NEW AMSTERDAM: NOW BRITISH NEW YORK |

This view of early British New York shows an almost tranquil village, marked by the orderly row of neat little houses in the left foreground. All have large front yards extending to the Hudson River waterfront. The substantial buildings behind, however, hint at a larger, busier settlement, with the biggest building being a handsome church or the town hall. The cargo hoist confirms the colony's role as a trading post, though very little ocean-going or local shipping is in view.

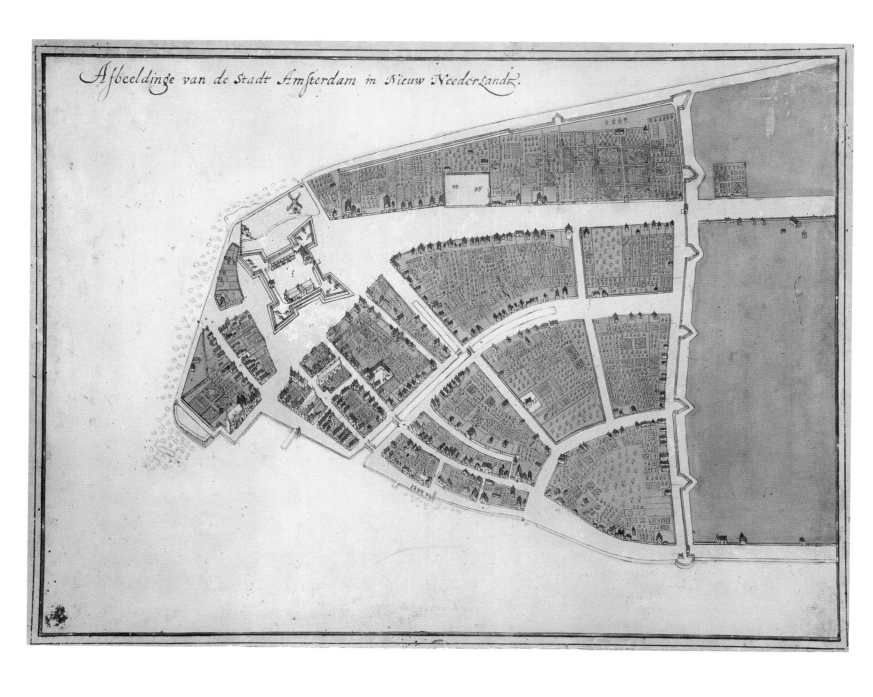

Afbeeldinge van de Stadt Amsterdam in Nieuw Neederlandt.

| 1660 | MAP AND STREET PLAN OF NEW AMSTERDAM |

The elaborate fort and breastworks shown here did not in fact quite measure up to the dimensions depicted; the four corner bastions were not built and the fort remained foursquare. The harbor now has a pier and an inlet to assist shipping. Though additional streets have been laid down, the houses on them are not crowded and have spacious gardens; no area appears to be fully built up. The defensive wall—the Wall Street of later years—is complete with bastions at intervals.

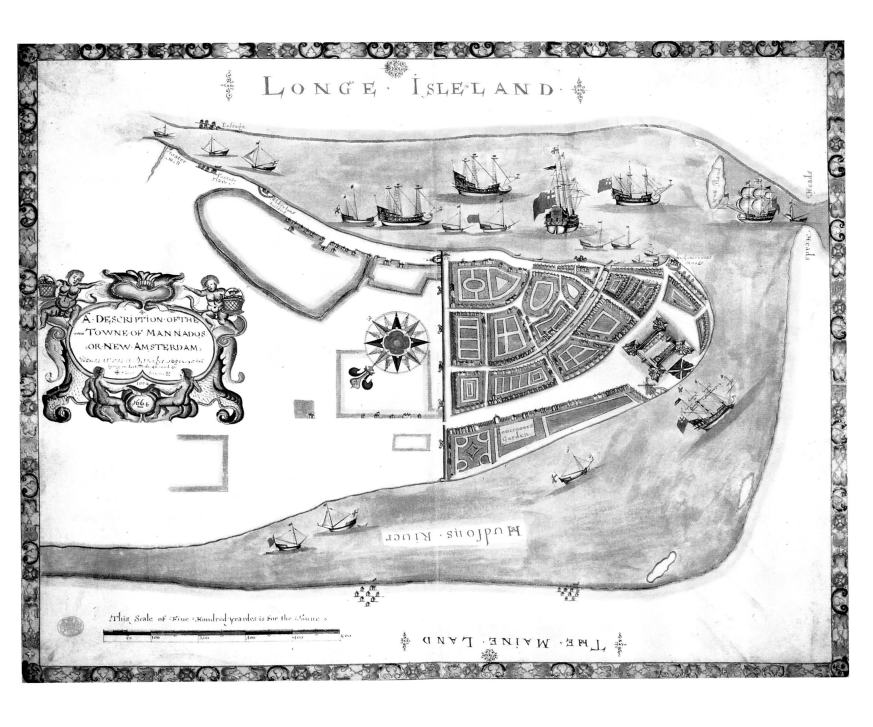

| 1664 | A DEPICTION OF NEW YORK AND ITS REGION |

This colorful map may be something of a sales piece in depicting what appears to be a very attractive planned township, with parkland, squares, and crescents. It clearly illustrates development beyond the wall, and the map is valuable in depicting Long Island (top), the Hudson River, and "the mainland" beyond (bottom). In addition, it provides a compass rose to allow for correct orientation, and a scale bar for help in determining distances.

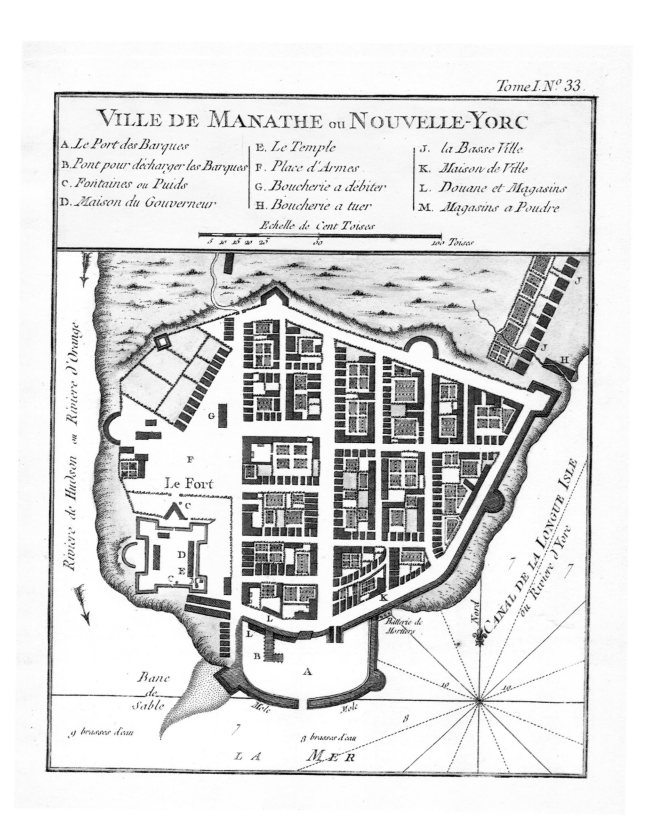

VILLE DE MANATHE ou NOUVELLE-YORC

A. Le Port des Barques
B. Pont pour décharger les Barques
C. Fontaines ou Puids
D. Maison du Gouverneur

E. Le Temple
F. Place d'Armes
G. Boucherie a débiter
H. Boucherie a tuer

J. la Basse Ville
K. Maison de Ville
L. Douane et Magasins
M. Magasins a Poudre

Echelle de Cent Toises

| 1763 | NEW YORK IN AN IMAGINATIVE DEPICTION |

Imaginative and artistic enhancements were not unknown in later depictions of early New York. In this retrospective map of 1763, the town's street layout is at odds with reality, and the "Wall Street" wall has assumed a new configuration, plus extensive east-side additions. A handsome complex of substantial and well-designed and built quays now extend from the tip of Manhattan. Streets are unnaturally straight, houses are bigger, and gardens smaller than was the actual case.

| 1776 | LAND USE AND DEVELOPMENT MAP OF NEW YORK |

This map is a useful corrective, showing scattered development way beyond Wall Street. Though Greenwich Road (to Greenwich Village) is depicted, the bigger Broadway, the main road leading north, is not. The commitment to farming and husbandry for grain, fruit, and meat needs is clearly shown. The Lower Manhattan foreshore is still ragged and irregular; "smoothing out" with landfill is not yet underway. Likewise, the terrain still shows undeveloped areas, with obstructive rises and ponds.

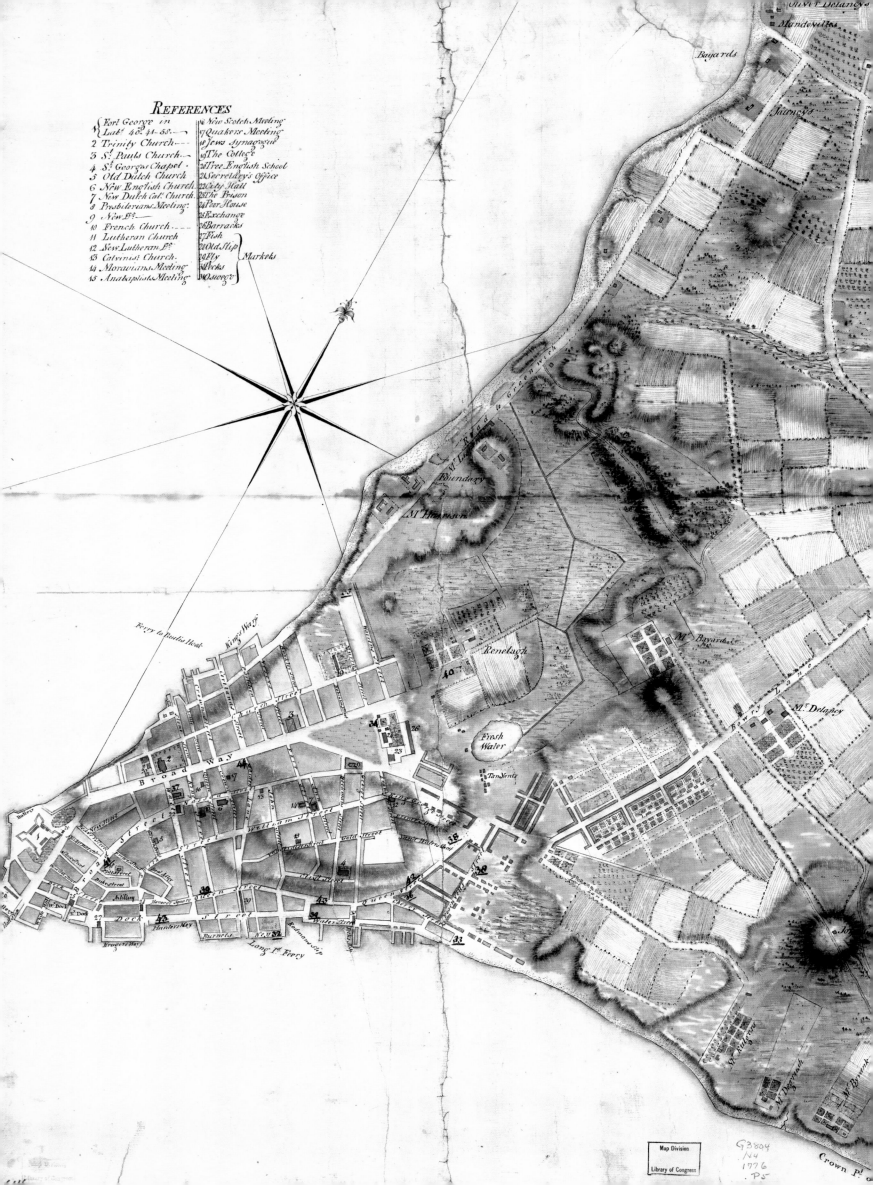

REFERENCES

1 Fort George in Latd 40°. 41'. 58".
2 Trinity Church
3 St Pauls Church
4 St Georges Chapel
5 Old Dutch Church
6 New English Church
7 New Dutch Cal. Church
8 Presbiterians Meeting
9 New Do
10 French Church
11 Lutheran Church
12 New Lutheran Do
13 Calvinist Church
14 Moravians Meeting
15 Anabaptists Meeting

16 New Scotch Meeting
17 Quakers Meeting
18 Jews Synagogue
19 The College
20 Free English School
21 Secretary's Office
22 City Hall
23 The Prison
24 Poor House
25 Exchange
26 Barracks
27 Fish
28 Old Slip
29 Fly
30 Oswego } Markets

Ferry to Paulus Hook

King's Way

Broad Way

Fresh Water

Renelagh

Tan Yards

Mr Harrison

Boundary

Road to Greenwich

Bowry Lane

Mr Bayard

Mr Delaney

Bayards

Delaney's

Oliver Delancey

Mandevilles

Mr Bayard

Mr Ridgee

Mr Delancey

Mr Bayard

Mr Bywank

Long Id. Ferry

Crown Pt

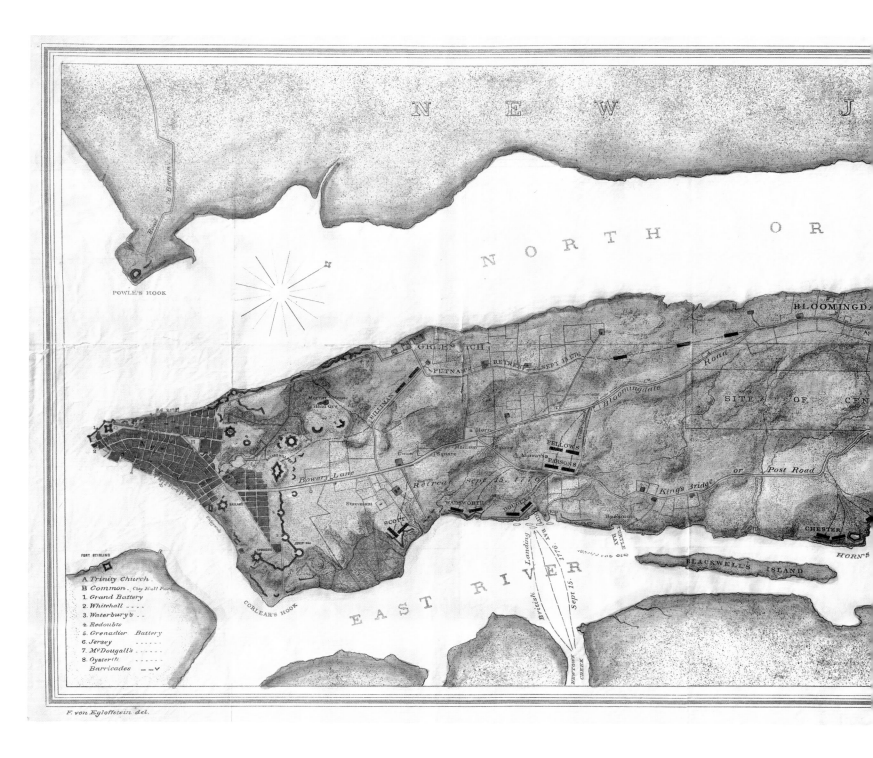

| 1776 | MAPS WERE VITAL IN THE REVOLUTIONARY WAR |

This contour map of 1776 shows military defense points maintained in New York during the Revolutionary War. The map shows both the Harlem River and also what is now Roosevelt Island in the East River. It depicts Manhattan Island before decades of landfill smoothed out the shore-lines, filling in creeks and gullies while creating more land on which buildings could be erected. Urban development was still very sporadic, though Blooming-dale and Harlem had both been founded in the 1600s.

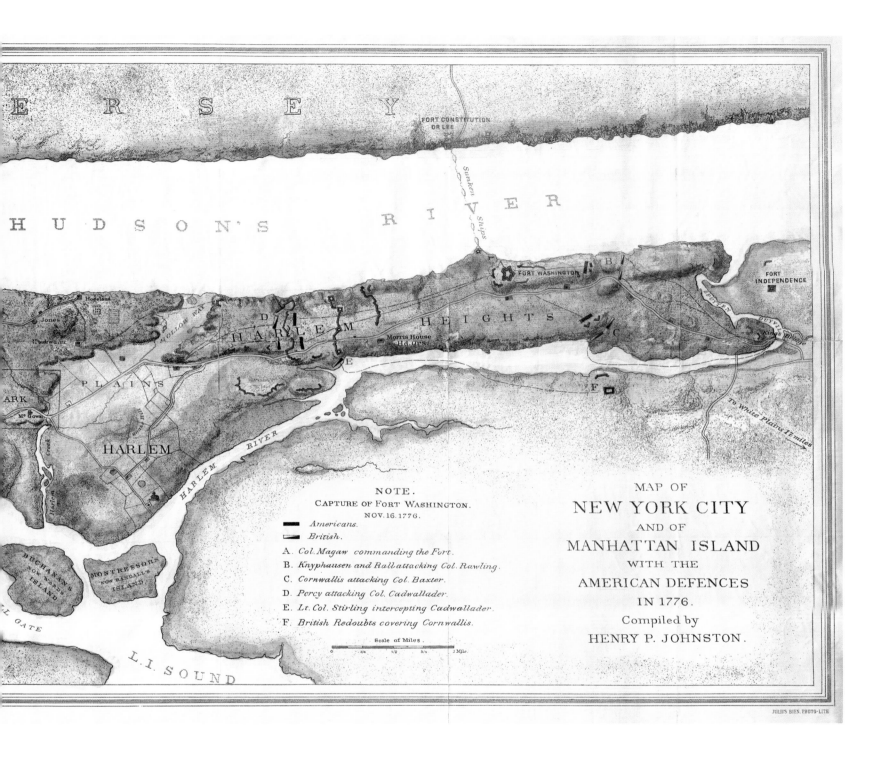

MAP OF
NEW YORK CITY
AND OF
MANHATTAN ISLAND
WITH THE
AMERICAN DEFENCES
IN 1776.
Compiled by
HENRY P. JOHNSTON.

NOTE.
CAPTURE OF FORT WASHINGTON.
NOV. 16. 1776.

▬ Americans.
▭ British.

A. Col. Magaw commanding the Fort.
B. Knyphausen and Rall attacking Col. Rawling.
C. Cornwallis attacking Col. Baxter.
D. Percy attacking Col. Cadwallader.
E. Lt. Col. Stirling intercepting Cadwallader.
F. British Redoubts covering Cornwallis.

Scale of Miles.

JULIUS BIEN. PHOTO-LITH.

A leap forward from 1776 to 1856 shows the almost incredible speed of development in Manhattan, with waterfront activity reaching the fever pitch so well captured by Herman Melville in his novel *Moby Dick* (1851). Steam and sailing vessels share the waterways. The circular Castle Clinton (bottom left) has replaced the old Dutch square fort, and, toward the center, Trinity Church overlooks Broadway. Buildings are densely packed together, and few rear tenants enjoy much light.

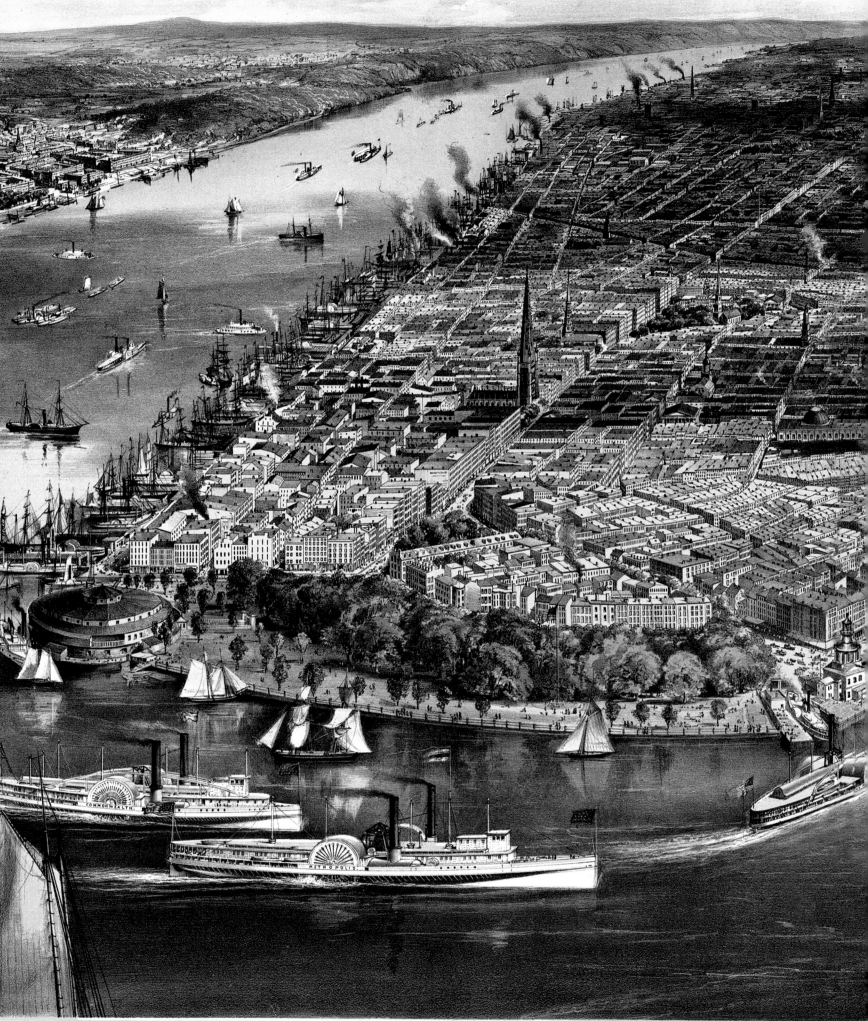

AND DRAWN ON STONE BY C. PARSONS.

HOBOKEN N. J.
HUDSON RIVER.
CASTLE GARDEN, *EMIGRANT DEPOT.*

BATTERY.

BOWLING GREEN.

St JOHN'S CHURCH AND PARK.
St PAUL'S CHURCH.
TRINITY CHURCH, BROADWAY.

CITY HALL AND PARK.
POST OFFICE.
CUSTOM HOUSE.

CRYSTAL PALACE. PALACD
WASHINGTON PARADE GROUND AND CHURCHES ON 5th URCHES W
MERCHANTS EXCHANGE WALL S½GE WALL
STATEN ISLAND FERRYND FE

CITY OF

NEW YORK, LITH. AND PUB. LITH
Entered according to Act of Congress in the yr of Congress in

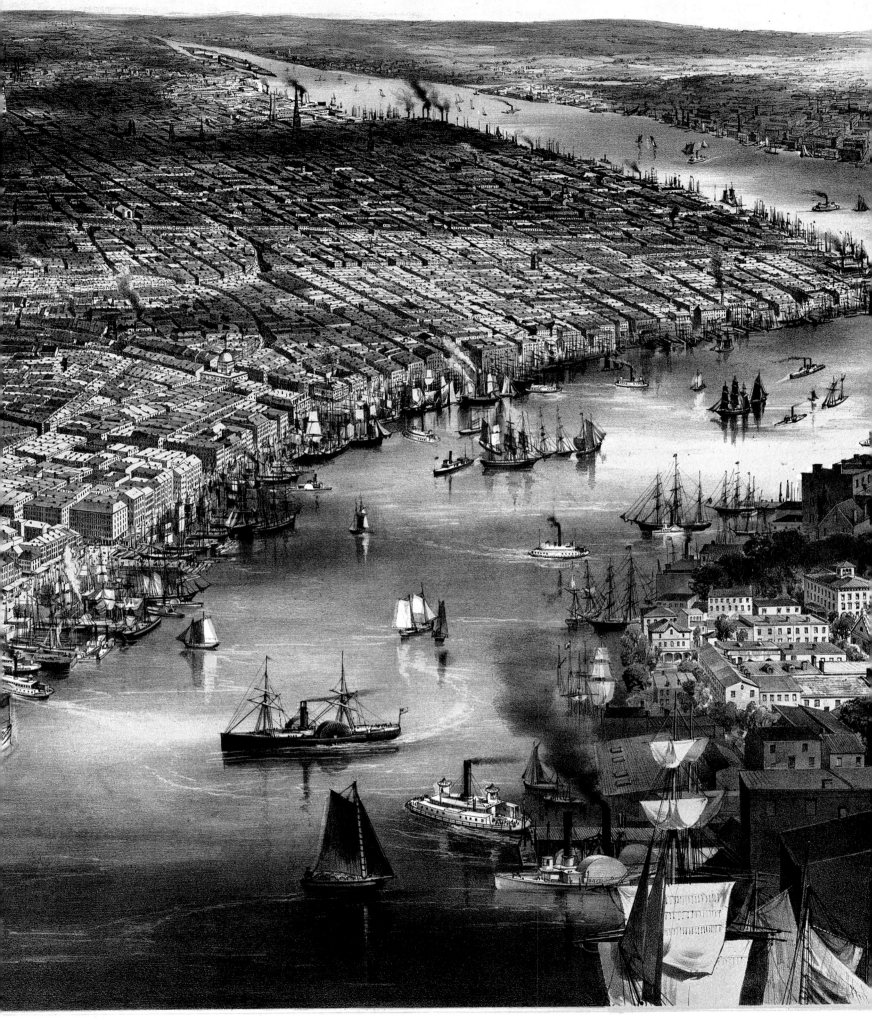

EW YORK.

N CURRIER, 152 NASSAU STREET.
e Clark's Office of the District Court of the Southern District of N.Y.

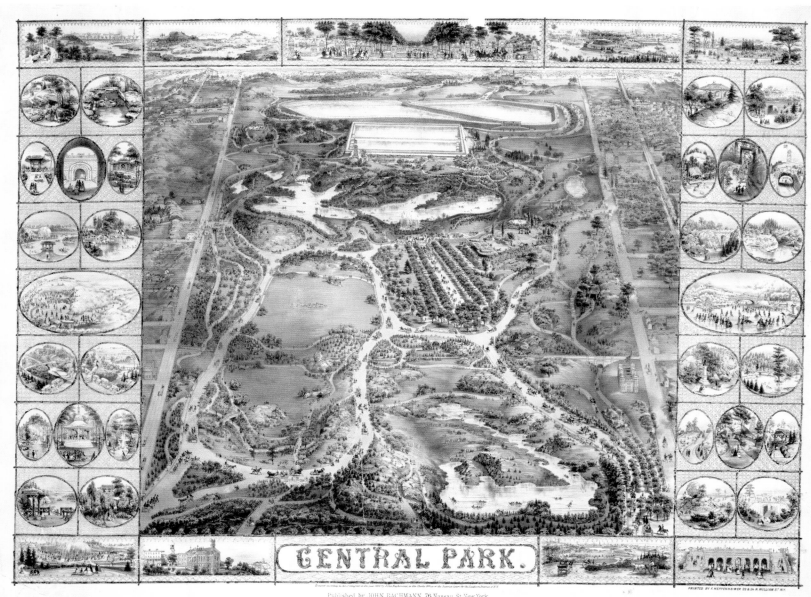

Published by JOHN BACHMANN 76 Nassau St. New York

| 1863 | CENTRAL PARK, WITH DESCRIPTIVE VIGNETTES |

This foreshortened view of Central Park shows the popular Mall (center) and, moving south to north, the Pond, the Lake, the Reservoir, and Harlem Meer—with this last now a single smaller lake. In its earliest days, the undeveloped park area housed tramps, ruffians, and many homeless persons, all of whom were removed as Frederick Law Olmsted's master plan was implemented and roadways, plantings, and meadows appeared. The greensward shown beyond the park's boundaries is a fanciful addition.

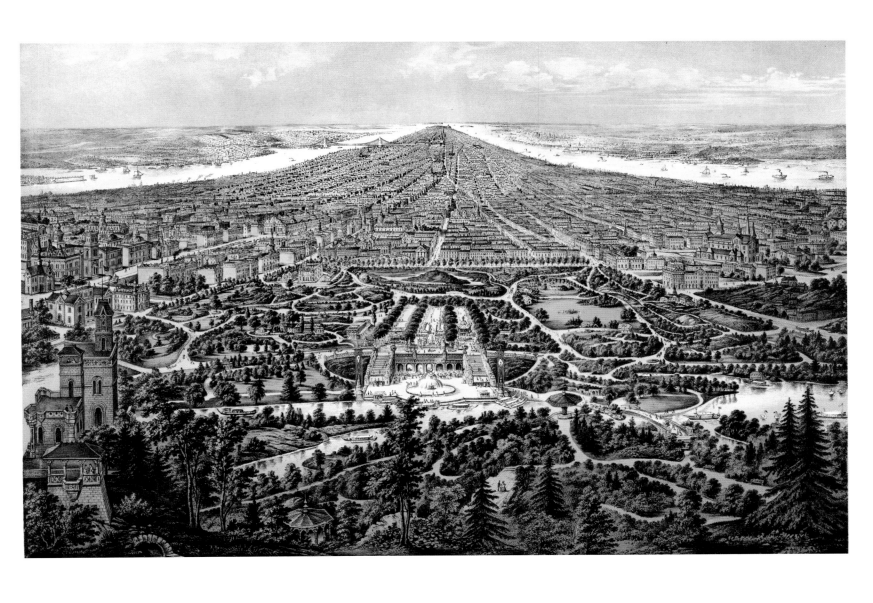

| 1873 | CENTRAL PARK: A VIEW FROM NORTH TO SOUTH |

Here the park is depicted looking south from the Mall. The drawing shows the handsome balustraded stairways on each side of the Mall, and the plaza and balcony overlooking the fountain, today a favorite trysting spot for young lovers. The drawing shows mansions beginning to dot Fifth Avenue, the park's eastern border. Also visible in an imaginative rendering is the mock medieval castle that serves as the park's on-site administrative offices. Adjoining it today is a children's zoo.

This map, printed as an advertising piece by the clothiers Rogers, Peet & Co. (in business from 1871 to the 1980s), had a long life as a handout. The copyright date is 1879, but the Brooklyn Bridge (here greatly oversized) did not open until 1883. The map highlights the bridge's powerful presence and great span, and also captures Broadway, marking its diagonal route north. New York was at its height as a great port city, bristling with piers and crowded with ships on all waterfronts.

38 · 39 | 1883 | NEW JERSEY, MANHATTAN, AND BROOKLYN |

This bird's-eye view manages to capture an impressive array of shipping of all types before we cross the Hudson from New Jersey to Manhattan, which is bristling with both shipping piers and church steeples. Lower Broadway is clearly depicted, and to the east rises the massive, but here grossly oversized, Brooklyn Bridge. Governors Island can be seen below the bridge, off the Brooklyn shore. Long a defense installation, Governors Island is now being redeveloped as a park.

40 · 41 | 1885 | THE PROUD AND INDEPENDENT CITY OF BROOKLYN |

Brooklyn was known as "the borough of churches," and a church often served a specific ethnic group that gave character to a neighborhood. The city was intensively developed and densely populated, the home of many wealthy merchants, and had fine parks, a museum, and public libraries. In 1898, Brooklyn fought—unsuccessfully—against incorporation as a borough of New York. The City of Brooklyn saw no reason to give up its independence and become a smaller part of a larger whole.

42 · 43 | 1885 | "THE GREAT EAST RIVER SUSPENSION BRIDGE" |

The Brooklyn Bridge was undoubtedly an engineering triumph, one whose demands shortened the life of John A. Roebling, its chief architect-builder. To achieve an above water-level height of 275 feet, on both sides of the East River, the approaches to the Brooklyn Bridge rose and loomed high above the waterfront streets. The foreshortening in this depiction brings the Upper Bay, Governors Island, the Statue of Liberty (completed in 1886), and the Lower Bay and the Narrows into view.

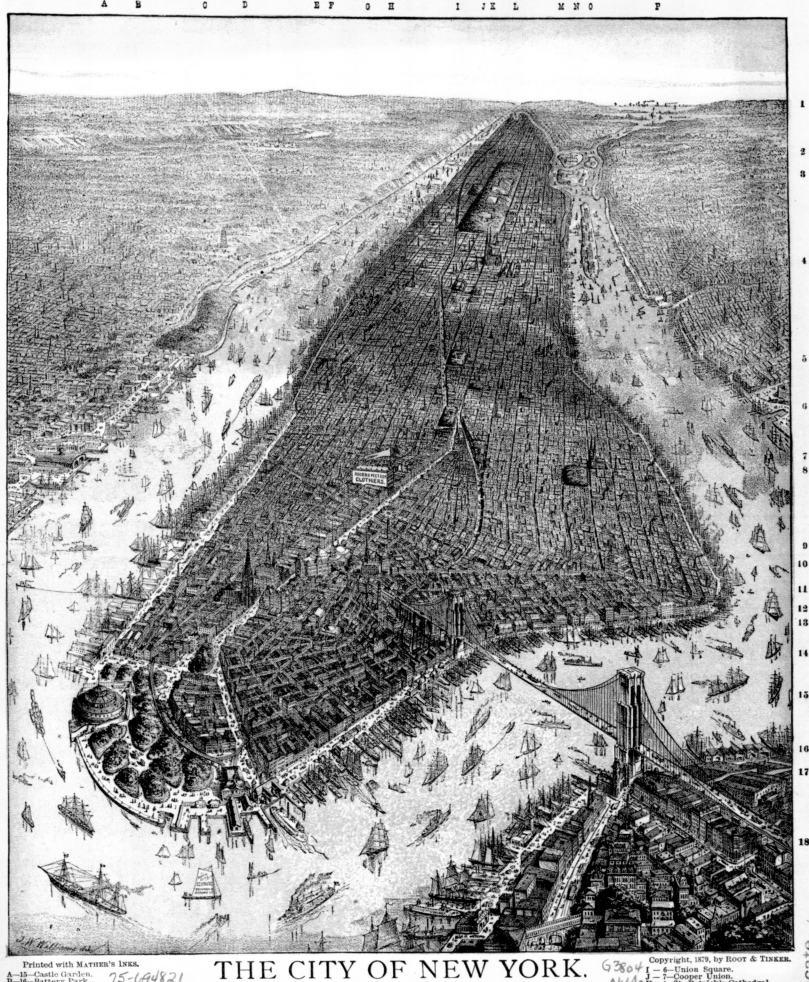

THE CITY OF NEW YORK.

COMPLIMENTS OF ROGERS, PEET & CO.,

WHOLESALE AND RETAIL CLOTHIERS,

BROADWAY, BROOME & MERCER STS., NEW YORK.

To each of the objects of interest catalogued herewith is prefixed a letter and a figure. To find the place indicated, draw an imaginary vertical line from the LETTER to where it meets a corresponding horizontal line from the FIGURE.

Printed with MATHER'S INKS.

A—15—Castle Garden.
B—16—Battery Park.
C—14—Bowling Green.
D—11—Trinity Church, head Wall St.
D—17—Elevated R. R. Depot.
E—10—Post Office.
E—12—Sub-Treasury Building.
F— 9—City Hall and Court House.
F—13—Custom House.
G— 8—ROGERS, PEET & CO.
H— 7—Washington Square.
I— 5—Madison Square.

I— 6—Union Square.
J— 7—Cooper Union.
K— 4—St. Patrick's Cathedral.
L— 3—Central Park.
L— 5—Grand Central Depot.
M— 5—Bellevue Hospital.
N— 2—Ward's Island.
N— 3—Randall's Island.
N— 8—Tompkins Square.
N—18—MARTIN'S STORES, BROOKLYN.
O— 4—Blackwell's Island.
P— 1—Long Island Sound.

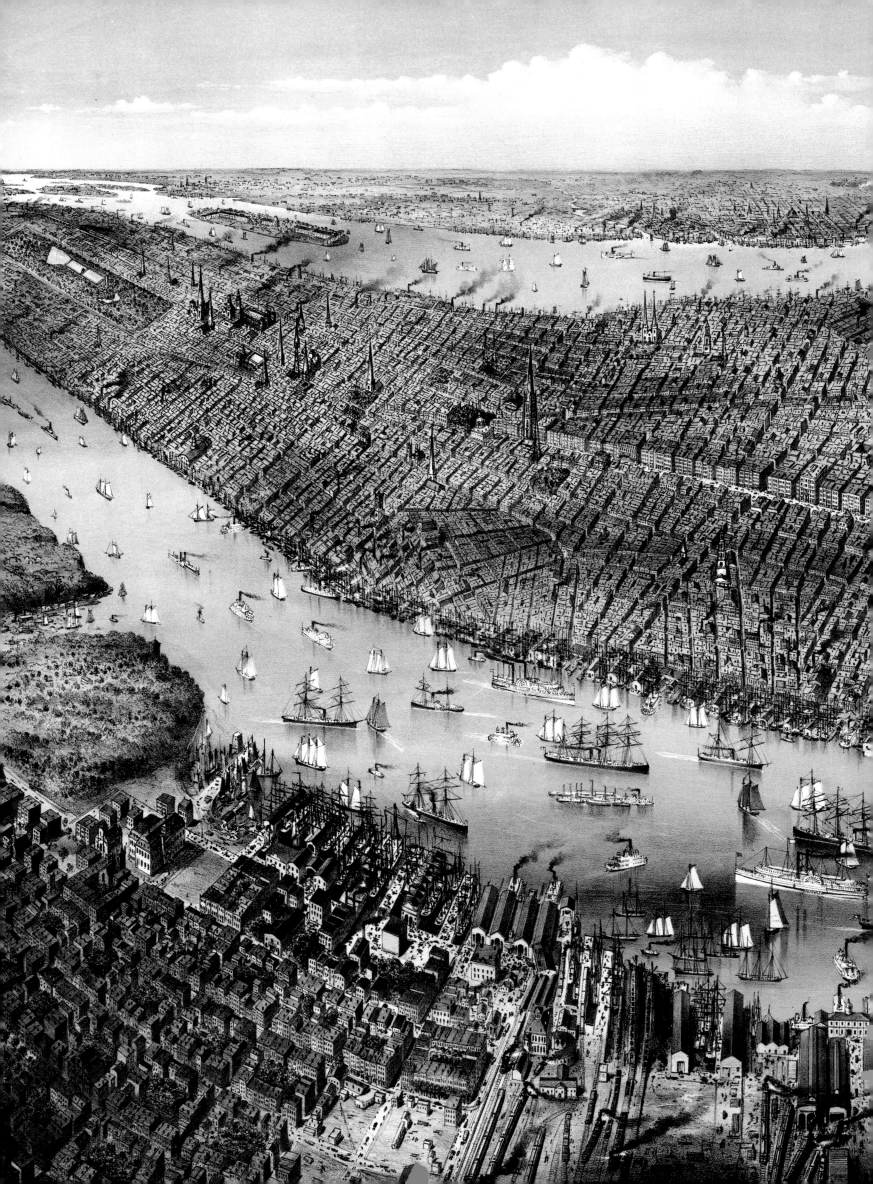

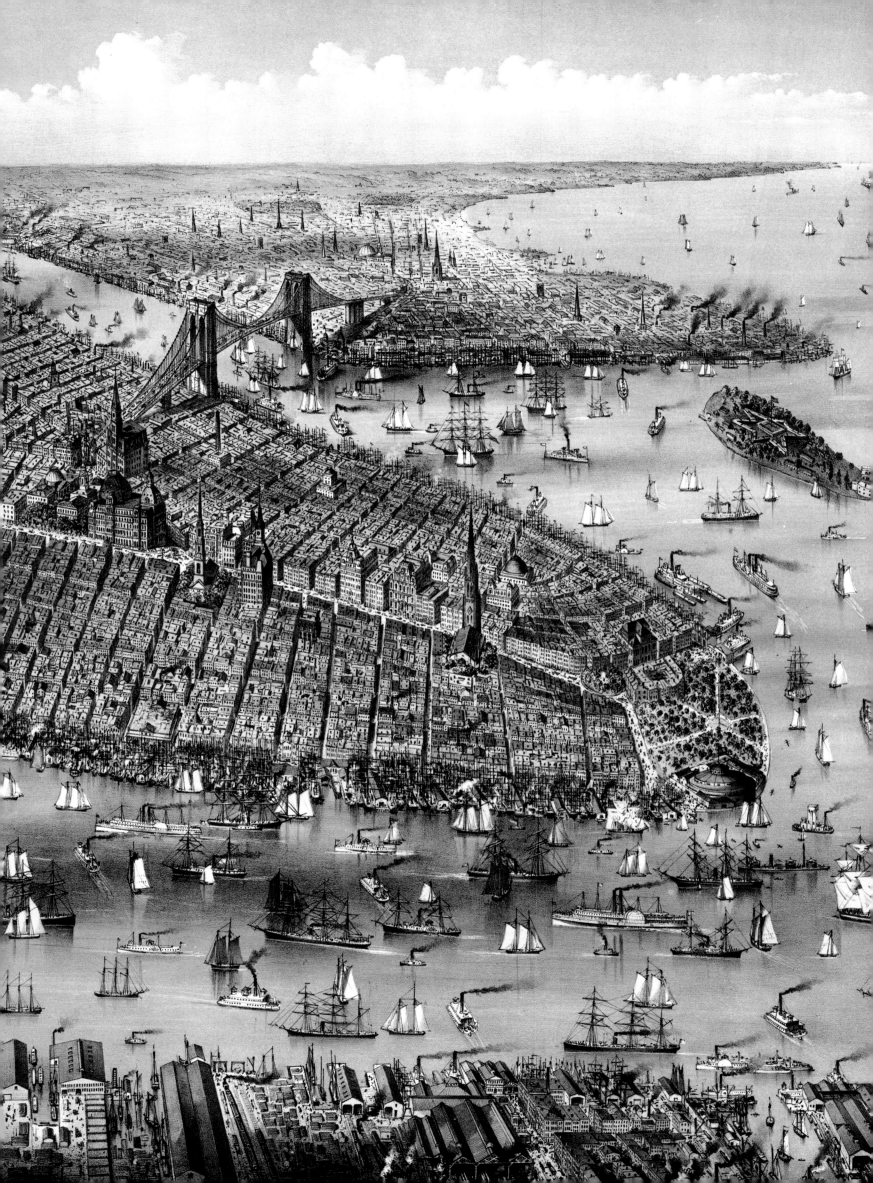

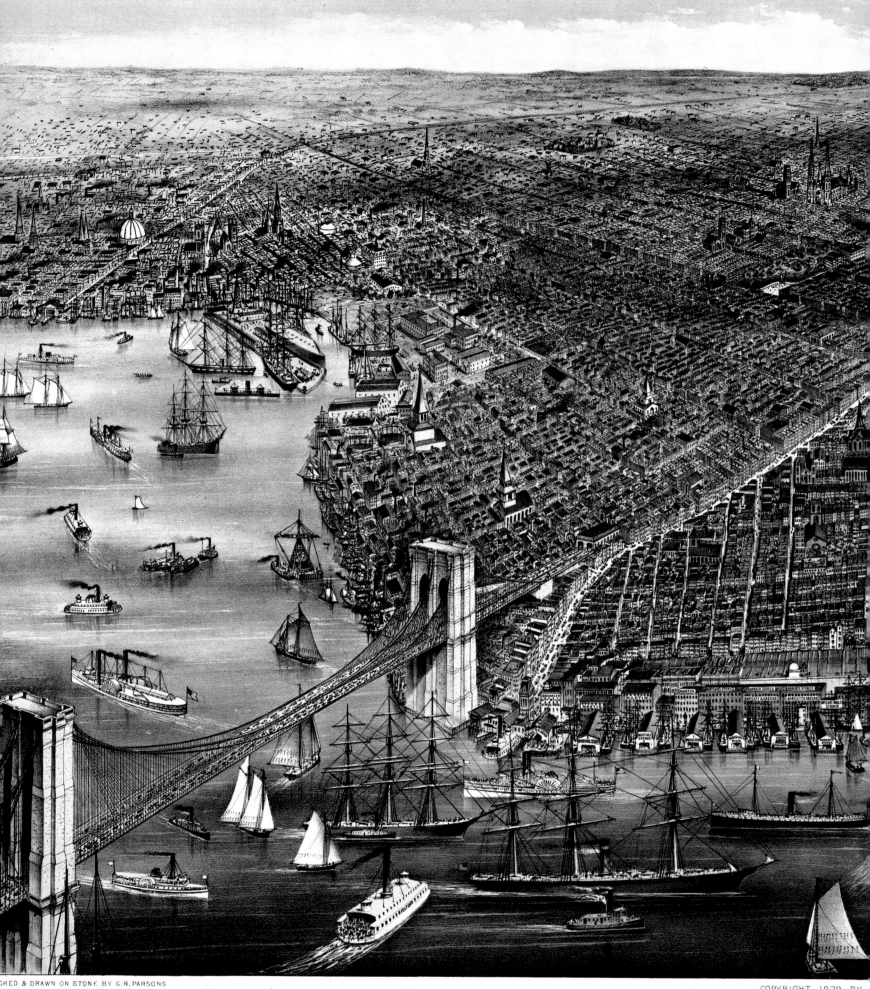

CHED & DRAWN ON STONE BY C.R.PARSONS

		John Wesley M.E.Ch.		Myrtle Ave.	Tompkins Sq.	Lefferts Park	Clinton Ave. Cong. Ch.		Fleet St. M.E.Ch.	
iamsbg.Presbt.Ch.	WILLIAMSBURGH-BROOKLYN, E.D.	St.Johns' M.E.Ch.							Catholic Cathedral	
3rd. St. Presbyt. Ch.	Williamsburgh Savings Bank	U.S.Naval Hospital	St.James' Cathedral			Simpson Methodist Ch.	Arsenal	23rd. Regt.Armory	Rink	City Jail
rry to Grand & Roosevelt Sts.N.Y.	Ross St. Presbt. Ch.	U.S.Cob Dock	U.S. Marine Barracks		City Park			Washington Park		
	Kings Co.Fire Ins.Co.	U.S.Receiving Ship.	Wallabout Bay	Navy Yard		Plymouth Ch.				
	EAST RIVER BRIDGE		Ch. of the Assumption of B.V.M.	Terminus of Bridge,-Sands St.					Holy	
		Catherine Ferry,-Main St.	EAST RIVER	Fulton Ferry, Fulton St.				Montague Terrace	Brooklyn Heights	

THE CITY O

NEW YORK, PUBLISHED BY C

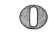

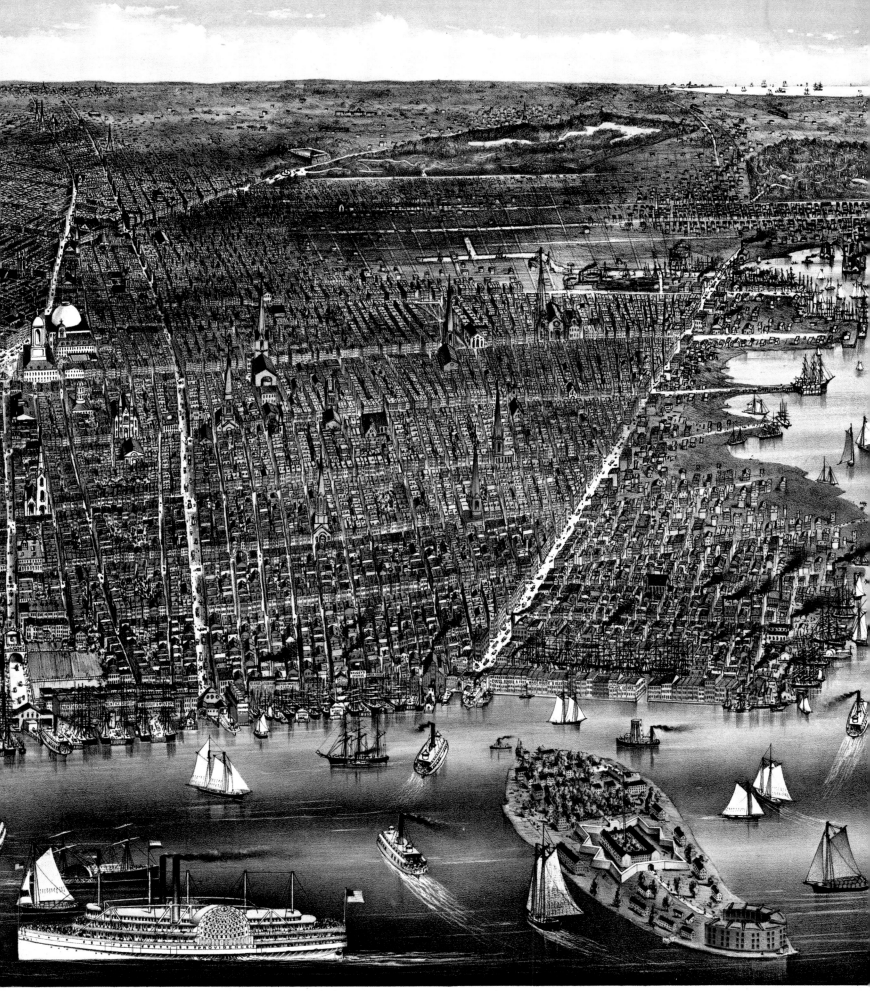

R & IVES, N.Y.

EAST NEW YORK Flatbush Ave. Kings County Bldgs. Coney Isd. Atlantic O

v. Presbyrn. Ch. **Tabernacle Ch.** 13th. Regt Armory Court St. Ridgewood Reservoir Flatbush PROSPECT PARK Penny Bridge Gravesend Bay

City Hall. Court House Entrance to Prospect Park. Gowanus Canal GREENWOOD CEME

Ch. of the Pilgrims. County Bldg. St. Anns' Ch. Strong Place Baptist Ch. Carroll Park St. Marys' Star of the Sea Gowanus Bay

h. Academy of Music. Packer Institute Ch. of St. Charles Borromeo St. Peters' Ch. St. Pauls' Ch. South Cong. Ch. Atlantic Docks Governors Isd. Ch. of Visitation of B.V.M. Red Hook

Wall St. Ferry, Montague St. South Ferry,-Atlantic Av. Ch. of the Reconciliation. Ist. Place M.E. Ch. Atlantic Basin. Fort Columbus Castle William

Hamilton Ferry St. Stephens' Ch. Hamilton Ave.

BROOKLYN.

R & IVES, 115 NASSAU ST.

Brooklyn Tower. Fulton Ferry, Brooklyn. Atlantic Ocean (in the distance). New York Tower.

75-694811

GRAND BIRDS

THE GREAT EAST RIVE
CONNECTING THE CITIES
Showing also the
THE BAY AND THE

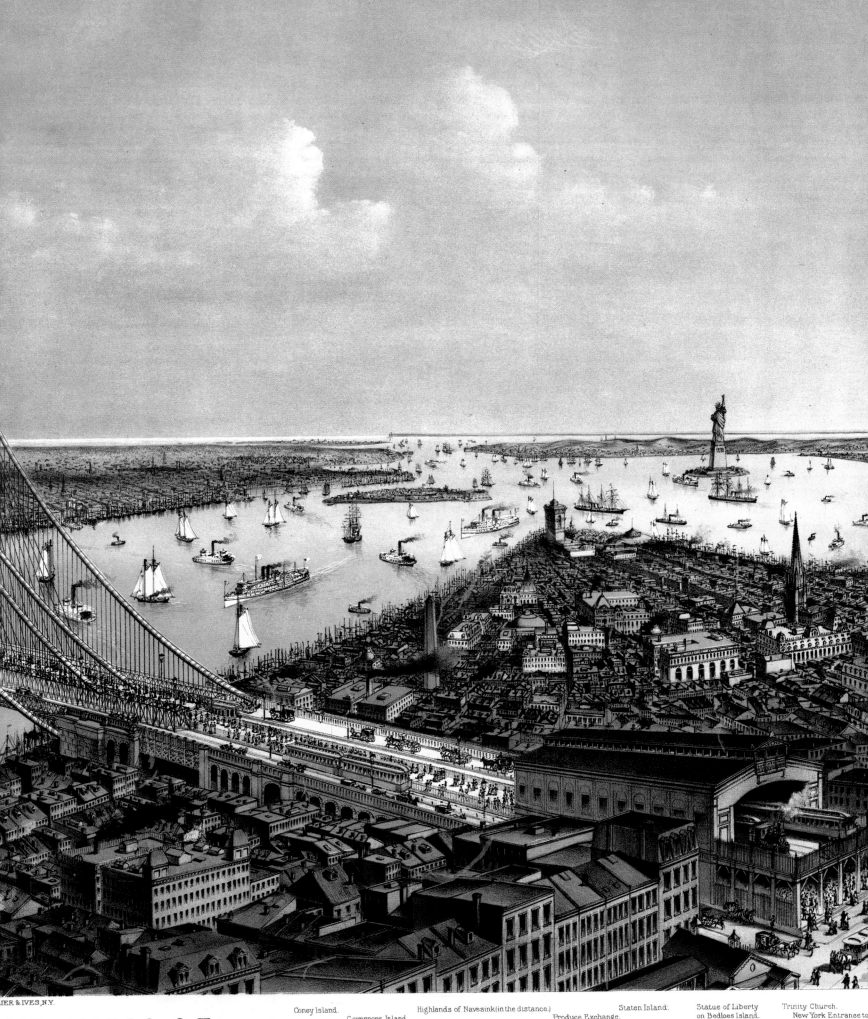

ER & IVES, N.Y.

Coney Island. Highlands of Navesink (in the distance.) Staten Island. Statue of Liberty Trinity Church.

Governors Island. Produce Exchange. on Bedloes Island. New York Entrance to

YE VIEW OF

R SUSPENSION BRIDGE.

NEW YORK & BROOKLYN

did panorama of

RT OF NEW YORK.

THE EARLY
DECADES

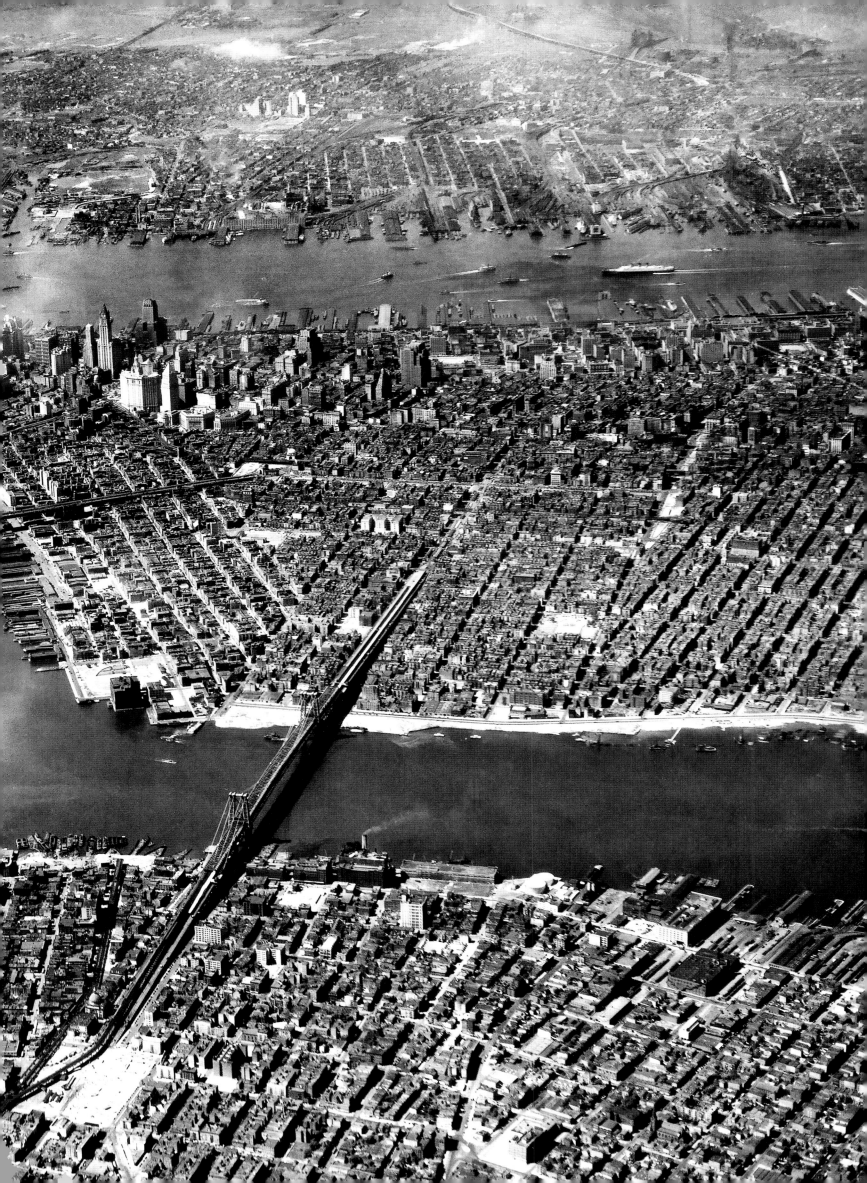

THE BIRTH OF THE EMPIRE CITY

The half-century from 1900 to 1949 marked the rise of New York—as Manhattan, the city's central borough, is universally known—to world predominance as a business, shipping, and residential center. New York was not a diplomatic capital. It was an economic capital: a powerful magnet for the ambitious young from all over the world, a center for the ambitious wealth-seeking businessman, a forum for the far-sighted banker who saw opportunity on every side, in the American West, Canada, South America, and the Far East. New York also had great universities and offered cultural exchanges for scientists, innovators, and scholars. Above all, New York was the long-dreamed-of goal for immigrants—European, Russian, South American, Chinese, and other Asian nationalities, whose annual inflow into New York in the early 1900s reached a million or so per year.

The city, with a population of 1,850,000, could not and did not absorb the great majority of the newcomers; they passed through to other destinations across the United States. Almost invariably, immigrants—"new Americans"—were seen as an economic gain, creating new communities and jobs, and expanding the market for goods and services.

In New York, perhaps more than in any other world-class city, limited physical space meant that, in many ways, the new constantly and visibly pushed out the old. This to a significant extent reflected the basic physical fact of New York; bounded by rivers and an ocean, it could not extend endlessly outward as could a city on an open plain. All the territory beyond the Hudson and East Rivers developed rapidly and densely, often in close lockstep with New York. But beyond New York's water boundaries, the Bronx (to the north), Brooklyn and Queens (to the east), Staten Island (to the south), and New Jersey (to the west) took on their own separate identities. In uncounted ways they served as suppliers of goods (particularly food) and services to New York and as reservoirs of cheaper and more spacious housing than New York could offer.

All cities are wed to the natural process of renewing, updating, and adapting themselves, but in New York the process moved faster, more intensively, more relentlessly. The fate of the elegant twenty-story Gillender Building bears witness to this. Erected on Wall Street in 1897, and one of the tallest buildings of its day, it was torn down in 1910; the plot on which it stood in the center of the Financial District was too valuable, and merited a bigger, more utilitarian building: the thirty-one-story Bankers Trust Company Building with its seven-story pyramidal roof. Other buildings, including the famed Singer Building, suffered a similar fate, and were replaced by larger, more efficient structures.

The year 1900 saw a prosperous, confident New York. The great financier J. P. Morgan was at the height of his power as a banker, investor, and industrialist. He was one of a coterie of great financiers who believed passionately in New York and its future, and did much to promote its growth; their confidence played a vital role in calming widespread popular anxiety during the 1907 financial panic. Conditions soon stabilized, becoming good for continued growth. One great milestone under-taking was the building of the Pennsylvania Railroad Station, completed in 1910. Architecturally, it was a fitting rival for Grand Central Terminal, marked by a hand-some Beaux Arts trim, and which served districts to the north of the city. Penn Station was designed with interior halls based on elements of ancient Rome's Baths of Caracalla; it was a palace offering train service. During World War II's peak demand for moving civilians and the military, Penn Station served over one hundred million passengers yearly. Decline set in during the 1950s, as more commuters drove or used bus or alternative services. In 1963, despite cries of "Renovate—don't amputate," the entire aboveground structure of Penn Station was torn down and redeveloped. Today's undistinguished replacement, largely belowground, serves over half a million passengers daily on over one thousand trains.

Not all of New York's development was driven by utilitarian goals, and one still expanding addition was Columbia University, whose central campus, two great libraries, and handsome buildings occupied a six-block site extending from 114th to 120th Street. Designed as a unified whole at the turn of the nineteenth century, the campus and buildings form an impressive architectural ensemble. Today Columbia admits some six thousand students annually. Another great public facility was Yankee Stadium, which opened in 1923 and could accommodate 57,000 baseball fans rooting for the New York Yankees. As its footprint space need was so great, the stadium was built in the Bronx, but within easy reach of New York. The stadium was rebuilt in 2009, and to accommodate today's larger spectators, seat breadth was increased from eighteen to nineteen inches, causing the total number that could be accommodated to drop to 50,000.

Business growth fuels all other growth. As New York increasingly became a city that drew visitors eager to sample world-class opera, concerts, museums, and exhibitions, the hospitality industry expanded rapidly. Not merely the number of hotels and rooms was important, but the comforts, cuisine, and ambience also mattered. The iconic Plaza Hotel at Fifth Avenue and 59th Street, built in 1907 and superbly sited facing Central Park, has survived in all its dignified elegance, a worthy new-comer to the world dominated by the older Waldorf Astoria Hotel at Fifth Avenue and 34th Street. Not only did the new Plaza Hotel face onto Central Park—already flanked by handsome apartment houses and a sprinkling of private mansions on its southern, eastern (Fifth Avenue), and western (Central Park West) frontages—but the Plaza's forecourt is the Grand Army Plaza (honoring the Army of the Potomac of the US Civil War), with its fountain, donated by the press magnate Joseph Pulitzer, honoring the goddess Pomona. The detached northern section of the Plaza forms the southeastern corner of Central Park, and features a gilded statue of the Civil War general William Tecumseh Sherman by the renowned sculptor Augustus Saint-Gaudens.

Although New York's high-cost, high-class social center moved northward, its southern tip did not sink into neglect. Like fingers on a hand, shipping piers grew out of the downtown waterfront, in the shadow of Wall Street. Long gone was the forest of masts and spars and merchandise-heavy waterfront streets of Herman Melville's *Moby Dick*; covered freight terminals serving all-steel ocean liners and freighters now stood in their place, and in tightly packed rows barges from New Jersey and Long Island waited to load or unload freight. Blocks of older, smaller buildings still stood, but massive office buildings dominated the scene.

Traffic of every kind built up with the increase in commercial activity, and Brooklyn was increasing rapidly in population. Already the Brooklyn Bridge (opened in 1883) had two companion bridges linking New York to Brooklyn: the Williamsburg Bridge (opened in 1903) and the Manhattan Bridge (1909). This latter reflected burgeoning communications needs; it carried four upper-deck roadways and three

1900

lower-deck roadways, together with four subway tracks. A year after the Manhattan Bridge was completed, in keeping with the "City Beautiful" movement, a monumental center arch and twin colonnades was added to the bridge to enhance its New York approaches. Increasingly, civic architecture was combining beauty with utility.

In 1914, the outbreak of World War I meant that the United States had to operate in a new geopolitical world, one in which it became a major exporter of military materiel to the British and French armies. But in 1917, the sinking of the SS *Lusitania*, with prominent Americans among its passengers, drew the nation into the war. It entered proudly and with public fanfare. While the shipping piers and troop ships saw many modest-sized send-off demonstrations, Fifth Avenue expanded its role as a grand thoroughfare. It become the scene of military marches involving thousands of troops off to fight for freedom and democracy; citizens crowded the sidewalks and the Stars and Stripes flew from windows of the high-rise commercial buildings flanking the avenue. Despite the show of patriotism, business went on as usual—one lane of the avenue remained open to normal traffic.

Far bigger were the parades in 1918 and 1919 for the returning troops, and far more joyful and exuberant were the attending crowds. Victory had to be celebrated in style, and New York put on a magnificent show. The events were so big and drew such a large popular attendance that upper Fifth Avenue (above 59th Street), with Central Park paralleling the eastern side of the avenue, became the venue. Soldiers now marched four abreast, and the welcoming crowds were often twenty people deep. The setting was superb, with the troops flanked on the one side by the dignified handsome high-rise apartment houses—almost a protective wall—and on the other the green expanse of Central Park, which could accommodate any number of enthusiastic citizens. The twin icons of the Plaza Hotel and Grand Army Plaza added a special presence to any celebratory event.

Midtown—the area between 34th and 59th Streets—continued to reflect prosperity. Bigger buildings were fast displacing smaller ones as business needs grew and the value of real estate inexorably rose. Times Square—not a traditional foursquare area but a slender seven-block-long triangle beginning at the crossing of Broadway and Seventh Avenue—lay at the very center of midtown. It was dominated by the New York Times Building, the "Times Tower," headquarters of the world-famous *New York Times* newspaper. Times Square has always been more than a mere address or physical space; it was a thronged, exuberant human forum, flanked by theaters and restaurants that generated their own vibrant street life, pulsing with energy, a backdrop to buskers, peddlers, street musicians—and gawkers determined to ex-perience New York at its most flamboyant. Times Square could well be called the heart of New York; its theater and movie crowds and throngs of out-of-town visitors and, above all, the forest of brilliant neon lighting at night, made for a permanent buzz of excitement.

1949

In sharp contrast to the bustle of Times Square and its busy stores, is the calm and tranquility found within St. Patrick's Cathedral, nearby at Fifth Avenue and 51st Street, directly opposite Rockefeller Center. The great neo-Gothic cathedral was dedicated in 1879; the soaring twin spires were added later. The cathedral occupies the site of earlier religious edifices, and is the diocesan seat of the Archbishop of New York.

Downtown, whether called the "Financial District" or simply "Wall Street," could be said to have worshipped other gods. By the 1920s it had taken on its permanent and universally recognized profile: a clustered forest of massive high-rise buildings, with their bulk and solidity emphasized by a smaller number of soaring skyscrapers that "topped out" in gothic spires and pinnacles, rich with terracotta decoration. Today both the Singer Building (demolished in 1968) and the Woolworth Building (the "Cathedral of Commerce"), proudly anchoring Lower Broadway, are admired for their richly detailed exteriors and magnificent marble-clad, soaring-roofed entry halls. But the human scale was not entirely lost. Battery Park (in which the massive, low-rise circular Castle Clinton, built in 1811, had long since replaced the quadrangular Dutch fort of the 1620s) had become a well-designed public park with clusters of shade trees and a magnificent waterfront promenade. Slightly to the east stood the Staten Island Ferry Terminal, its cavernous hall more utilitarian then aesthetic, but always alive—and vibrant with surging armies of commuters in the morning and evening rush hours as a huge sector of the workforce entered or left New York.

Seen from high above, Battery Park and the southern tip of New York reveal a number of things that will strike the viewer. One is the concentration and density of the buildings in the area of Wall Street: How many more could be crammed in? Another is the occasional skyscraper to the north, where such buildings generally rose from the city's central spine. Yet another is the endless row of piers projecting into the broad Hudson River from the city's western flank. An entire import-export industry thrived, with armies of stevedores, immense warehouses, and, of course, endless truck traffic bringing goods to the rail lines along which imports reached markets nationwide, and along which goods of every kind reached the New York docks for export.

Far across, on the other flank, the great bulge of the Lower East Side extended far into the East River. The huge area was home to endless streets of low-cost housing: the cramped, crowded six-story tenement buildings whose residents—so often newly arrived immigrants—have provided many a brightly colored thread in the tapestry of New York's human history.

No quarter, no corner of New York was left untouched by continued development during the 1930s. Avenues and streets adjoining or close to parks became prestige addresses for homes or businesses. Just as Fifth Avenue and 59th Street, at the southeastern corner of Central Park, had the handsome civic amenity of Grand Army Plaza, so could the park's southwestern corner boast an added embellishment.

1900

Columbus Circle accommodates the crossing of Broadway and Eighth Avenue, and at the circle's center stands a statue of Columbus, created by the Italian sculptor Gaetano Russo in 1892 to commemorate the 400th anniversary of the great navigator's discovery of the New World—though he made no landing on the North American coast itself. The statue's column is the official "center point" of New York; all distance calculations, all mileages to and from New York to another city, are made using it. The grand—almost ceremonial—entry into the park is dominated by the USS *Maine* Memorial. This two-part sculptural ensemble (with Columbia Triumphant atop a massive plinth and a base ringed by fountains) commemorates the USS *Maine*, which blew up, with great loss of life, in Havana Harbor in 1898. The loss of American lives inflamed the nation and served as a pretext for the ensuing Spanish-American War and the invasion of Cuba, then part of the troubled and fast disintegrating Spanish Empire.

In Union Square, located downtown between 14th and 17th Streets, Columbus Circle has an older and more tranquil counterpart, a park that prevents the confluence of Park Avenue and Broadway, and to the west University Place (in fact an avenue). The square was mapped out in the 1830s but did not achieve its final form until some fifty years later, and was designed to ensure that traffic flowed along its perimeter, not through it. Although the name is thought to celebrate the Union of the States or labor unions, "Union" here referred to what would have been the more mundane union of thoroughfares. However, in its sculptures, Union Square certainly celebrates the history and the heroes of the nation, as exemplified by the massive equestrian statue of President George Washington at the square's center. It dates back to 1856 and was later joined by more modest statues of Abraham Lincoln (1870), the Marquis de Lafayette (1876), and Mahatma Gandhi (1986). The square has long been a popular venue for protests and demonstrations, and also quieter battles fought over the chess tables.

For the sheer variety of carefully contoured landscapes, no other park or square can rival Central Park. Its terrain is in places wild, with rocky outcrops, hidden dells, open water, and noble trees; in other places, extensive meadows, trimmed shrubs, and well-tended walks suggest the landscape has been successfully tamed. An open-air band shell, a small zoo, and the centerpiece of a mall with fountains and colonnades all add to the park's enjoyment, as do the annual open-air opera and concert seasons. In all seasons and during all weathers, Central Park has its walkers and strollers; to them New York's "green lung" is always an escape, an oasis far removed from New York's unceasing hum of activity. Wealthy New Yorkers—domestic and foreign—expend large sums to purchase or rent apartments in buildings flanking Central Park, which they consider, almost proprietorially, to be their front garden. One palatial building, with its classical façade and forecourt extending over four blocks, cuts into the greensward. The Metropolitan Museum of Art (opened in 1872) soon became one of the world's premier fine arts centers, not so much as a showcase of American art but of great works—paintings, sculptures, armor, costumes, religious art—purchased in Europe and elsewhere by wealthy patrons, who made gifts of their acquisitions to the museum.

"Green lungs" along New York's central axis—from south to north within the developing city—were increasingly necessary, as despite the generally buoyant tide of development, smaller buildings survived in their tens of thousand, even in the shadow of Wall Street. The business elite worked almost side by side with the humblest of factory workers. If a structure was built for manufacturing, warehousing, or to house a street-level retail establishment with offices or storage above, a standard "loft" design was usually adopted. This provided clear-through interior space, with a staircase built against an inside wall. Elevators, if included, usually were placed at the front for easy access from the street. The tenement—a near-standard multifamily residential building—became increasingly common after the 1860s. Tenements were normally built in solid rows, with light wells created by "cinching" the mid-zone of each of a pair of adjoining buildings, providing an open shaft from the roof to the basement level. Four apartments per floor, entered from a long central corridor, was the norm. Elevators were very rare, and shared toilets were common. Given the outbreak of fires, external balcony-and-stair steel fire escapes were required by law. Generally, both industrial buildings and tenements were designed for twenty-five-by-hundred-foot lots, with tenements usually reserving between ten and twenty feet in the rear as a shared yard. Overcrowding, poor sanitation, and the lack of light led to a number of reform programs aimed at improving these very poor conditions.

Washington Square Park, at the southern tip of Fifth Avenue, is perhaps the best known of New York's smaller parks. Its central fountain and plaza have traditionally been the end zones for marches and parades down the avenue. It has often been the site of demonstrations, and has always drawn performers, musicians, and folk singers.

1900

If Wall Street was the main artery of the "Kingdom of High Finance," then the New York Stock Exchange, built at 8 Broad Street in 1903, is its citadel. The exchange's Corinthian temple façade has drawn many a quip that in New York Mammon is God, and the worship of money the people's religion. The New York Stock Exchange—now a far remove from its earliest incarnation in the 1790s, when a group of brokers operated under a buttonwood tree—remains one of the world's greatest financial powerhouses. It is usually reported on in ever more impressive superlatives of the number of companies listed, the number of shares traded, and the value of capital flows and other arcane data.

A truncated Wall Street had long replaced the old Dutch river-to-river wall, and the modern Wall Street extends from Broadway, a midpoint, almost to the East River. Though the popular imagination doesn't fasten so readily onto New York's smaller river—the broader Hudson has seized first place—it bounds an immense slice of Lower Manhattan. The lengthy elevated approach ramps to the Brooklyn (1883), Manhattan (1909), and Williamsburg Bridges (1903) all rise in Lower Manhattan. They soar above Lower East Side neighborhoods, which pulsated with life as tens of thousands of immigrants took up residence in the packed streets of tenement

buildings. Many residents worked on the waterfront or in the small manufacturing and other enterprises housed in the downtown loft buildings. In view rose a dozen iconic buildings—the Woolworth, Equitable, Singer, and Municipal Buildings among them.

Looking south from New York, across the waters of the Upper Bay, the Statue of Liberty, completed in 1886, punctured the skyline, her illuminated torch a permanently reassuring symbol in the night sky. Inexpensive ferries from Battery Park provided access to Bedloe Island. Once on the island, and within the statue, the energetic visitor could make the tortuous ascent up the statue's internal staircases and gaze out from the apertures under the rim of Liberty's helmet—gaining an inspiring view of all of lower New York. One key point of interest is Ellis Island, the receiving center for arriving immigrants, a way station in sight of the Promised Land. The immigration station operated from 1892 until 1954, and millions of Americans have vivid memories of passing through en route to their new homeland.

In midtown, another future icon was under construction, almost as an act of faith. Despite the Great Depression of 1929, construction of the Art Deco-style Empire State Building, at Fifth Avenue at 34th Street, began in 1930. Upon completion one year later, the building, at 102 stories and 1,454 feet in height, was the world's tallest until surpassed by the World Trade Center in 1973. The building gained fame in 1933 with the making of *King Kong*, starring Fay Wray, and again in 1945, when in heavy fog it was struck by a B-25 bomber, without lasting damage. Fortunately, the daytime flyby of three U.S. Navy and other corporately owned dirigibles over Manhattan in the 1930s did no harm. The uppermost part of the Empire State Building is floodlit at night, often to celebrate a nation or national event. The colors used in the lighting reflect those of the nation, event, or organization being celebrated.

By the mid-1930s high-rise Wall Street had a fully developed counterpart in mid-Manhattan. Skyscraper and high-rise office buildings now dominated the cityscape, clustering in the area between Seventh and Third Avenues, from 34th Street up to 59th Street. Among the most iconic skyscrapers were the perennial rivals to the Empire State Building, namely, the Art Deco Chrysler Building, the Newsweek Building, and Rockefeller Center. John D. Rockefeller began this immense and magnificent project in 1930, financing it personally as the effects of the Depression were still being felt—and construction of the fourteen original buildings continued until 1947, occupying the area between Fifth and Sixth Avenues, from 48th to 51st Street. The soaring, clean-lined, and elegant RCA Building is the centerpiece, flanked by matching low-rise buildings and flower-lined walkways, and set back beyond a lower-level plaza. This attractive open area, with its access to restaurants and retail shops, offers a venue for such events as horticultural exhibitions; in winter it becomes a very popular and immaculately maintained skating rink. In the lee of the awe-inspiring Rockefeller Center—and in contrast to it—people go about their everyday business, flooding across more ordinary streets and crossings en route to their offices or to pursue shopping and other errands. Traffic lights rule and the great majority of pedestrians heed their warnings.

1949

Without respite, New York grew out from its central spine toward its river boundaries, seeing the land flanking the watercourses as an opportunity for siting major highways. Both the East River Drive, with the bordering streets and riverside close to the roadway, and the more wooded and open West Side Highway, became essential arteries carrying through traffic moving at high speed, with only widely spaced entry and exit ramps.

Despite all other developments, New York never let go of its role as a working port for both freight and passenger services. In the heyday of transatlantic crossings, the Hudson River piers served the ocean-liner companies of almost all European nations. Great Britain to New York was a very well-serviced route, and the *Queen Mary* and the *Queen Elizabeth* made regular crossings, as did the *Île de France* and the *Normandie*, with German and Italian liners adding to the traffic. Departures were more than just service events; going-away parties were often held onboard, many of the events being both festive and splendid. Transatlantic crossings brought much to New York's economy; they required a large variety of support industries, in particular victualing, laundry, and fueling services.

Given the dynamo-like energy of New York, it is easy enough to forget the city's other boroughs. Brooklyn (a proud, prosperous, independent city until the legal formation of the City of New York in 1898) maintained a strongly separate identity, though it was physically the closest to New York and linked to it by the Brooklyn, Manhattan, and Williamsburg Bridges. The "borough of churches" has always been proud of its distinct ethnic communities, for each of whom their church was not only a place of faith but also a cultural, social, and family center. Farther north on Long Island, adjoining Brooklyn but likewise looking over the East River to New York, lies the borough of Queens. Despite early Dutch settlements, Queens developed somewhat later than Brooklyn, and has remained more residential—though home to both LaGuardia and JFK Airports, and with the magnificent open expanse of Jamaica Bay and adjoining Atlantic beaches.

| 1935 | THE COURAGE TO SOAR |

The American photojournalist Margaret Bourke-White (1904–1971), seen here astride a Chrysler Building stainless-steel eagle-head decoration, made a point of pursuing danger. In World War II she accompanied U.S. Air Force missions over Europe and also ground operations, becoming known as "Maggie the Indestructible."

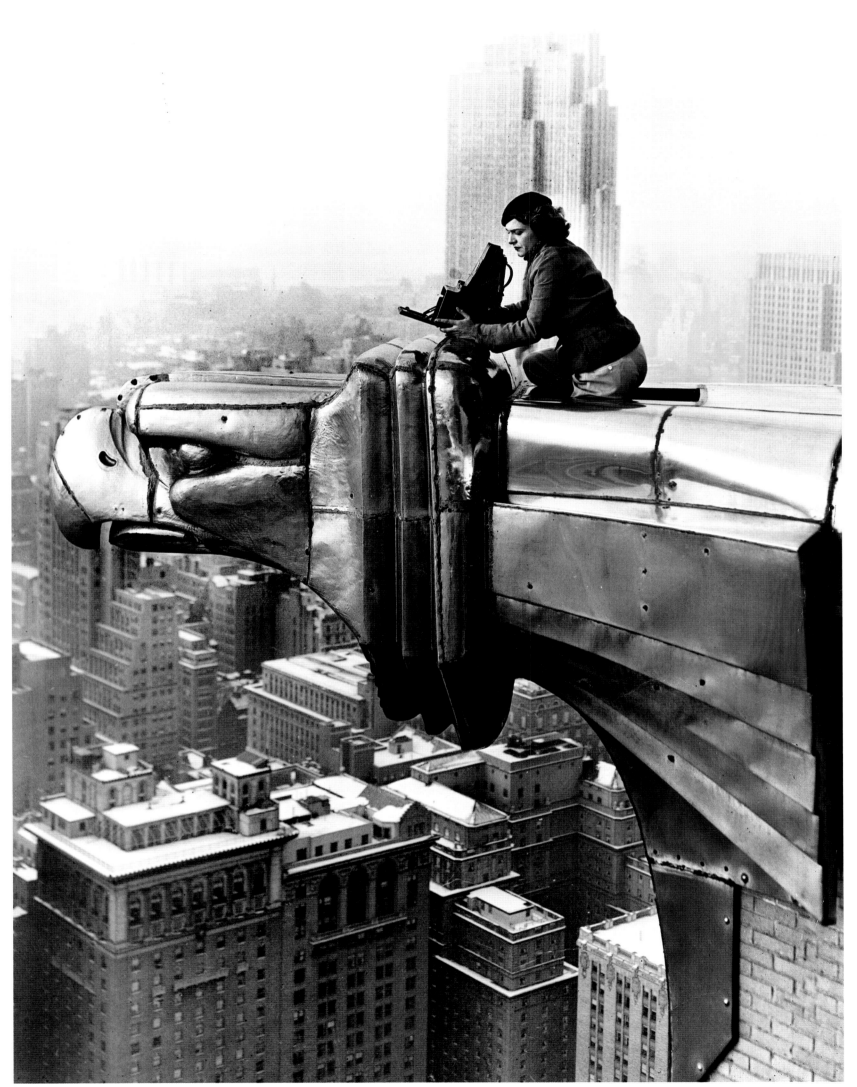

In 1902, the Brooklyn Bridge was already carrying heavy traffic, some of it on streetcars (until 1950) and some of it pedestrian; this latter is now again in practice and popular. Piers and warehouses are visible on both sides of the East River, and both steam and sailing vessels ply the waters.

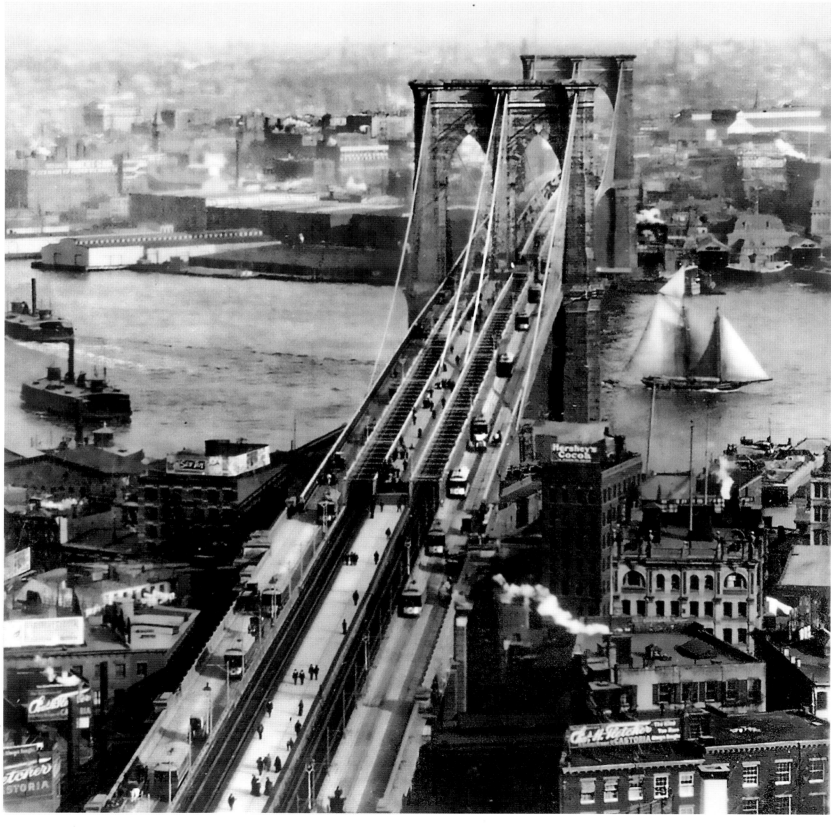

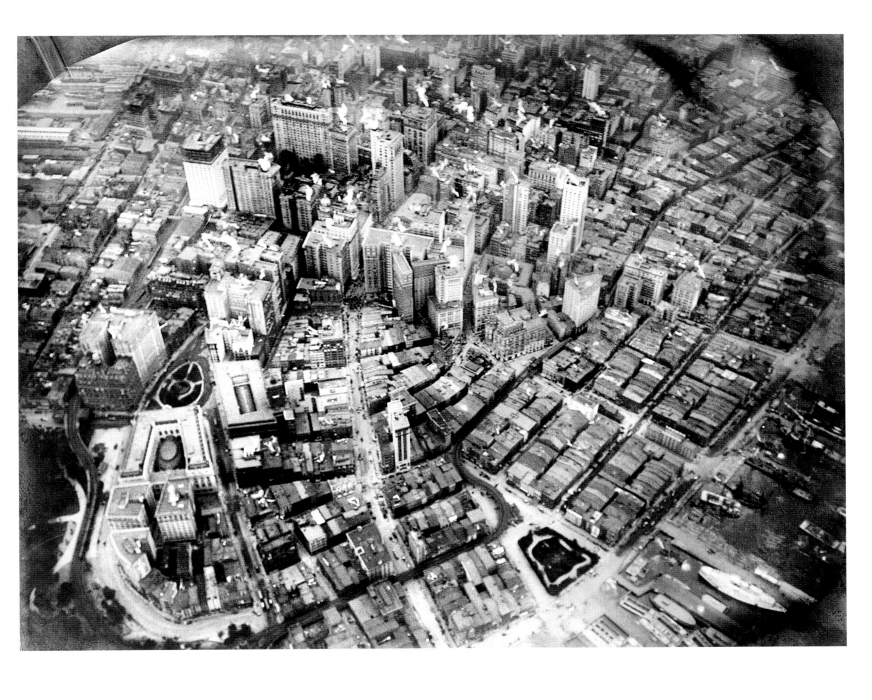

| 1906 | MANHATTAN FROM A BALLOON |

This view of Lower Manhattan in 1906 shows the advent of the first wave of high-rise office buildings, though low-rise apartment buildings and houses predominate. Commercial vessels crowd the piers. In the last century maritime activity moved to New Jersey and office buildings now occupy the waterfront.

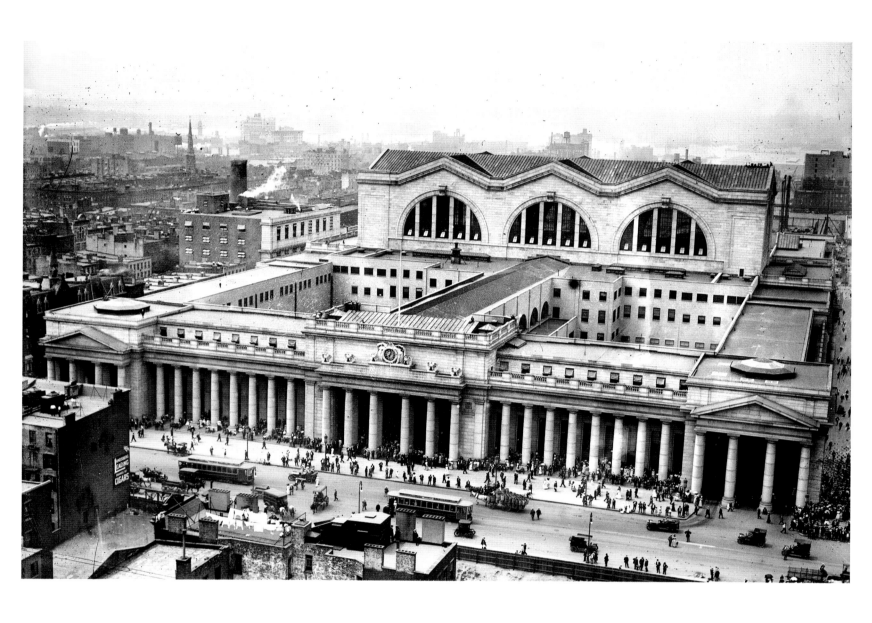

| 1911 | PENNSYLVANIA STATION |

The elegant Beaux Arts neoclassical lines of Penn Station at 33rd Street and 7th Avenue offered a palatial entry portal to New York. Built in 1910, it was demolished in 1963, in what many consider an act of vandalism. The modern-day subterranean station and aboveground area have never enjoyed popular approval.

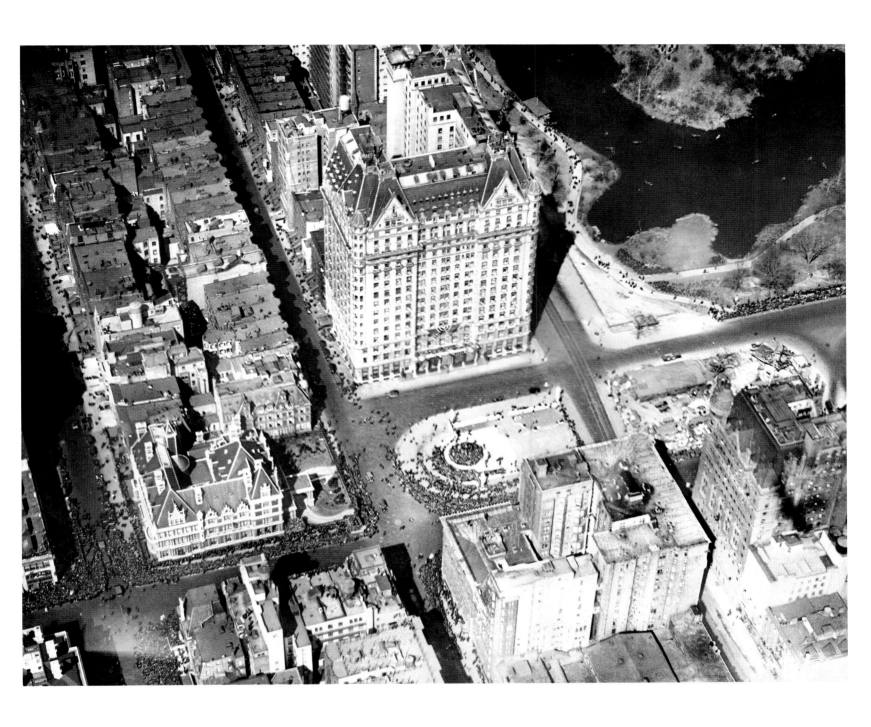

| 1914 | THE PLAZA HOTEL |

The Plaza Hotel, circa 1914, with Grand Army Plaza in the foreground. The hotel's park-side location and the adjoining plaza, with its statue of General William Tecumseh Sherman and the Pulitzer Fountain, make it a prestige address. In recent years many of the hotel's suites have been sold as permanent residences.

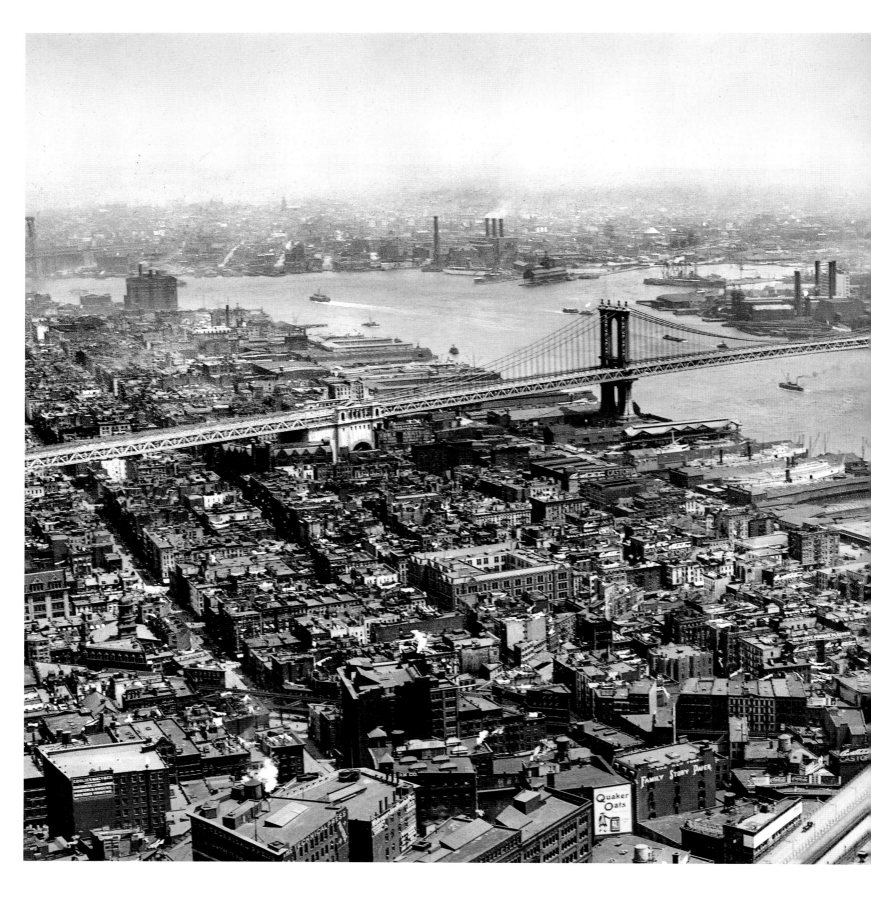

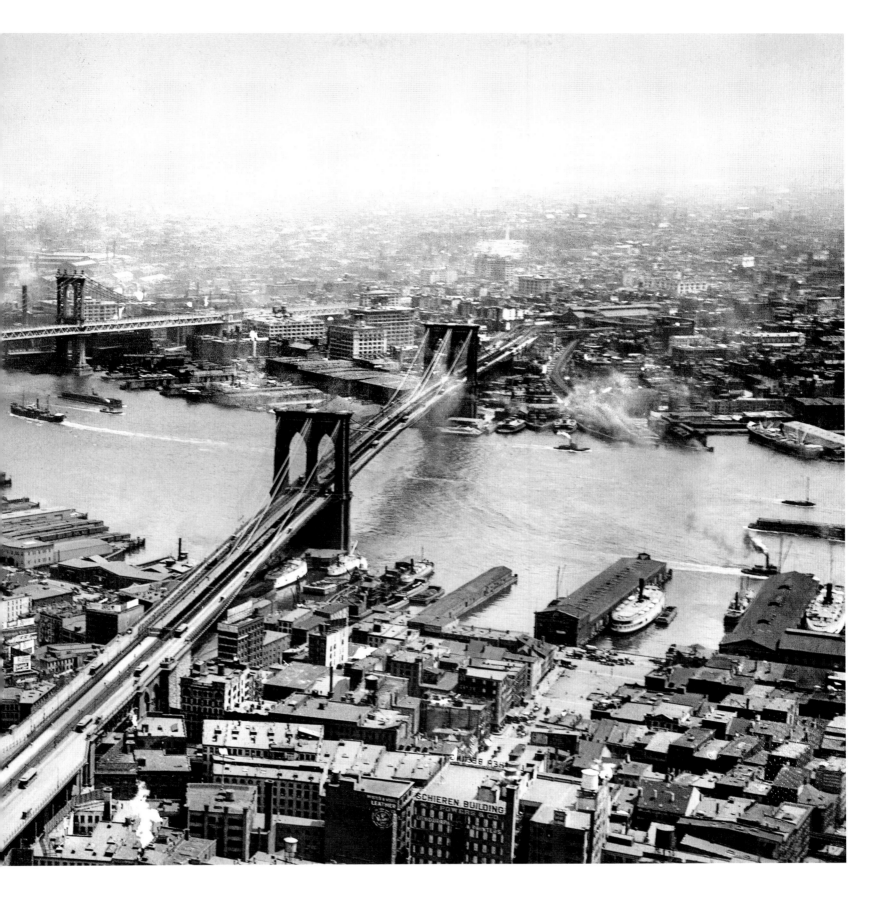

| 1916 | THE EAST RIVER SPANS |

The Brooklyn Bridge (with a total span of 5,989 feet) was completed in 1883 and the Manhattan Bridge (an all-steel structure with a total span of 6,855 feet) in 1909. In both cases the bridge approaches begin to rise many blocks inland to ensure sufficient clearance for the passenger liners and freighters that had to pass beneath them.

| 1922 | A SOLITARY DOWAGER |

One Times Square still dominates the junction of Broadway and Seventh Avenue at West 42nd Street, though entirely refurbished and reclad. Built in 1904, it served as the headquarters of the *New York Times* until 1913, and remains the gateway to the Times Square theater district, a beacon and an icon for visitors.

| 1924 | HOW IT USED TO BE... |

The Columbus Circle of 1924 is truly a vanished scene, save for the street plan. The Time Warner Center now occupies the mid-right quadrant and the triangular site at lower right is now home to the Trump International Hotel and Tower, with both overlooking the southwest corner of Central Park.

64 · 65 | 1925 | A SMOKE-CLOUDED HARBOR... |

In this 1925 photograph the focus shifts to the West Side, showing the many piers extending toward New Jersey. The tallest building visible is the Woolworth Building—the "Cathedral of Commerce." Bottom left the circular Castle Clinton can be seen anchoring Battery Park. "Clean air" was not yet a policy.

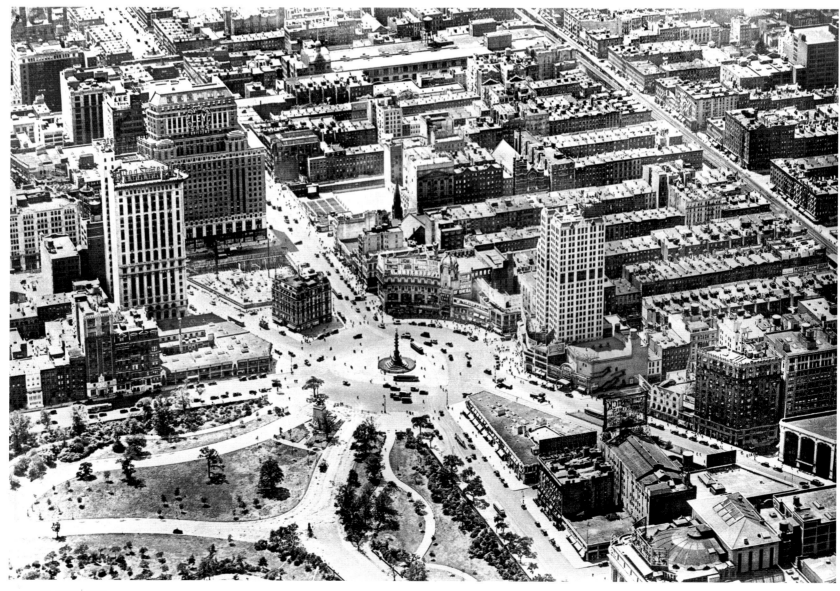

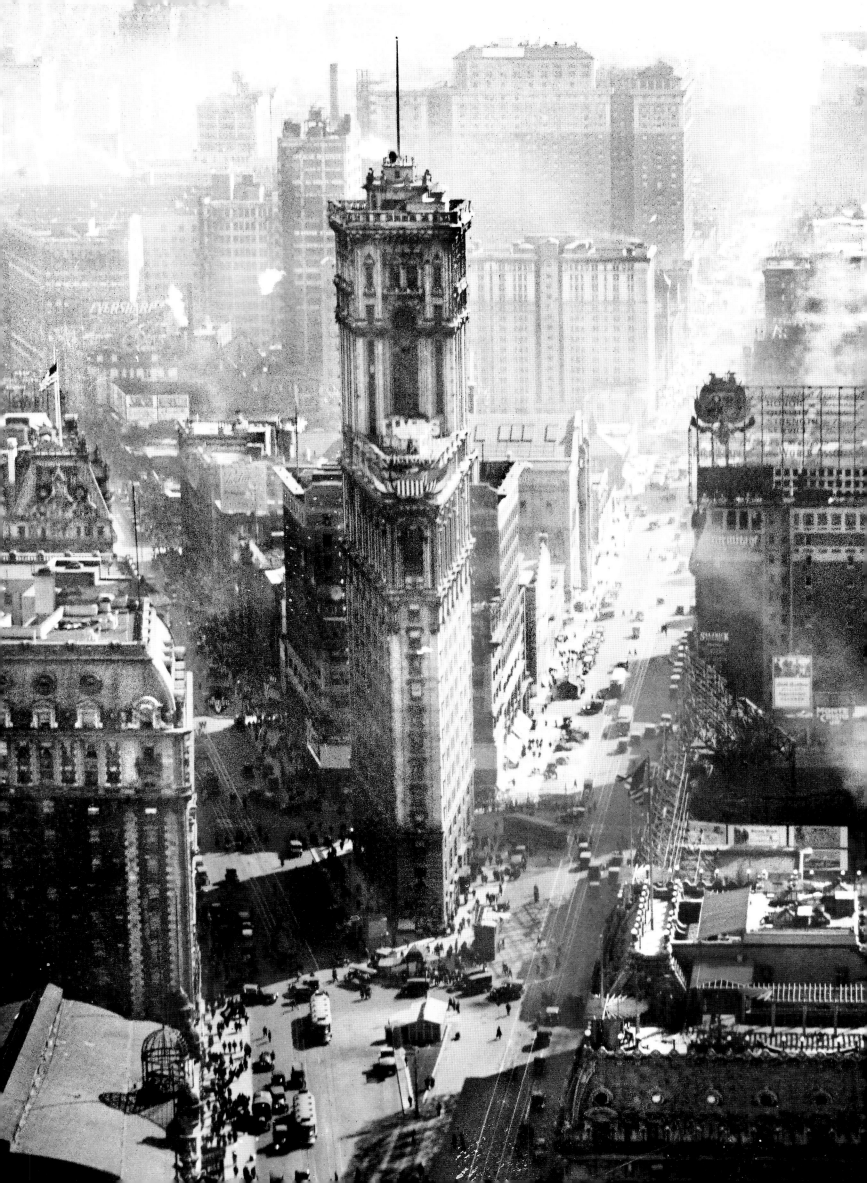

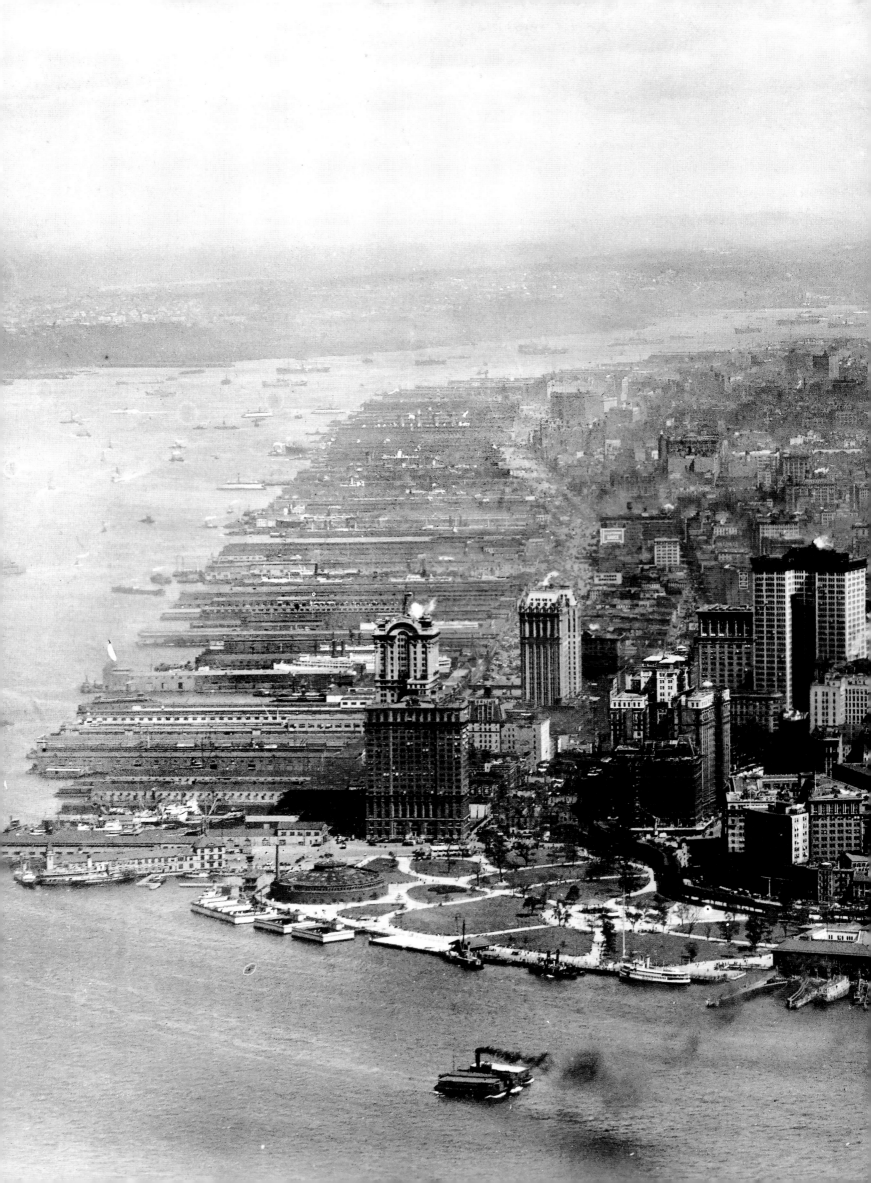

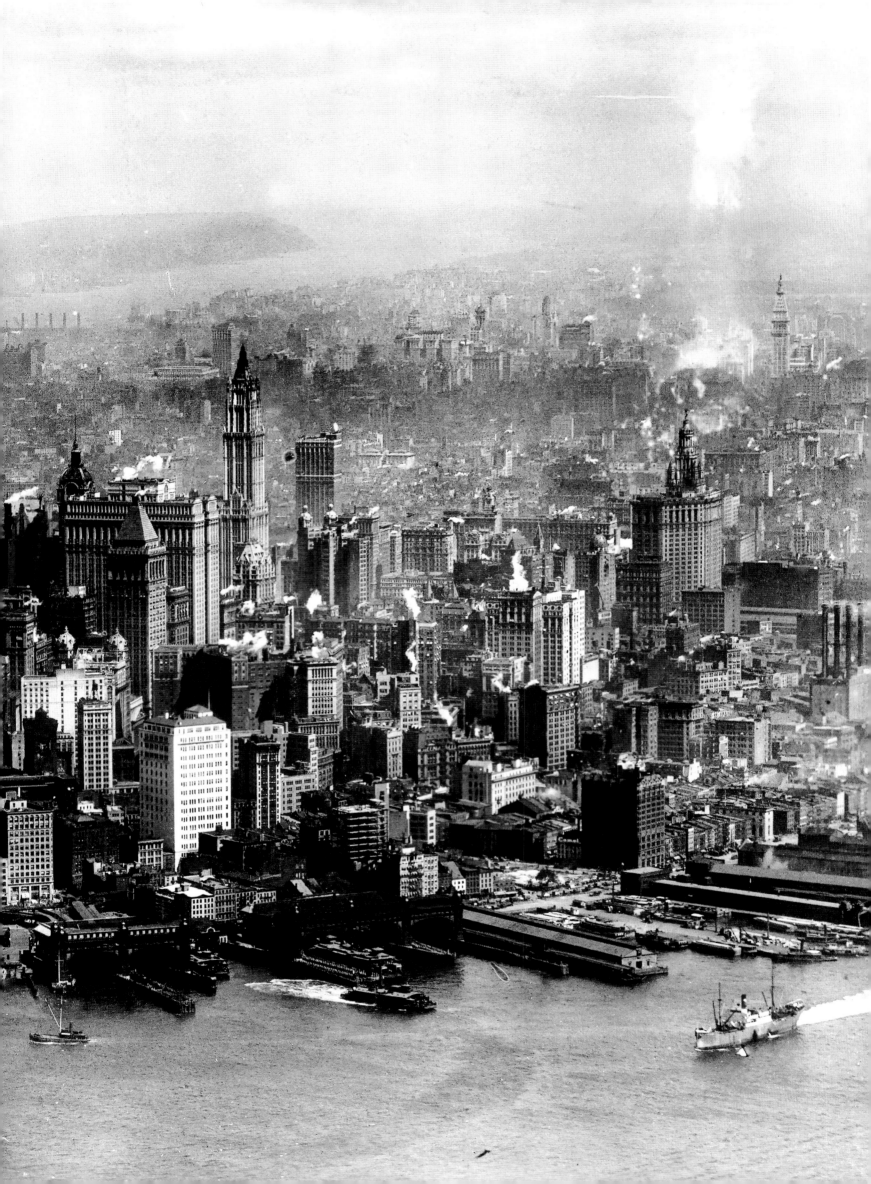

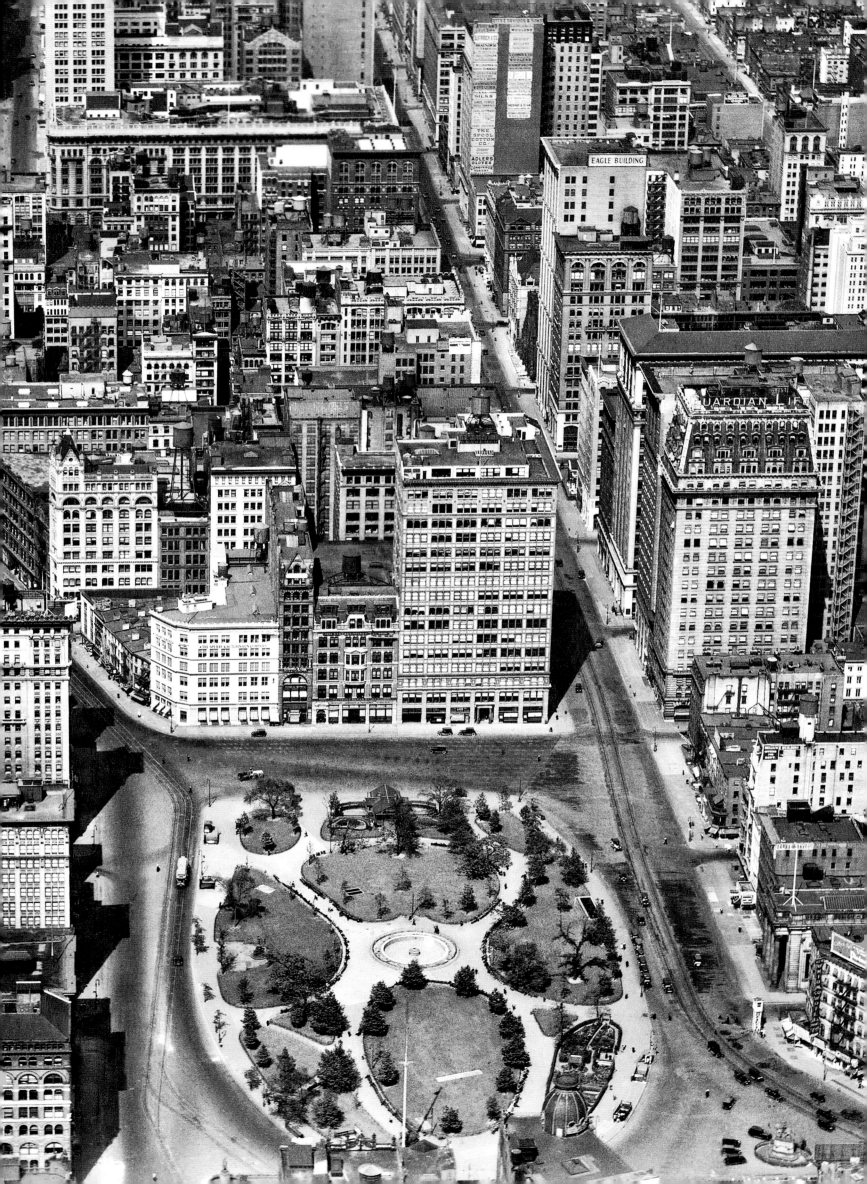

| 1928 | PARK AS ARCHITECTURE |

In 1928, Union Square (between Broadway and Park Avenue South, from 14th to 17th Street) was already surrounded by mid-rise office buildings. It remains a popular gathering place and the site of many demonstrations. More than most New York City parks, Union Square reflects a fixed, formal design.

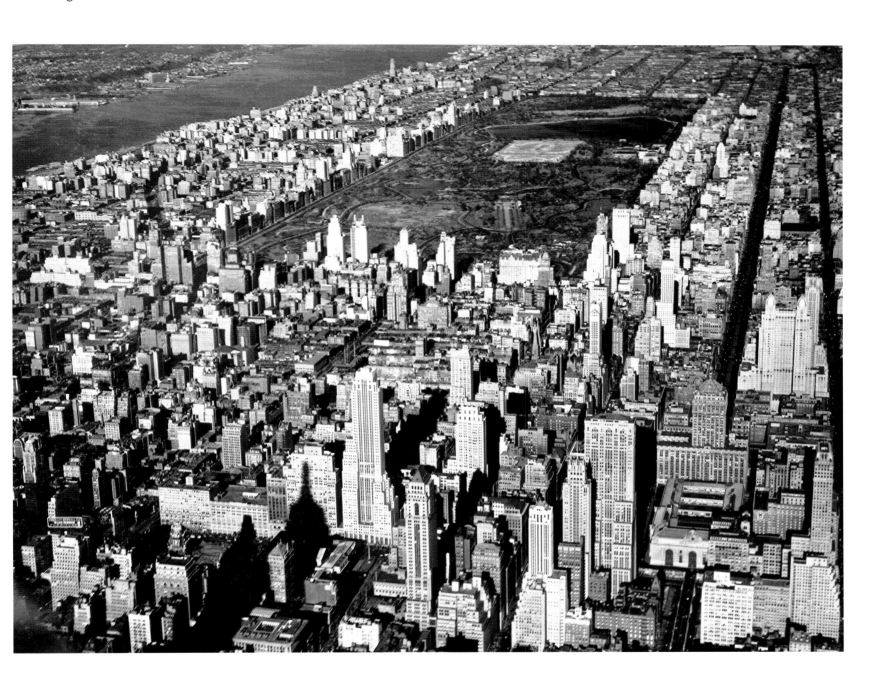

| 1930 | MIDTOWN AND CENTRAL PARK |

In the late 1920s, high-rise apartment houses began to dot Central Park South and were increasingly well established on Fifth Avenue and Central Park West. The shadow of the recently completed Empire State Building, at Fifth Avenue and 34th Street, dominates the lower central part of this image. Grand Central Terminal and the Waldorf Astoria can be seen on the right.

| 1929 | THE BURGEONING FINANCIAL DISTRICT |

Even as late as 1929, Wall Street had not yet extended the whole way south to Lower Manhattan's shoreline, and low-rise mixed-use buildings were still plentiful. Shipping piers are just visible at the lower margin of the image, though maritime activity was decreasing, and was further hit by the Great Depression.

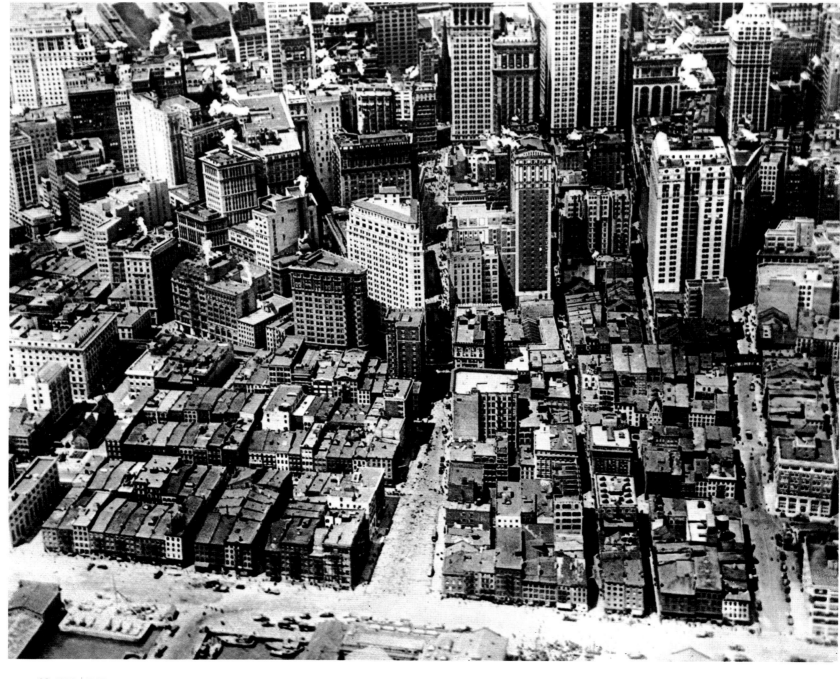

| 1931 | GEORGE WASHINGTON BRIDGE |

The soaring and clean-cut bridge—informally known as the GWB—is the only bridge in New York City that spans the Hudson River. When completed in 1931, the bridge's total span of 4,760 feet was the longest in the world. To accommodate ever-increasing traffic, a planned lower deck was added to the bridge in 1962, but without the pedestrian walkways featured on the upper deck.

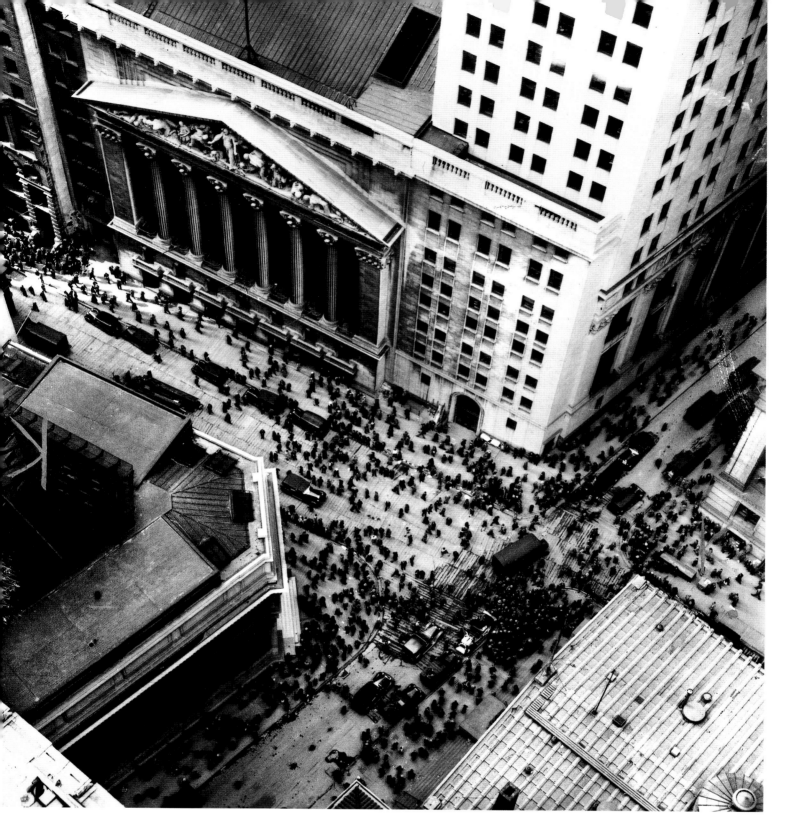

| 1929 | THE STOCK MARKET CRASH... |

Not unnaturally, anxious crowds swarmed around the New York Stock Exchange in the opening days of the 1929 Crash. The building appears remarkably solid; the economy it represented was not, and millions of businesses and investors were forced into bankruptcy and poverty. World War II sparked a recovery.

| 1931 | THE EMPIRE STATE BUILDING |

The clean lines of the Empire State Building give it a presence and dignity that remain unassailable. On its completion in 1931, it was the world's tallest building, and remained so until the World Trade Center was completed in the 1970s. The 86th- and 102nd-floor observation desks remain magnets for visitors.

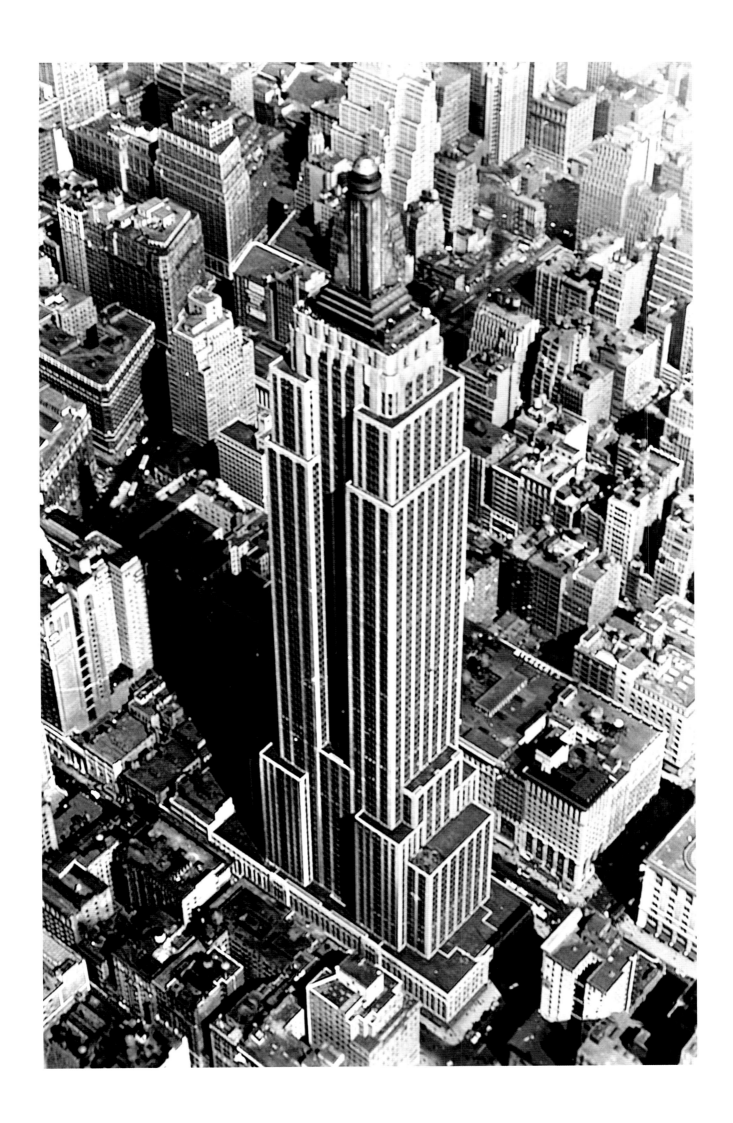

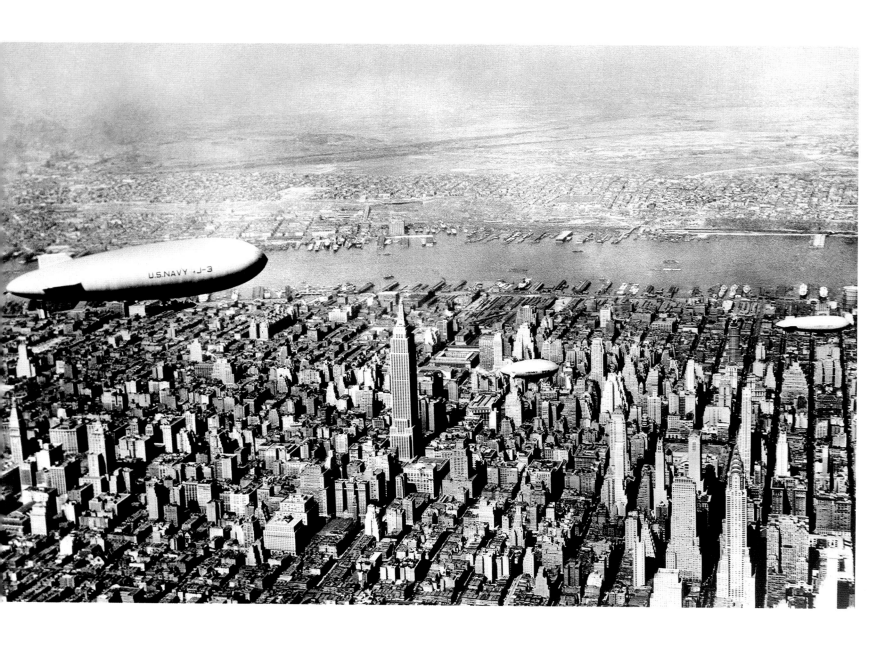

| 1931 | SERENELY CRUISING... |

Soft-skin U.S. Navy dirigibles (seen here in 1931) are far less of a threat to high-rise buildings than hard-shell aircraft are: in 1945, a B-25 bomber flew into the Empire State Building, causing the loss of fourteen lives. Today, aerial navigation over Manhattan is strictly controlled and monitored.

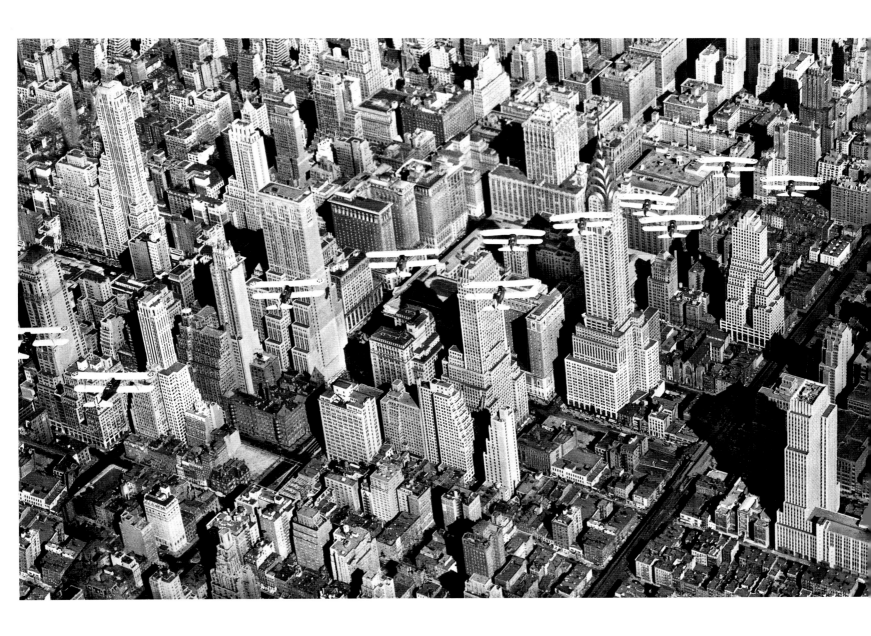

| 1932 | IN TIGHT FORMATION |

This 1932 flyover by U.S. Army Air Corps biplanes shows midtown bristling with office towers. Right center is the 1,046-foot Art Deco Chrysler Building, completed in 1930, and the world's tallest structure until surpassed by the Empire State Building in 1931.

| 1933 | A GIANT IN ITS DAY |

The USS *Macon* flying over Manhattan and New York Harbor circa 1933. The Financial District's high-rise towers now occupy almost all of Manhattan's southern tip, including the shoreline. Dirigibles are still occasionally seen above New York and its environs, usually as special elements in advertising campaigns.

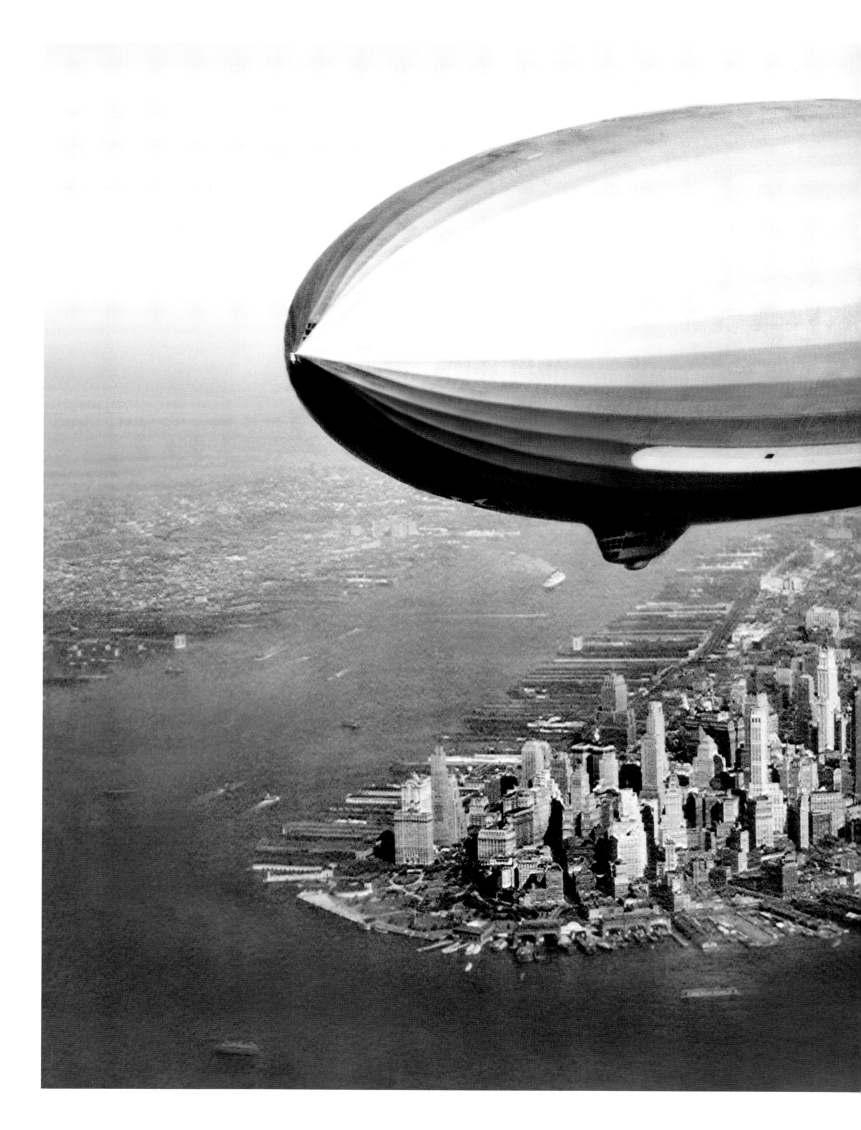

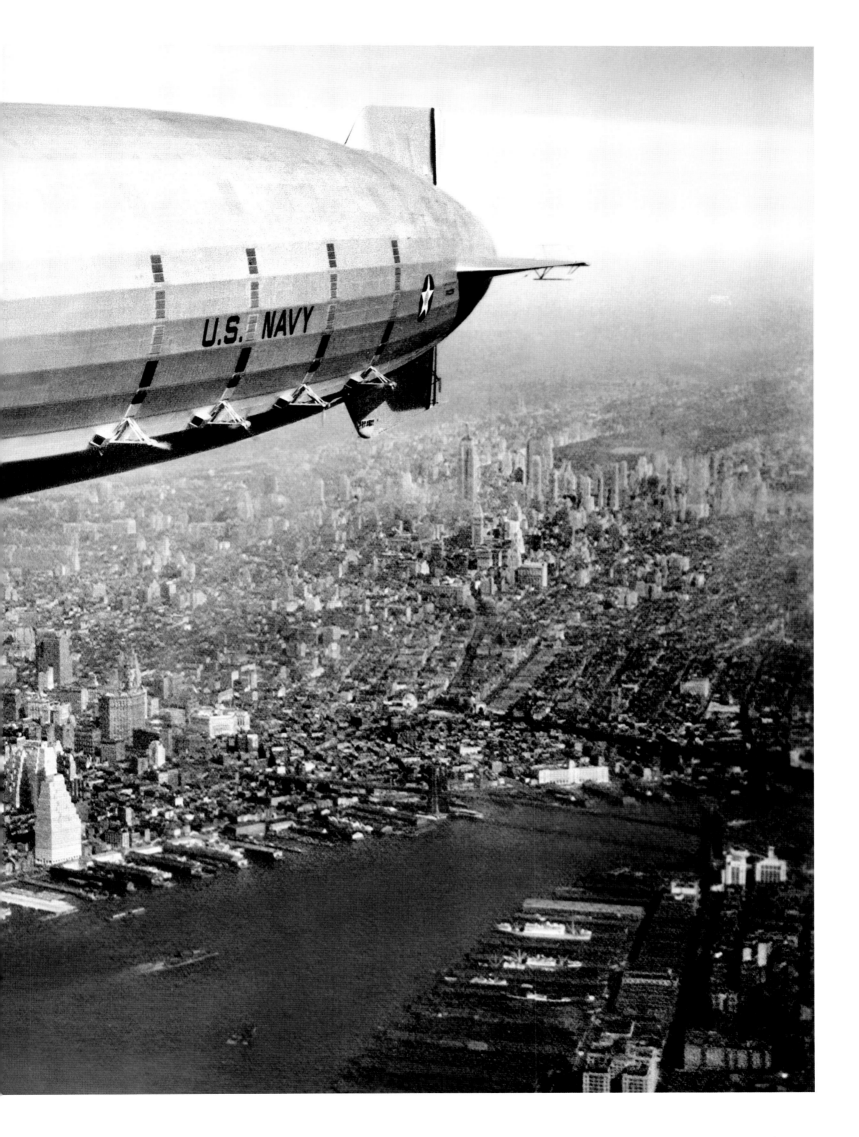

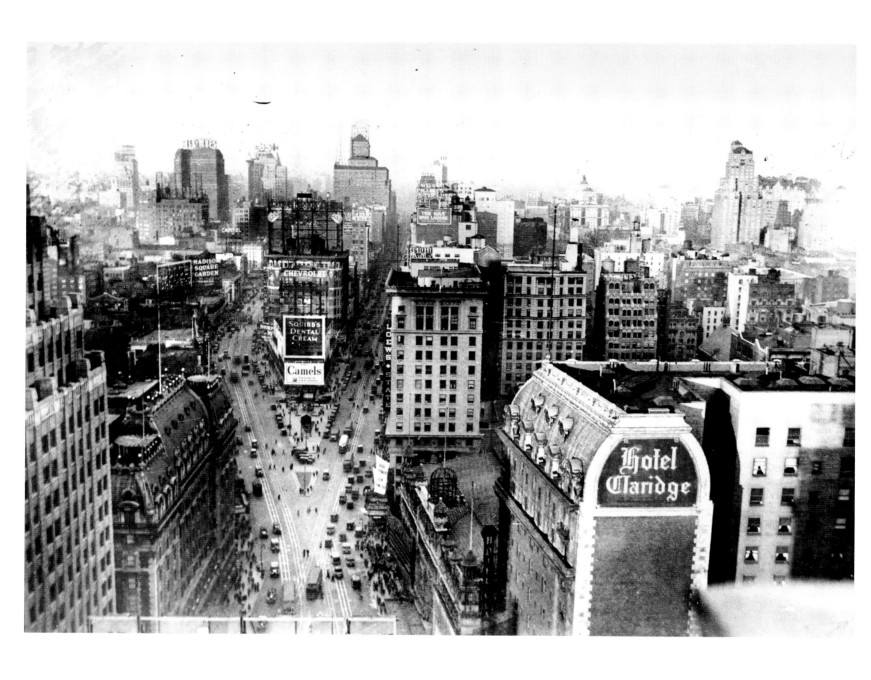

| 1935 | WHERE THE ACTION IS... |

Times Square in 1935, with One Times Square at the junction of Broadway and Seventh Avenue, partly obscured by immense advertising billboards. Times Square never claimed architectural preeminence; people and theater gave it life and light. Today, revitalized and bathed in neon, it is a premier visitor attraction.

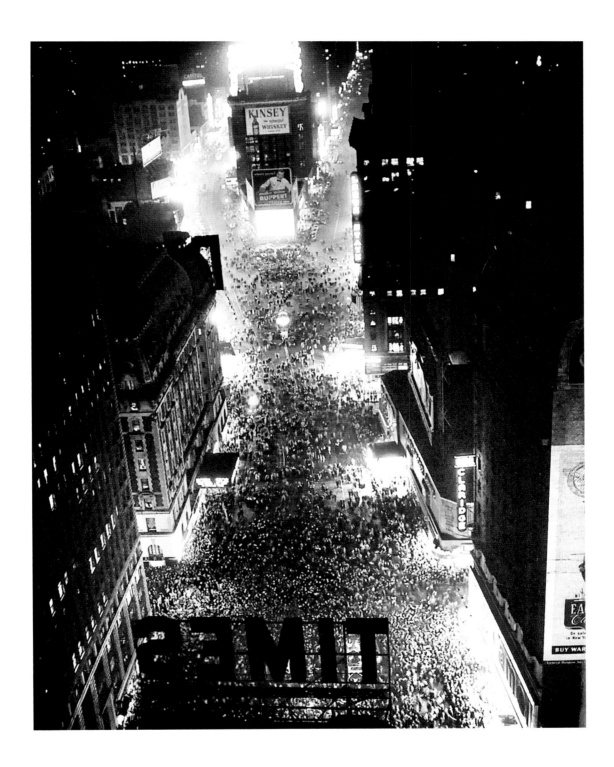

| 1945 | VICTORY AT LAST |

May 7, 1945, brought American families together in a national expression of joy and relief. Families that had lost fathers or sons could take a measure of comfort in knowing they had not died in vain; families whose loved ones would return were relieved of a terrible anxiety by the German surrender. Some two million New Yorkers and others gathered in Times Square in true celebration.

| 1936 | IN FULL COLOR |

The year 1936 saw the publication of the first successful aerial color picture of the Statue of Liberty. The semi-military architectural style of the statue's base, the trees and lawns, and the protective stone framing of the island's perimeter is clearly depicted. For millions each year, the statue is a "must visit" site.

Re-published October 1963 p

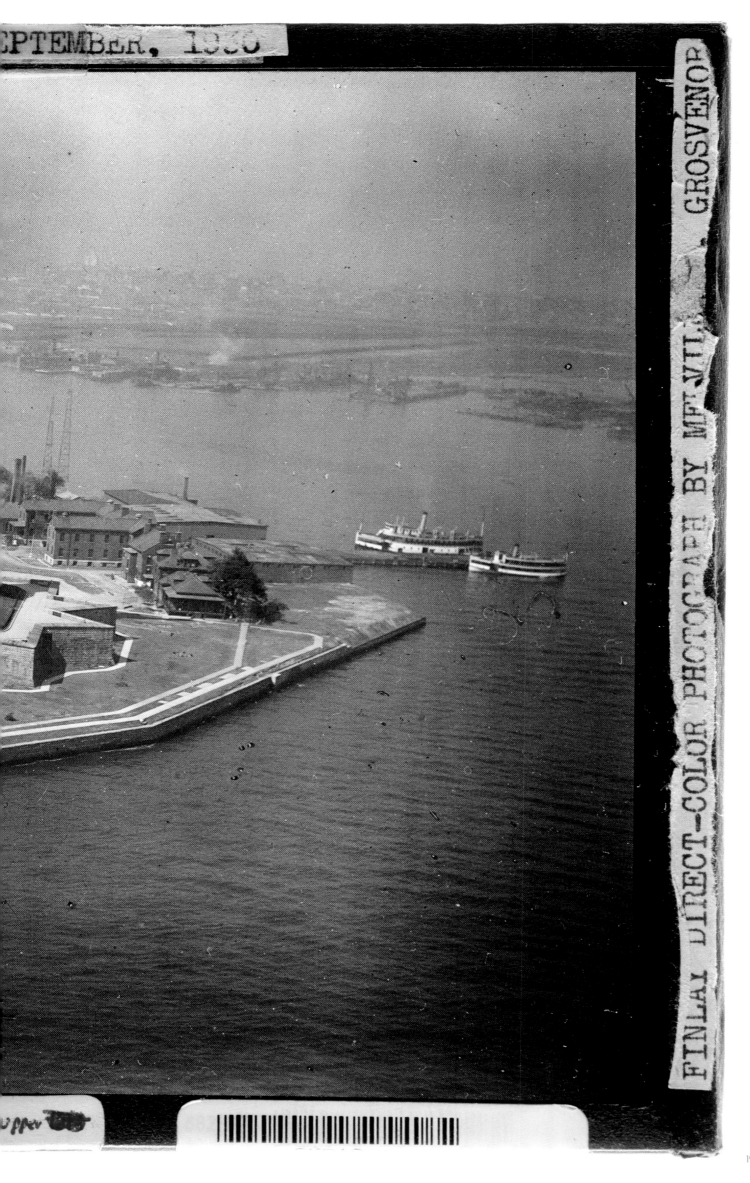

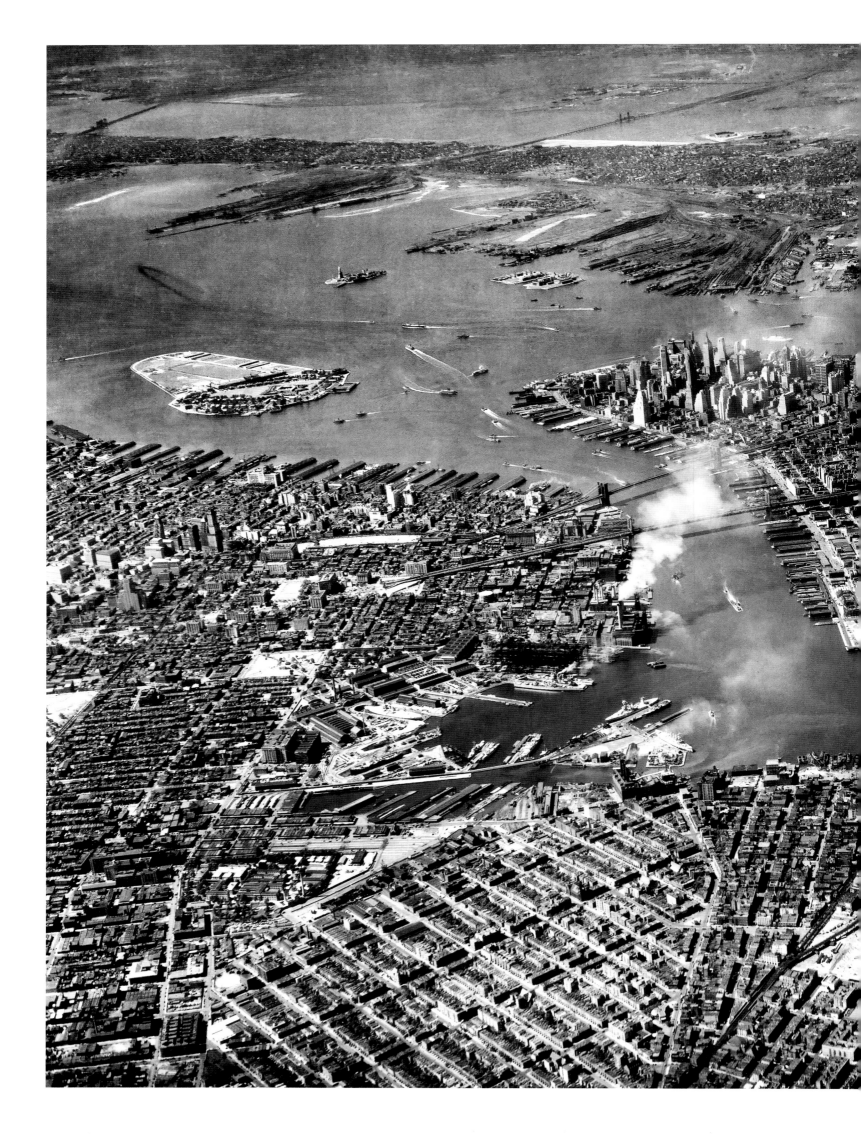

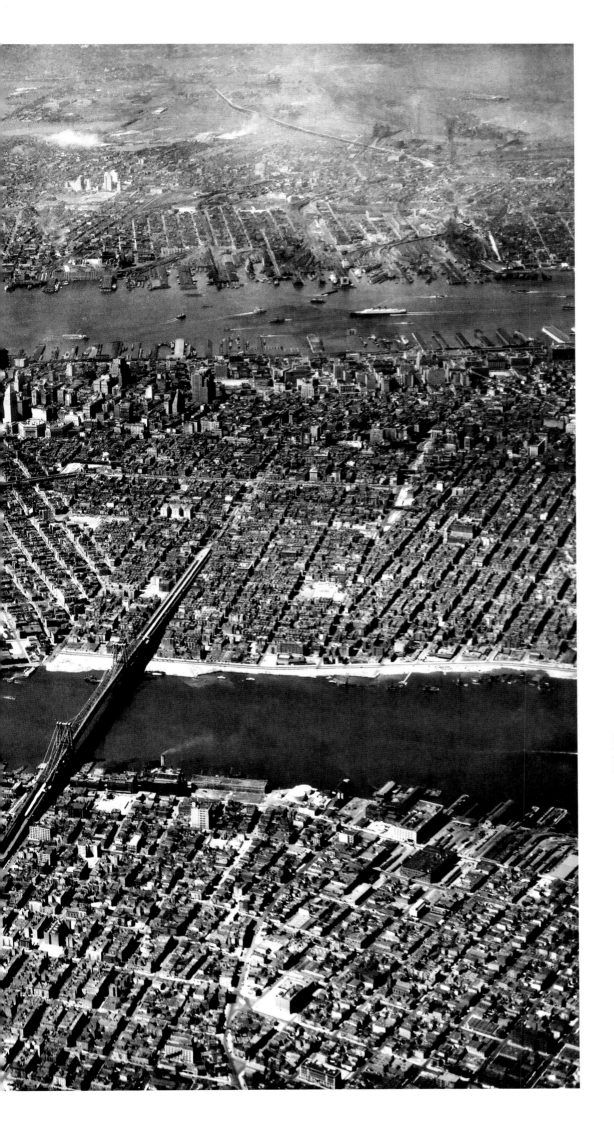

| A VITAL LINK |

This photograph focuses on the Lower East Side and the Williamsburg Bridge, completed in 1903, the second of the three Manhattan-to-Brooklyn crossings. To the west, semi-obscured by a plume of smoke, are the Manhattan and Brooklyn Bridges. Governors Island can be seen on the upper left of the image.

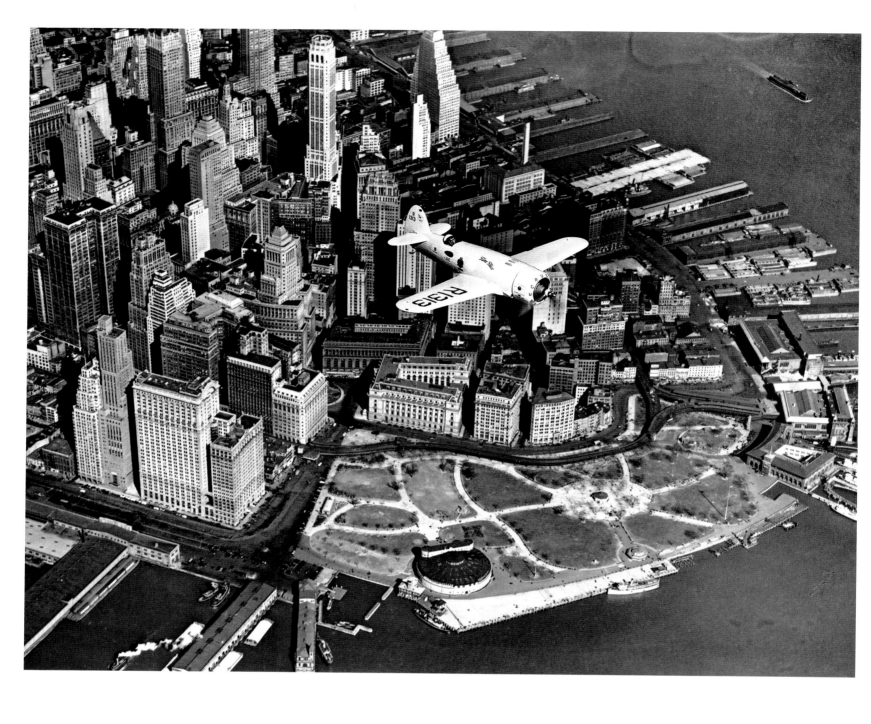

| 1937 | AN AERIAL SURVEY |

By 1937, very little building space existed in the Financial District; the demolition of older buildings increasingly had to precede construction of newer, taller ones. Battery Park, with the familiar circular Castle Clinton, remained a green oasis. The plane was flown by Captain Frank Hawks, a high-speed pioneer.

| 1940 | TRAVELING IN STYLE |

In the heady days of Atlantic crossings, luxury liners like the RMS *Queen Mary* were regularly berthing at the Hudson River piers. All this has passed with cheaper air transport—and the *Queen Mary* is now a floating hotel, moored off Long Beach, California. Many regret the ending of luxurious ocean crossings.

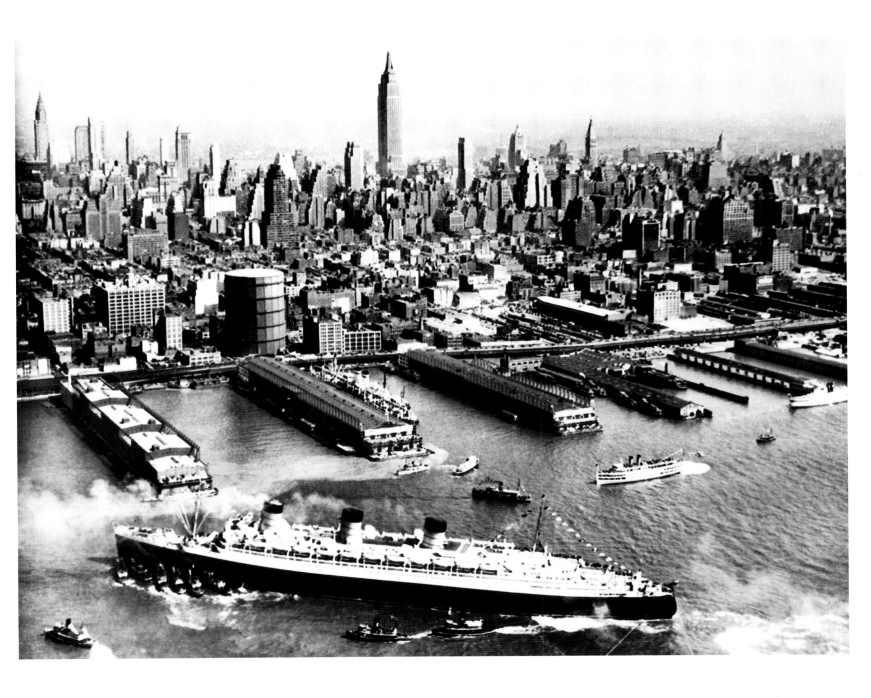

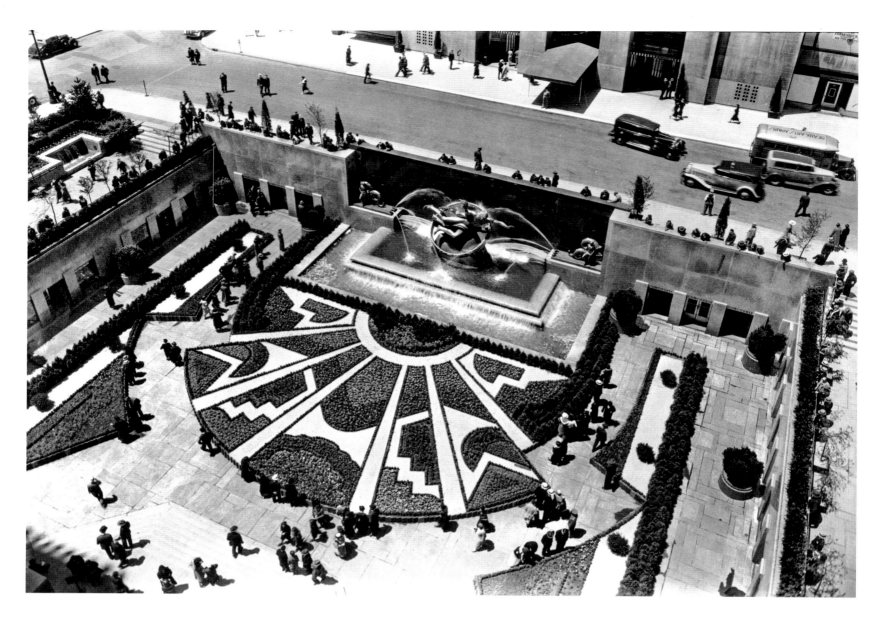

| 1935 | URBAN AESTHETICS: ELEGANT DESIGN |

The sunken plaza in front of 30 Rockefeller Plaza (the complex's tallest building) hosts many events, including, here in 1935, a City Garden Club exhibition. In winter, the plaza becomes an ice-skating rink, over which rises a great bronze rendering of Prometheus. December brings many thousands of visitors to view the famed Christmas tree.

| 1939 | THE VIEW FROM ABOVE |

The popular ice-skating rink at 30 Rockefeller Plaza, with the keynote building rising on the left. Coming off Fifth Avenue, the visitor walks through the mall between the two matching low-rise buildings, bottom right. Flowerbeds, lighting, and human activity make for a warm and colorful welcome in a distinguished setting.

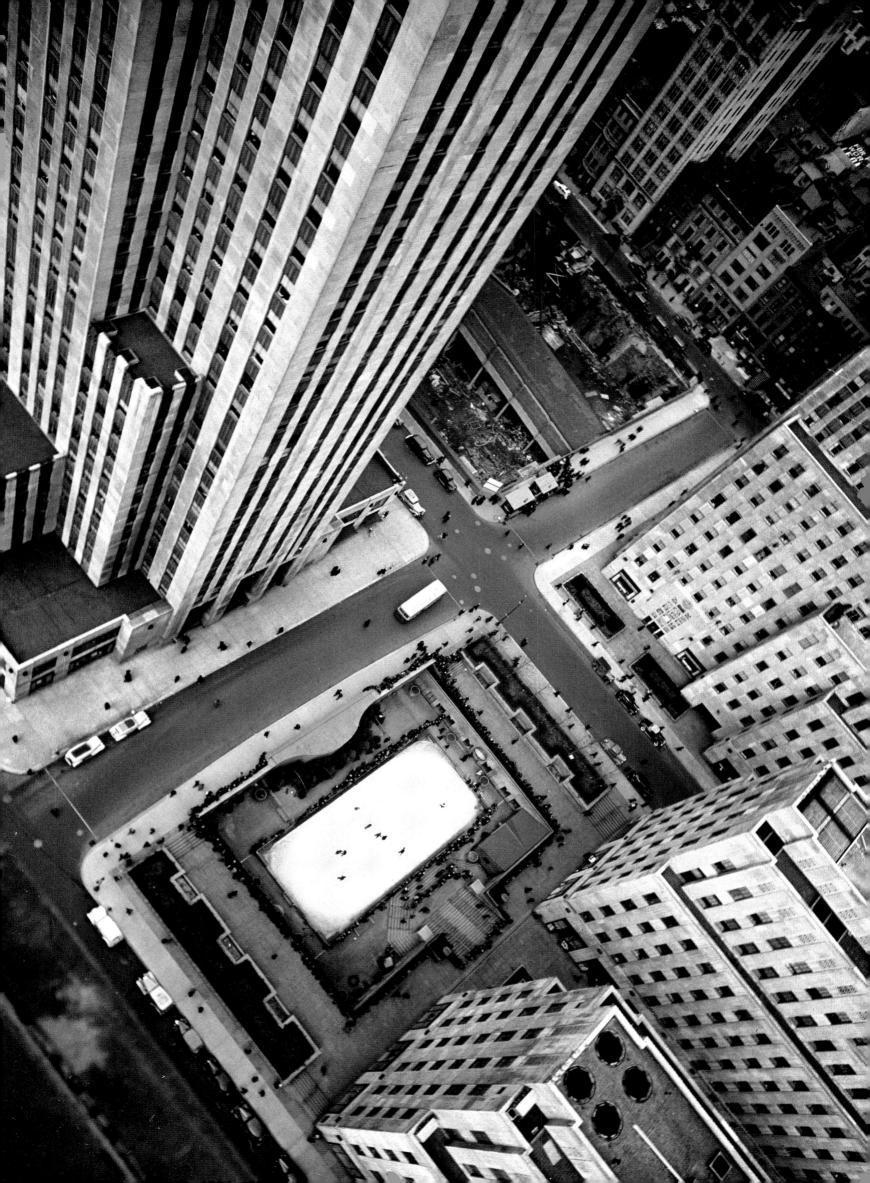

| 1946 | MEETING SPIRITUAL NEEDS... |

St. Patrick's Cathedral is the diocesan church of the Roman Catholic Archdiocese of New York. It is highly decorated in a neo-Gothic style that recalls the great cathedrals of Europe. Construction began in the 1870s, the spires were added in 1888, and the building was finally finished and rededicated in 1910.

| 1949 | IN ALL ITS GRACE... |

The Art Deco Chrysler Building (completed in 1930) is the most admired of New York's iconic skyscrapers; it is more decorative and elegant than the somewhat austere Empire State Building, built one year later. In 1949, when this photograph was taken, there were still many high-rise-free blocks in Midtown.

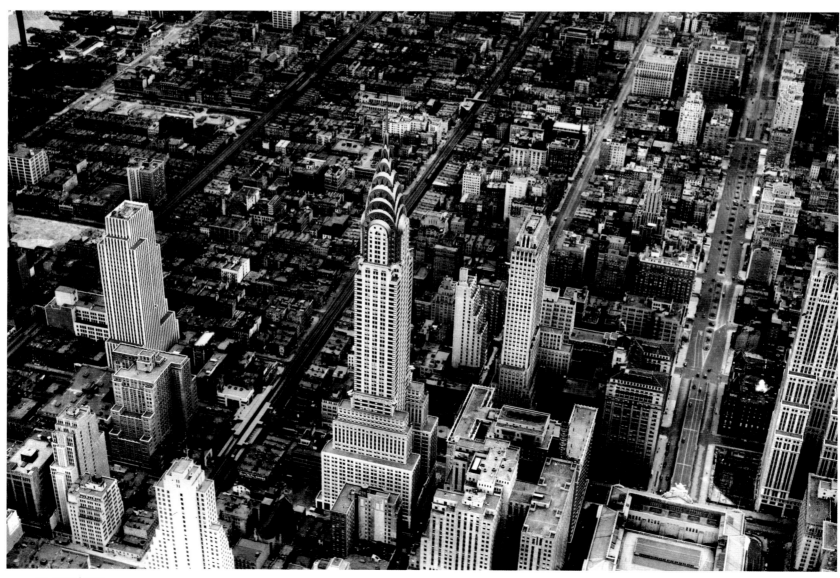

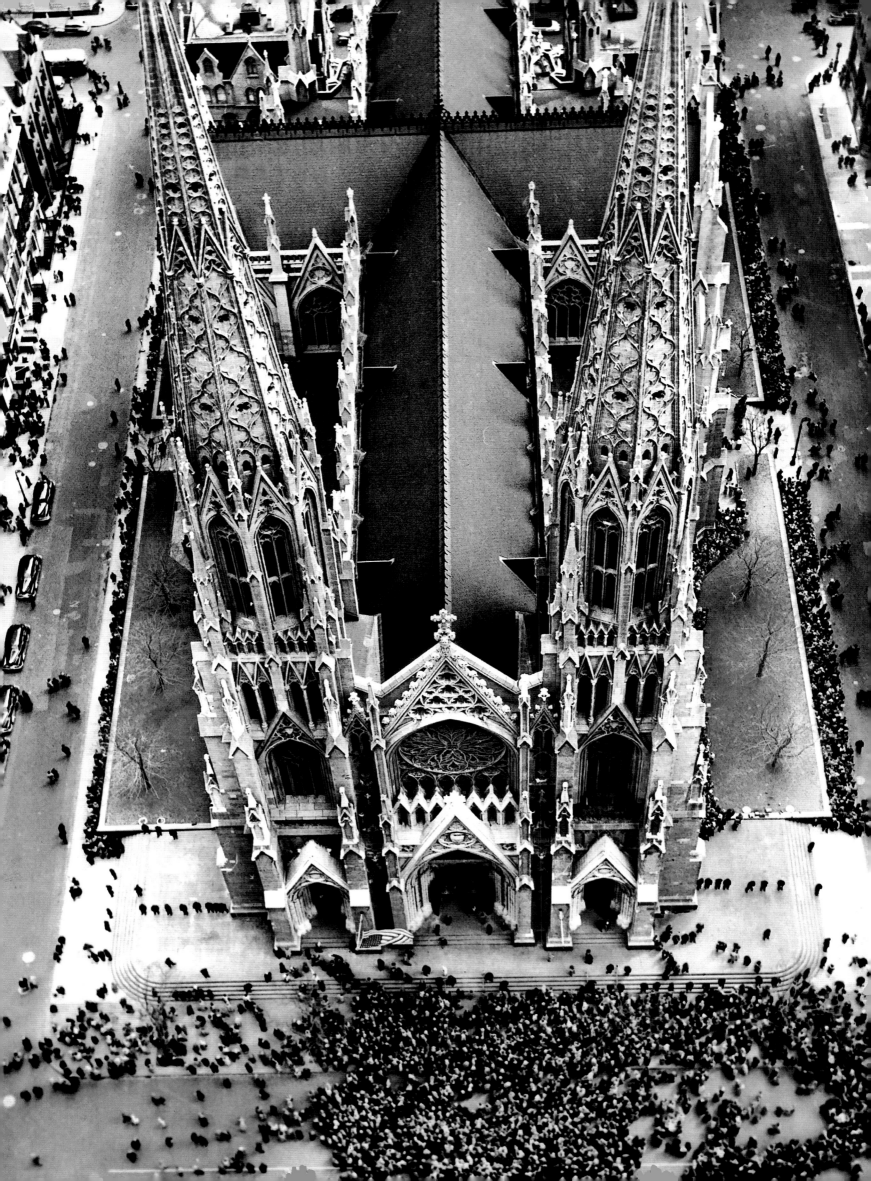

| 1937 | WHERE THE FANS GATHER… |

Though Yankee Stadium of 1937, home to the city's much-admired but much-criticized baseball team, looks fully functional, a comprehensive rebuilding (not the first!) was undertaken in 2009, resulting in an enhanced—and the most expensive ever—stadium, seating 50,000 spectators, fewer than before.

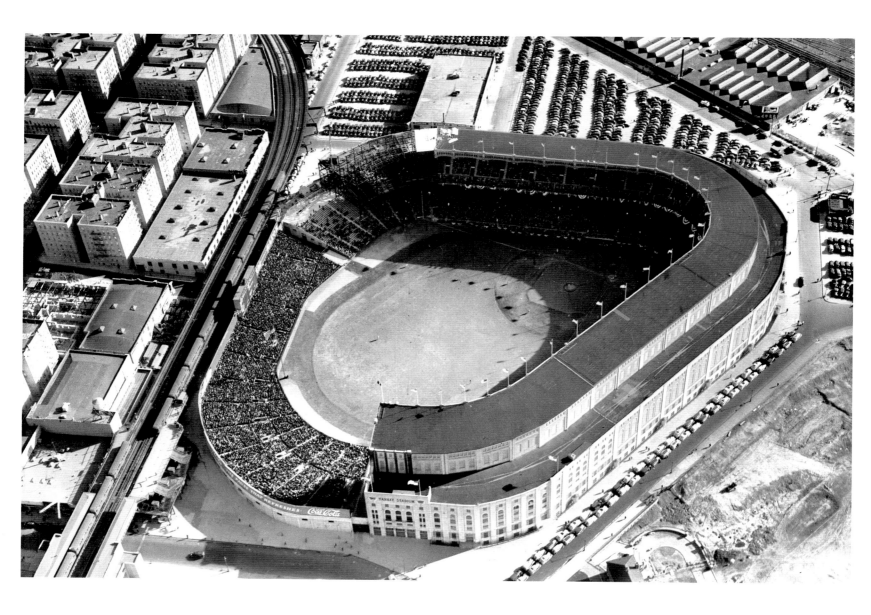

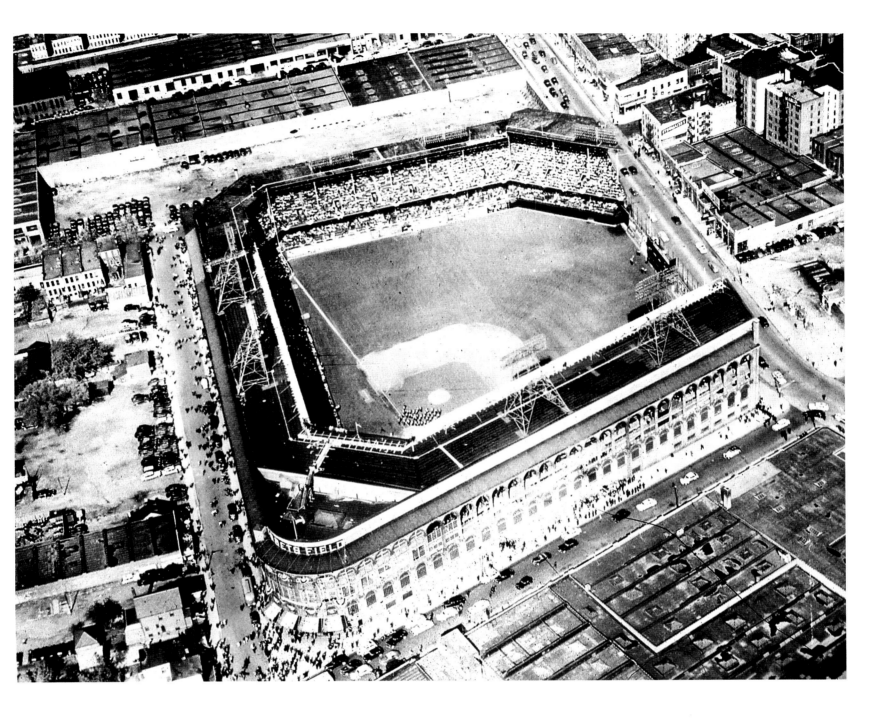

| 1948 | ALIVE IN POPULAR MEMORY |

From 1913, when Ebbets Field opened, to 1957, the much-loved Brooklyn Dodgers drew the faithful to their games. When the team moved to Los Angeles in 1957, the stadium fell into disuse, and was demolished in 1960. The faithful still regret the loss of the stadium and discuss a bygone golden era of Dodger games.

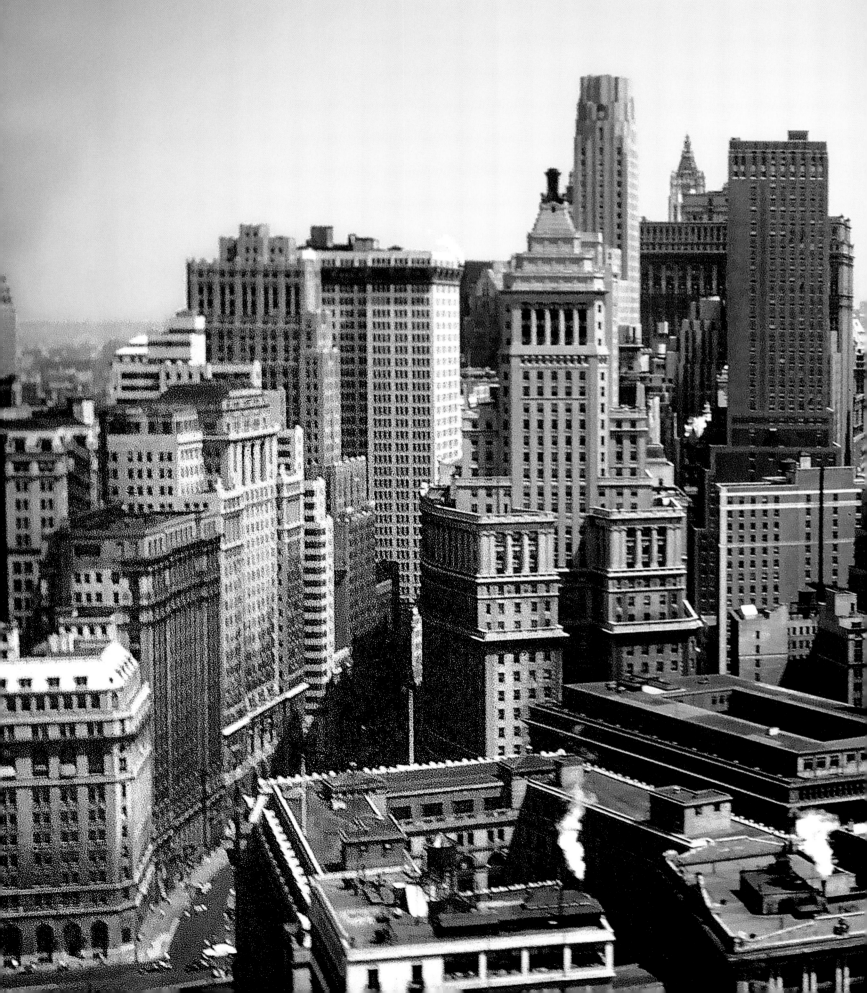

THE MODERN ERA

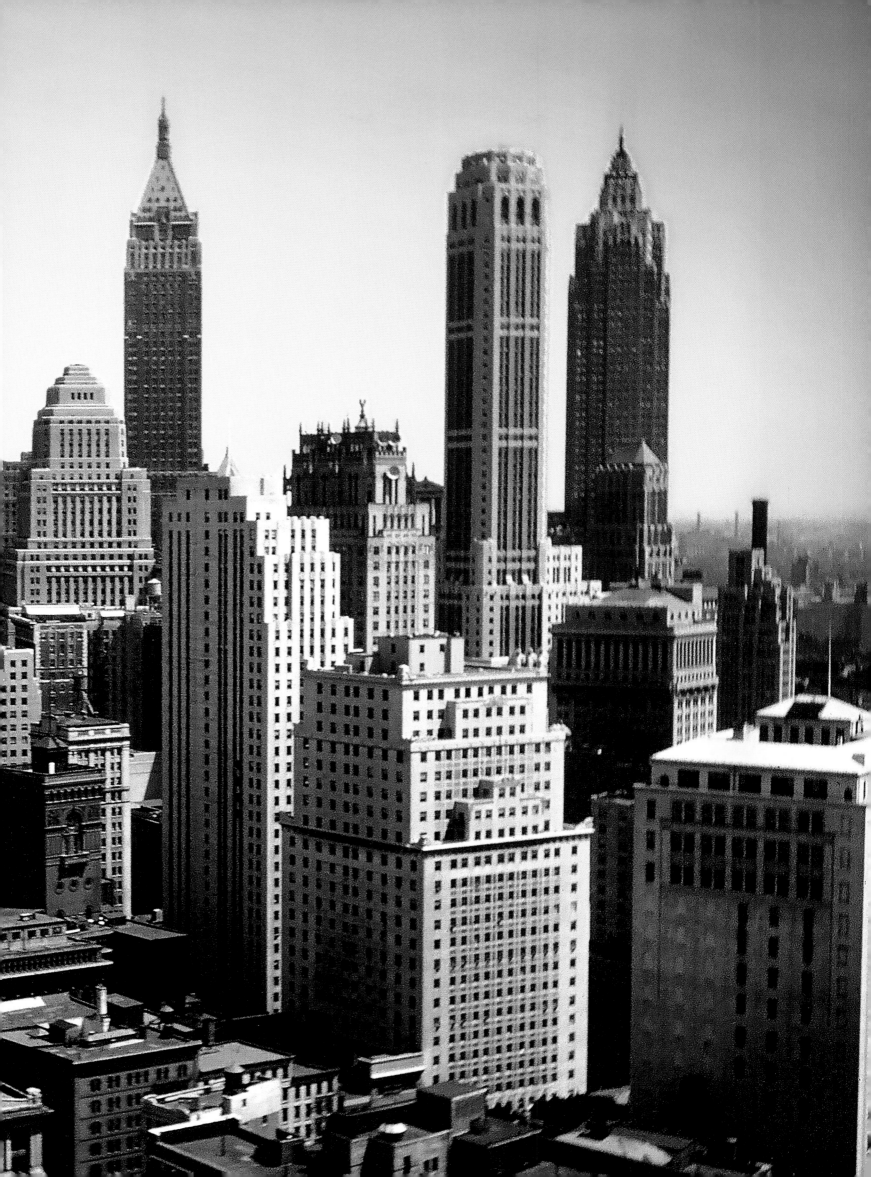

A LEADER AMONG THE WORLD'S SUPERCITIES

By 1950, the concept of the "world city" had become established. Those cities considered to be members of this informally designated group had transcended being national, political, or economic capitals to become tourist destinations offering sightseeing, museums and concerts, fine dining, and shopping. London, Paris, Berlin, Rome, Vienna, New Delhi, Singapore, Rio de Janeiro, and Buenos Aires were all striving to be great, to be progressive, to be magnets, and to keep the fast amounts of investment and trade money flowing. Given their nations' political creeds, Moscow and Beijing remained outside the group.

New York, host city to the United Nations, could claim to head this league. Such a position—recognized or not—brought many challenges. Chief among them were land use and the construction of new institutional, infrastructural, business, and transportation facilities. What should go where? What is the right balance between great design and utilitarian affordability? When must the past, even the present, be sacrificed for the future?

The 1960s brought about a significant reshaping of the New York skyline. The Wall Street area was so crowded that any new buildings meant expensive demolitions of what was already standing, and large sites were difficult to assemble. But in 1961, David Rockefeller, president of Chase Manhattan Bank, saw the opportunity to reinvigorate the now somewhat static financial area and initiated construction of One Chase Manhattan Plaza, a free-standing sixty-five-story, 813-foot monolith clad in black paneling. The plaza on which the building stood was much welcomed as open public space.

Midtown also saw dramatic change. In 1968, the General Motors Building was completed at 59th Street, directly across Fifth Avenue from the Plaza Hotel. It rose above an extensive sunken plaza, flanked by high-quality retail shops, emphasizing the thrust of major corporate towers in incorporating public amenities. A decade late, in 1977, the striking Citigroup Center was completed at Lexington Avenue and 53rd Street. The fifty-nine-story, 915-foot building reflected a number of new technological advances and also the now expected public space and facilities enhancements. The building rose on four immense pillars, not placed at its corners but in the middle of each of the four sides. One corner cantilevered out over a small church, preexisting but now rebuilt; sheltered below the other corners was a handsome plaza with sunken shopping arcades and subway access that formed an attractive public space. The building's roof featured a forty-five-degree slope, originally intended to support solar panels; however, the structure's orientation was such as to make these of limited value, and the plan was abandoned. In a second top-of-the building innovation, a "tuned mass damper" (with a weight of some 400 tons) was installed to minimize sway in high winds. This technology has been adopted for other new high-rises.

Other such buildings followed, and many were designed for primarily residential use. One is the Trump Tower, which was completed in 1983. It stands at Fifth Avenue between 56th and 57th Streets, the former site of the elegant Bonwit Teller department store. The Fifth Avenue façade of this fifty-eight-story, 664-foot building is flat, but the south side's façade is marked by a series of regular setbacks. The use of a whitish, pink-tinged marble gives the building a lighter look than its neighbors (over which it soars), an effect replicated in the lobby and public spaces, which feature mirrors and brass work. Overall the building was very noticeable among its more traditional neighbors.

Less glamorous but equally needed buildings arose. New York entered the 1950s with two huge low-rise (under fifteen-story) housing developments completed and occupied. Stuyvesant Town extended from First Avenue to the East River, from 14th to 20th Street, and Peter Cooper Village, offering larger apartments, occupied a far smaller site from 20th to 24th Street. In total, 110 residential towers were built in the parklike setting, with 11,250 apartments accommodating more than 25,000 residents. The apartments were affordable, and attracted many middle-class tenants, veterans returned from World War II, and young professionals.

Communications—bridges, tunnels, and highways—are vital to any great city; in New York, these facilities had to be of a huge capacity given that a high percentage of the city's workers lived across the East River in Brooklyn or Queens, across the Hudson in New Jersey, or north of the city in the Bronx. Not only people but also goods had to move. The southern Brooklyn, Williamsburg, and Manhattan Bridges had all been built before or at the turn of the twentieth century, but two important northern bridges, one spanning the Hudson to New Jersey and the other spanning the East River and serving the Bronx and Queens, had been completed before 1950. The George Washington Bridge had been completed in 1931 and was—at 3,500 feet between the towers—the largest of any span until the Verrazano-Narrows Bridge (4,260 feet) opened between Brooklyn and Staten Island. More ordinary, but equally vital, the Triborough Bridge opened to traffic in 1936, linking Manhattan and Queens and featuring an additional link to the Bronx. Both bridges were arteries of growth, vital to New York's expansion beyond its rivers.

1950

Crossing New York's bridges, soaring above the waterfronts and waterways, is always an exhilarating experience. However, buses departing from the Port Authority Bus Terminal, at 40th to 41st Streets and Eighth Avenue, for New Jersey and points beyond did not offer this experience: the buses cross the Hudson via a tunnel. The terminal, which opened in 1950, is the world's largest: some 8,000 buses and 225,000 passengers use its 223 departure bays every weekday, providing for an annual total of more than 2.2 million departures. Passenger needs have long since outstripped service capacity, and in 1979 a second wing of the same size was built. Currently, there is discussion of a complete rebuilding, as its service capacity is again falling behind its needs.

The Port Authority also operates the much smaller George Washington Bridge Bus Station at 179 Street, with exit routes feeding into the bridge and serving many New Jersey communities. The elegant terminal, which was designed by Pier Luigi Nervi, was opened in 1963; over 1,000 buses serve 20,000 passengers each weekday. The facility has recently been renovated to secure increased service capacity.

Little has been said so far of New York's government buildings. Though attempts have been made to disperse government offices to different areas of the city, a significant cluster remains solidly entrenched at New York's southern tip. The most striking of these is the forty-story Municipal Building, designed by the architects of McKim, Mead and White, who were later to design Columbia University. Though an older construction, completed in 1914, it was the result of surprisingly forward-looking thinking. Not only did its massive bulk accommodate a workforce of over 2,000 people in a variety of local government departments, but it also incorporated a subway station. Surprisingly, the building does not align with a street or avenue but is built astride a street, and is furnished with a central arch under which the street continues. Uniquely eclectic in style and decoration, the building's architectural influence extends even to Stalin's more grandiose governmental buildings in Moscow. The Municipal Building has been renamed the David N. Dinkins Municipal Building in honor of the city's first African American mayor. Contrasted with the slender high-rise financial towers at New York's southern tip, the Municipal Building has a reassuring down-to-earth bulk and solidity.

Despite the immense costs of building the Financial District's early skyscrapers and the huge revenues they produced, some were destined for destruction—to be torn down. In some cases, floor plans and construction precluded adaption for current use needs, in others the land on which they stood could be used for a larger building. The saddest case was that of the elegant forty-seven-story Singer Building on lower Broadway, torn down in 1953. Its replacement is a fifty-four-story office block, which does not offer refined decorative detail, nor has it achieved iconic status, but it does feature much larger floor plans.

Some five years later, in 1959, New York could boast a new and iconic building, the Solomon R. Guggenheim Museum, designed by Frank Lloyd Wright and George Cohen. It is in every way a total departure from traditional museum architecture. The visitor sees no white-cube galleries but ascends up a ramp on the inside of the curving wall to the glass dome at the uppermost level. En route, the museum's collections, or special exhibits, are displayed. The museum's focus is on Impressionist, Post-Impressionist, and modern and contemporary art, and it has long been a popular favorite. The museum has expanded, and now has several overseas branches, of which the Guggenheim Museum Bilbao (1997), with its striking building by Frank Gehry, is the best known.

Unfortunately, gains are often accompanied by losses. Eero Saarinen's TWA Flight Center, opened in 1962 at John F. Kennedy International Airport, known for its arresting wing-like curvilinear lines and roof forms, no longer serves as a passenger

1999

terminal. Part of the original structure has been demolished, and the remainder awaits possible conversion into a hotel. To the on-the-ground passenger, JFK appears to be an encircling array of terminals, all of markedly different designs; from the air, an overall design can be perceived, with a huge area of the whole given over to parking lots and garages. Other buildings remain inviolable despite demolitions and new structures around them: having won the rare privilege of permanency, no one would propose their removal. The updating of mechanical systems is carried out without any destruction of the existing fabric. Predominant among such buildings/complexes is Rockefeller Center, with its fourteen buildings, and its neighbor across Fifth Avenue, St. Patrick's Cathedral.

The concept of permanency for any structures in New York was entirely shattered with 9/11, the terrorist attacks of September 11, 2001 on the World Trade Center. Just as Rockefeller Center symbolized Midtown, the Twin Towers symbolized Downtown and the Financial District. Rockefeller Center reflected the limits of the steel-and-masonry construction technologies of its day; its tallest building rose seventy stories to 872 feet; its twenty-two-acre site accommodated fourteen buildings offering some eight million square feet of office space. The World Trade Center far exceeded these usage data. Though it occupied only a sixteen-acre site, the Twin Towers rose 110 stories to a height of over 1,360 feet, with the center's seven buildings offering over thirteen million square feet of office space. The buildings' steel frames and steel-and-glass exteriors reflected the most advanced construction technologies and safety features of the day; rather than the impact, it was the superheat of blazing jet fuel that destroyed the integrity of the steel frame. In their day, the Twin Towers dwarfed their neighboring buildings and redefined the Financial District's silhouette and skyline. The immense volume of rock and soil excavated for the towers' multilevel basements and foundations was dumped in the Hudson, and, with more land-fill added, formed the ninety-two-acre riverfront tract on which the striking World Financial Center and Battery Park City rose in the 1980s.

Some iconic buildings survive, though dwarfed and partly hidden by their neighbors. The Helmsley Building, designed in the Beaux Arts style and completed in 1929, straddled Park Avenue just north of Grand Central Terminal. Rising high above Grand Central, its vertical thrust contrasted powerfully with Grand Central's horizontal mass. Completion of the fifty-nine-story, 808-foot-high Pan Am Building (now the MetLife Building) in 1963, which also straddles Park Avenue, but rises between Grand Central and the Helmsley Building, destroys the classic view of either. The broad slab and unadorned utilitarian bulk of the unloved MetLife Building offers nothing to the eye but the loss of sunlight and the visual power and grace of its unfortunate neighbors. The Empire State Building has so far escaped any assault; it rises solitary and unrivaled at Fifth Avenue and 34th Street, though with the development of Penn Plaza on the site of the demolished Penn Station—Seventh to Eighth Avenues and 33rd Street—its surroundings are fast changing.

1950

1999

In the Financial District, another handsome building, constructed in 1930 as the Bank of Manhattan headquarters but today known as the Trump Building, shares the same type of distinctive and steeply rising pyramidal cap to its seventy-one stories as does the Empire State Building, ornamented here with a highly decorative spire, with the green luster of the copper adding visual appeal. Extremely few new buildings, mainly designed in the generic International Style, offer anything other than a flat roof without cornice or trim.

Park Avenue itself is the broadest of New York's avenues, and the only one to have a continuous median planted with scrubs and flowers. From 14th Street north to about 50th Street, Park Avenue is flanked by solid older commercial buildings, mainly under twenty-five stories high. After 50th Street, there is a shift to residential buildings of the same height, whose solid construction, elegant interiors, and large and high-ceilinged apartments have long given them a desirable cachet, even though they offer no views of Central Park.

If Central Park's interior—the walks, the woodlands, the shrub and flower plantings—remain and are better maintained than ever before, and if the summer open-air opera and concert seasons are ever more popular, then the park's boundary avenues and streets are slowly undergoing change. A modest number of new high-rise apartment houses have been built on Fifth Avenue, Central Park West, and Central Park South and North. Not only are long-familiar urban panoramas changing, but behind the park's traditional boundaries spectacular new high-rises—particularly on East 57th and East 58th Streets—are springing up. Park views are now available to those in high-floor apartments in high-rises set well back from the park.

If Fifth Avenue has slightly more social cachet than Central Park West, the latter has rather more iconic buildings, most dating to the 1930s. The block-long bases of the San Remo and the Eldorado develop into twin towers topped by spires, while the Majestic was built without towers. The much older, nine-story gabled Dakota (so-called because in 1884 its 72nd Street site was considered to be in the city's far north) was designed in a vaguely Victorian Gothic style and built around a courtyard. It offers magnificent apartments, no two identical, and has always been a preferred address for performing artists.

Another high-rise apartment tower is actually a conversion from a commercial building. Between 1995 and 1997, the forty-four-story, 583-foot Gulf and Western Building, which had been completed in 1970, underwent an extreme makeover and was stripped to its steel frame, to be refinished as an apartment building. Its location at Columbus Circle and 59th Street provides for unimpeded views over Central Park, which was a compelling factor in favor of conversion. Though New Yorkers lost a basement movie house, they gained much improved access to the subway system.

New York boasts a unique new park in the making—Governors Island. The 172-acre island lies half a mile beyond the tip of Manhattan, and less than a quarter of a mile from the Brooklyn waterfront. Over its varied history, the island has been the residence of the Dutch governors of Manhattan, a Continental Army base during the Revolutionary War, and then, until 1996, a U.S. Coast Guard base. The island reflects a building boom in near reverse; some modern utilitarian buildings are being demolished, while at the same time the careful restoration of historic ones continues. One fanciful development proposal called for the island to be connected to the mainland, with the connecting berm serving as a storm defense for Lower Manhattan. Given that a substantial amount of Governors Island is made up of landfill, the proposal is not too far-fetched.

Very few New Yorkers can hope or afford to live in palatial and iconic buildings overlooking Central Park, but in the last half-century a number of large-scale developments have marked the New York skyline, and offer housing options. Among them are Trump Place, on the west side between 66th and 70th Streets, and the adjoining Riverside South development. The development offers over 5,500 residential units, with views of the Hudson River and a riverside park among their attractions. More modest in size is Waterside Plaza, a self-contained complex of three high-rise towers and a number of low-rise townhouses. Built on a platform above the East River, the apartments offer spectacular views of the waterfront both to the south and to the north, where the United Nations Secretariat Building rises at 42nd Street, now flanked by twin high-rise apartment towers and a hotel.

1950

If between 1950 and 1999 New York led the world in the construction of towers—office and residential—the city did not lag in constructing iconic buildings devoted to the performing arts. Given the plaza-like setting in which its stands, Lincoln Center has a unique and welcoming presence. At the farther end of the central plaza stands the Metropolitan Opera House, flanked to the north by the Symphony Hall and to the south by the New York State Theater—all completed and opened during the 1960s. A substantial part of the initial $185-million construction budget came from the Rockefeller family and its philanthropic institutions—and John D. Rockefeller III served as Lincoln Center's first president. Since the center's founding, the Juilliard School of Music and Martin Luther King, Jr. High School have been built in close proximity. Recent renovations of the Symphony Hall and the New York State Theater has led to their being renamed after the donors as David Geffen Hall and the David H. Koch Theater, respectively—a situation unexpected and confusing to many overseas visitors.

New York has always loved public entertainments, especially king-sized parades, which range from the huge Saint Patrick's Day Parade down Fifth Avenue to Macy's Thanksgiving Day Parade, through many "national day" celebrations of immigrant

groups to special events honoring some major personal achievement. New York thus honored astronauts Neil Armstrong, Buzz Aldrin, and Michael Collins, following the US's moon landing on July 20, 1969. The procession moves down Lower Broadway beneath the windows of the financial institutions, from where confetti (replacing stock ticker tape) is showered on them and the many thousands in the streets and plazas below.

On the eve of the twenty-first century, a cluster of new giants deserves note. One was the Jacob K. Javits Convention Center, which was completed in 1986 and occupies a Hudson River waterside site extending from 34th to 40th Street. Overall, the center contains 1.8 million square feet of space, about as much as a sixty-story high-rise office building. A modular steel frame carries continuous walls and a ceiling of tinted glass, enclosing an open floor plan. The center has already undergone one major renovation to ensure it remains a leader in the trade fair and expo world; though only twelfth in size, it has been the busiest such center worldwide in terms of the total number of events held. In 2016, proposals were launched for a second renovation and an extension to capture up to one million more square feet of space. The Javits Convention Center can be deemed a glass palace—but one that endlessly seeks to expand.

A trio of other apartment towers deserve passing mention; all three stand very close to each other on West 56th and West 57th Streets; all three differ distinctly in design concept, and an aerial observer would enjoy a visual feast. The sixty-eight-story, 716-foot Metropolitan Tower, completed in 1987, can be described as postmodern; it is a triangular tower placed on a rectangular base—with the point of the triangle facing toward Central Park, two blocks to the north. This once meant spectacular open views. But now it can be said that the neighborhood has become crowded.

In 1989, just after the Metropolitan Tower was completed, the broad-based, more massive CitySpire Center opened its doors on West 56th Street. The seventy-five-story, 814-foot multiuse building reflects some unique design features; its upper section has an unusual octagonal shape and is crowned by a ribbed dome. This feature produced a disturbing whistling sound that led to lawsuits from tenants and neighbors—and required modification of the dome.

The third new building adhered far more to tradition. The slender sixty-story Carnegie Hall Tower, completed in 1991, rises 757 feet alongside the famed West 57th Street concert hall after which it is named. The design sought to create a respectful bond with the dark stone and brick of Carnegie Hall, and is clad in brick of similar color, retaining several traditional features, including lintels above the windows. The building did much to harmonize with its parent neighbor and hall, but it is distinctly different than its two slightly older neighbors.

1999

Today, West 57th Street, two blocks below Central Park and a traditional divide between business-oriented Midtown and the residential Upper West Side, is now a magnet for residential towers (with some retail use on lower floors), and residents who once celebrated unimpeded views may no longer have them.

Such is the variety and the energy of New Yorkers that well-paid jobs and expensive high-floor apartments are only part of life's pleasures. Recreation is also needed—and eagerly sought. Central Park accommodates bicyclists, runners, walkers, horseback riders, tennis players, baseball enthusiasts, kayakers and canoeists, frisbee players, and numerous others. But downtown, on the Hudson waterfront from West 17th Street to West 23rd Street, extends the great recreation complex known as Chelsea Piers.

"Piers" harks back to the great days of transatlantic ship travel and the glamor of ocean liners steaming up the Hudson River to their berths. Now the piers—mainly unused since such liners as the *Lusitania* and its younger sisters ceased their ocean crossings—support a full-fledged sports and recreation complex: Chelsea Piers Sports & Entertainment Complex—or Chelsea Piers for short. Typically, with too little land available onshore, New York made the best of land offshore.

Perhaps the complex's most striking element is the golf driving range with its towering net walls; it overlooks a fully equipped marina that provides berths for chartered pleasure boats. A gymnastics training center, indoor soccer fields, ice rinks, climbing walls, basketball courts, and dance studios are all on hand. Food and drink are also available. Many visitors begin their exercise programs en route to the complex: they jog or bike on their way to it.

Throughout the half-century from 1950 to 1999, New York was on a continuous roll—to use a typical American phrase. The roll was most forcibly expressed by a relentless drive to build—and to build ever higher—that had set in, as elegantly captured by the photographs that follow this section. What aerial photographs cannot capture are interiors: what lies within a flamboyant high-rise.

In addition to prestige buildings at fashionable addresses, residential buyers and renters wanted sumptuous interiors. Entry doors became bronze portals, often with permanent marquees; lobbies became marble-clad, often mirrored, and finished with classical or ultramodern trim in materials ranging from mahogany to stainless steel. Balconies and terraces were often a part of a building's design, as might be rooftop observation decks. Increasingly often buildings incorporated gymnasiums or even swimming pools, and party or event rooms became common—with kitchens that would challenge even experienced chefs and catering teams.

1950

1999

Apartments were often termed "unique luxury residences" and sported master bedroom suites, galleries, grand rooms, media rooms—and frequently more bathrooms than bedrooms. Kitchen counters might be curvilinear polished quartz or an attractively striated marble. Refrigerators were invariably double-door and finished in polished steel. Bedrooms would have "walk-in double-sized" closets. Bathrooms had "vanities"—areas with shell-shaped marble sinks and enough mirrors and lighting for a film star—and faucets might well be gold-plated, while the polished marble floor had built-in heating. "Superb high-floor views" were frequently advertised as an "added attraction." Little was made of the fact that these views might be largely composed of the full sight of another high-rise residential tower. Words have been exchanged on the open views and partially or fully blocked views of the Metropolitan Tower, CitySpire Center, and Carnegie Hall, to which the huge One57 (as it calls itself) was added in 2014.

The selling of and taste for luxury, the different, and the better (though neither quality guarantees the other), has certainly trickled down to street level in almost all areas of New York. The old street-corner diner has all too often become a gluten-free, organic-produce, fresh health bar; the old coffee and pastry shop is now purveying "artisanal brands" of coffee and handcrafted European gâteaux. Even the small brown takeout bag has become a luxury packaging item.

New Yorkers seem unfazed; whatever is new in the Skyscraper City they happily subscribe to. To live at all seems to be to live beyond one's means, to shuttle one's children from pre-kindergarten to primary school, with therapists and child psychologists in tow as necessary supports. To go to private school and to college demands enormous financial sacrifices. But the great high-rise office buildings shelter hundreds of leading-edge employers offering jobs that can bring real wealth. Living in a luxury apartment tower means meeting large numbers of one's peer group in the daily comings and goings—and romance can beckon. And then, of course, there is opera, music, and dance—and for the less high-browed restaurants, bars, and clubs.

Whatever the cost, the excitements and rewards are worth it: Skyscraper City is the place to be. The city remakes itself, its citizens reinvent themselves—and the beat goes on.

As 2000 rolled in with a raft of political promises, economic analyses, and never-before cultural offerings, New Yorkers realized that there was no looking back—but only ahead as new excitements, new opportunities, and new rewards beckoned in the world's greatest city.

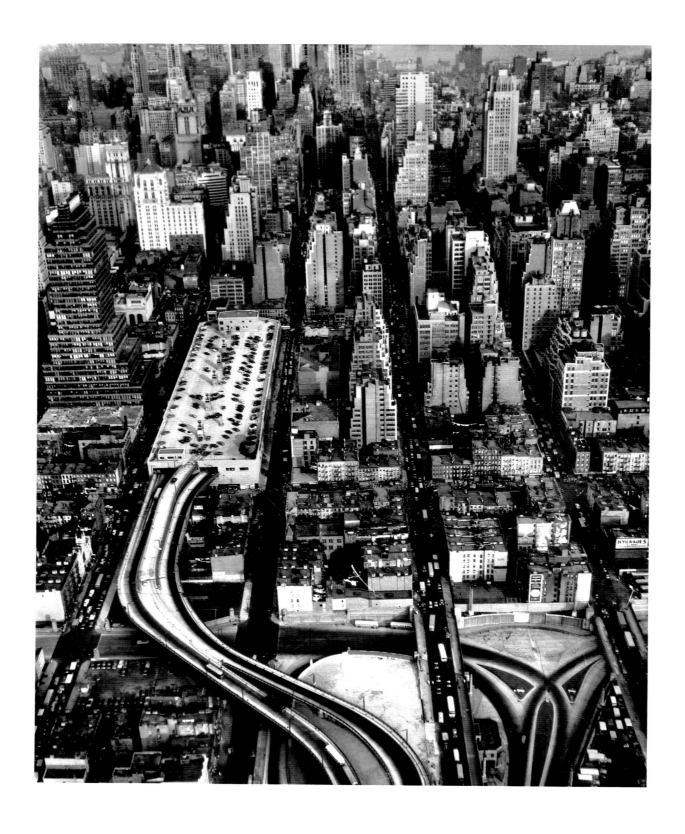

| 1951 | THE BUS TERMINAL'S EXIT RAMPS |

The Port Authority Bus Terminal at Eighth Avenue and 41st Street is a vital link to New Jersey and points beyond for thousands of daily commuters. It opened in 1950, and in 1979 was extended with a second wing to add 50 percent more capacity. Currently, there is talk of complete redevelopment and enhanced customer facilities.

| 1951 | GEORGE WASHINGTON BRIDGE |

The George Washington Bridge, in Upper Manhattan, is the only bridge linking Manhattan to New Jersey. Its main span of 3,500 feet was the world's longest until surpassed by that of San Francisco's Golden Gate Bridge in 1937. In 1962, a lower deck was added to the bridge, which carries approximately 315,000 vehicles daily.

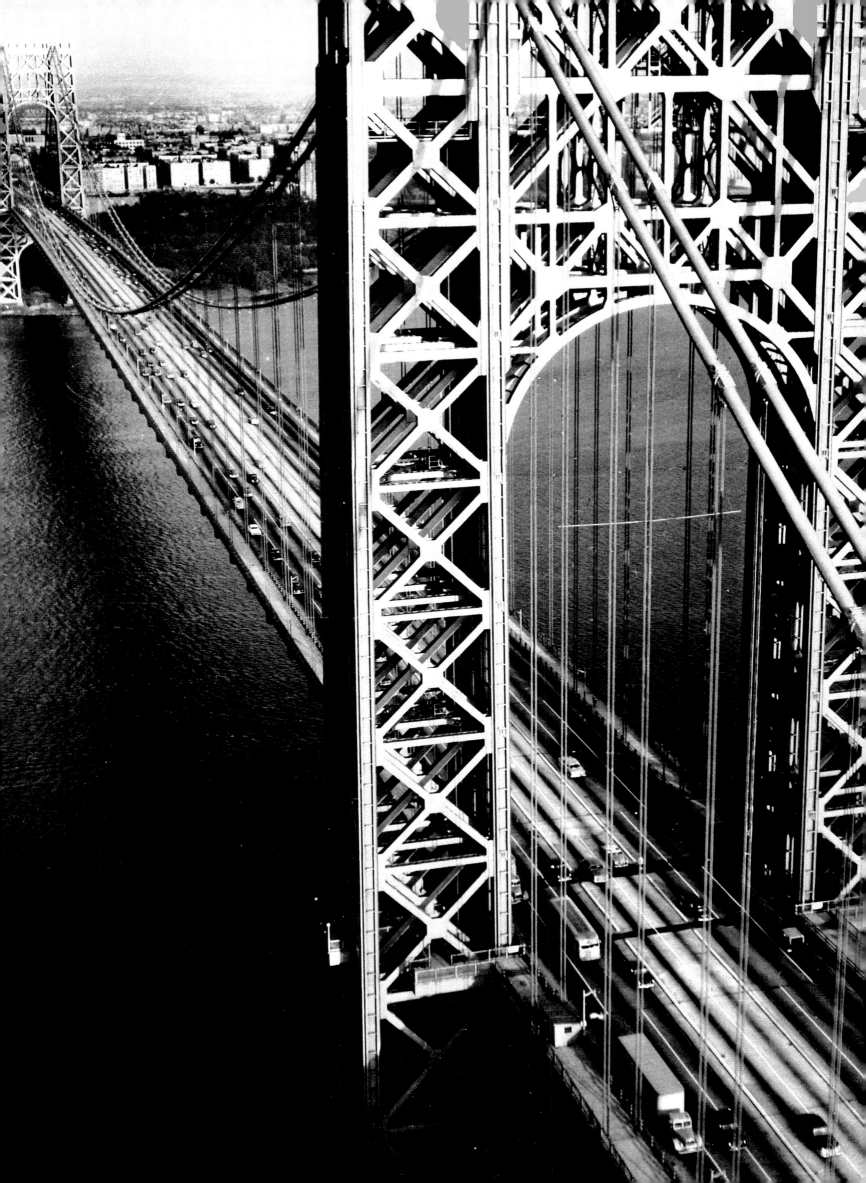

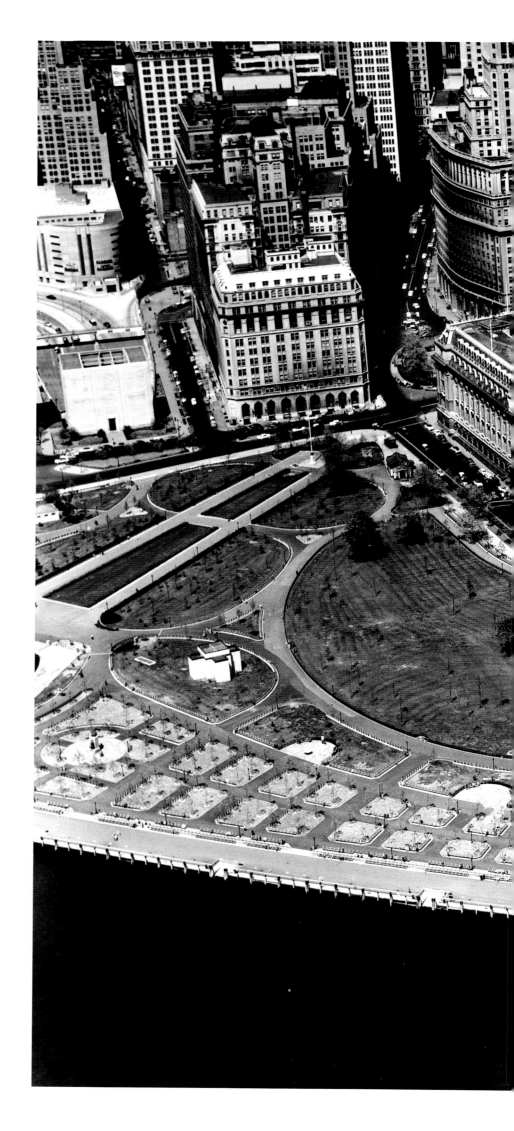

| 1955 | BOWLING GREEN |

Before being designated as a public park and bowling green in 1733, this open waterfront area at the southwestern tip of Manhattan had been a cattle and produce market. The statue of King George III of Britain was demolished in 1776. The green's original metal railings still stand, but lawn bowling is no longer played.

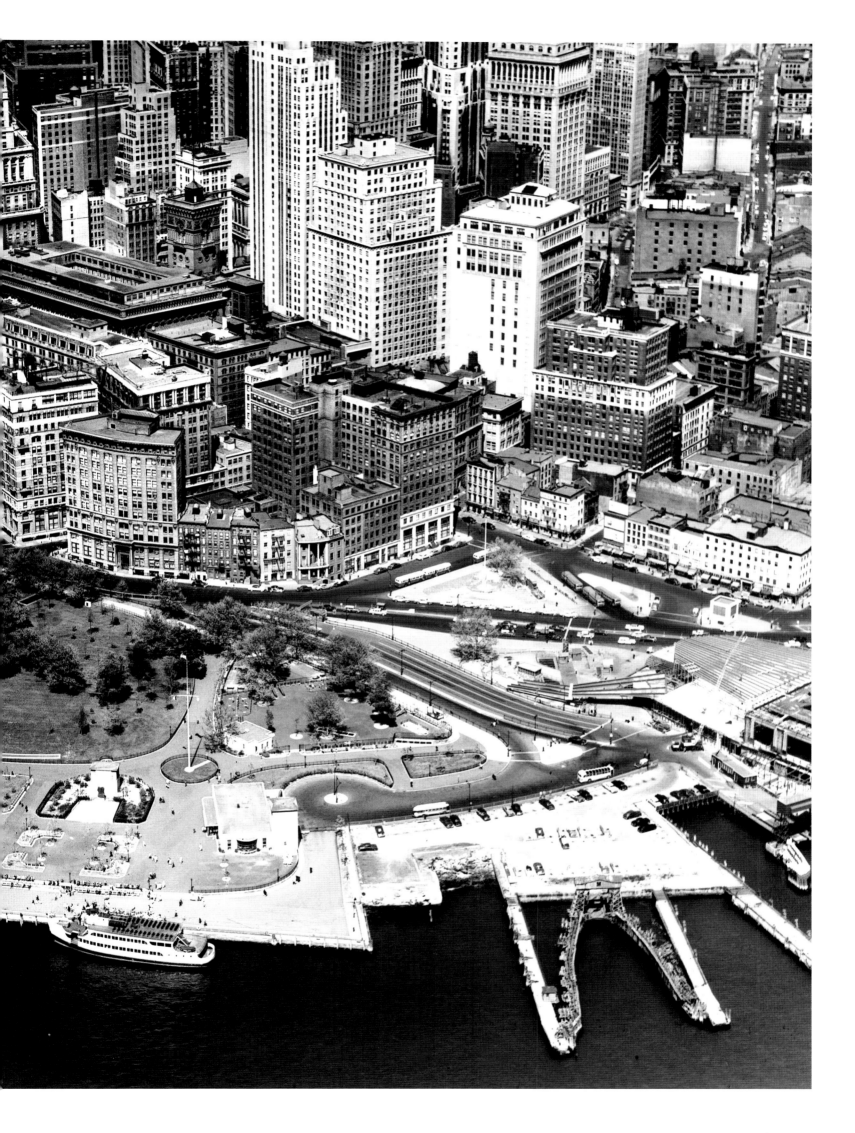

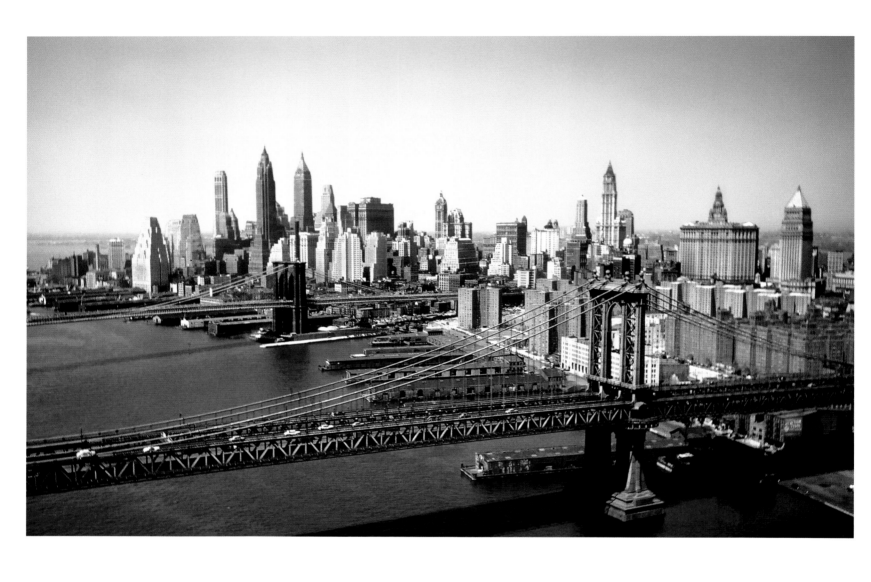

| 1952 | THE FINANCIAL DISTRICT AND WATERFRONT |

In the foreground is the Manhattan Bridge linking Manhattan and Brooklyn, carrying road traffic and subway trains. Center right is the broad-based New York City Municipal Building, with the Woolworth Building to its left and the bronze-roofed Federal Courthouse to the right. Also visible are waterfront housing blocks.

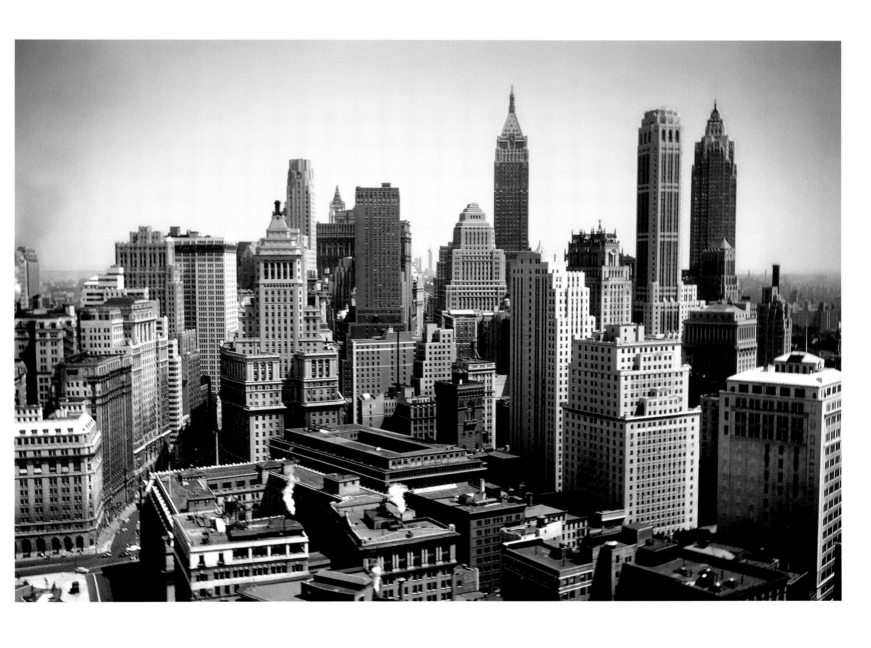

| 1952 | FINANCIAL DISTRICT BUILDINGS |

By the mid-1950s, business towers old and new, plain and decorative, were crowding Lower Manhattan, though a few low-rise mixed-use buildings can still be seen.

Today a number of these handsome building profiles can no longer be seen in their entirety; some have been demolished, others have been blocked by newer towers.

This striking image captures all of the original Rockefeller Center, emphasizing the power of its uncluttered design and architecture. The soaring 30 Rockefeller Plaza tower is central; in front of it is the sunken plaza and the mall approach from Fifth Avenue. Also visible are the spires of St. Patrick's Cathedral.

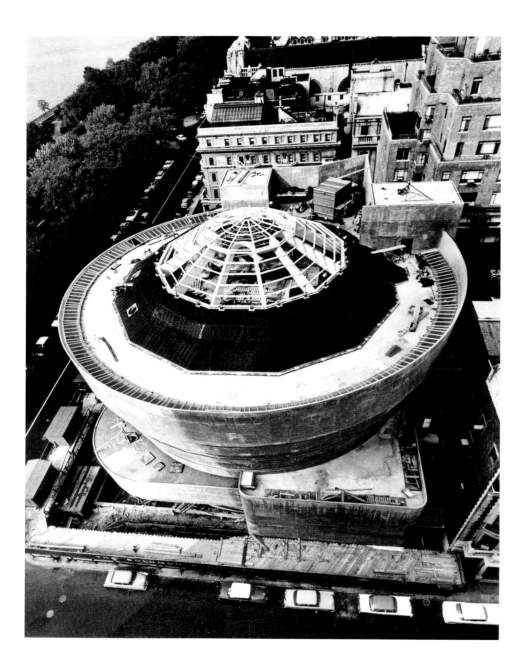

| 1958 | THE GUGGENHEIM MUSEUM ROOF |

The Guggenheim's steel-ribbed glass dome is familiar from the inside and below to millions of modern-art aficionados who have visited the museum, which is unique among its sister institutions for its circular design. The museum's white finish is in striking contrast to the varied greens of Central Park.

110 · 111 | 1961 | MANHATTAN |

This panorama captures the Hudson River piers, Bowling Green and Castle Clinton, the Staten Island Ferry Terminal, the East River, and the Brooklyn Bridge, with the Financial District towers behind. The changing economy has led to new high-rise buildings, and declining maritime activity to the demolition of many piers.

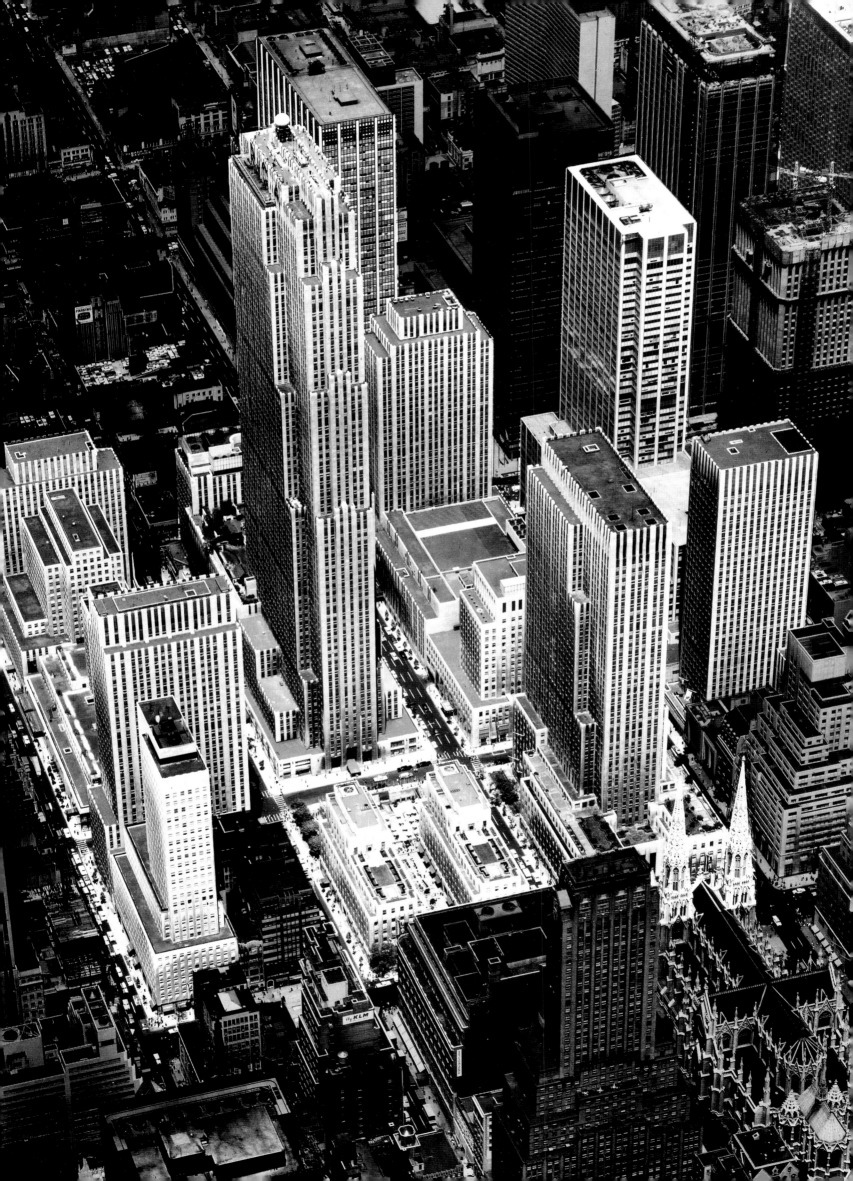

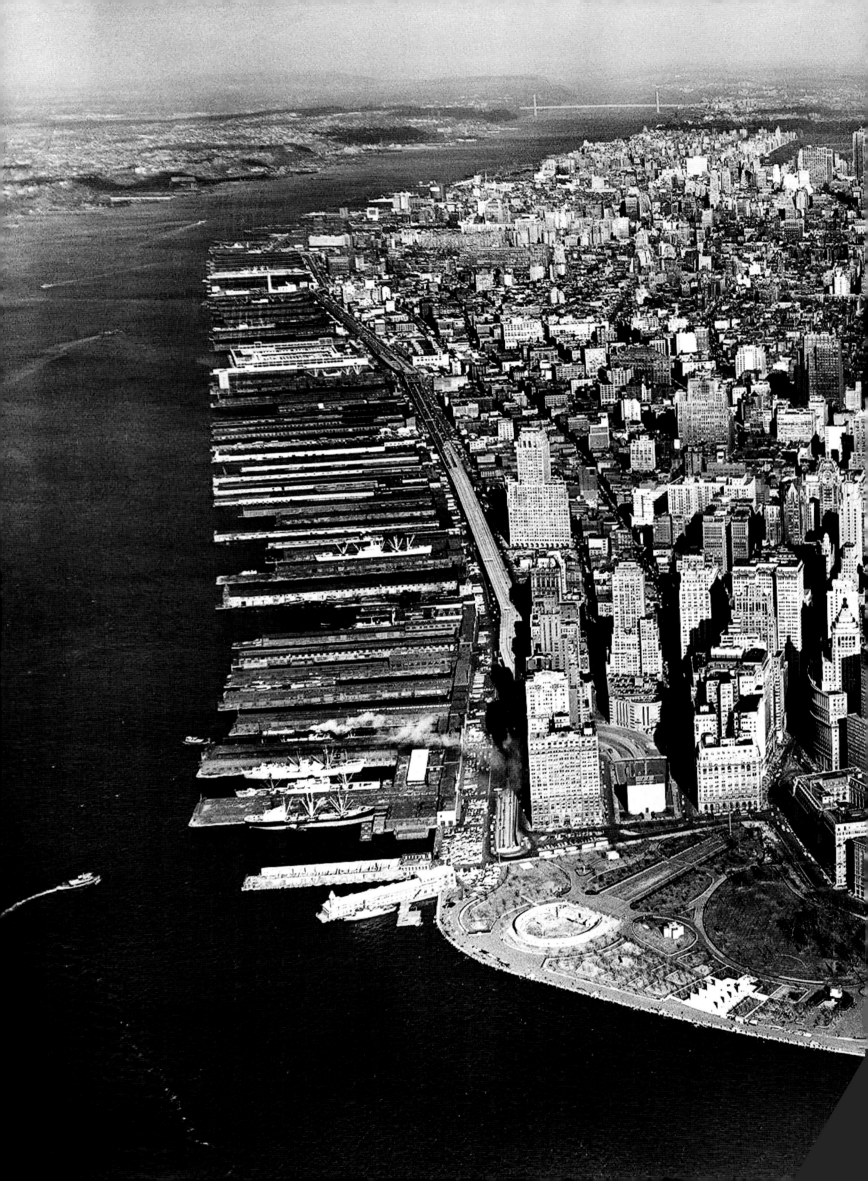

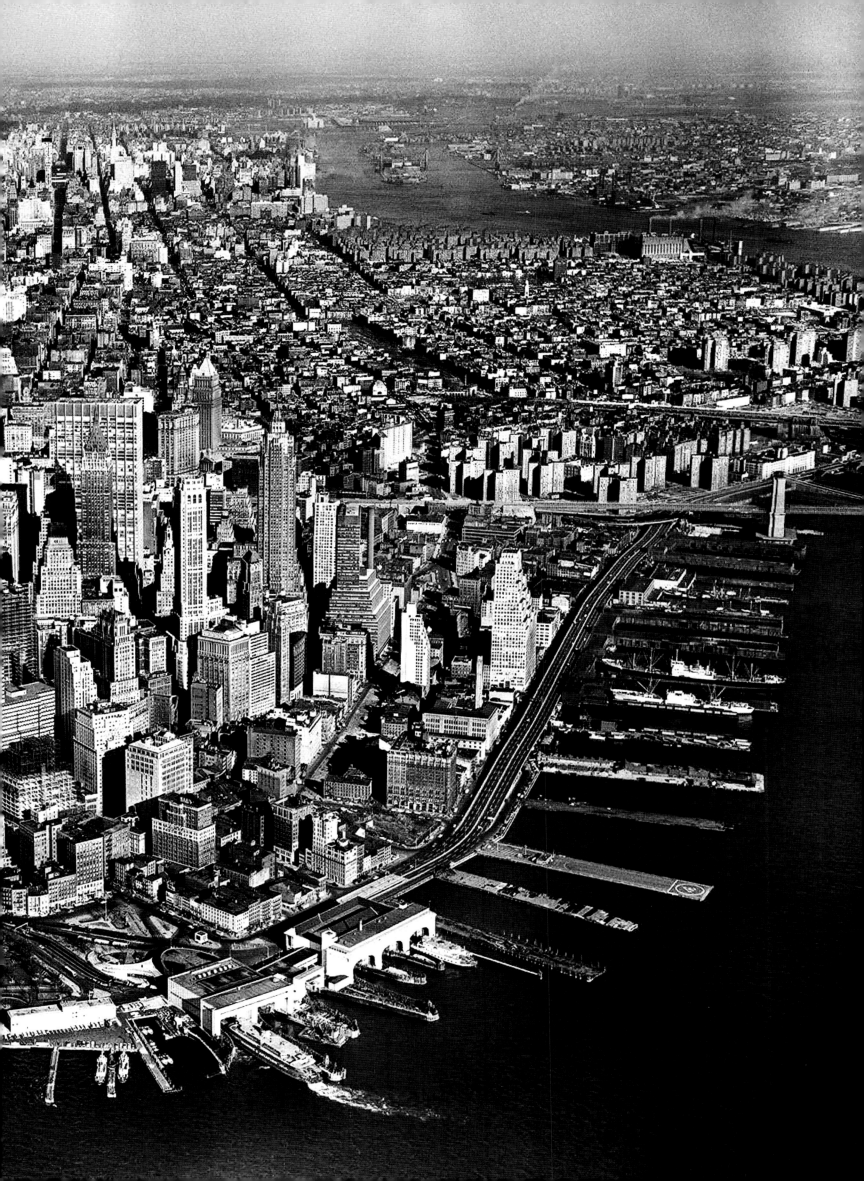

Long before completion in the 1970s, the World Trade Center's Twin Towers were rising high above the iconic Woolworth Building (behind, center), and dwarfing their neighbors to the left. It took New Yorkers several years to accept the Twin Towers' sheer physical domination of the Financial District's skyline.

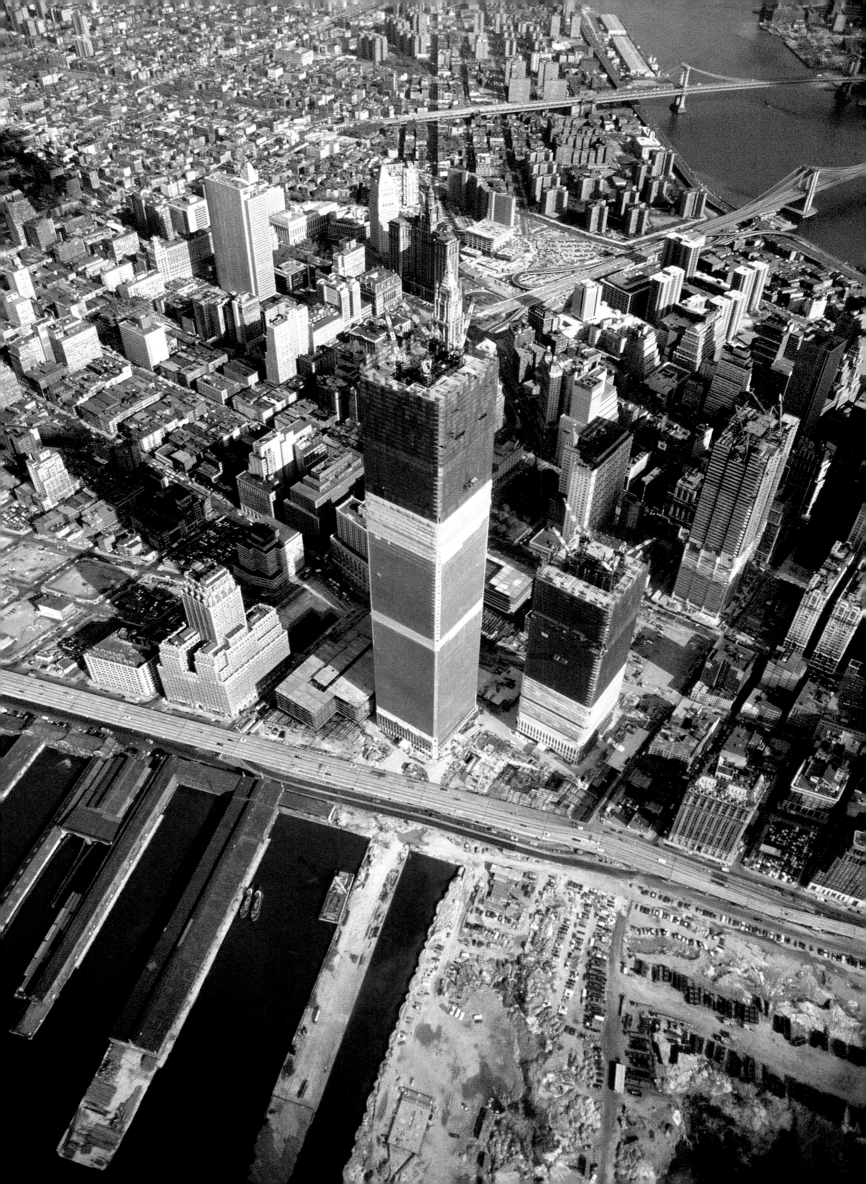

The Twin Towers are so striking and dominant that little thought or representation is given to the World Trade Center's other five buildings or to Battery Park City, built in part on landfill excavated from the WTC site. So massive are the Twin Towers that they create their own microclimate, with challenging winds.

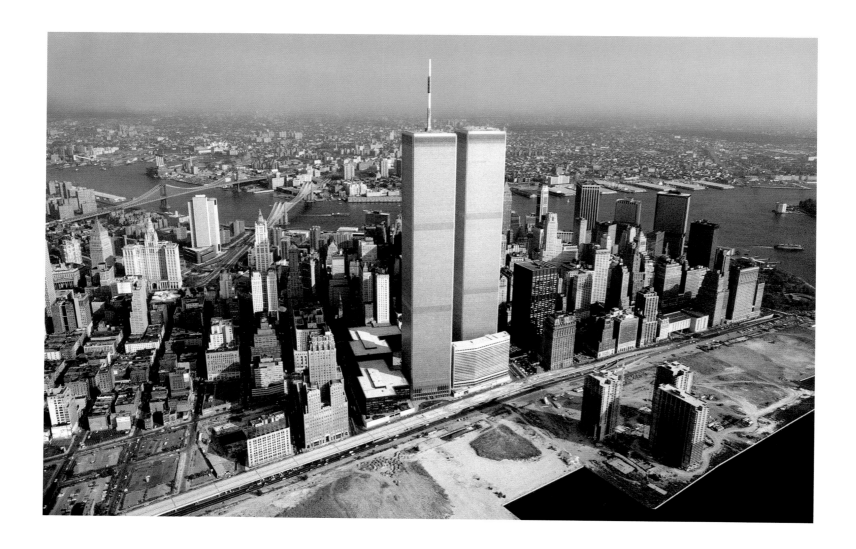

| 1982 | THE TWIN TOWERS BY DAY |

For many people, the Twin Towers were out of scale, overwhelming their neighbors and blocking natural light. Battery Park City rose on the site seen in the foreground to become a handsome waterfront community, favored by many Financial District workers as a place to live. A marina adds to neighborhood amenities.

116 · 117 | 1997 | A CROWDED SCENE |

The shoulder-to-shoulder jostling of the Financial District's towers reflects the narrow, curving streets of old Manhattan. The Brooklyn waterfront still supports significant maritime activity, as evidenced by the piers visible to the left. The cooper roof and finial of 40 Wall Street is just visible in the foreground.

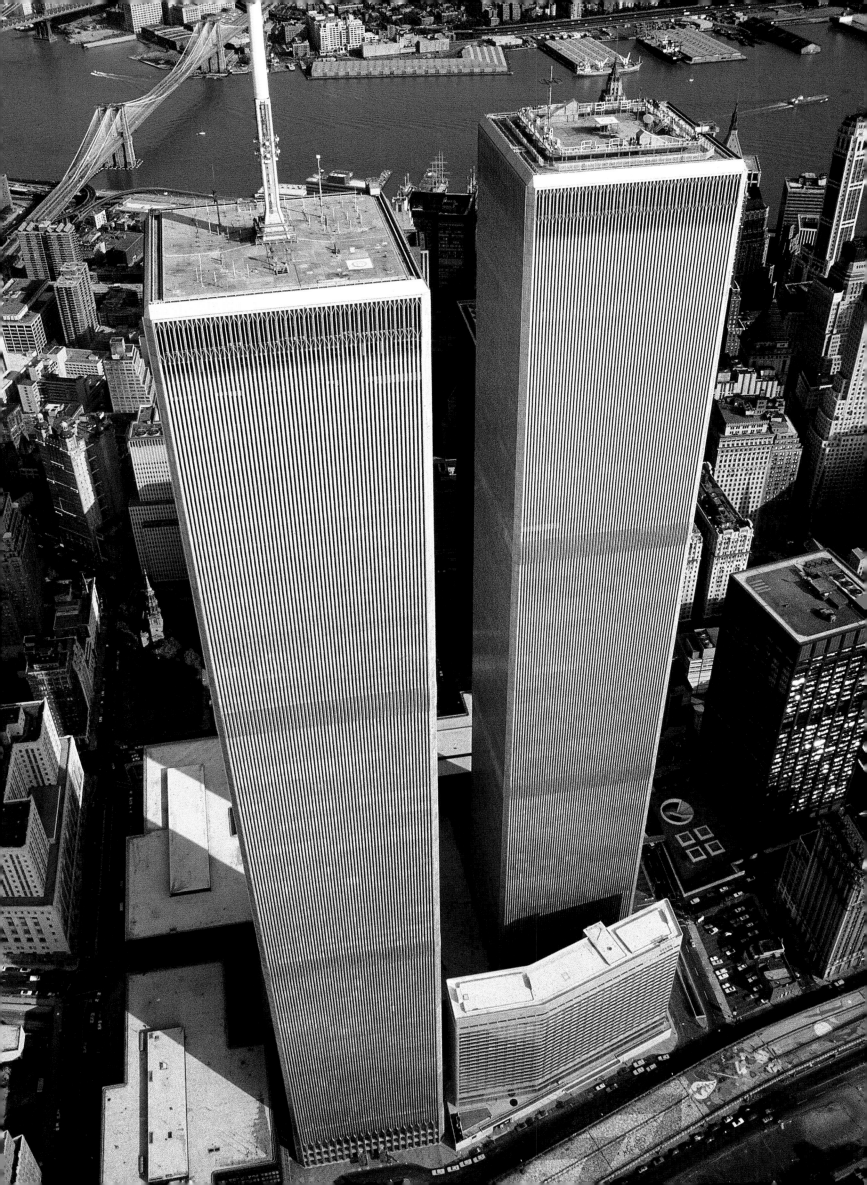

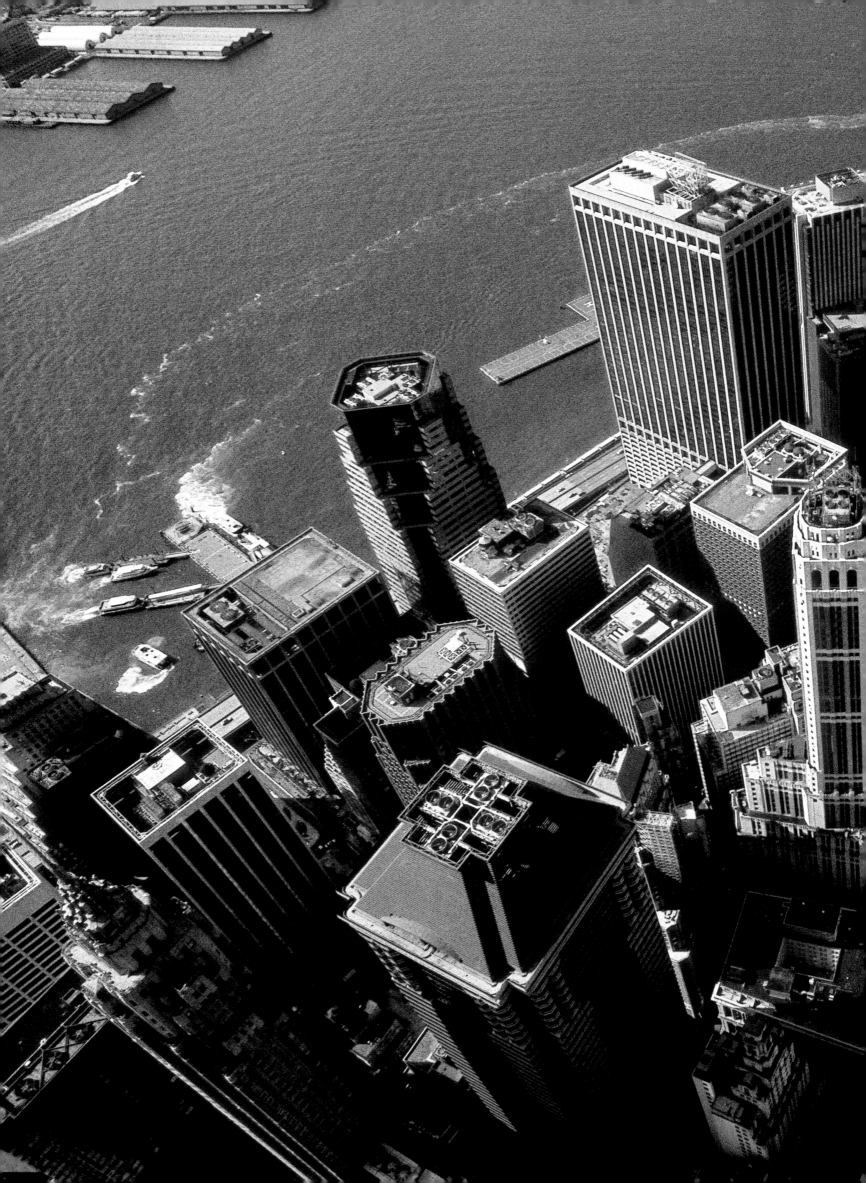

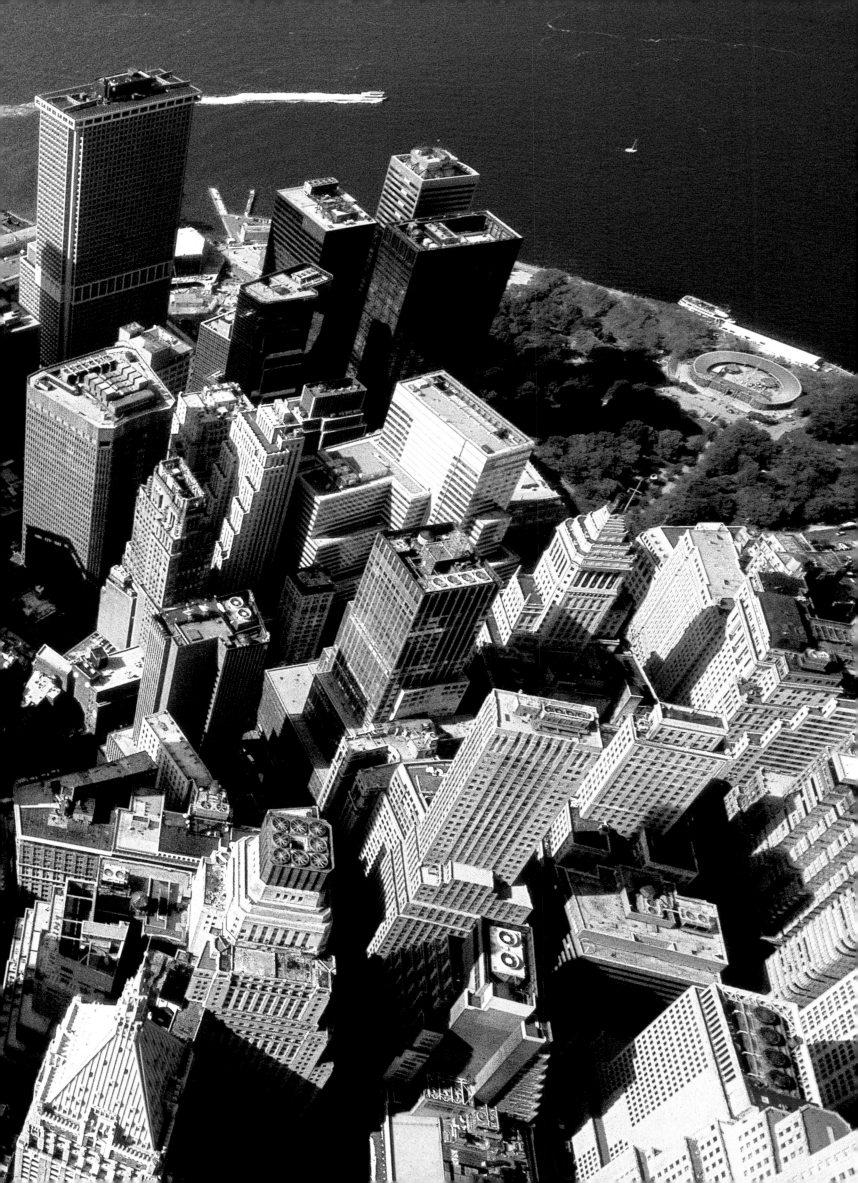

| 1995 | 40 WALL STREET |

The 40 Wall Street building was constructed in 1930 as the Bank of Manhattan Trust Building, with everything about it suggesting solid value. Its rich detailing, with contrasting vertical and horizontal emphases, and its ornate spire-tipped copper roof reflect the expansive architectural imagination of yesteryear.

120 · 121 | 1997

| BROOKLYN AND MANHATTAN BRIDGES |

In the 1970s, on both sides of the East River many new high-rise buildings have been constructed and many remaining low-rises have been converted into residential buildings. Rapid population growth and new business demands have led to both waterfronts being rapidly developed, with the river adding desirability to the area.

122 · 123 | 1997 | WASHINGTON SQUARE PARK |

This hugely popular park was created in 1871, and the Memorial Arch, at the foot of Fifth Avenue, was erected in 1892. On the left, New York University's buildings include the green-roofed Law School, the curved-roofed Law School addition, and the cream-walled Student Resource Center. The Byzantine-style church dates to 1888–96.

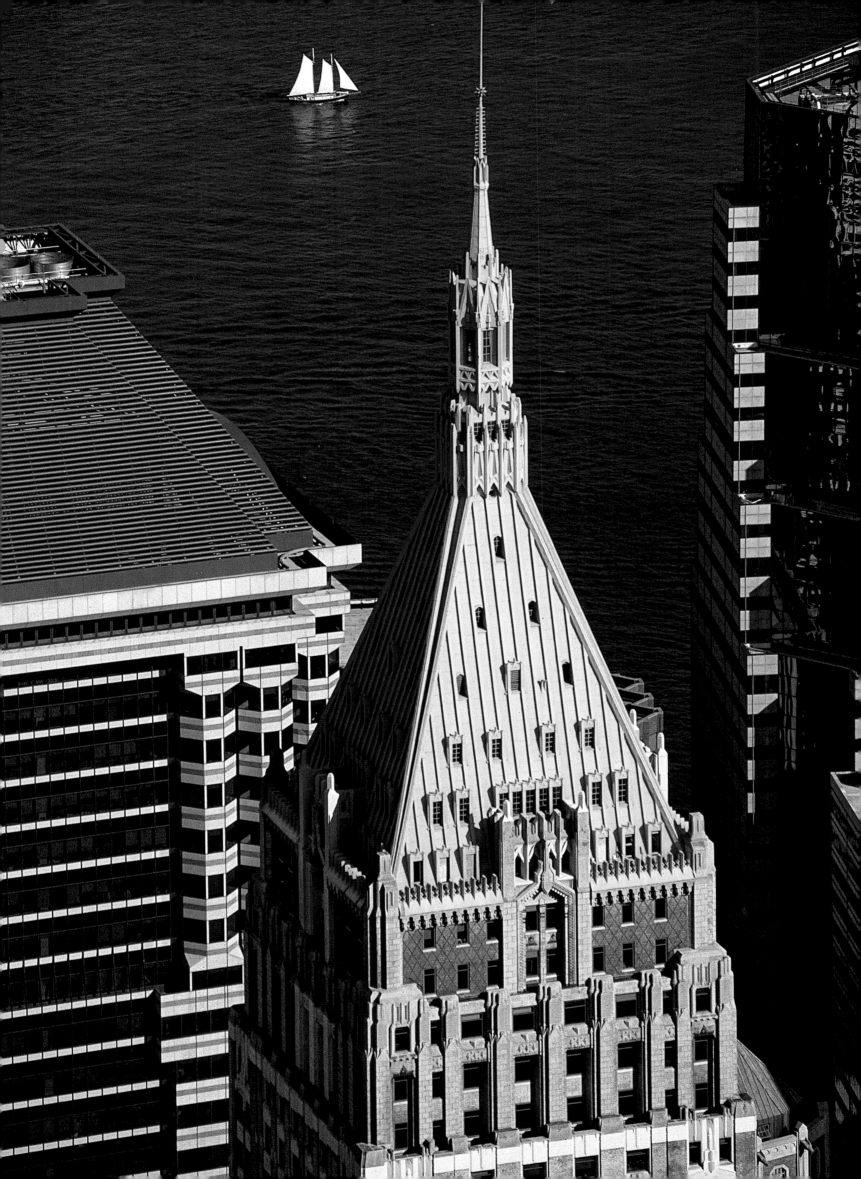

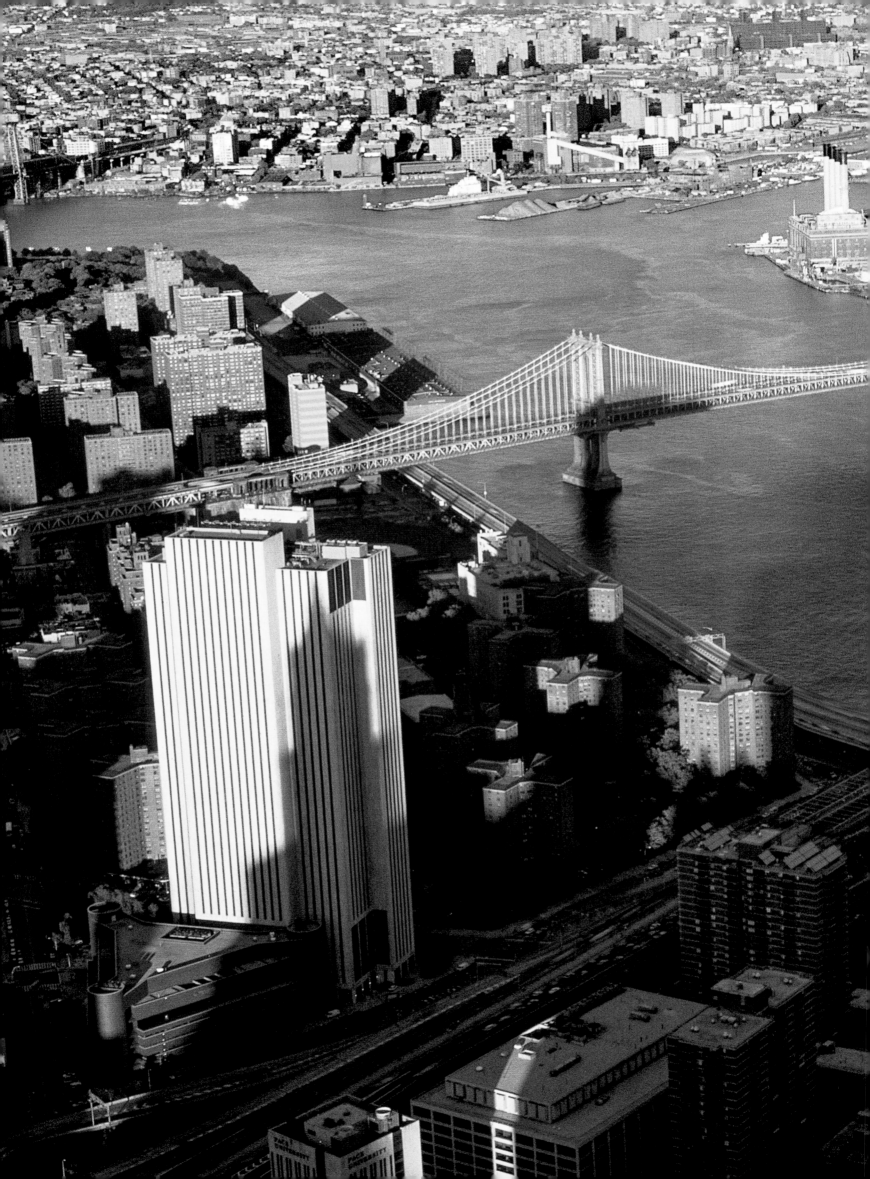

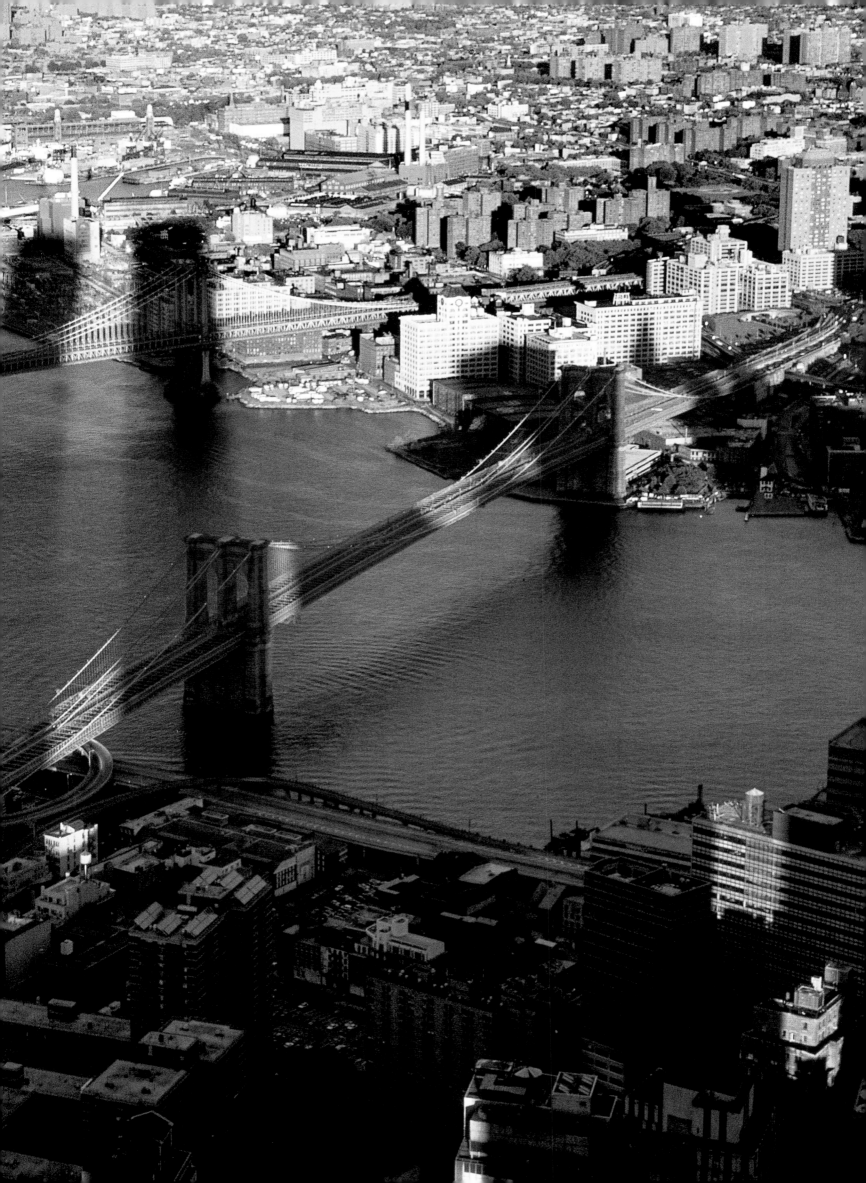

Macy's flagship store dominates Herald Square (corner of 34th Street and Sixth Avenue). There the store's name is preceded by the familiar big red asterisk. Other stores differ in architectural style—and, in this case, in presentation of the name, seldom seen in a vertical format. Lurking nearby is a parade balloon figure.

126 | 1982 | THE CHRYSLER BUILDING SPIRE |

The Chrysler Building's spire—or needle—is purely decorative, suggesting an arrow's speed and thrust. The spires of One World Trade Center (Freedom Tower) and the Empire State Building serve electronic and telecommunications functions. Flattop buildings may conceal equipment needed for such purposes.

127 | 1998 | THE CHRYSLER BUILDING |

Few New York City buildings can challenge the Chrysler Building's elegant spire and dramatic, eye-catching Art Deco embellishments—which make it many New Yorkers' and visitors' favorite structure. The building's silvered metal decorative features reflect the flowing chrome automobile trim of the 1930s.

128 · 129 | 1996 | ST. PATRICK'S CATHEDRAL |

St. Patrick's Cathedral's iconic 330-foot twin spires were added to the 1879 nave in 1888, completing the structure's form as a perfect model of European High Gothic church architecture. The subdued masonry façades of the Rockefeller Center buildings makes them visually comfortable neighbors for the much-loved cathedral.

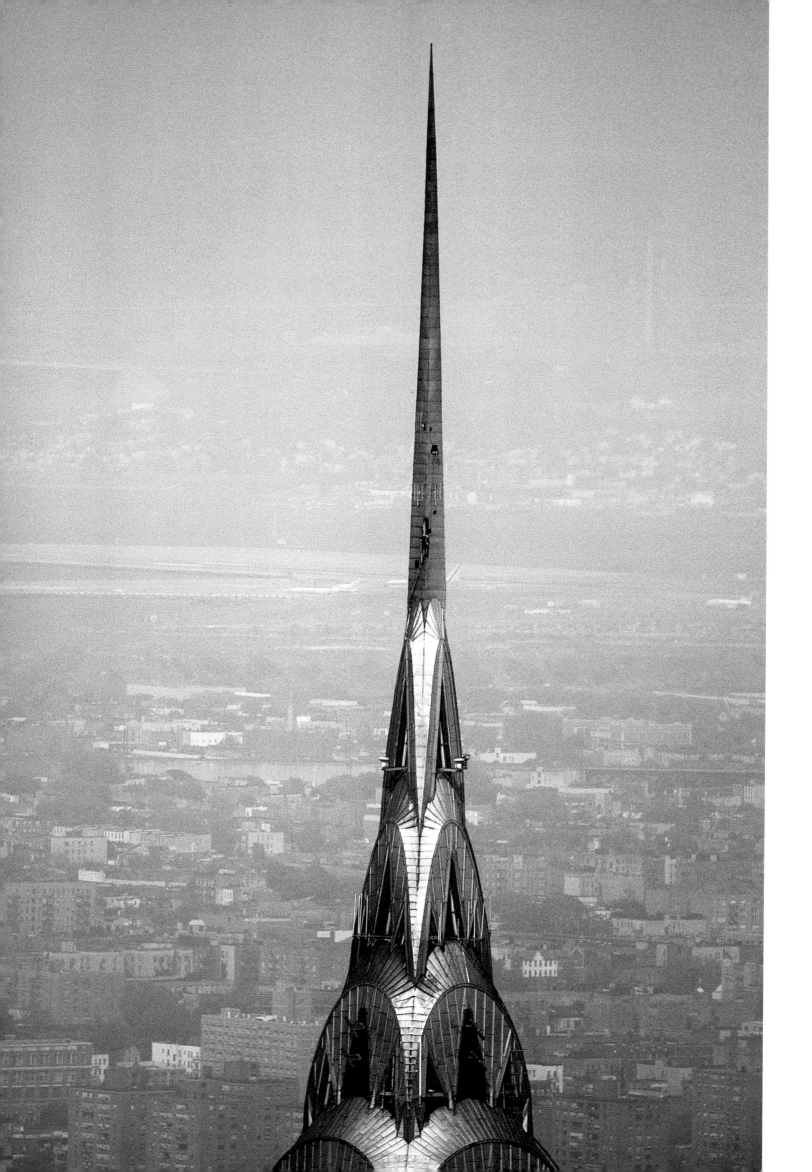

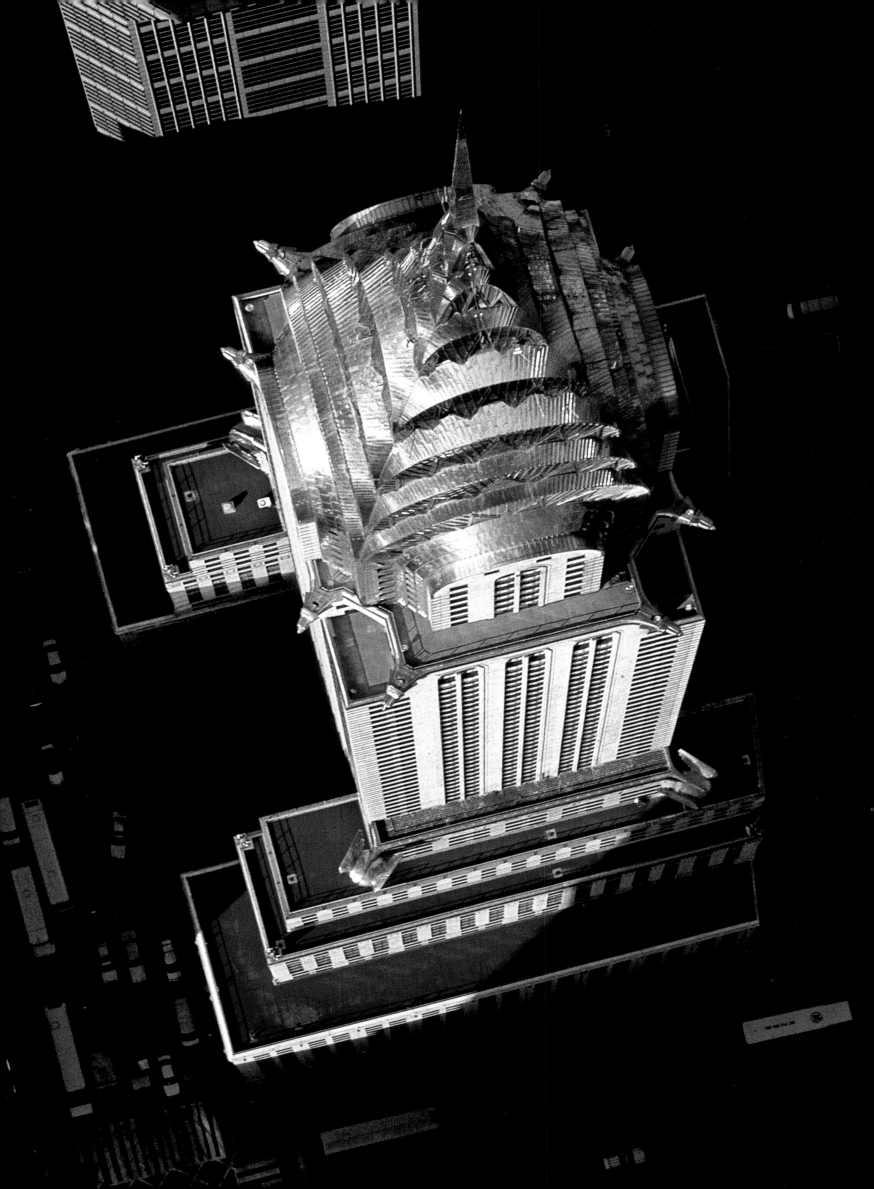

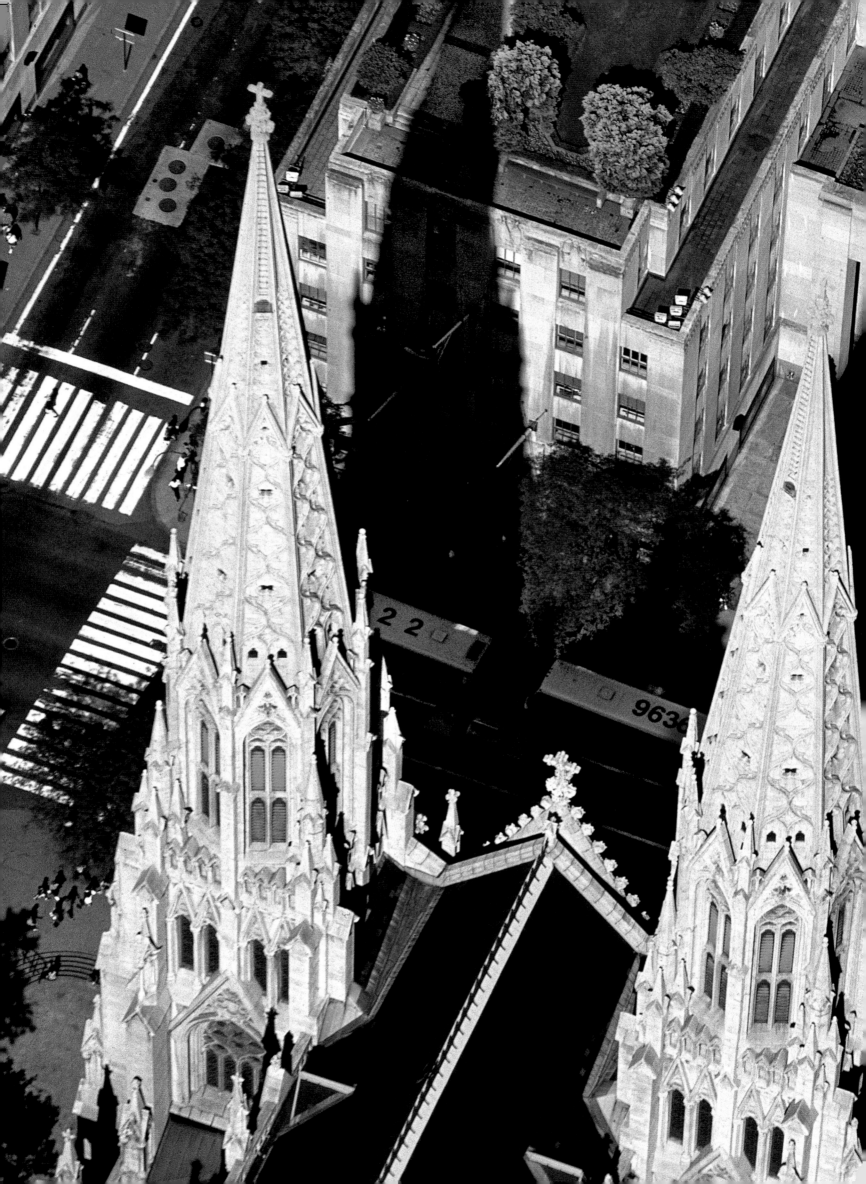

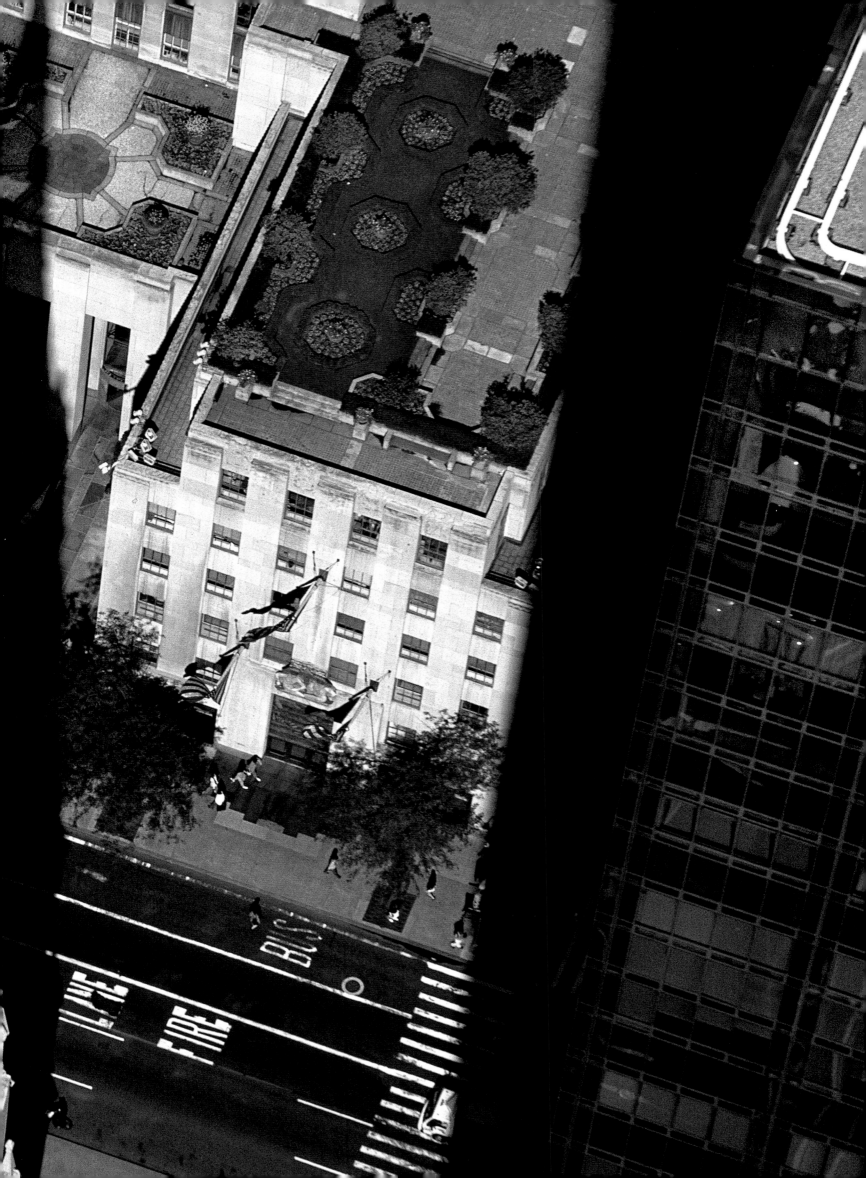

This view is along 59th Street, looking from west to east. Center left, toward the top, is the vertically ribbed General Motors Building at 5th Avenue and 59th Street. To the left is Central Park, along whose southern border East 59th Street becomes the more fashionable Central Park South, where apartments command premium rents.

132 | 1981 | NEW YORK'S PARK AVENUE |

Park Avenue is one of New York's most favored addresses, even though it has no view of Central Park. From Grand Central Terminal at 42nd Street to 96th Street, the avenue is known for a no-trucks, no-buses policy and for its center median with planted flowers and shrubs. At 96th Street, the railroad tracks rise aboveground.

133 | 1982 | THE HELMSLEY BUILDING |

Many of New York's newer high-rises are built in what is called the International Style, which favors straight-edged, unadorned steel-and-glass boxes. The elaborate spire of the New York Central Building (constructed in 1929 and now named the Helmsley Building) shows how exuberant and refined decorative design can be.

134 · 135 | 1997 | EAST TO ROOSEVELT ISLAND |

Distinctive in this image are the 1984 thirty-seven-story postmodern beige masonry-clad Sony Tower, with its notched "Chippendale" pediment, and the 1977 fifty-nine-story Citigroup Center with its distinctive sloping roof. Top left is the Queensboro Bridge, which passes above Roosevelt Island in linking mid-Manhattan to Queens.

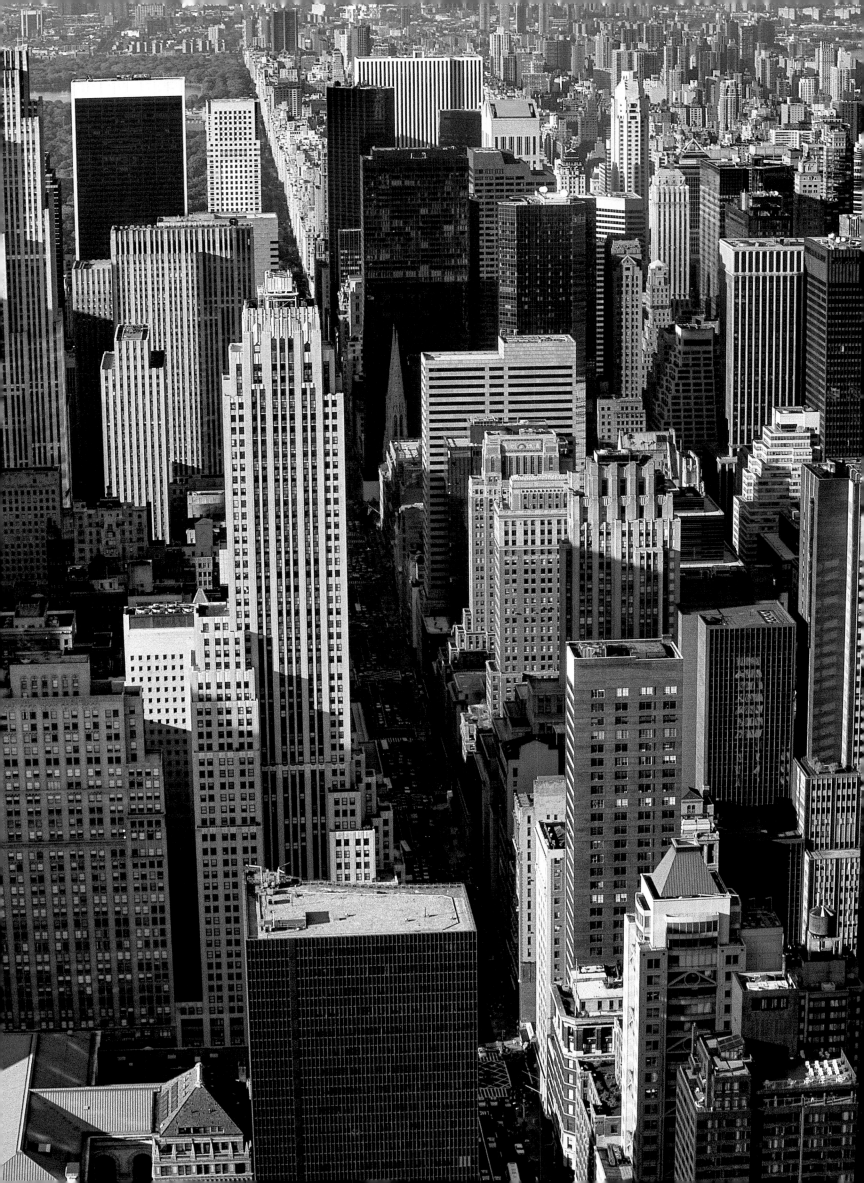

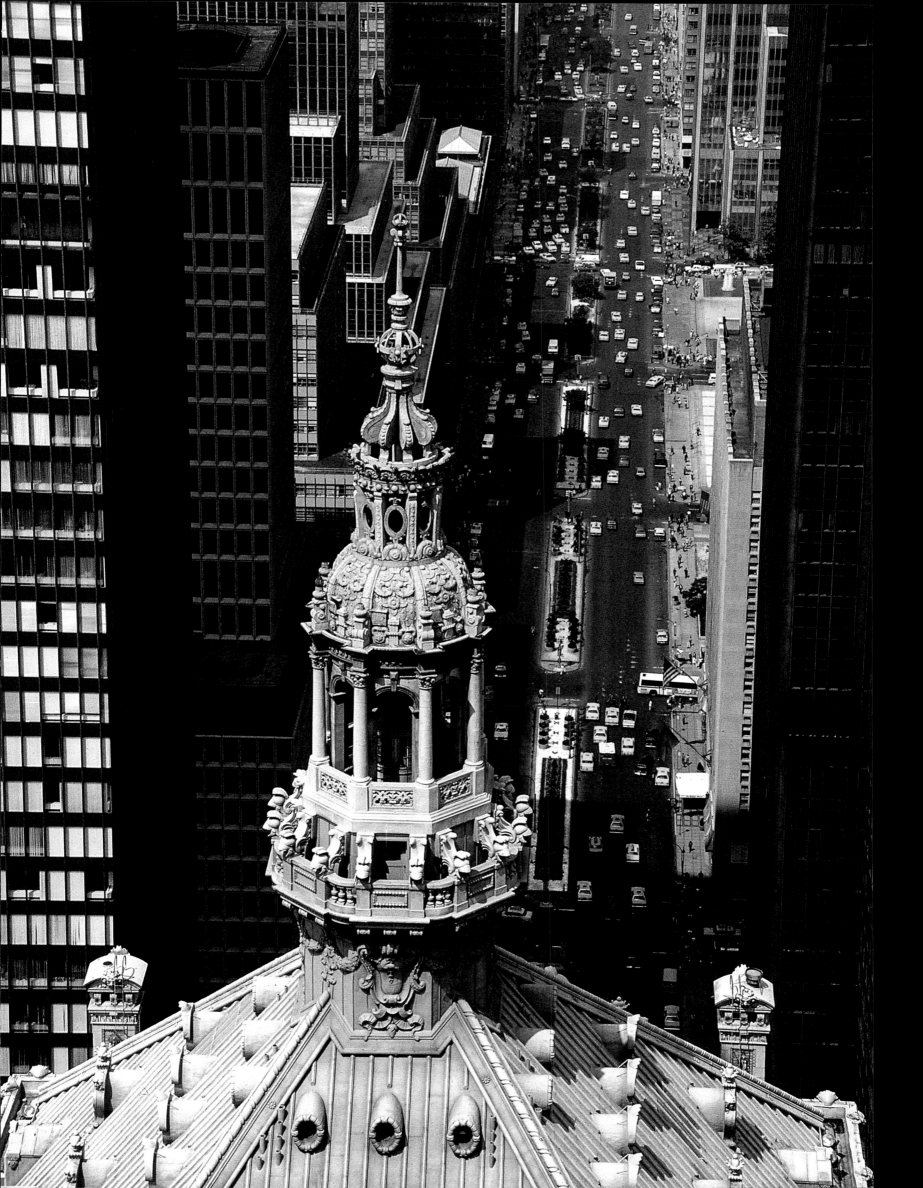

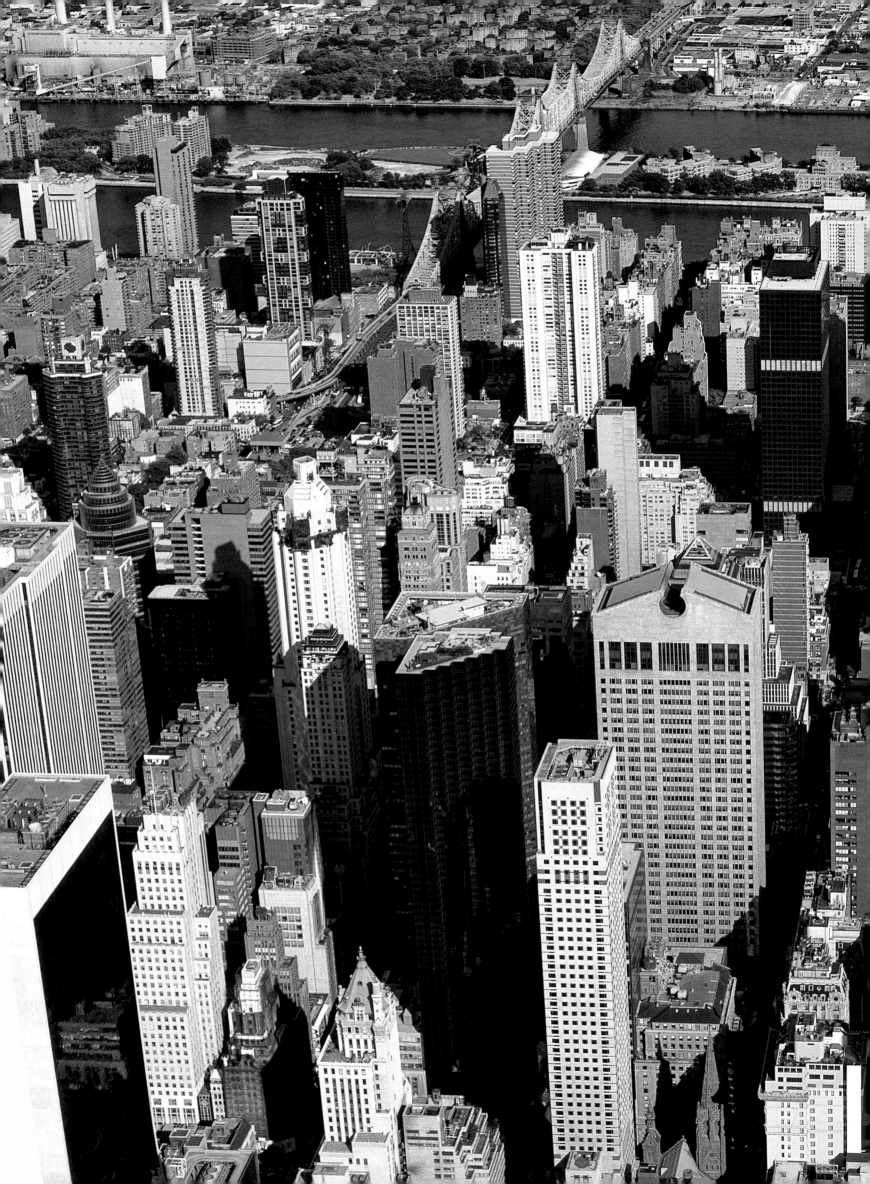

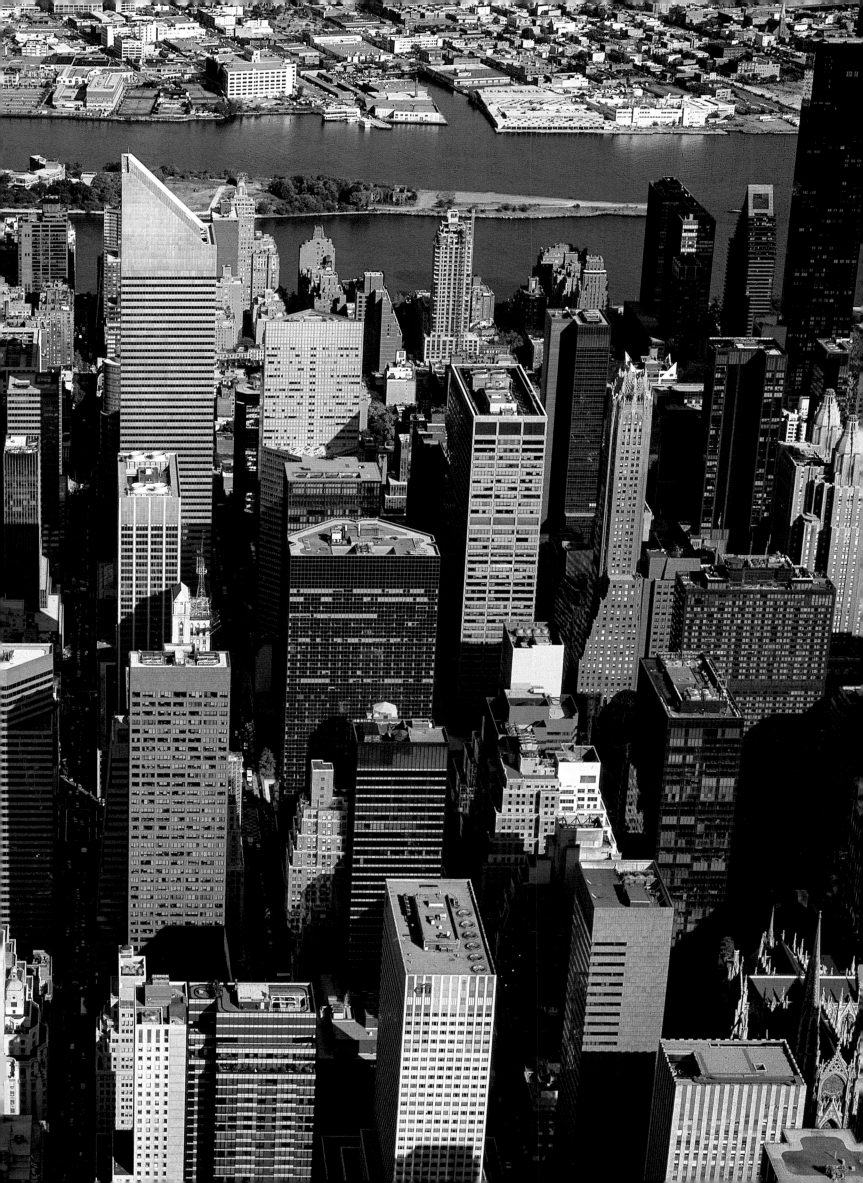

The Citigroup Center's steeply angled roof (forty-five-degree slope) was a pioneering initiative to gain benefits from solar panel technology; the building also incorporated advanced stabilizing technology. To the center's left is the horizontally detailed thirty-four-story Lipstick Building, constructed in 1986, and named for its shape.

138 · 139 | 1997 | THE PLAZA HOTEL |

The famed Plaza Hotel at Fifth Avenue and Central Park South (59th Street) is designed in a comfortable "late nineteenth-/early twentieth-century Revival style." Its location adjoining Central Park attracts a wealthy clientele (note the abundance of taxis). A number of the hotel's rooms and suites are now privately owned.

140 · 141 | 1998 | CENTRAL PARK |

This view of Central Park is from the southwest to the northeast corner, with Central Park West to the left and Fifth Avenue to the right. Residents in the buildings facing the park pay premium purchase prices or very high rents for their splendid views and their extensive front garden. The park is now very well maintained.

142 · 143 | 1998 | CENTRAL PARK AT DUSK |

This view from Central Park West into Central Park was taken in fading light, with the greensward darkening. The twin-towered Eldorado was among the luxury apartment houses built on Central Park West during the 1920s and 1930s, and, like the San Remo, the Majestic, the Beresford, and others, has a rich social history.

144 · 145 | 1981 | THE TWIN TOWERS AT DUSK |

For some, the Twin Towers were more attractive at dawn and dusk than by day; in the gentler light the tinted metal lattices and glazing of the World Trade Center's Twin Towers truly glowed, giving them an unforgettable and unrivaled golden luminescence. Battery Park City residents and waterfront strollers had much to appreciate.

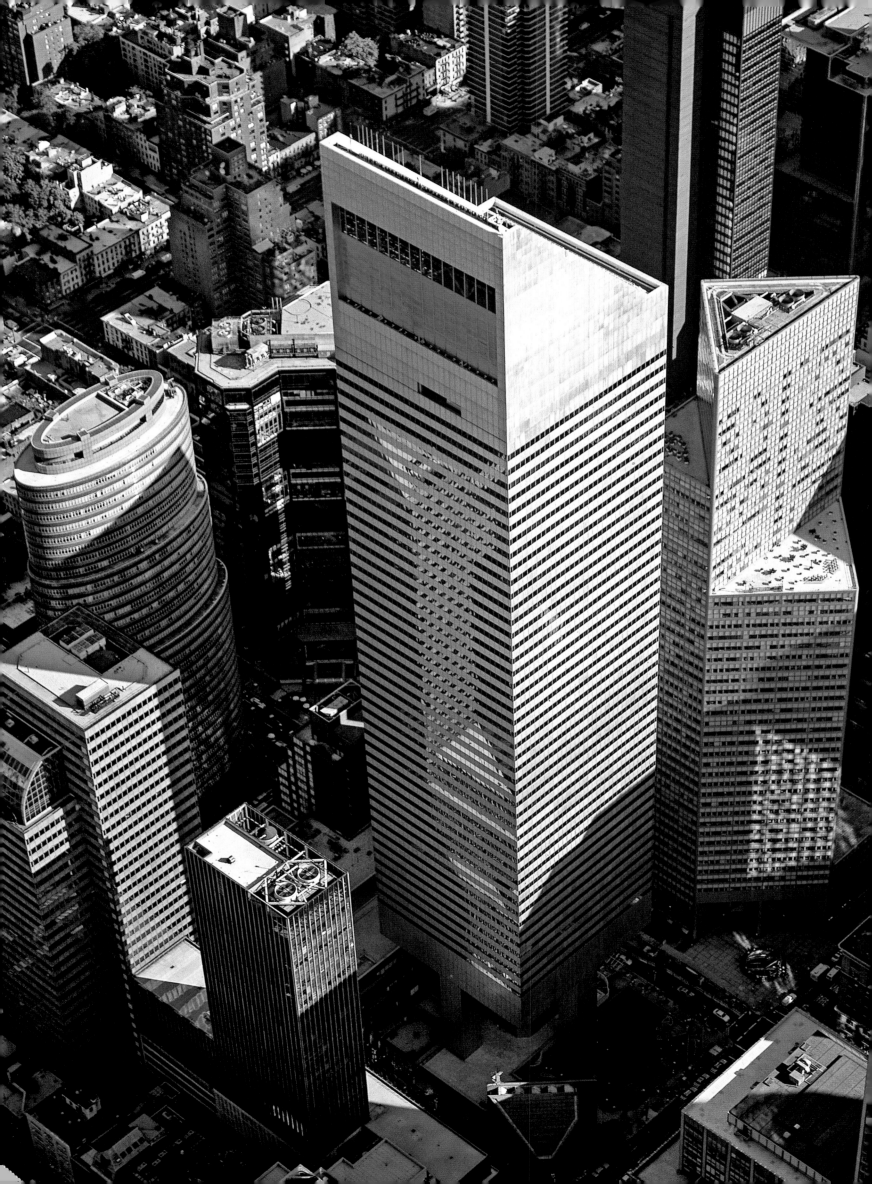

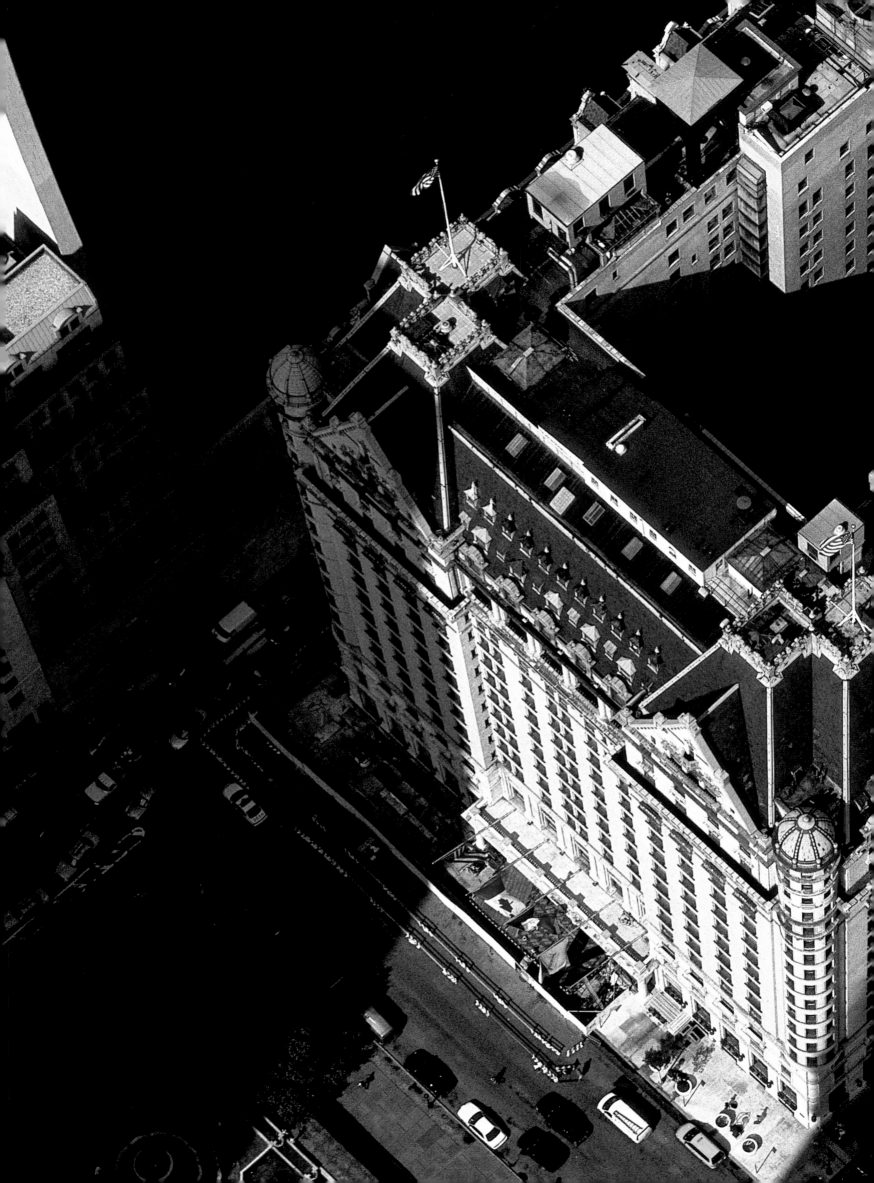

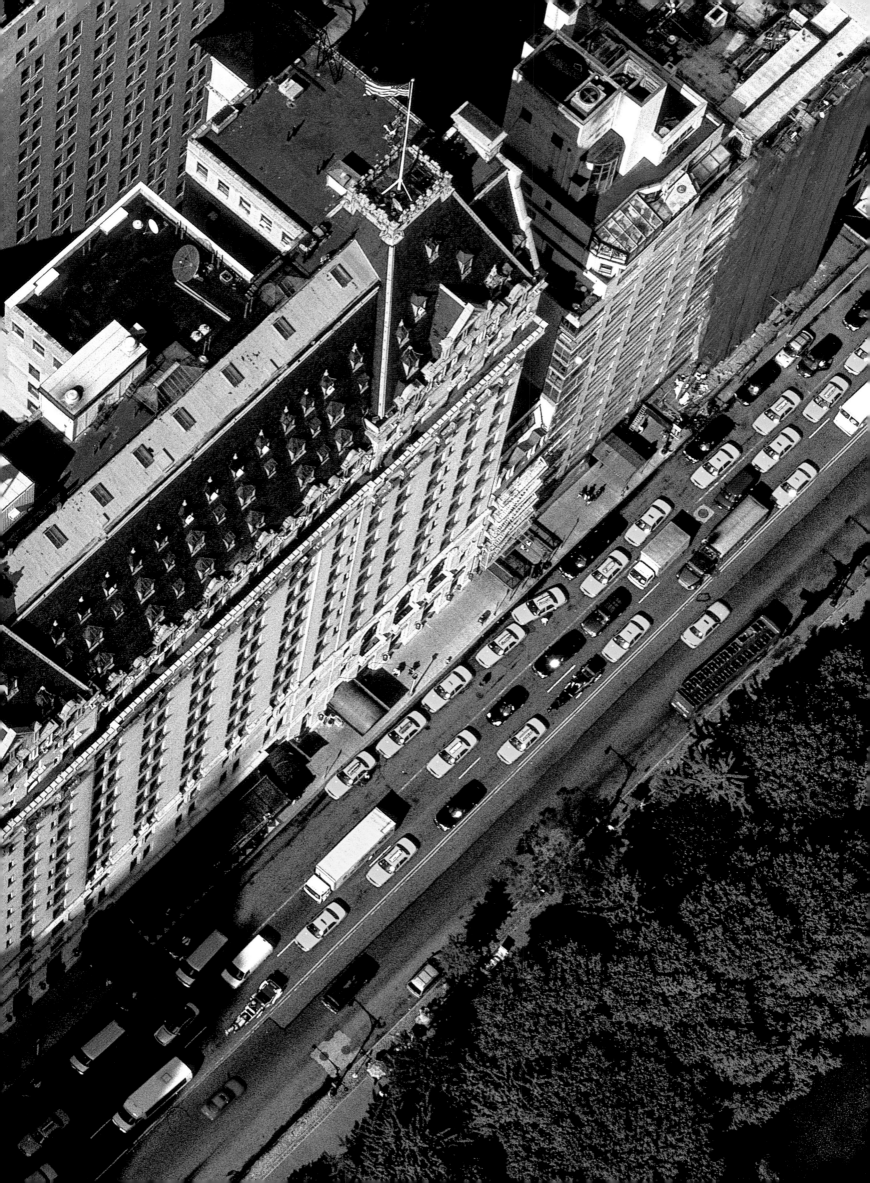

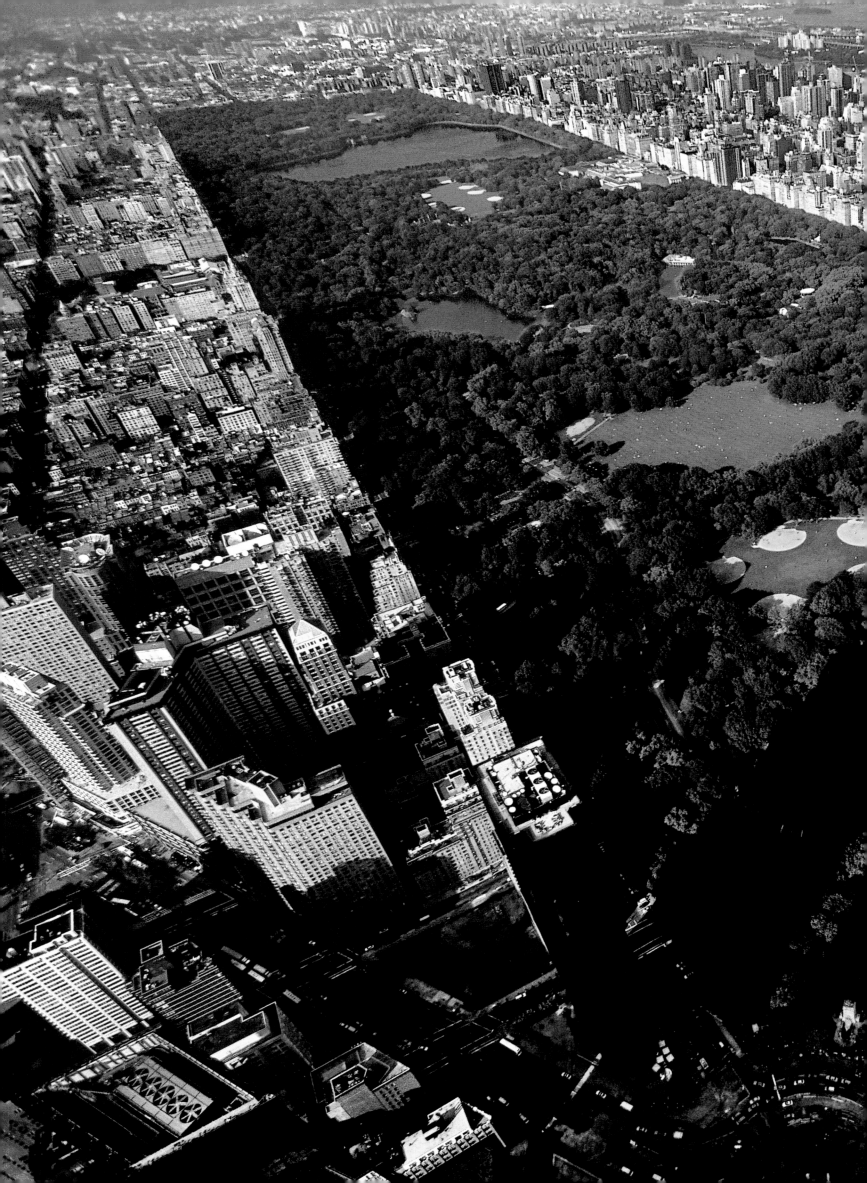

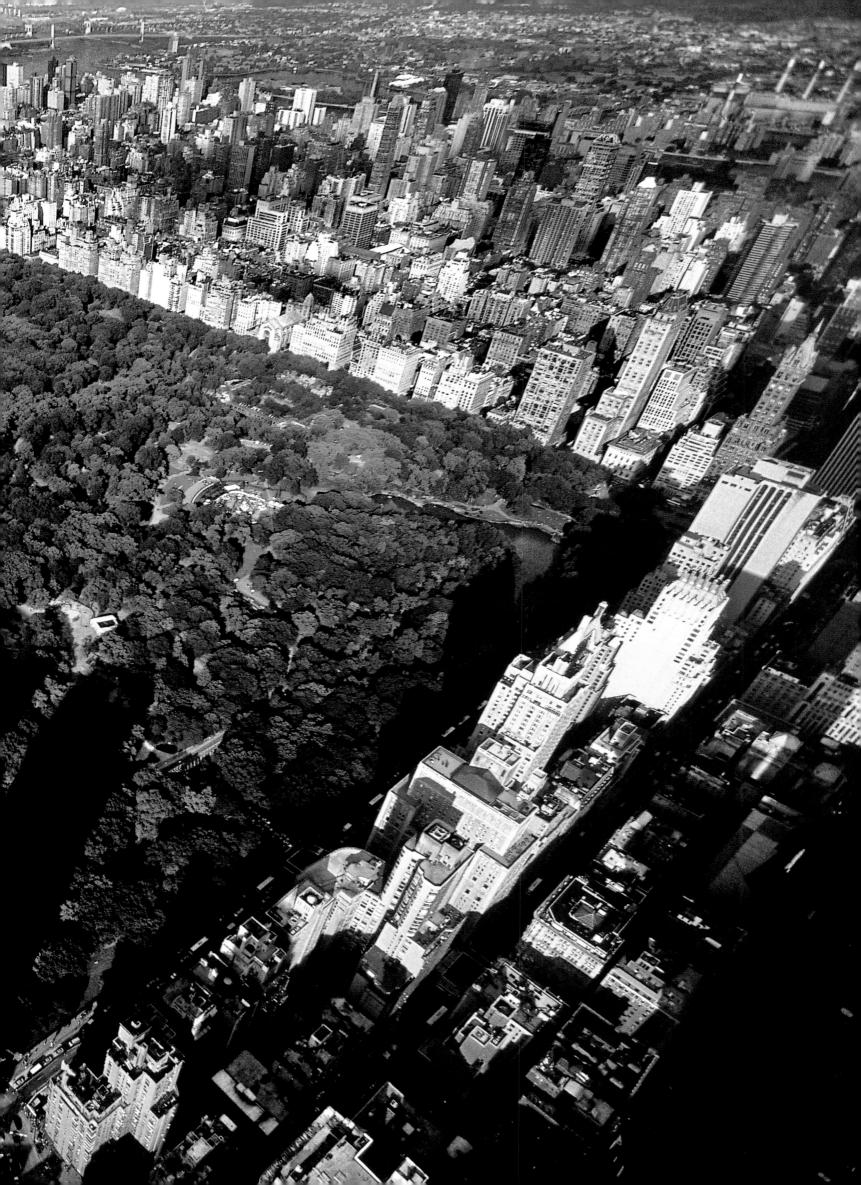

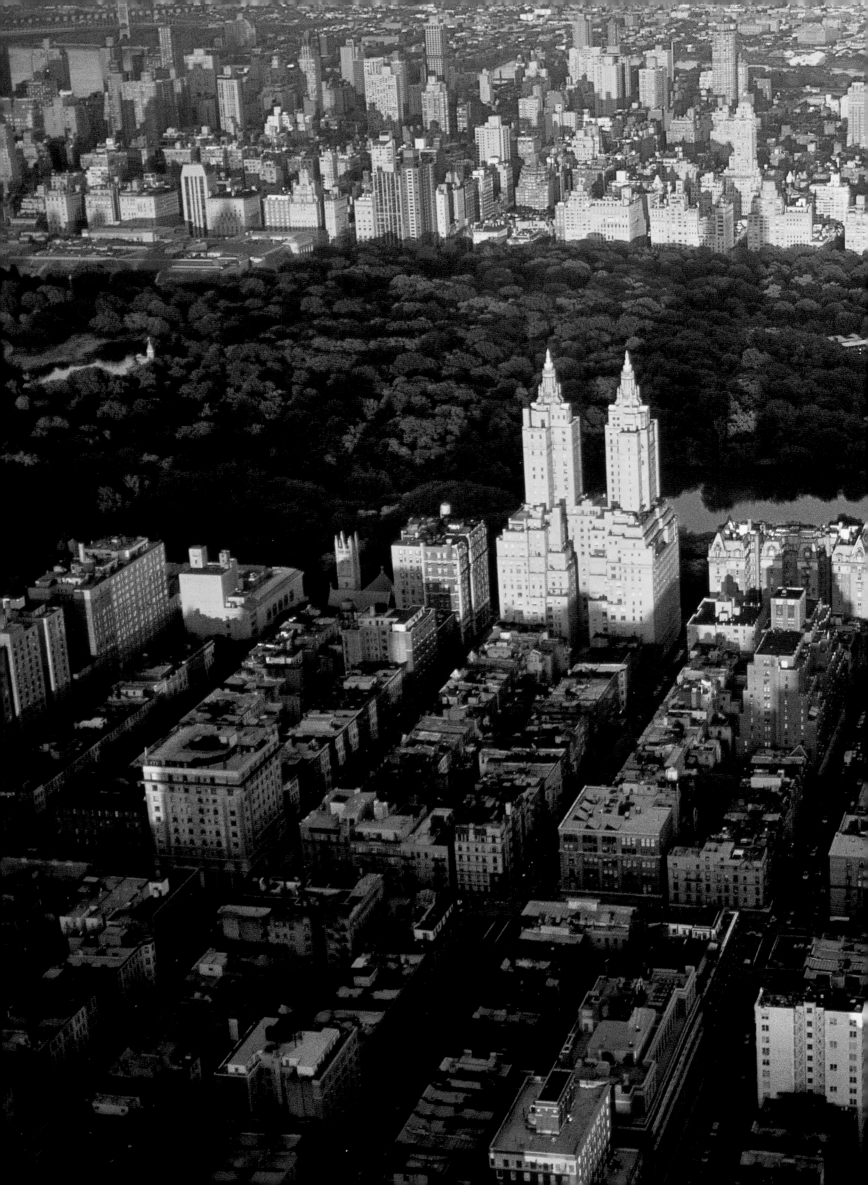

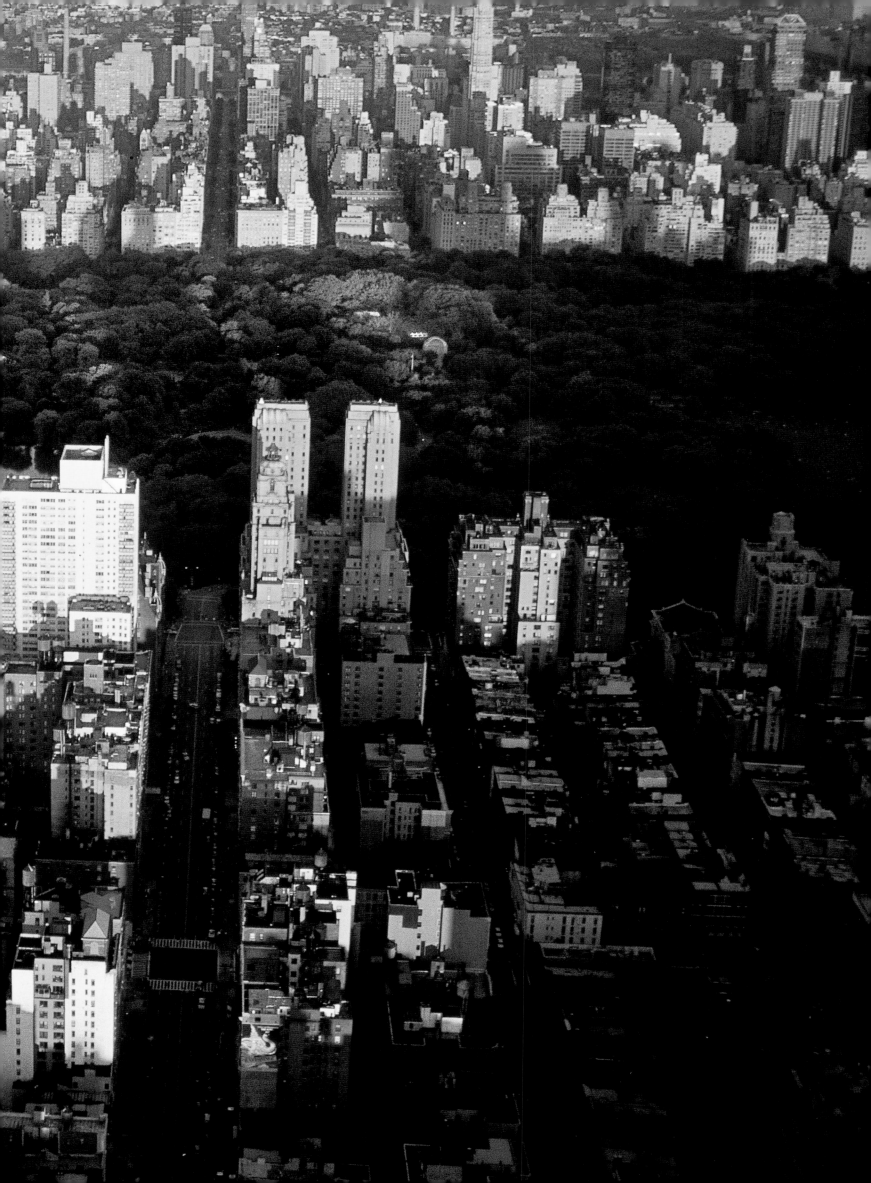

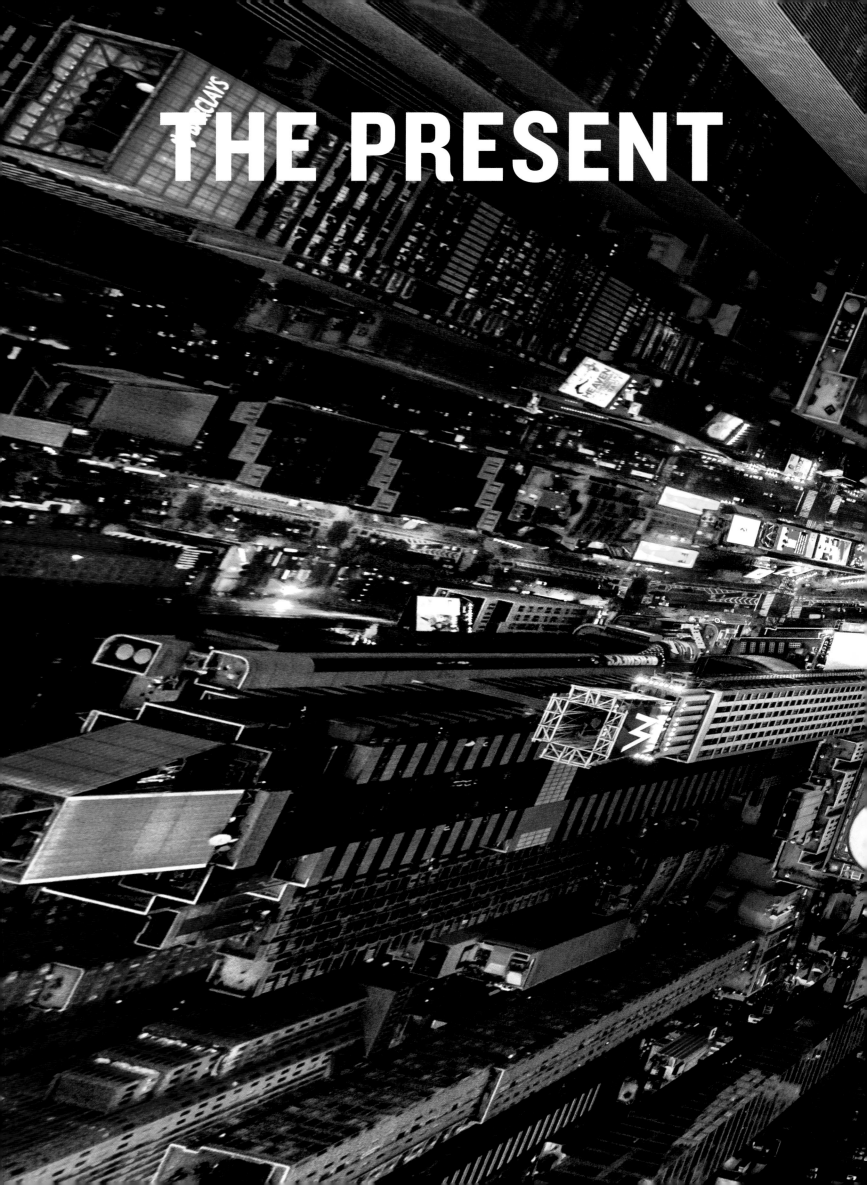

THE PRESENT

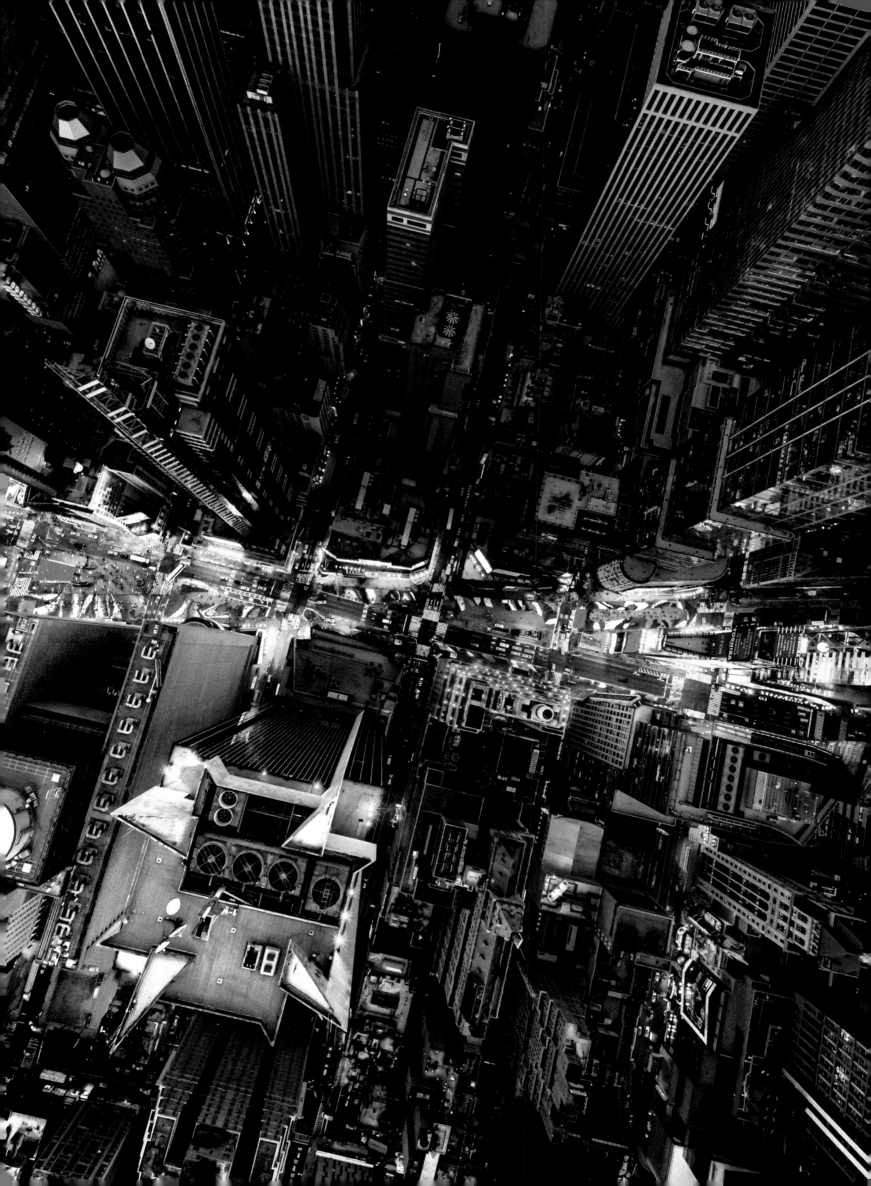

REBIRTH AND VISION...

The advent of the twenty-first century was a time of reckoning for the world's major cities, particularly for New York, London, Paris, Rome, Moscow, New Delhi, Shanghai, Tokyo, and a handful of others. All had entered an era of acute land shortage, high construction costs, congestion, and air-quality and environmental concerns. All saw surges in population; all sought to attract the brightest and the best; all sought to have world-class museums, concert halls, theaters, and universities. Each wanted its urban landscape to be stellar: the best buildings, the most advanced transportation facilities, and the most rewarding business opportunities. Architecture—and with it the race to the skies—was only one arena of competition for cities striving to win the most plaudits.

But not all development is a race to the skies. A second arena is on-the-ground change, with the remaking of basic infrastructure and the creation of miniparks, open waterfronts, and other public facilities, and redirecting traffic flows to open up pedestrian space. These developments may be less obvious than soaring high-rises, but no less important in that they affect and improve quality of life, and we shall note them.

The most iconic new building in New York is One World Trade Center, originally called the "Freedom Tower," which was completed in November 2014. It stands on the northwest section of the site of the former World Trade Center, destroyed by the terrorist attacks of 9/11, but does not occupy the actual footprint of either of the Twin Towers, whose foundation levels have become key parts of the 9/11 Memorial complex. In accepted architectural terms, One World Trade Center rises 100 stories to 1,776 feet; it reflects a powerfully imaginative design with tapering sides of elongated triangular form that far removes it from the "shoebox-on-end" category. Special design and security features added to the building's cost, which totaled over $3.9 billion. Upon completion, One World Trade Center was the world's sixth-tallest structure and the tallest in the Western Hemisphere.

The overall rebuilding of the World Trade Center calls for the construction of five more high-rise office towers on the sixteen-acre site to replace World Trade Center buildings destroyed or damaged in the 9/11 attack. Five of the six have been completed. The National September 11 Memorial and Museum, which incorporates the foundation pits of both of the Twin Towers, already draws a large attendance of foreign and domestic visitors.

Three significant high-rises had been constructed in mid-Manhattan just before or at the turn of the century, all linked to world-famous cultural institutions. In the early 2000s, the Museum of Modern Art (MoMA) on West 53rd Street embarked on a massive expansion program that almost doubled the museum's space and greatly enlarged the areas given over to library collections, training workshops, and class-rooms, significantly benefitting many types of visitors. In 2003, MoMA (which in 1983 had commissioned the building of a fifty-six-story high-rise on land it owned adjacent to its main building) sold a second plot at 53 West 53rd Street, on which a building of eighty-two stories, rising 1,050 feet, is under construction. Designed by Jean Nouvel and originally called the Tower Verre (now 53W53), the building features a cubic boxlike structure, behind which rise two tapering glass-clad spires. The design is dramatic and deemed to be an exciting architectural achievement, creating a real change in the city's midtown profile.

One57 is the newcomer to the 57th Street District high-rises, and at seventy-five stories and a height of 1,005 feet was, when completed in 2014, the biggest boy on the block. One specially designed duplex penthouse is reputed to have been sold for $100 million, but some other potential buyers are said to have chosen not to buy in the building, on the grounds that obstructed views lessened the pleasure of otherwise spectacular apartments—the massive CitySpire, Metropolitan, and Carnegie Hall Towers are indeed making for a crowded neighborhood and, in some cases, blocked views.

A few new buildings have won fame for reasons other than mere height, and a leader among these is the Time Warner Center, completed in 2003. Located at Columbus Circle, across from the southwest corner of Central Park, the center's twin fifty-five-story towers, which top out at 750 feet, are connected by a multistory atrium offering an array of fine shops on each level. The towers house a hotel, business offices, and very expensive apartments with superb views over Central Park. The overall setting, with the busy nexus of Columbus Circle in the foreground, is open and spacious, and the human mix of center residents and visitors, park visitors, and people out and about on their daily errands makes for a remarkably lively scene.

Another new iconic building is the Hearst Tower, on West 57th Street, only minutes away from the Time Warner Center. To state that it is a "new" building slightly stretches the truth: the forty-six-story, 597-foot tower is new, but its six-story base is not; it was built and given its stone facing in 1928. Given the economic uncertainties of the Great Depression (1929), the tower was postponed, and was not built until 2006. The tower's striking configuration is better depicted than described: the terms "diagrid" and "triangular framing" will not evoke a clear image for most people. An ice-sculpture fountain—which has cooling and humidifying functions—and a seventy-foot-tall fresco give Hearst Tower's lobby added distinction.

The interested observer who peers through and below the forest of high-rises that now conjure up the popular image of New York will observe much of interest. Underway in the city is a growing movement to ensure that ever more rapid development walks hand in hand with increased livability—that the urban landscape shows real gains.

One large-scale result of this civic thinking has been the makeover of New York's "green lungs"—the parks. Central Park has received improvements of every kind, making it a truly enchanting and relaxing strolling place after a visit to the Metropolitan Museum of Art. New lighting; new roads and pathways; extensive replantings of trees, shrubs, and flowers; and the refurbishment of pavilions, restaurants, and service buildings have all gone ahead. Automobile traffic has been cut, with the happy result that more cyclists, runners, and walkers are to be seen. In all weathers and at all times, Central Park appears as a jewel, offering an escape from humdrum reality. It is indeed fitting that the truly great park showcases two of the world's greatest museums: on the east side the Met, and on the west side the American Museum of Natural History, both situated at the park's midpoint.

2000

Madison Square Park, where the diagonal of Broadway crosses Fifth Avenue at 23rd Street, is also a very welcoming green oasis, much enhanced. The park stands diagonally across from the twenty-two-story Flatiron Building, a handsome dowager among high-rise buildings, dating to 1902 and entirely masonry-clad. It takes its name from the familiar domestic flat iron of yesteryear, whose triangular form it perfectly resembles.

Union Square has seen similar improvements, and today is a bustling gathering place, with an open-air market in the park's southern plaza. In Washington Square Park, the Roman triumphal arch at the starting point of Fifth Avenue has been fully cleaned and restored, with nighttime floodlighting adding to its attractiveness, and the fountain has been relocated and is now aligned with the avenue and the arch, making an impressive sightline north to the Empire State Building and south to the Freedom Tower.

New York boasts one park that is not clearly visible from the air. The High Line Park is unique in every way. It runs from 16th Street parallel to the Hudson River up to 30th Street, where it makes a turn west to the shoreline. Throughout its course the park is no wider than an average street—and runs along Tenth Avenue. This narrow ribbon of park is in fact an abandoned rail line, rendered unnecessary by the decline in manufacturing—and it has been brilliantly redeveloped as an "elevated" park, providing an interesting twenty-block hike, with great views of the Hudson waterfront.

The Empire State Building has long been recognized as a major city landmark, and it conscientiously sustains this status by an ever-changing cycle of nighttime illumination. Special events are marked by special coloration, skillfully capturing or reflecting the origin or homeland of the event being celebrated, such as green for Saint Patrick's Day. Another landmark structure also lights the night sky, but only with white floodlights. This is Yankee Stadium in the Bronx, impossible to miss from the air on game nights—and on occasion a slightly errant flight path as an aircraft approaches JFK or LaGuardia airports will give passengers a memorable sighting.

Those indulging in helicopter sightseeing will have their curiosity piqued—and hopefully well satisfied—by close-ups of the "crown" of the Statue of Liberty or the "shoulders" of the Art Deco Chrysler Building, where the shell-like latticework hints at a free-form radiator grille. For those with an eye and mind that can take in a whole area's street design and architectural layout, then there is no better multifunctional, mixed-use scene than that of Columbus Circle, showing the wraparound curve of the Time Warner Center. Madison Square Garden, sitting on top of Penn Station and housing a sports arena, is also of interest as one of Manhattan's very few perfectly circular buildings—the more so as it might be lost to possible future redevelopment.

Despite the rapid development of Midtown Manhattan and the bristling new stands of high-rises, Rockefeller Center retains its image of untroubled apartness. It is not only a complex of solid buildings housing the crème de la crème of American and international business, but it is also an example of the near-perfect integration of public and private space. 30 Rockefeller Plaza is the grandest of the nineteen

Today

buildings that today comprise the complex. The magnificent approach from Fifth Avenue across the sunken plaza flanked by flowerbeds and matching low-rise buildings remains awe-inspiring.

Part of the livability and urban-amenities thrust has been a "take back the streets" campaign, often titled "streets are for people." In part, this recognizes that the increase in the number of high-rise buildings brings ever-larger numbers of workers into the city—which in turn leads to congested sidewalks, with pedestrians spilling over into the roadways. Interesting solutions are being tested. Herald Square, at Sixth Avenue and 34th Street, with Macy's and other high-volume shopping magnets at its margins, has been redesigned to have narrow traffic lanes and two large triangular pedestrian seating areas, with shrubs, flowerbeds, and food kiosks. A similar area has been carved out for pedestrians between 65th and 66th Streets at Broadway, with the diagonal crossing allowing for a triangular plot to be set aside as a pedestrian minipark. In both cases, these miniparks are becoming home to committed users, who come in each day armed with coffee and a newspaper or book.

Times Square has not been formally replanned or physically redeveloped, but in keeping with a long-standing New York tradition the area is treated by residents, daily workers, and tourists as a public square and gathering place. The draw may be the opening night of a star-studded show, or a major movie premiere, or—biggest and best known—the New Year's Eve celebration, when the crystal ball descends at the stroke of midnight. The brilliant marquee lighting, the billboards, the running neon messages, and the surging crowds create a high-energy dynamic, generating a sense of happiness and escape.

On two very festive occasions, citizens crowd the sidewalks as the parade goes down the avenue. The biggest of these annual events is Macy's Thanksgiving Day Parade, beloved by children but feared by parents who all too often cannot escape expensive gift-buying. The parade begins uptown at 81st Street and Central Park West, moving onto Fifth Avenue at 59th Street, and onto Sixth Avenue (Avenue of the Americas). It is famous for a colorful array of brilliantly colored gigantic balloon characters—renderings of the most popular comics and games of the moment.

Rather more serious is the Saint Patrick's Day parade, featuring uniformed marching bands and colorful banners representing a variety of Irish organizations. The parade draws a huge turnout of the city's Irish-born and Irish-descended residents. The parade is one of the very few that marches northward up Fifth Avenue, from 44th to 80th Street. Falling on March 17, Saint Patrick's Day is often considered a harbinger of a hoped-for spring.

One annual event that truly gives the streets back to the people is the New York Marathon, now in its forty-sixth year. It takes place on the first Sunday in November, and in 2015 attracted over 50,000 participants eager to complete the 26.2-mile five-borough route. Perhaps the most recognized highlight is the marathoners crossing the Verrazano-Narrows Bridge, coming in from a start in Staten Island over to Brooklyn.

2000

Today

The bridge's center span is 4,260 feet in length, compared to the George Washington Bridge's 3,500 feet, and the span is 693 feet above the water, compared to the GWB's center-span height of 212 feet. As some runners have joked, "The air is healthier up there—but a little thinner; you need more of it." Numbers have not yet thinned, and the colorfulness of endless varieties of running gear—with some reflecting national backgrounds, which can range from Albanian to Zambian—is truly striking. The Verrazano-Narrows Bridge is closed (except for one lane held open for emergency vehicles) during the crossing period, and the runners streaming off on the Brooklyn side head north through the borough into Queens, across into Manhattan, and up to the Bronx, with a later U-turn back into Manhattan for the finish at the south end of Central Park.

Non-marathoners who prefer rather more sedate lengthy personal trips can now use well-marked bike trails which will soon allow for a complete trip around the margins of Manhattan, crossing both the Verrazano-Narrows Bridge, which opened to traffic in 1964, and the Manhattan Bridge, linking the tip of Manhattan to Brooklyn, which opened in 1912, just over fifty years earlier. Both are all-steel structures, and offer an interesting contrast in style; the decorative ironwork trim of the Manhattan Bridge and the clean, uncluttered lines of the Verrazano-Narrows. Despite the many bridges linking Manhattan to the outer boroughs and the George Washington Bridge linking Upper Manhattan to New Jersey, many people still think of Brooklyn, Queens, the Bronx, and Staten Island as entirely separate communities, focusing inward on their own institutions—their universities, schools, hospitals, libraries, theaters, sports facilities, and beaches. "Going to the city" is universal shorthand in the boroughs for any work, shopping, or other trip into Manhattan.

Modern aerial photography incorporates many technological advances, of which one of the most interesting and useful is high-altitude photography that retains clear detail in "seen from space" images. Another is the use of special lenses that shape an image, creating circularity, curvature, or elongation. Another is the ability to create "thrusting towers" photography, when a group of high-rises (or trees, or even grasses) broaden at the upper end, not unlike an array of fingers expanding upward from a vertically positioned palm.

New York, and Manhattan at its heart, can be presented in very striking images through the use of such photographic techniques. Manhattan, appearing like a large orange segment, with New Jersey and Long Island appearing as separate segments to the left and to the right, provides a particularly striking example. Such images also capture much that is of geographical-geological interest, showing the Hudson River as having "clean-cut" shores, but the East River as having "ragged" shores. This is entirely understandable as over the millennia the Hudson River cut a gorge through rocky terrain, leaving Manhattan as a detached section of the mainland. Long Island, truly a free-standing island, was scoured and eroded by the tongues of glaciers that created moraine and low-lying areas.

Detailed high-level photography also indicates the intensive degree of urbanization on Long Island and on New Jersey's Hudson shore. Long Island, being closer to Manhattan and easier to access, was settled earlier and more intensively than New Jersey, with Queens developing beyond Brooklyn's northern border. Both the New Jersey townships and the Long Island boroughs adopted grid plans for street layouts. So dense is development that neighborhoods and townships across the rivers from Manhattan are almost seamlessly joined within, with little to demarcate local boundaries.

Population pressure makes itself felt in many ways. One visible indicator is increased use of the parks—New York's "green lungs" or "tranquil oases," as they are often called—of which Central Park in Manhattan and Prospect Park in Brooklyn are the best known, though the great green swathes of the Bronx's parks—Van Cortlandt Park, Pelham Park, and Bronx Park—offer great escapes. Bronx Park is home to a magnificent zoo and an immense Botanical Garden; both are world-class institutions.

Under initial discussion is a plan for a streetcar line to run through Queens and Brooklyn, parallel to Manhattan's Second Avenue Subway (still under construction), extending deep into Brooklyn.

Private entrepreneurs have also entered the commuter transportation arena, and have organized and operate a number of ferries variously linking Manhattan, Brooklyn, Queens, and New Jersey. Over a dozen routes are currently in operation. New York has not forgotten its traditional alliance with ships and waterways. South Street Seaport, downtown on the East River at Fulton Street, is home to a number of historic vessels, ranging from schooners to a tugboat and a lightship. On the landward side of the piers is a historic square with restored houses; once chandlers, naval supply outlets, and sailors' lodging houses, they are now home to restaurants and boutiques, some with maritime themes.

2000

Though South Street Seaport's historic square is backed by a phalanx of highrises, it very successfully recaptures the New York of the 1820s to 1870s, when the city was still primarily a port, and finance meant counting gains and losses incurred in carrying cargo.

If New York's sports enthusiasts have their marathon, New York's families and children have their parade. Macy's Thanksgiving Day Parade is not designed for families only but provides colorful entertainment for almost all groups—old or young, married or single, American or foreign. The parade was first held in 1924, and has steadily grown bigger and better over the years. It is a grand New York City event, to be celebrated come sun, rain, or wind. The boisterous, we're-going-to-have-fun audience lines up along the parade route early in the day—prepared for the soaring cartoon character balloons and the razzle-dazzle of colorfully clad Broadway and pop culture figures. It's a something-for-everybody day, infused with a large dose of the popular culture of the moment—vibrant, visual, and musical.

Today

"The beat goes on!" as New Yorkers say, "the city's on a roll!" The city is indeed moving forward at what for many New Yorkers is an exhilarating if not exhausting speed. Most noticeable for many is the increasing rate at which high-rises are being built on every available site between Battery Park and Central Park, across the whole breadth of Manhattan from First Avenue to Eleventh Avenue. Pedestrians now pick their way around scaffolds and hoists, wary of delivery trucks hauling building materials and supplies nosing in and out of cavernous entries that will, upon completion, become palatial marble-clad entry lobbies or imperial-sized showrooms and retail stores.

Concurrently, as the previous section noted, large-scale attempts are being made to improve traffic and pedestrian flows, to enhance the transportation facilities on which the work force is dependent to enter and leave Manhattan. Many of the city's biggest subway transfer points, where two or more lines meet, cross, or pass each other at different levels, have been totally reengineered at different levels. The focus is on the clean, light, and bright, with artistic elements highlighted. These range from large-scale, whole-wall mosaics depicting local history or offering fanciful designs, to bronze sculptures or decorative iron screens. Other stations have been totally redesigned, with the overall physical structure, halls, stairways, and platform areas designed as an interconnected work of high design married to utility. This is the case in the heart of the Financial District, where the rebuilding that followed the destruction of the Twin Towers has allowed world-class architects to offer comprehensive designs. Glass fins and oculi are among the features favored to maximize natural light.

Enhanced facilities are highly visible aboveground, where the realization that increased numbers of people on the streets means increased danger at every intersection for them and vehicles alike. New railings, bollards, plantings, signage, and street narrowings or broadenings are appearing daily—and to good effect. Bike lanes are doing much to accommodate the huge increase in cyclists that has followed the wholesale introduction of a city-sponsored rent-a-bike network.

Ironically, the Internet has brought into play a factor that is becoming an increasing challenge to every effort to lessen or control congestion. Anything and everything can be bought by smartphone with delivery by messenger—and all need street space in which to accomplish their errands. The battle of convenience versus congestion is clearly growing. How much more can the city grow until it becomes necessary to build platforms far out into the rivers, to extend the commuter transportation systems, and to tear down every low-rise building? How many more students can come from all over the world to study at prestigious universities, or professionals from abroad to work in finance, medicine, design, and other disciplines in constant demand in New York? What will tomorrow bring?

This striking image suggests that between the steel-and-glass towers of the Financial District there is space and air. For those who walk the congested streets, most buildings are claustrophobically close, presenting unbroken walls.

Entry is a formidable process of clearing security and being announced and met. Though the buildings are glass-walled, the majority of offices are in windowless interior grids. Architecture calls for economy; design calls for maximum usable space.

158 · 159 | FOOTPRINTS |

This photograph captures a much-discussed but less often depicted scene: the footprints of the Twin Towers. The square foundation and basement areas of the Twin Towers are central components of the 9/11 Memorial & Museum, which includes a museum, various memorials, and a proposed art center. The World Financial Center occupies the foreground: its five buildings are distinctive for their traditional masonry cladding and green copper roofs in the shape of domes and pyramids.

160 · 161 | THE FINANCIAL DISTRICT |

Wall Street, with the copper Gothic-style roof of the Trump Building, now presents a medley of architectural styles, with most newer buildings of a utilitarian design, though presenting some nuance of contemporary style. Nonetheless, the lit windows add brilliance to the night.

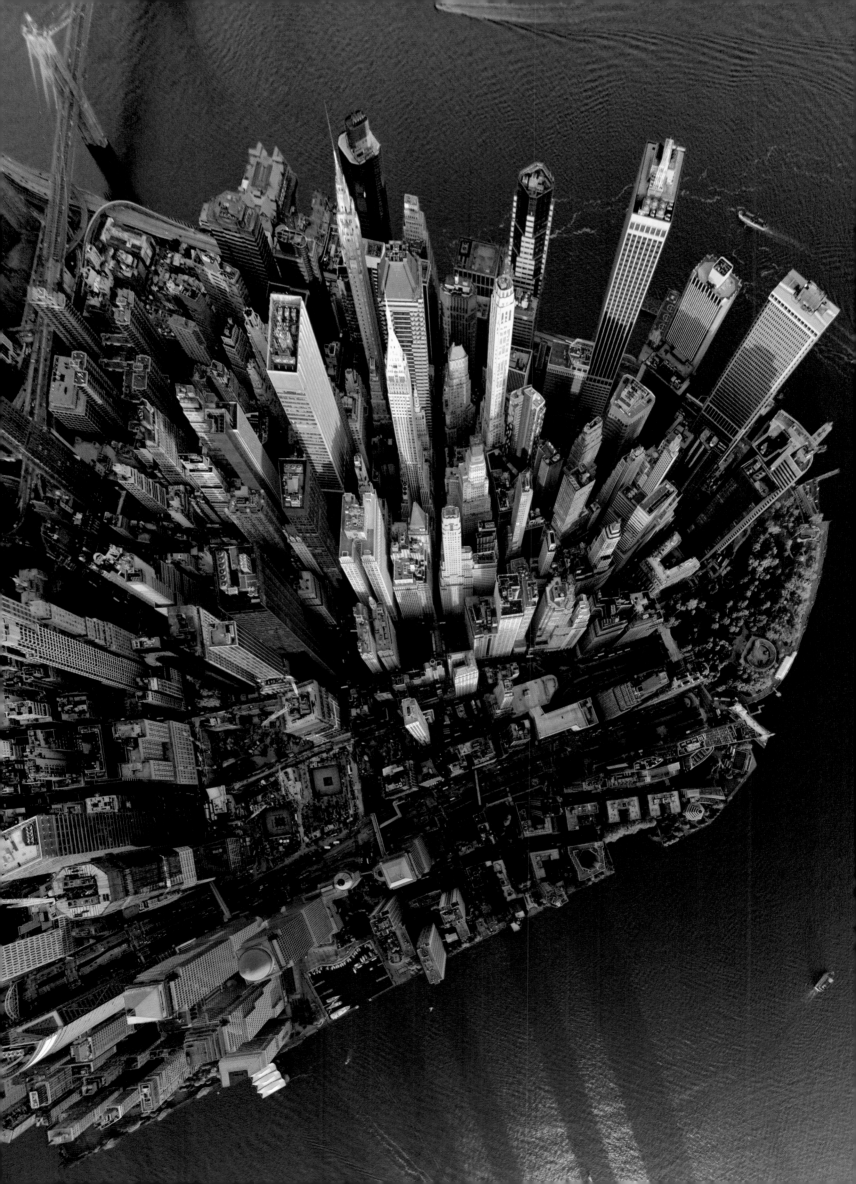

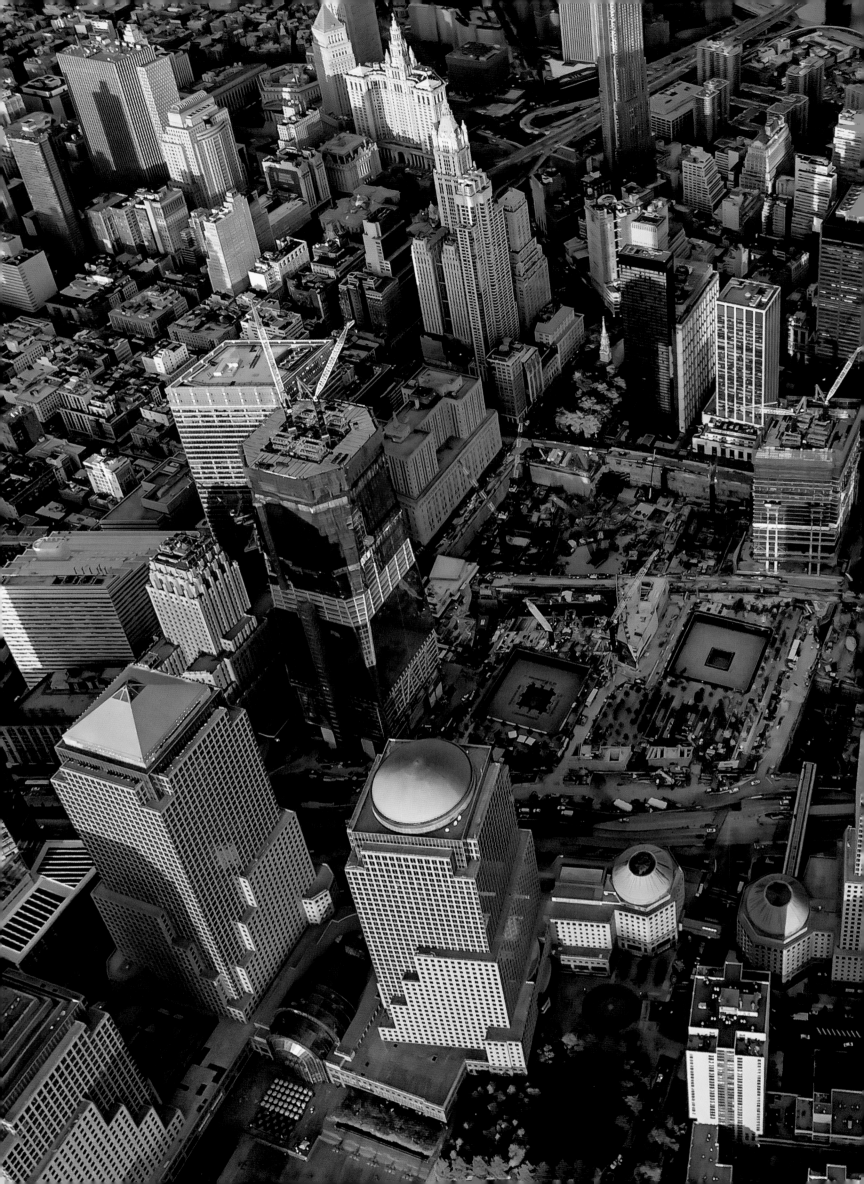

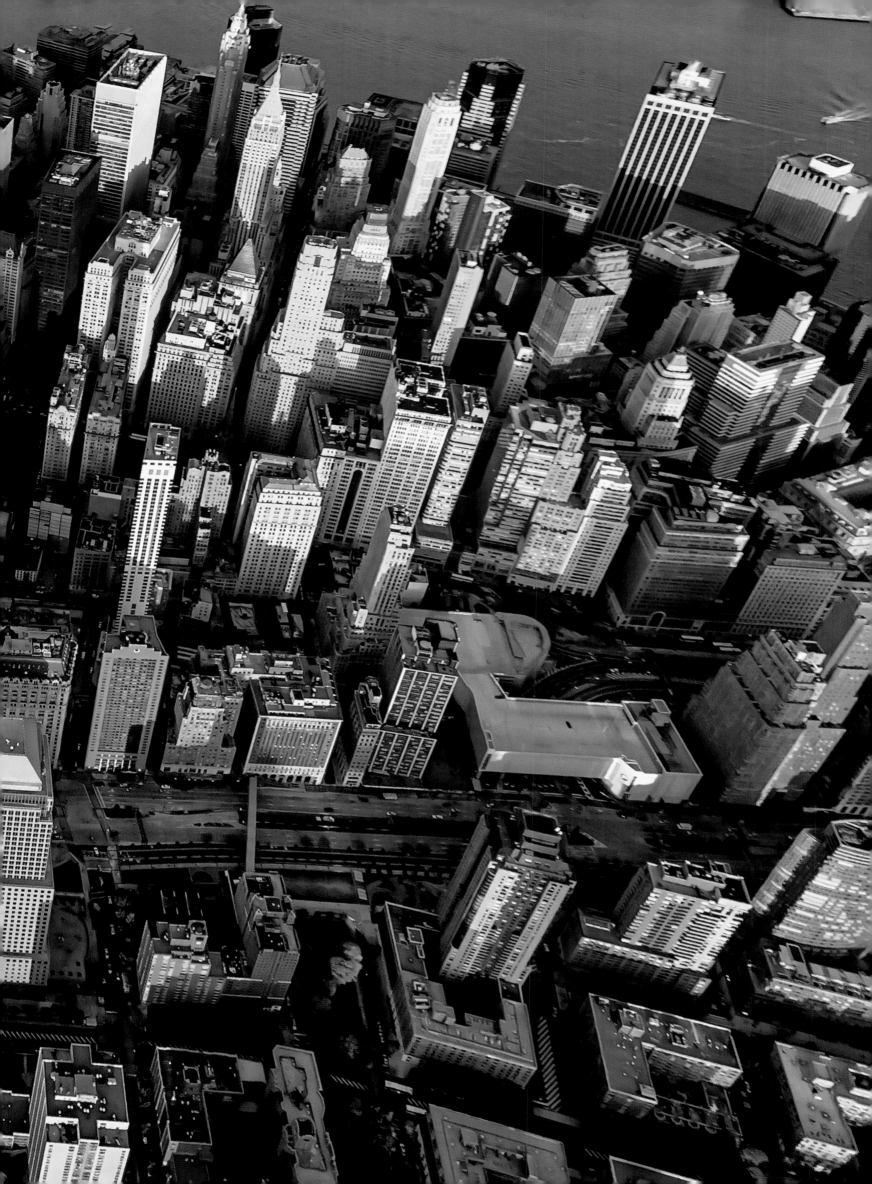

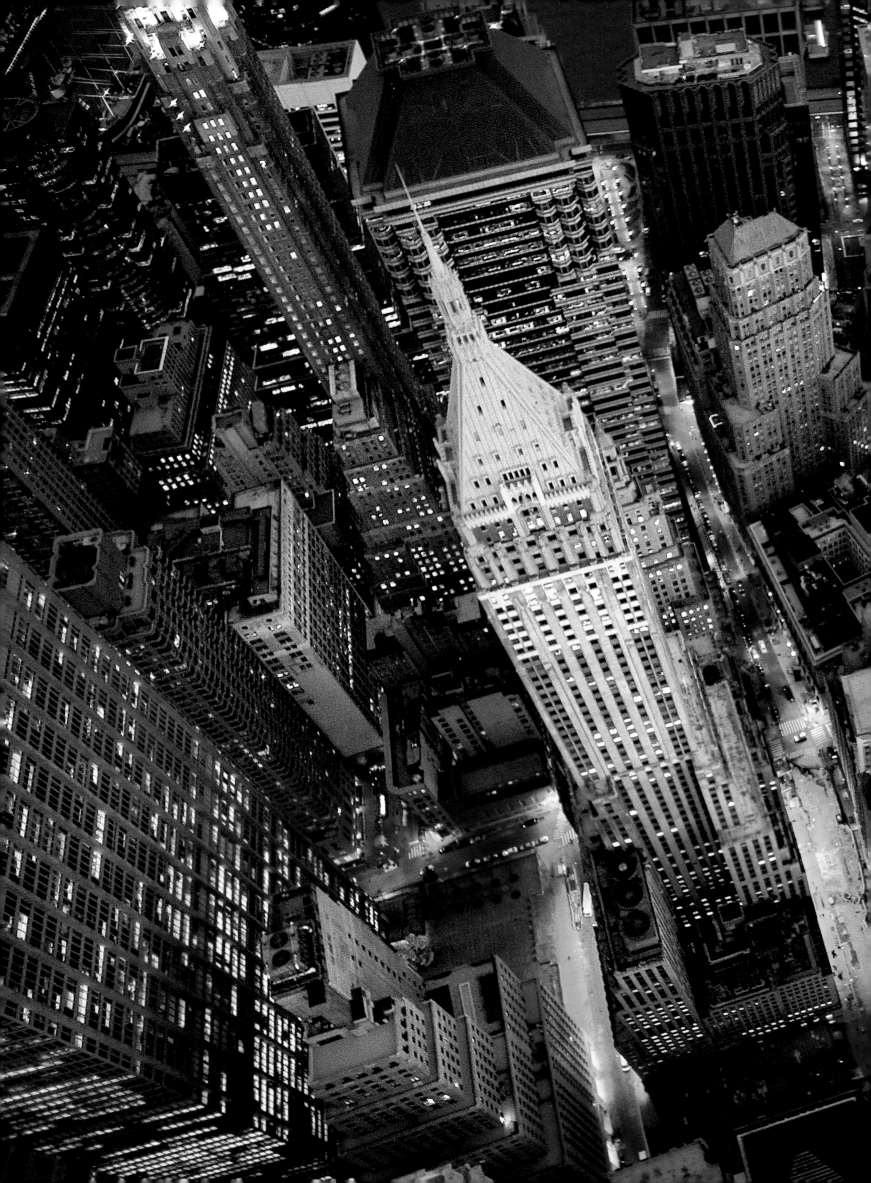

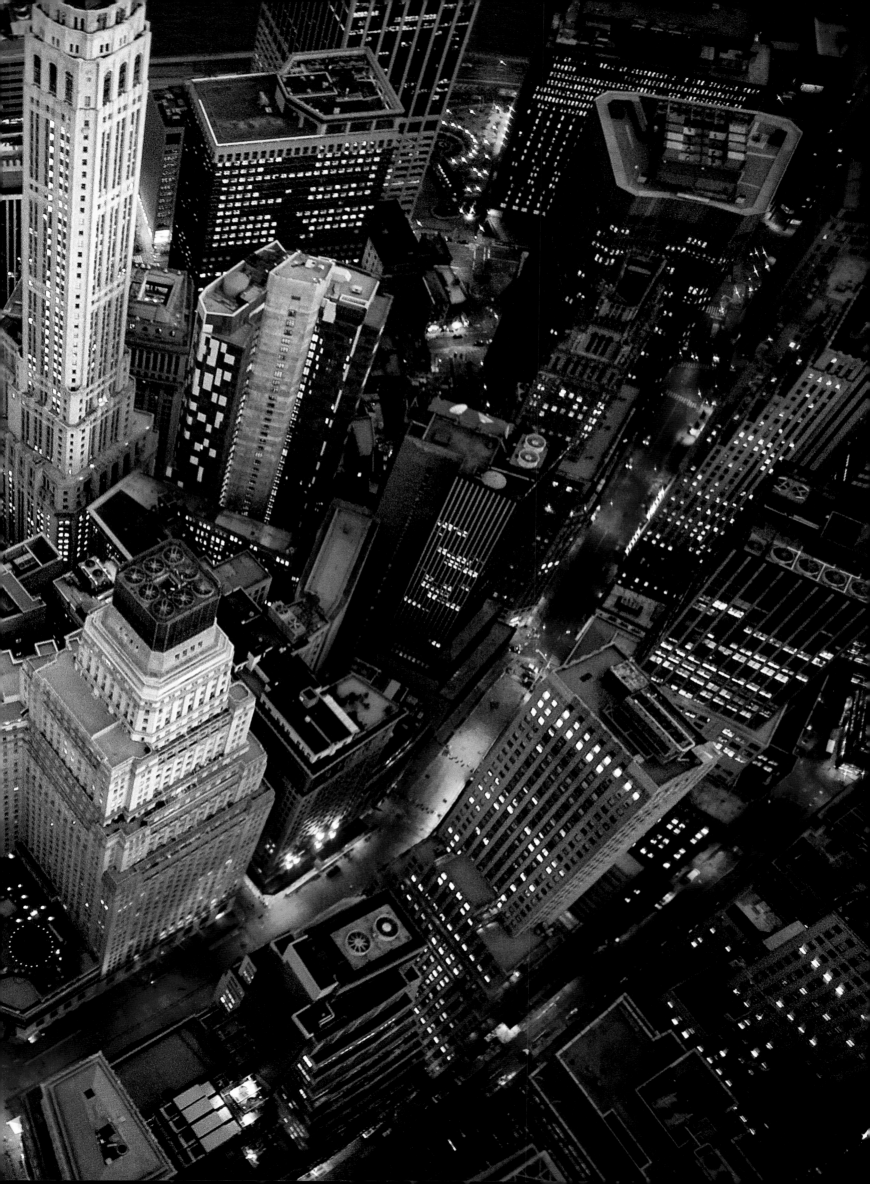

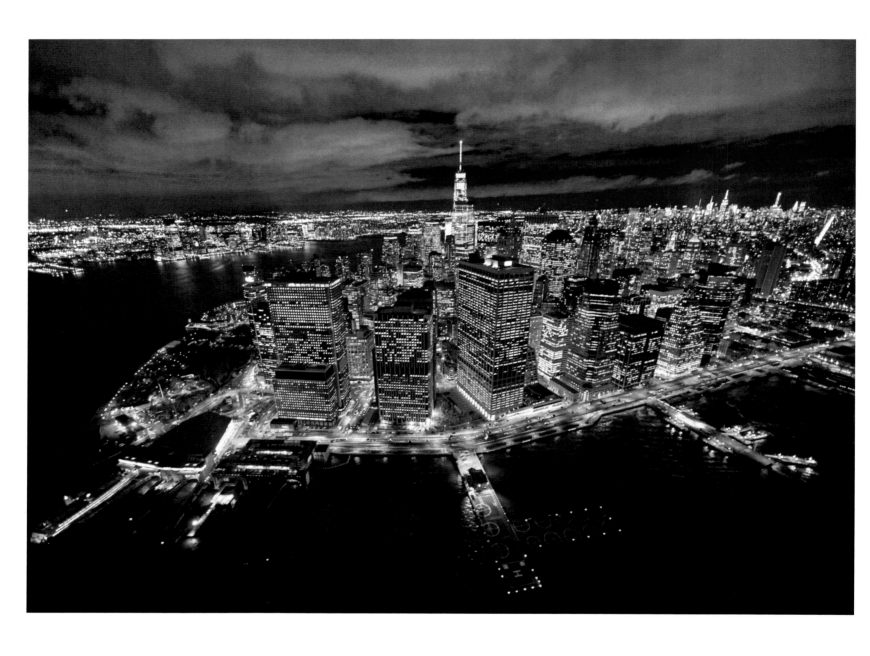

| HIVES OF WORKER BEES |

The brightly lit beehives of the Financial District and much of Lower Manhattan remain occupied well into the night as the digital world of finance and banking pulses nonstop. To the lower left, scarcely lit, is Battery Park and its circular Castle Clinton. On the upper right, the Empire State Building can be perceived. To many New Yorkers, most buildings are entirely anonymous, unknown, unvisited, and without human interest—but they do light the streets at night.

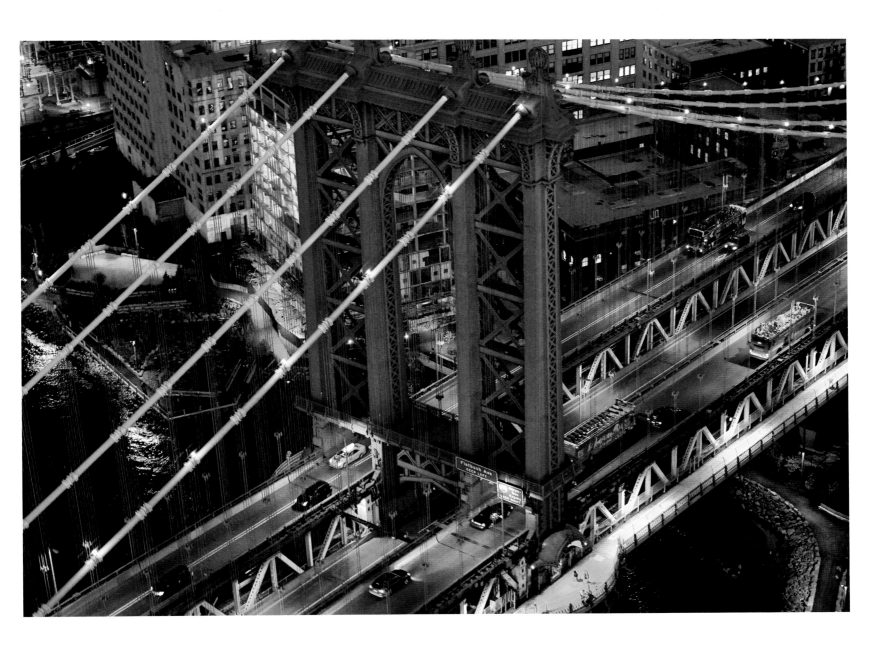

A SISTER BRIDGE…

Manhattan Bridge opened in 1909, twenty-six years after the Brooklyn Bridge, with all-steel construction superseding the steel-and-masonry construction of its sister bridge. The Manhattan Bridge also differs in that it carries subway tracks. Both bridges have much-used bicycle and pedestrian lanes.

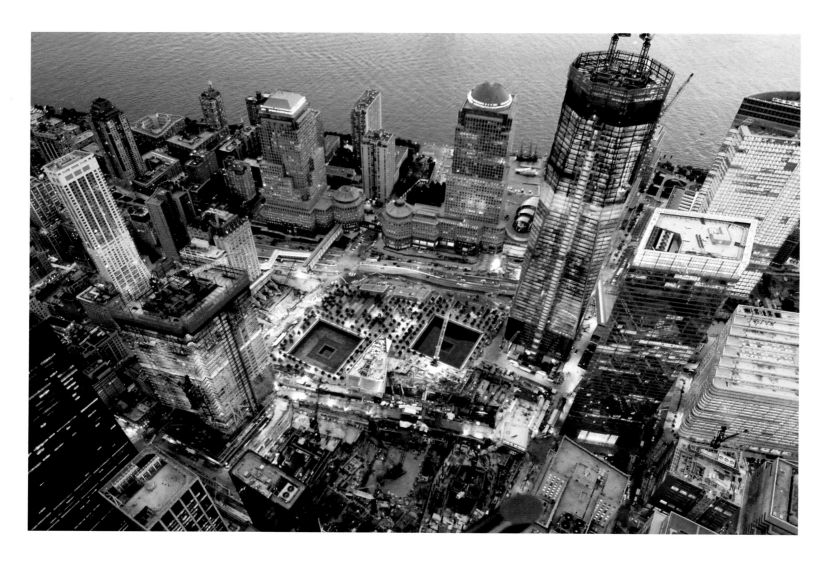

| FREEDOM... |

The triangular elements in One World Trade Center's design are already becoming iconic. The building, lit up at night, is a symbol of New York's resilience and confidence. Prior to construction, the several designs offered for the building—which varied from generally traditional to the hardly possible—underwent significant changes. The elegant tower that was finally built has won widespread approval from New Yorkers—who recognize its powerful symbolism.

| THE UNDISPUTED QUEEN... |

By night One World Trade Center is fully lit, and its upper reaches, soaring high above nearby towers, form a slender spear of light against the night sky. When questions are raised as to the fuel and environmental costs of through-the-night lighting, it can be stated that many offices have late-evening or night-shift workers, and that all maintenance is done at night. Lower right, the "footprints" of the Twin Towers can be seen; they are now part of the WTC memorial site.

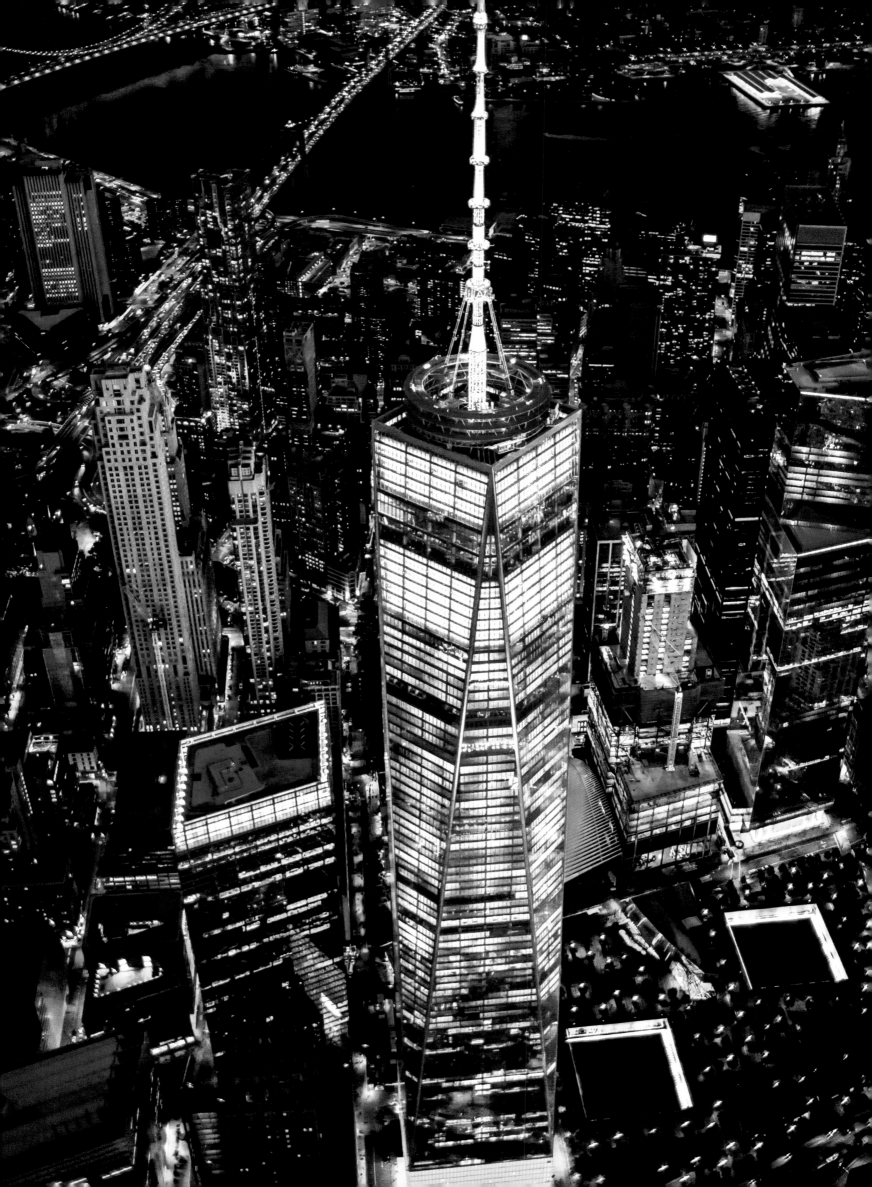

One World Trade Center (Freedom Tower), with its popular observation deck, soars above the two square black "footprints" of the North and South Towers destroyed on 9/11; these form part of the National September 11 Memorial & Museum. To the left are the distinctive roofs of the World Financial Center's buildings.

168 · 169 | TOPPING OUT... |

A building's "topping-out" ceremony usually occurs when the building has reached its full height, and it is a celebration for those most closely connected to the design, financing, and construction of the building, together with the developer, in this case the Port Authority of New York and New Jersey. The communications spire rises an additional 408 feet above the upper equipment and systems levels that sit above the top office floor, for a total building height of 1,776 feet.

170 · 171 | HIGHLIGHTS |

Here the immense popularity of the Empire State Building's 102nd-floor observation deck is fully evident. Not only is it at capacity, but there are invariably more people to come—most having made reservations in advance. New York hosts 55 million visitors a year. It is of interest that the building's decorative features are carried to the 102nd floor—and that metal tracery is visible above. To the left is the Manhattan Bridge as well as residential buildings.

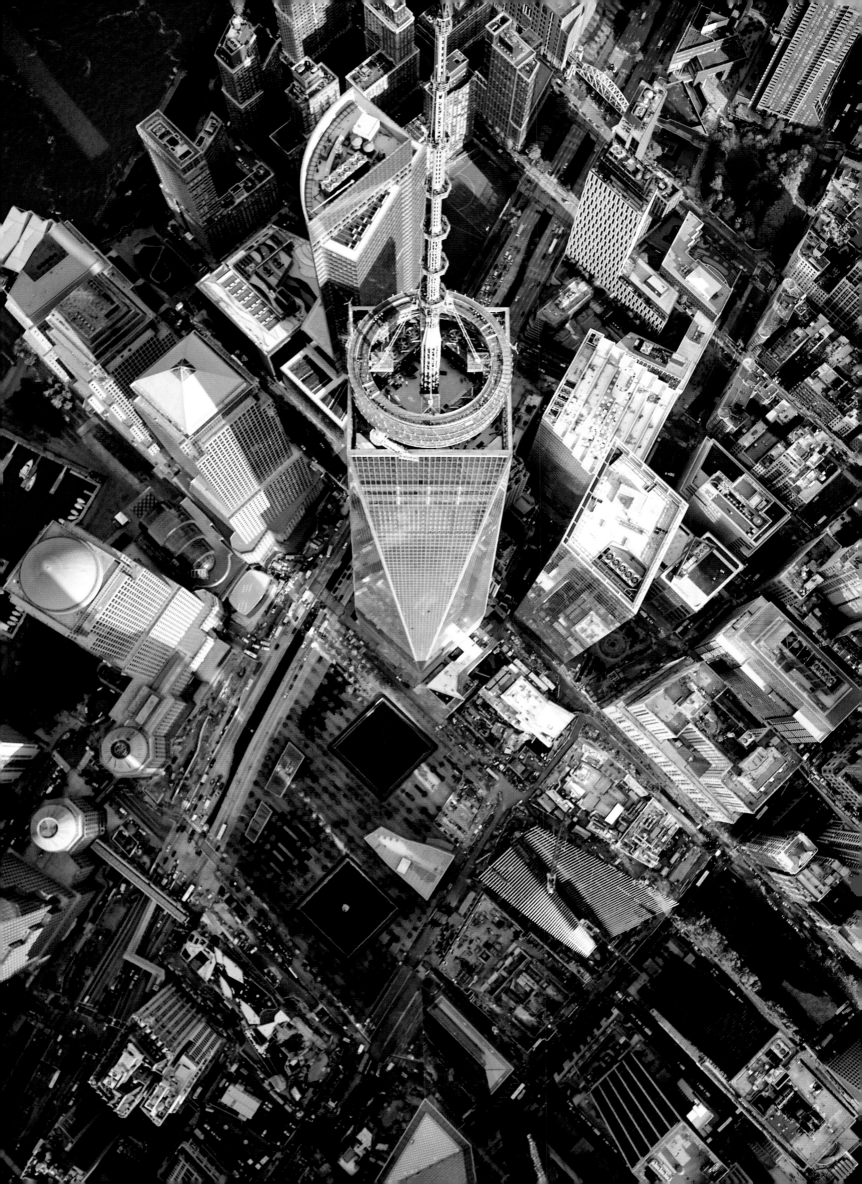

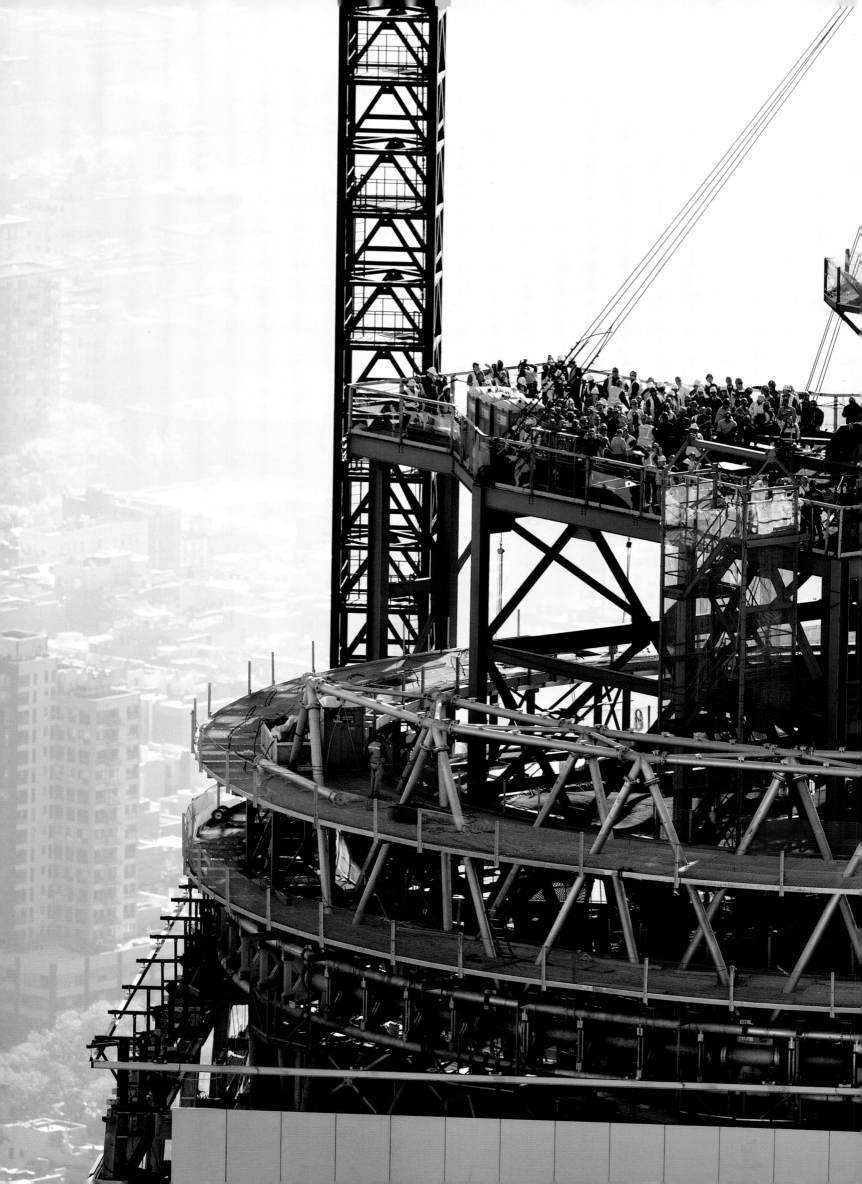

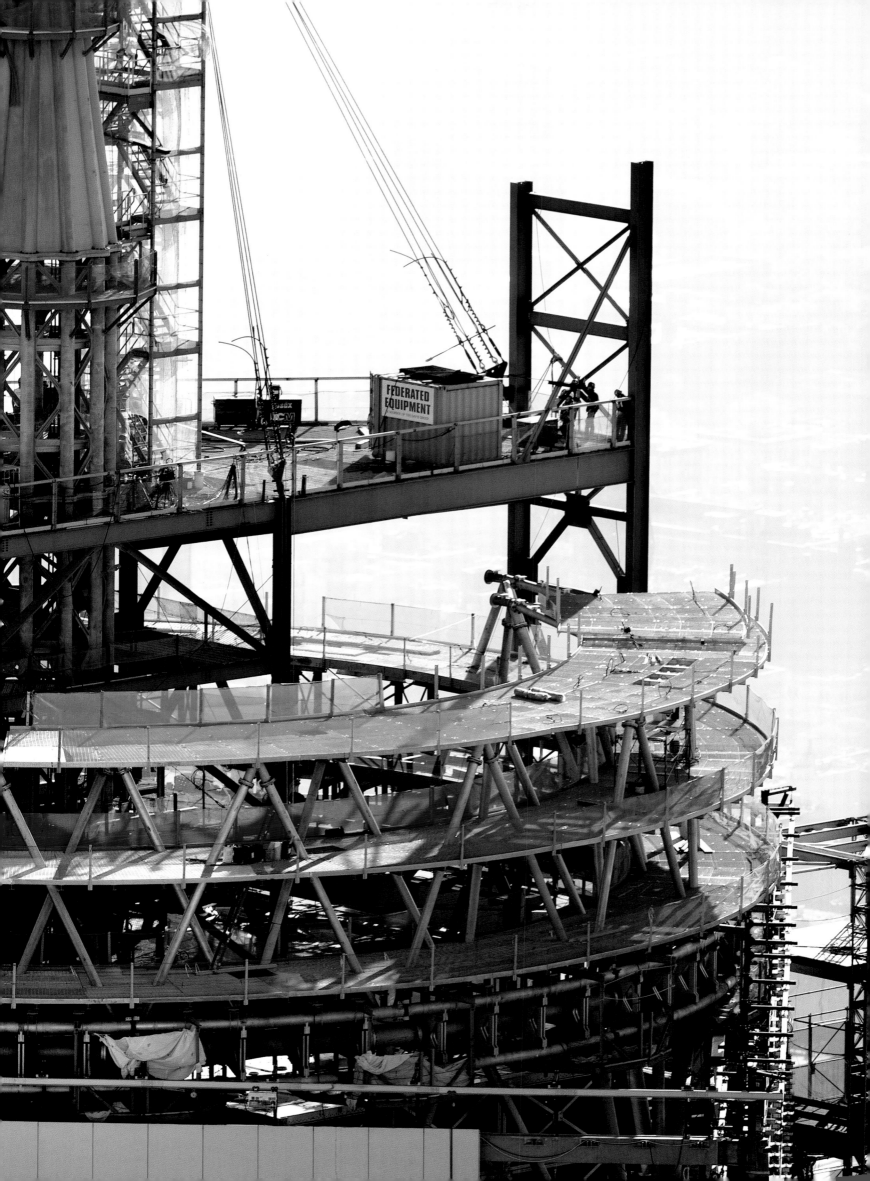

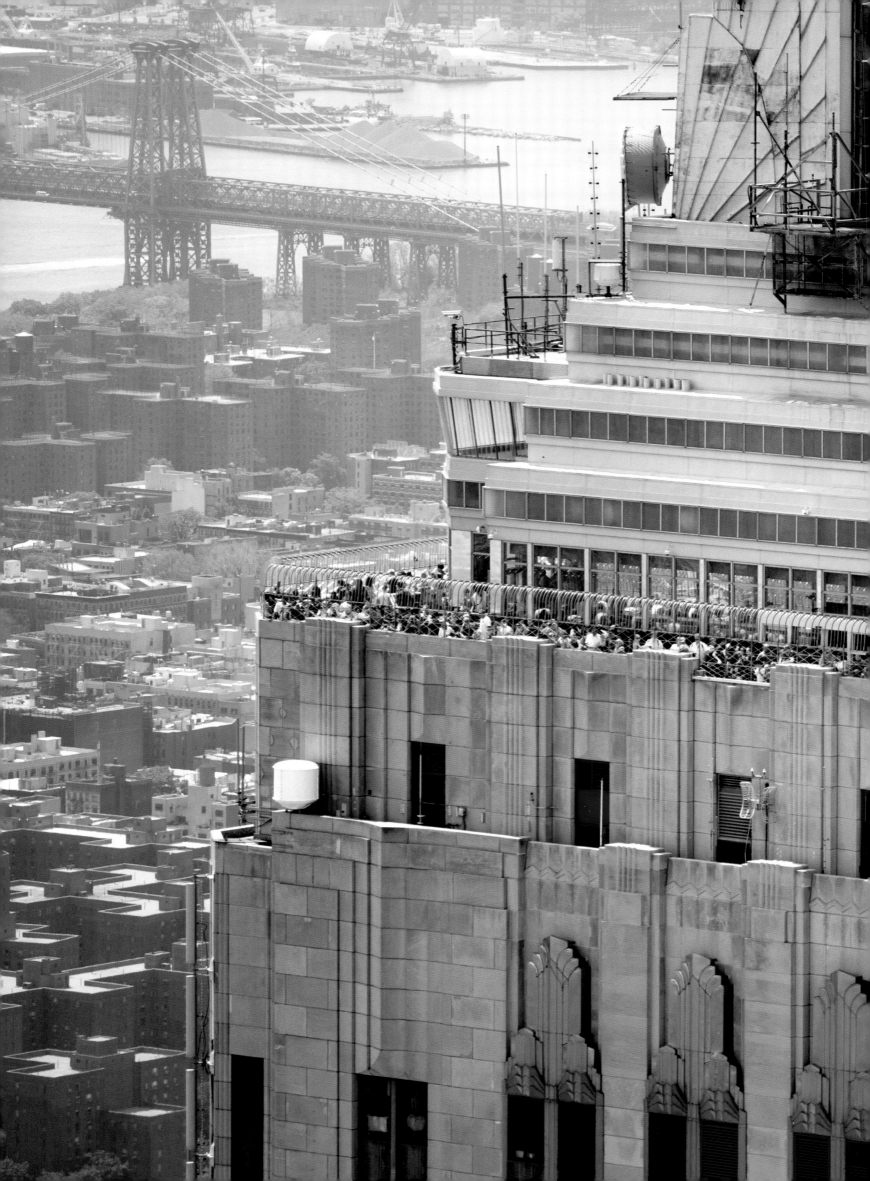

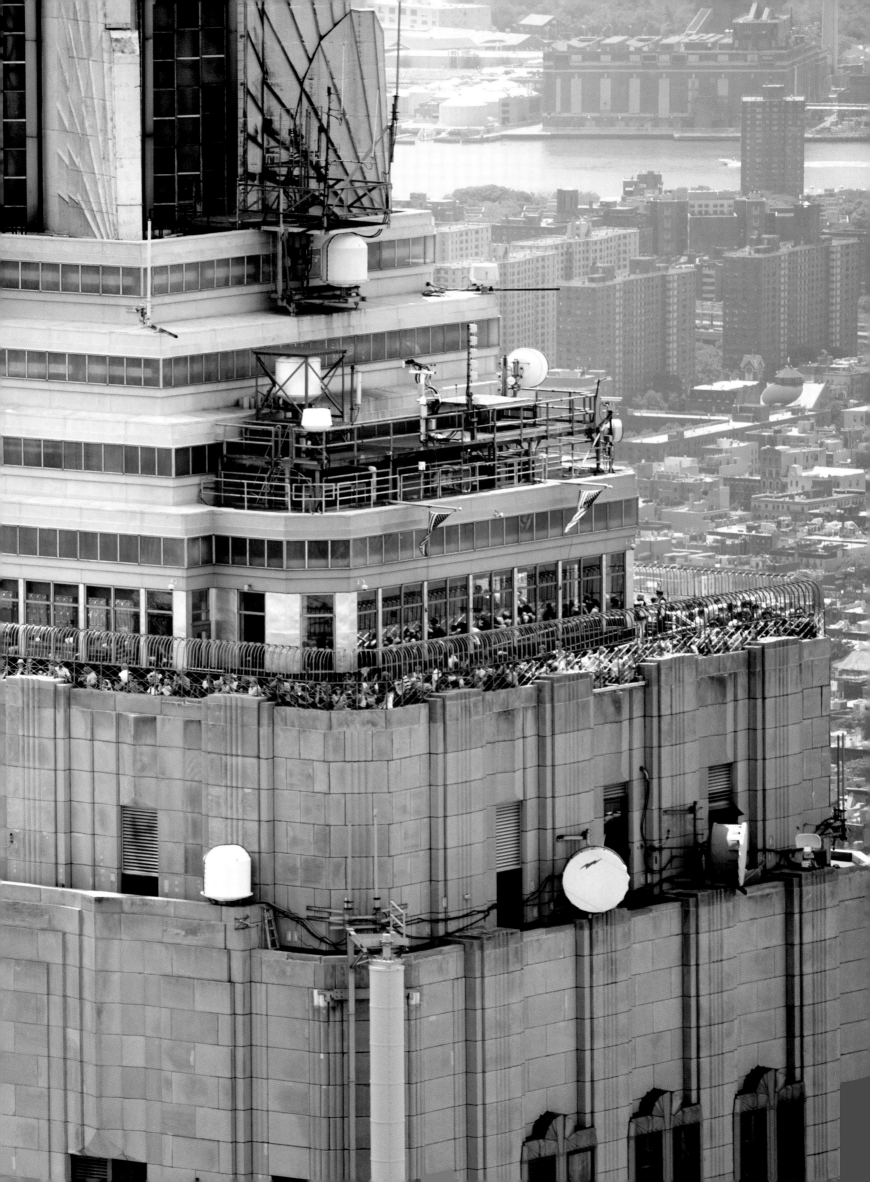

Structures from the 1930s, such as the Empire State Building, the Chrysler Building, and the Helmsley Building, traditionally featured setbacks with terraces or viewing platforms at intervals in the tower's upper stories. These might be private balconies for senior executives or might serve as public viewing platforms. This latter use is no longer common as congestion, security, and safety have become significant issues. However, the Empire State Building maintains observation decks on the 86th and 102nd floors.

174 | A VITAL FUNCTION |

This image of the Empire State Building brings into focus the size of the radio mast that serves electronic reception and transmission systems, absolutely vital in today's digital world. On this occasion the building is presenting red, white, and golden illumination. The main entry pavilion on Fifth Avenue can be seen, and Broadway's diagonal route (upper middle) is also visible. The current building boom has resulted in high-rises being constructed in close vicinity.

175 | EMPIRE STATE BUILDING |

A dowager among New York City's interwar skyscrapers, the 102-story Empire State Building (named after the familiar term for never-shy New York State) has never shed the serene, clean-cut look its limestone cladding provides. One little-known fact is that when the building was struck by a Mitchell bomber in 1945, an elevator operator survived a seventy-five-floor plunge inside the elevator car, which still appears to be an unchallenged record.

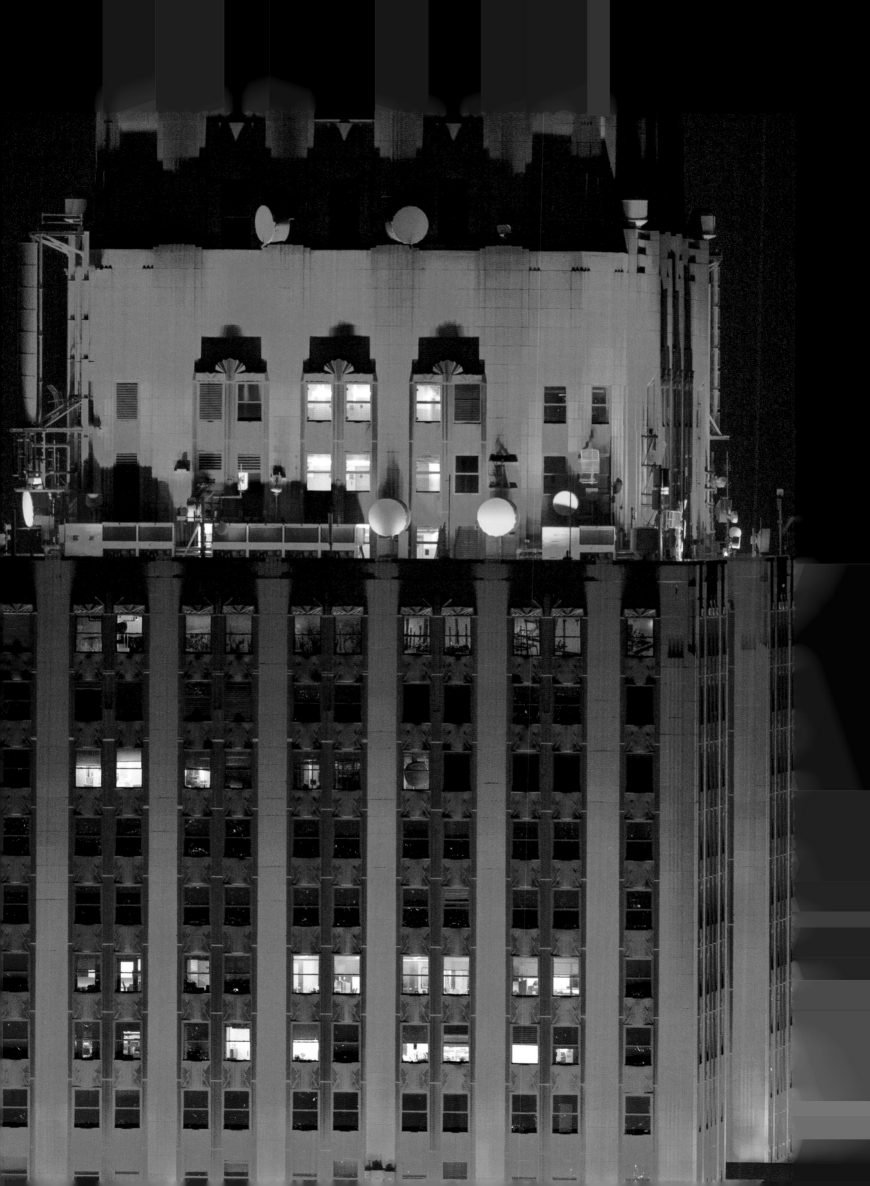

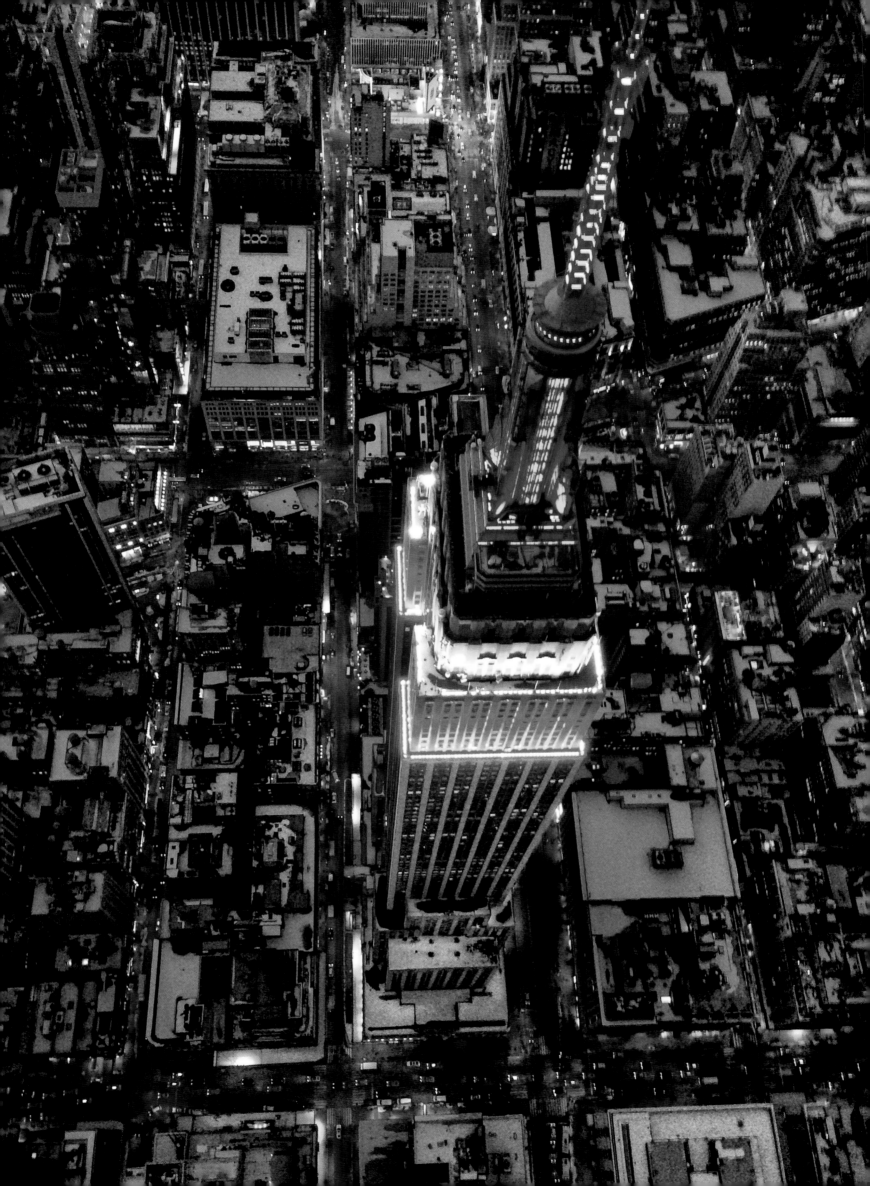

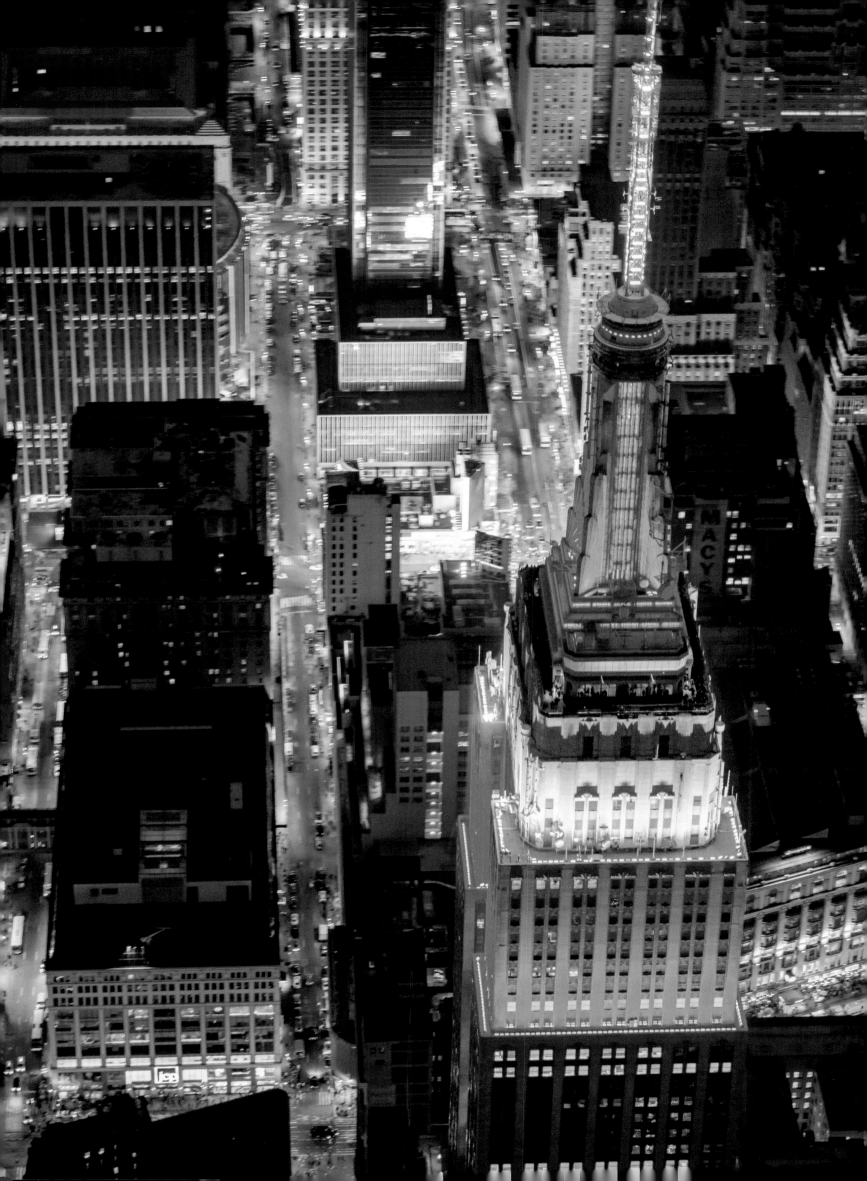

The twenty-two-story Flatiron Building stands at the northern extremity of this view, with One World Trade Center dominating the southern extremity. The bright lights of Fifth Avenue end abruptly at the white stone arch of Washington Square Park; the smaller streets of Greenwich Village replace it to the south. The cube to the left of the arch, with its five vertical columns of golden light, is New York University's main library. The park, in darkness here, is the heart of the Village.

178 · 179 | MADISON SQUARE GARDEN |

Though it has an undeniable identity as one of New York's few circular buildings, neither Madison Square Garden sports arena nor the looming black-glazed Penn Plaza office tower rank high in the minds of critics or the hearts of New Yorkers. The former Pennsylvania Station, with its magnificent architecture and presence, reflecting elements of the Baths of Caracalla in ancient Rome, was demolished to allow for the Garden's construction. The station remains, in cramped quarters below.

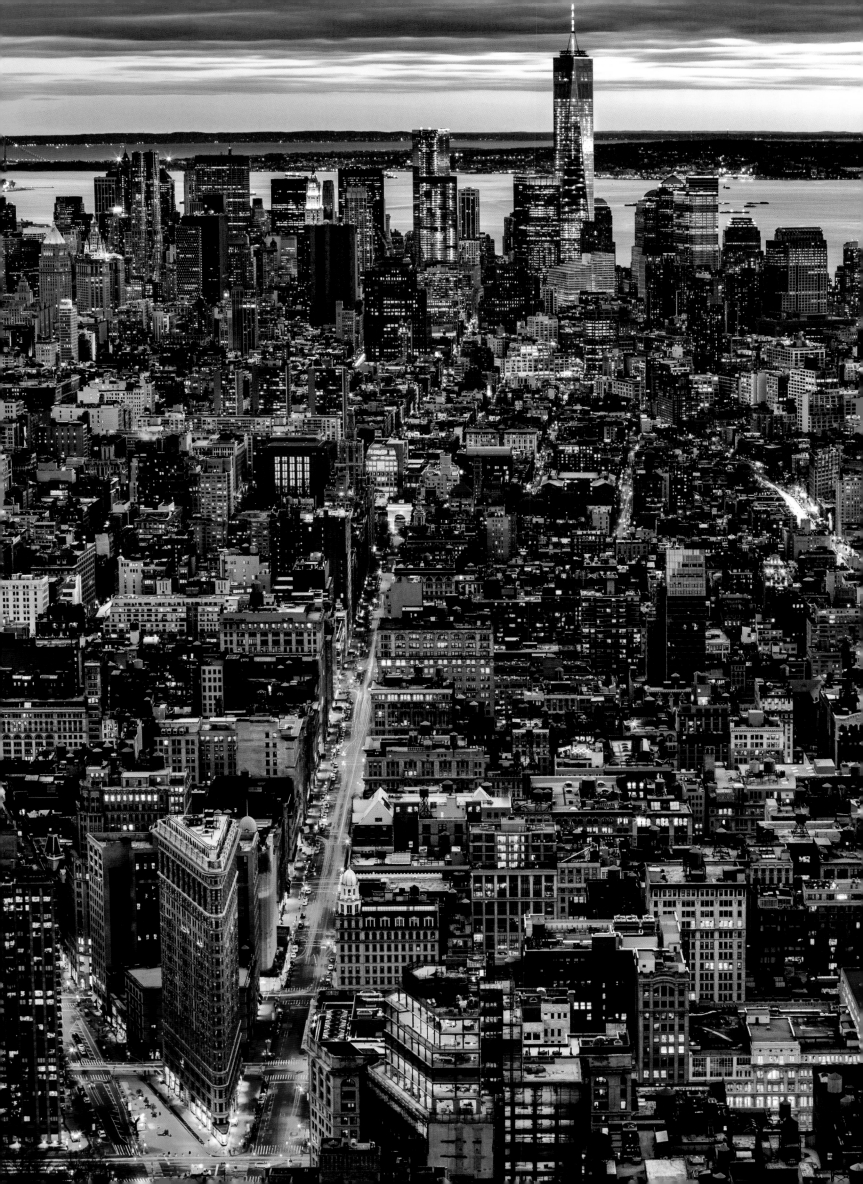

The Flatiron Building, constructed in 1902 and dominating the crossing of Fifth Avenue and Broadway at 23rd Street, has long been seen as a grand old dowager among New York high-rises; design, fenestration, and the decorative stonework finish all reflect pride in craftsmanship. The building's appeal has led to the successful reinvigoration of its now thriving neighborhood, with Madison Square Park, extending from 23rd to 26th Streets, a well-maintained and much-appreciated amenity.

182 · 183 | MASONRY AND MASS |

The Brooklyn Bridge—the first bridge linking Manhattan and Brooklyn—exudes strength and stability; it's impossible for most New Yorkers to imagine its demolition and replacement, so far never discussed. Such is the curvature of the earth that the tops of the Brooklyn Bridge's towers are nearly an inch farther apart than the bases. The "rippled" building in the foreground of One World Trade Center is an apartment tower. Small building plots mean greater heights.

184 · 185 | EAST RIVER ISLAND… |

The Queensboro Bridge, spanning the East River at 59th Street, was opened in 1909, and remains a vital link between Manhattan and Queens. Beneath it lies Roosevelt Island, once the site of fever and isolation hospitals and now redeveloped as a family-oriented neighborhood of mid-rise housing set in parkland.

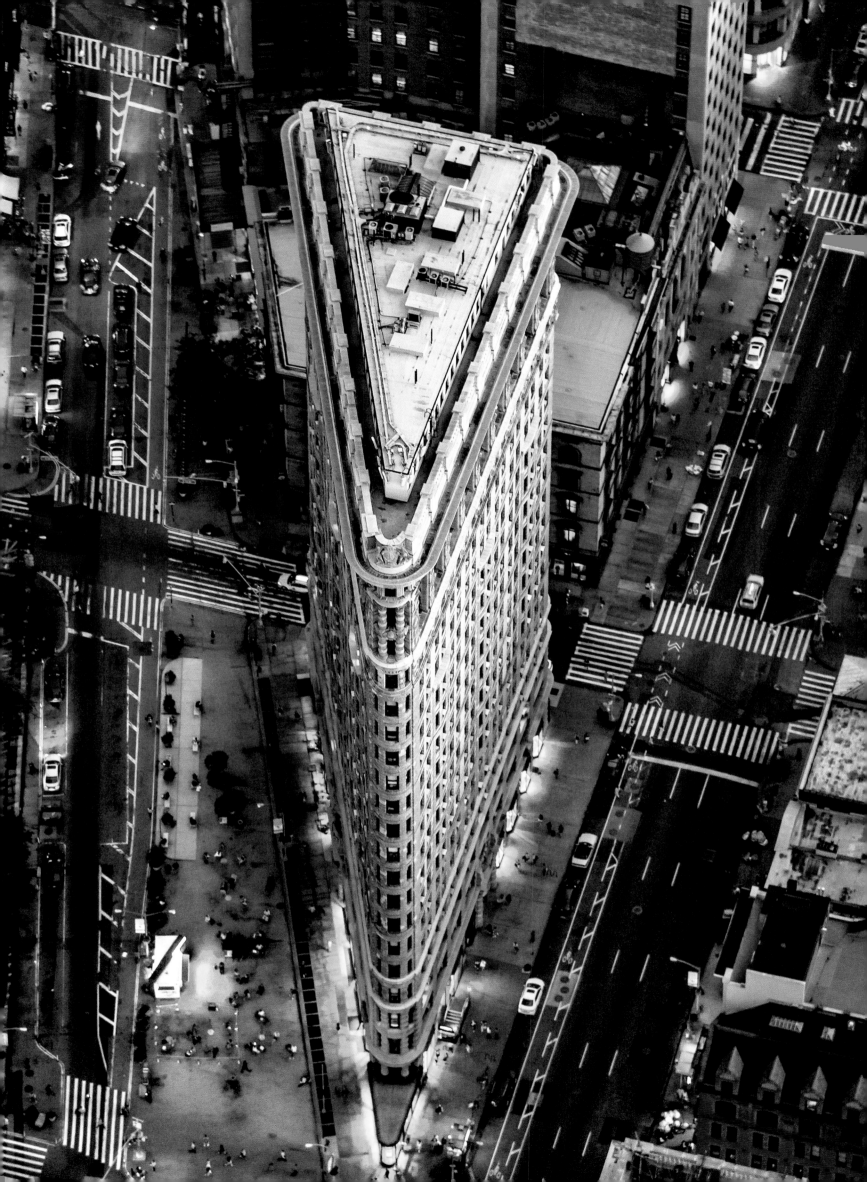

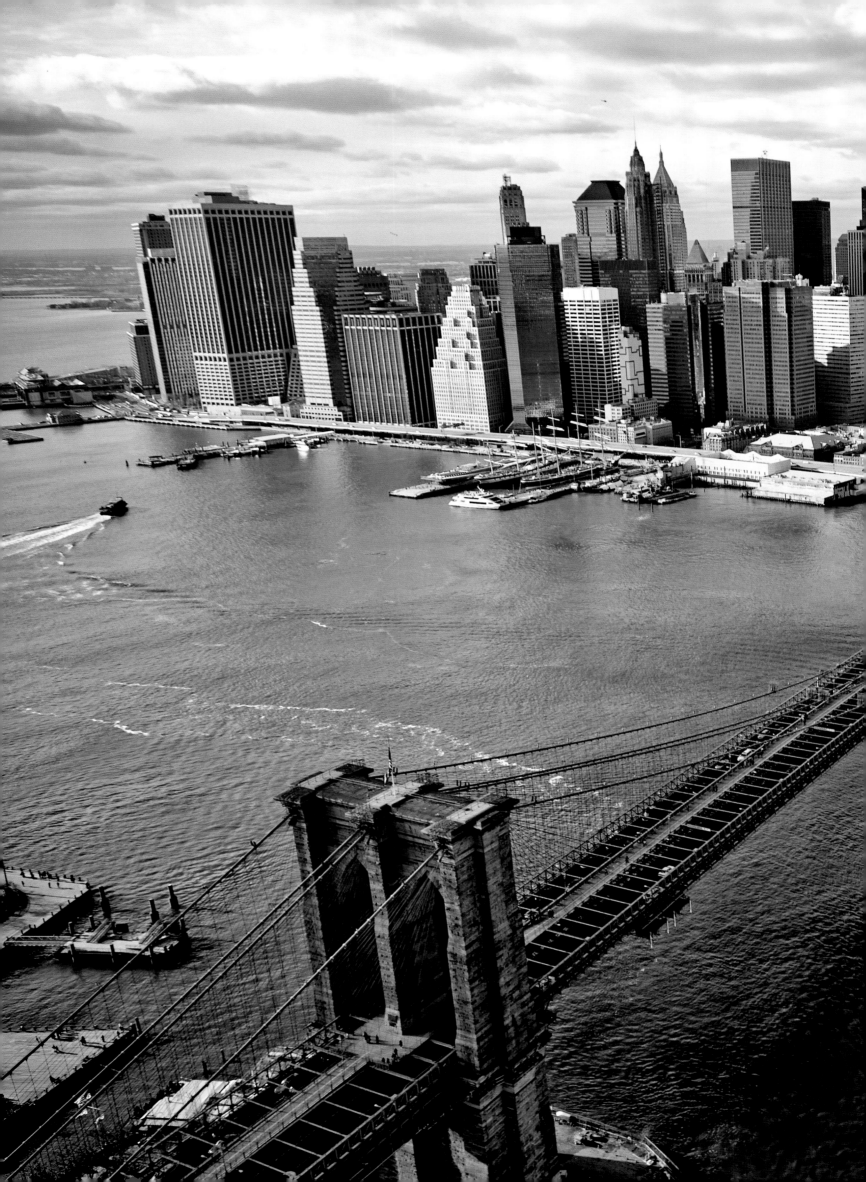

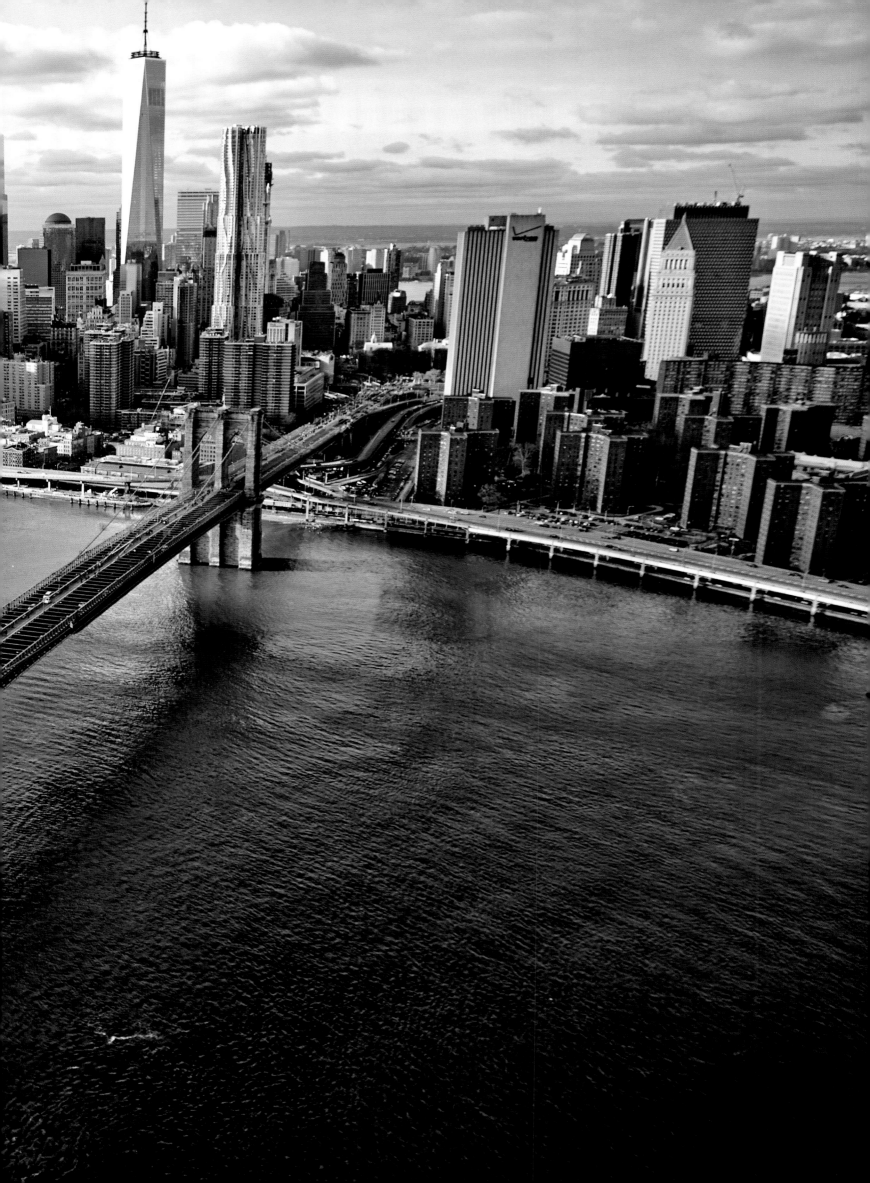

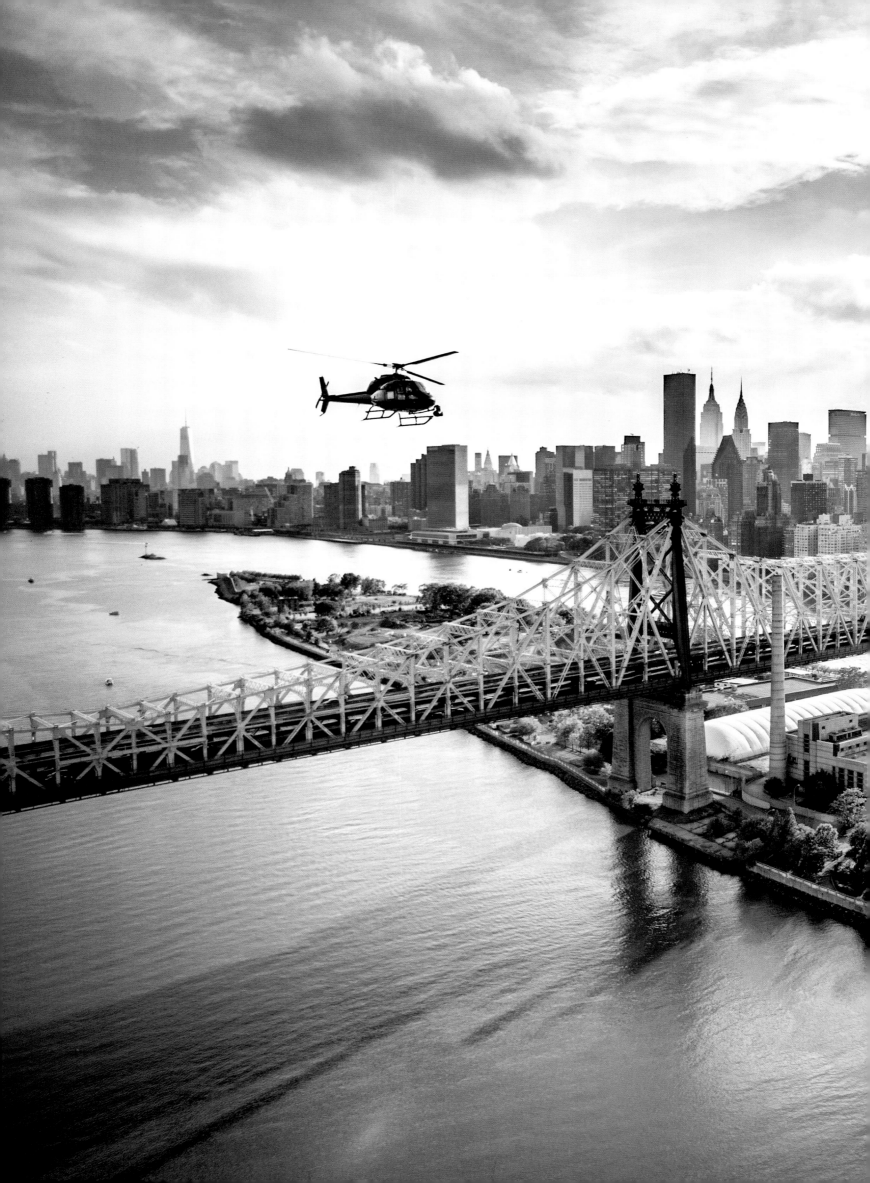

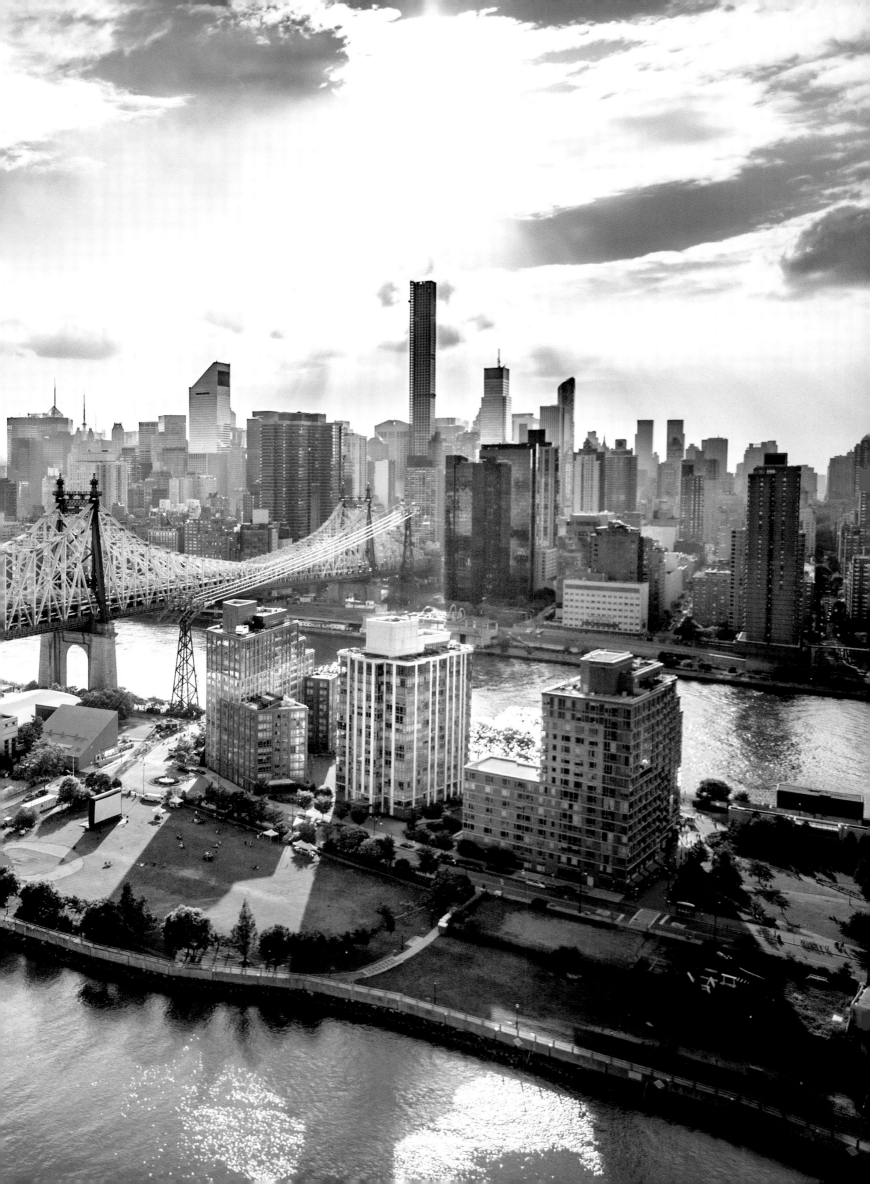

The elegant and iconic Chrysler Building, completed in 1929, may be New York's favorite; its striking silvered Art Deco design whorls and flourishes are unrivaled—and to some extent reflect the decorative elements of automobile styling and grilles. The building was commissioned and personally paid for by the automobile manufacturer Walter Chrysler. When finished in 1929, it was the world's tallest building—but only until completion of the Empire State Building a year later.

The massive and unrelieved bulk of the MetLife Building (left), completed in 1963, dwarfs the neighboring Helmsley (1929) and Chrysler Buildings (1930), which were designed, built, and decorated in periods that reflected very different— and, to many visitors, very attractive—architectural aesthetics.

190 · 191 | A BLAZE OF LIGHT |

The twin spires of St. Patrick's Cathedral (bottom center) at Fifth Avenue and East 50th to 51st Streets orient this image. Rockefeller Center rises diagonally across from the cathedral; directly down Fifth Avenue, the illuminated upper section of the Empire State Building can be clearly seen; beyond, at the top of the image, the lit-up One World Trade Center rises. Lower left is a cluster of midtown high-rises, with the unmistakable Chrysler Building visible on 42nd Street.

192 · 193 | THE HIGHER, THE BRIGHTER… |

High-rise buildings along mid-Manhattan's central spine provide thrilling patterns of light, contrasting sharply with their less lit-up low-rise neighbors. This view is westward to New Jersey, with the gold-tipped Worldwide Plaza Tower (center right) rising at 50th Street and Eighth Avenue.

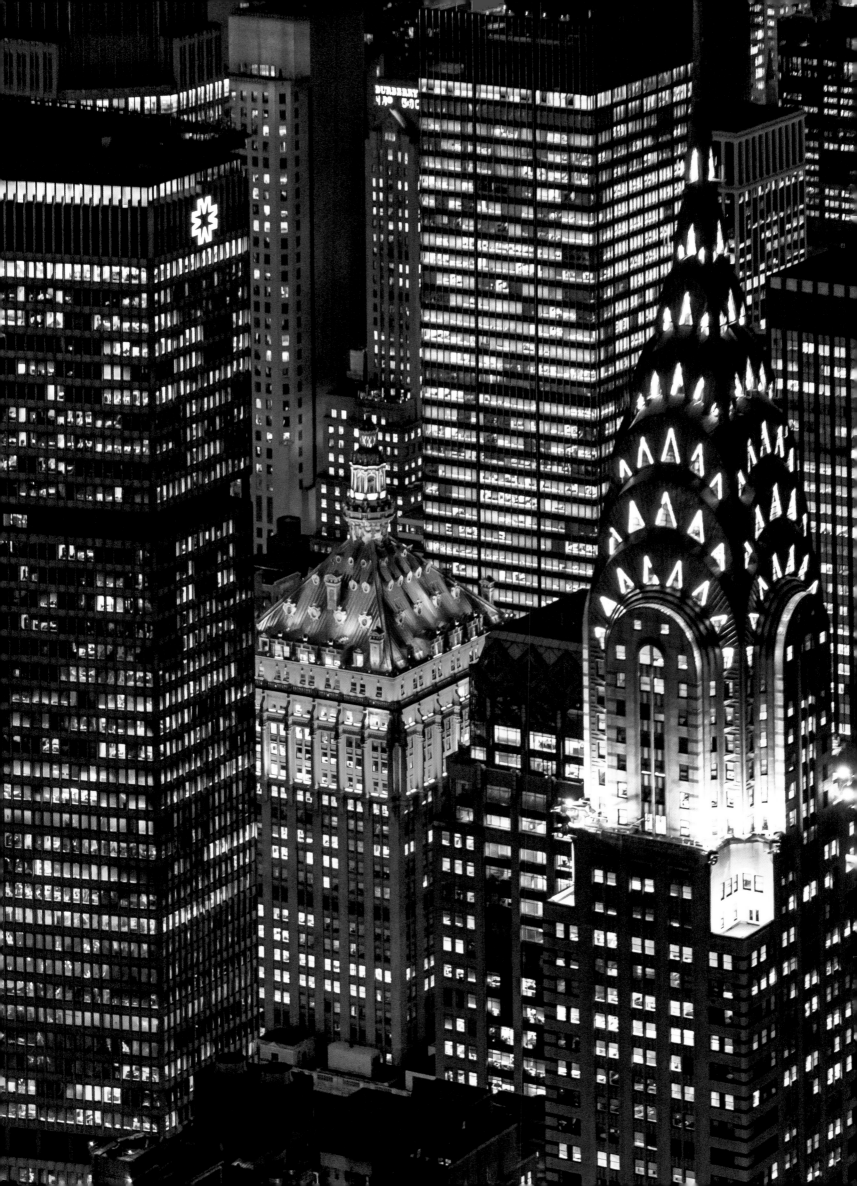

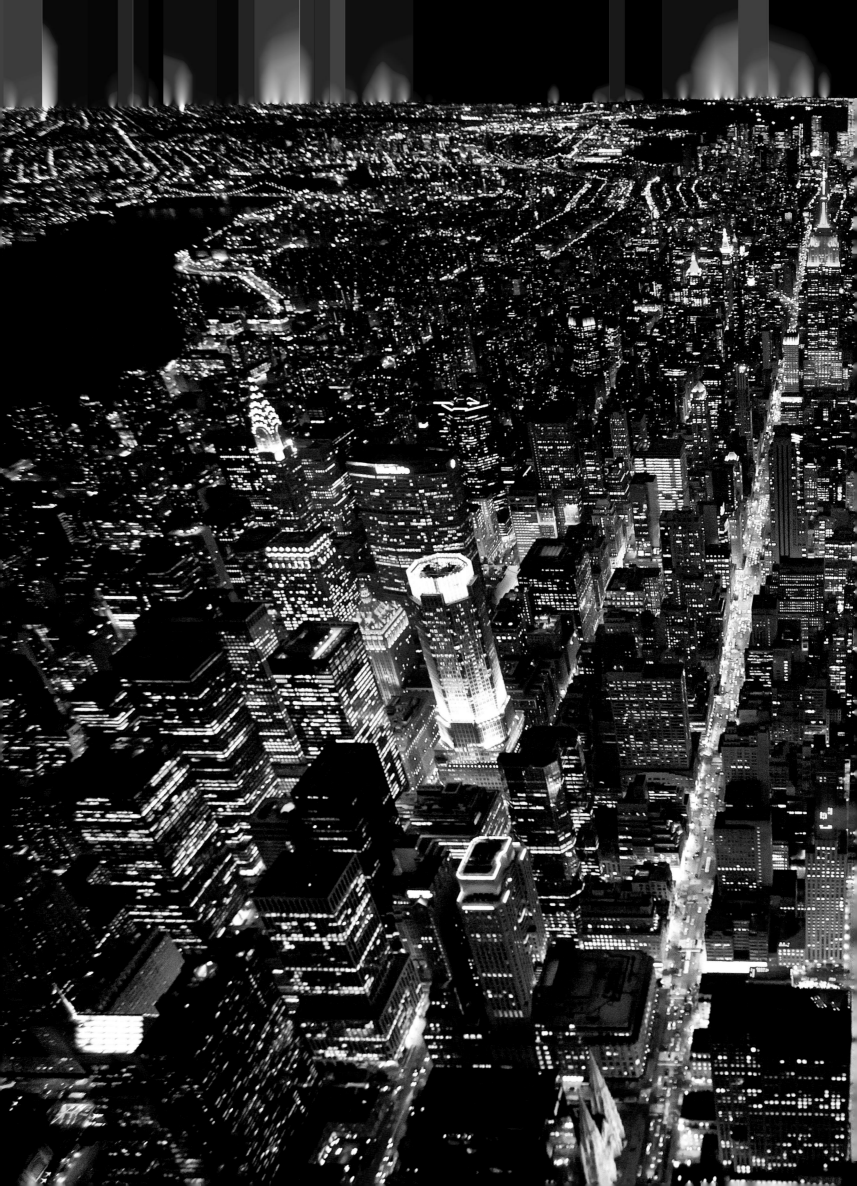

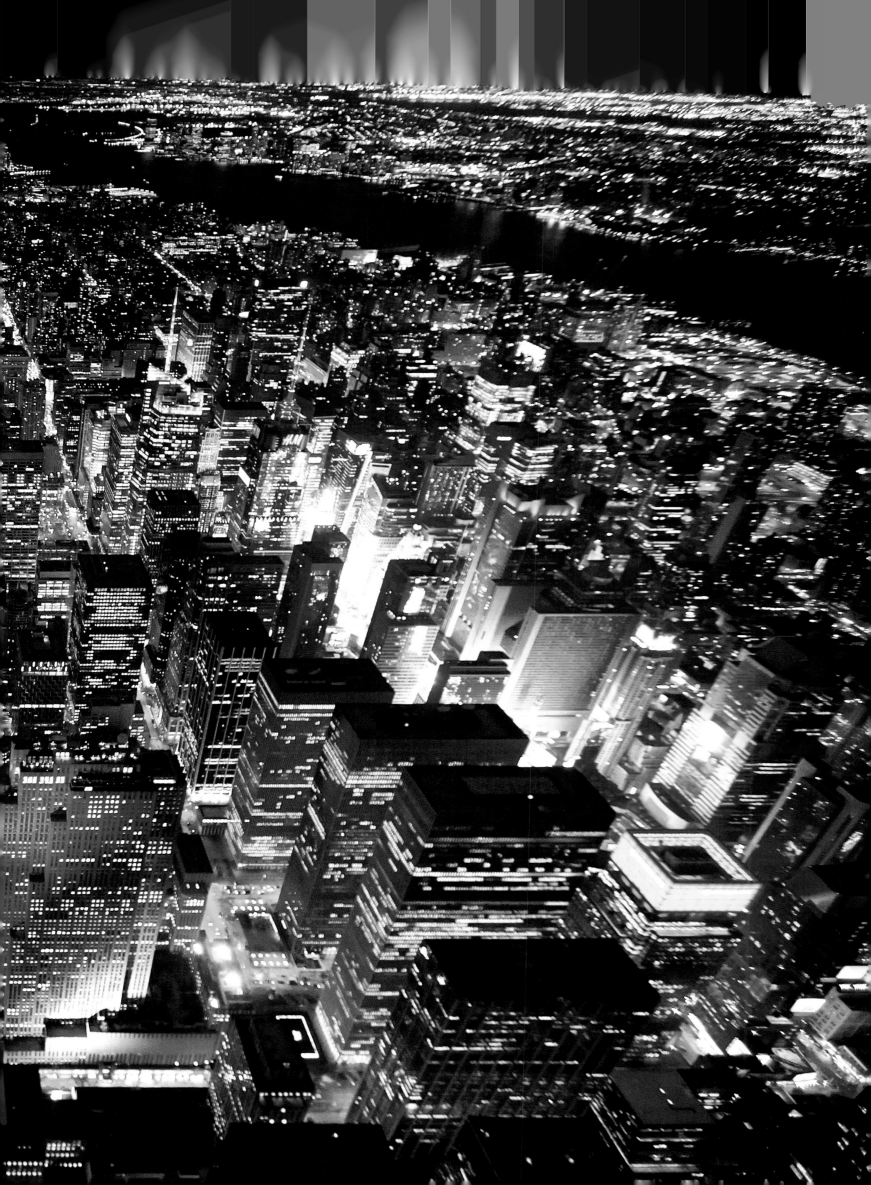

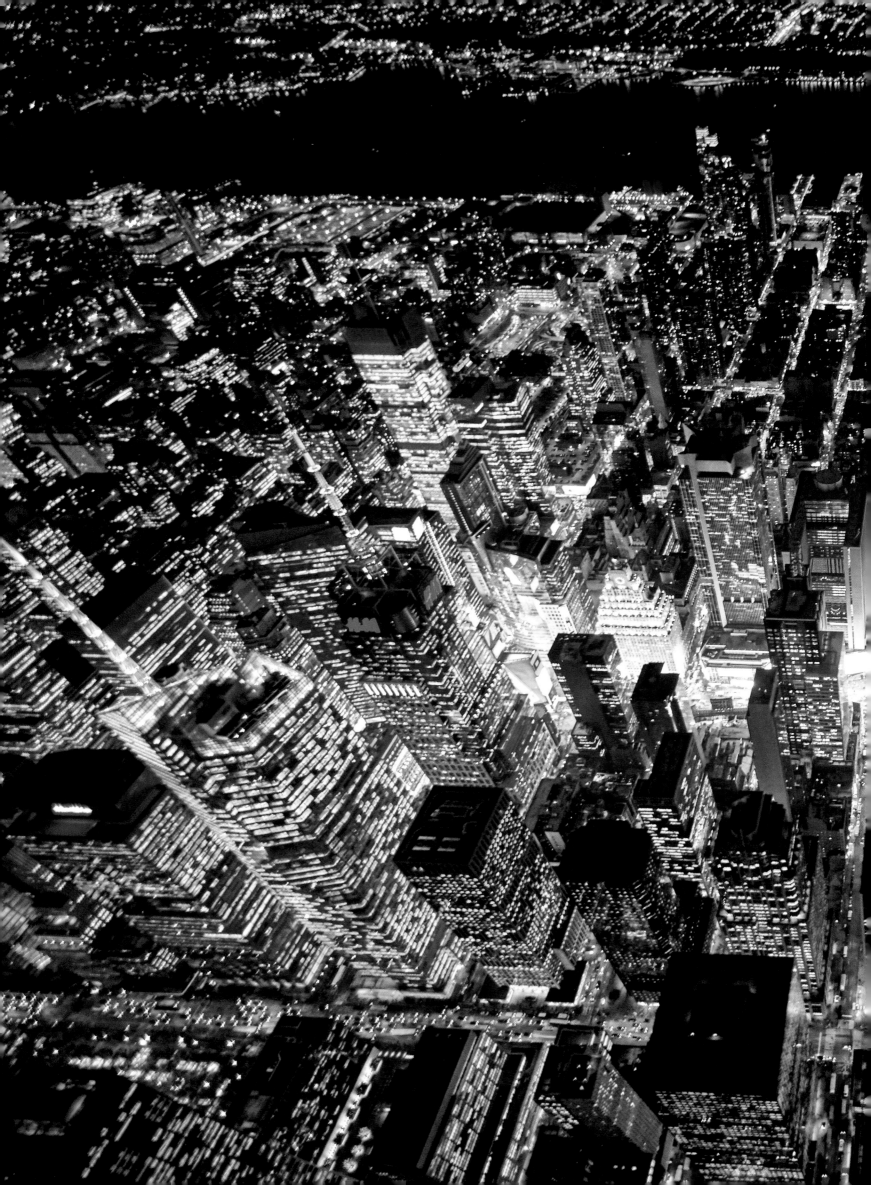

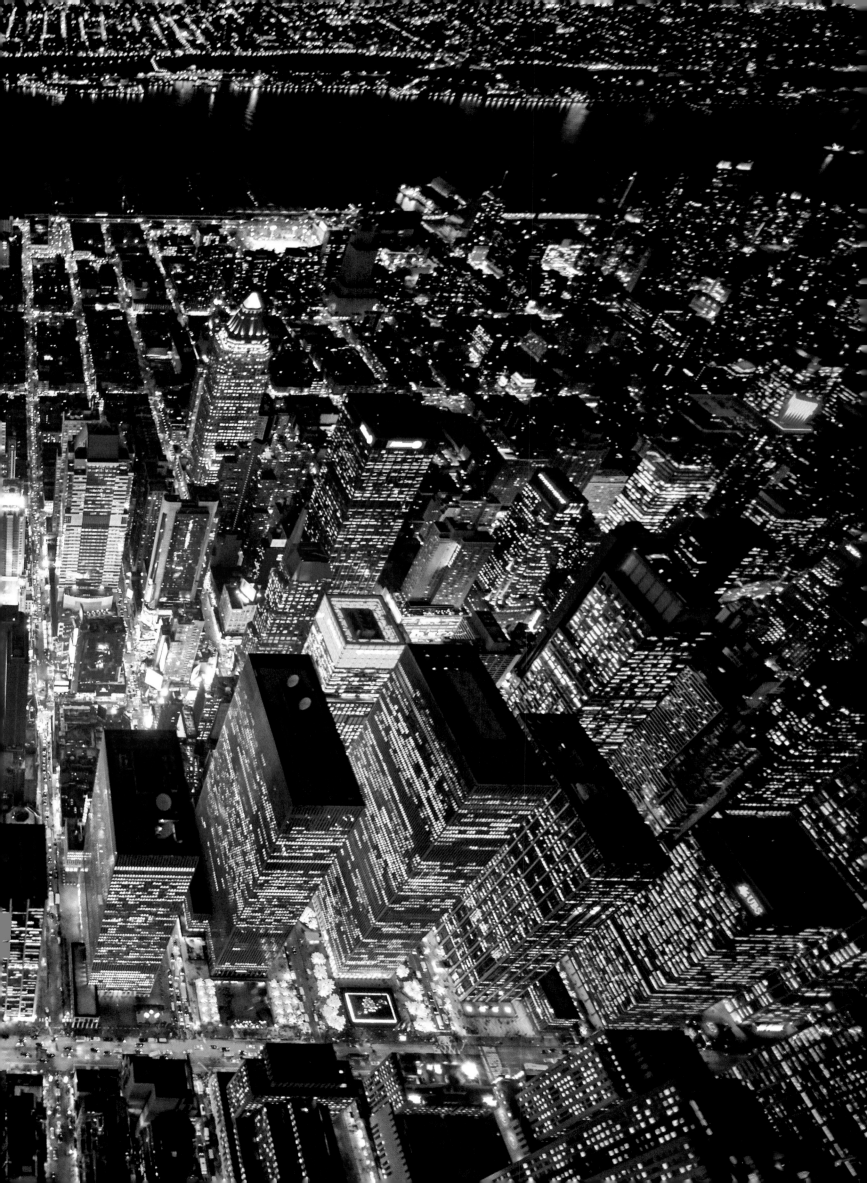

Times Square by night—to millions of tourists it is the unforgettable "City of Light" and entertainment. Bottom right is the new H&M Building, an "anchor" of the recently redeveloped shopping mecca of 42nd Street; the white-light vertical building (center) is the old One Times Square building.

196 | LIFE ON THE MOVE |

Times Square creates its own microclimate: crowds, color, and enthusiasm give it a life of its own—pepped up by an array of theaters, movie houses, and hotels. Major movie or theater premieres or events brings thousands of have-a-good-time pleasure seekers. Saturday nights in summertime bring in tens of thousands—and for millions among New York's annual 55 million tourists Times Square is a must. How everybody gets into a chosen show remains a mystery, but somehow they do.

197 | TAKING THE PULSE |

Navigating Times Square's array of beckoning entertainments takes time and energy—and it's best to know in advance the exact block or street corner on which a friend is anxiously waiting. But many people go, as they say, "to feel the buzz," not knowing what experiences or adventures might await within the ten-block triangle. The square is an open social forum—but with a friendly atmosphere. And, as there is a U.S. Army recruiting station, other adventures can be sought.

198 · 199 | TIMES SQUARE |

New additions to the Times Square area are far from staid—but lit up and exhilarating. New hotels, like Hotel W, are among them. But it is street-level lighting that makes the magic: huge lit-up billboards advertising shows; wall-sized, multicolored, moving-light advertisements on cinema façades and on hotel and shop signs—but always color and movement. It is noteworthy that new buildings adopt new technologies; witness the immense solar panels on the building on the left.

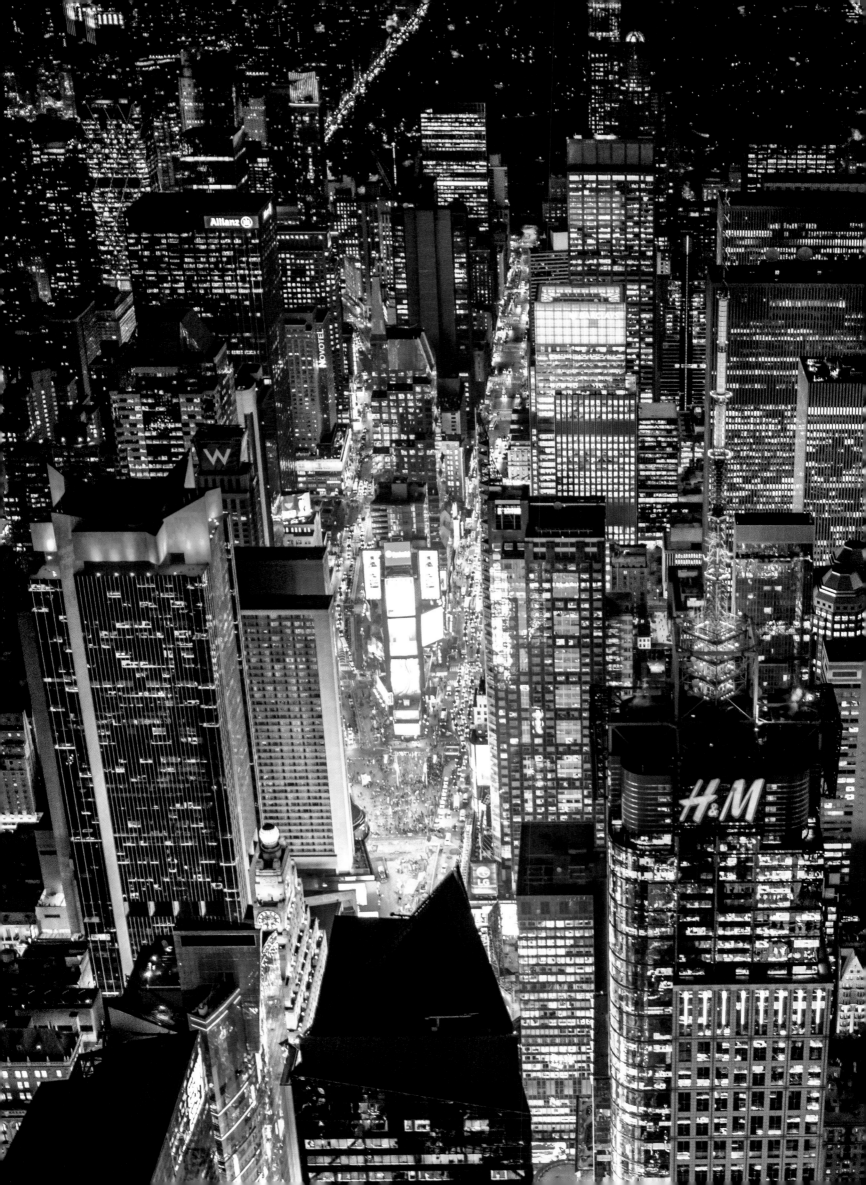

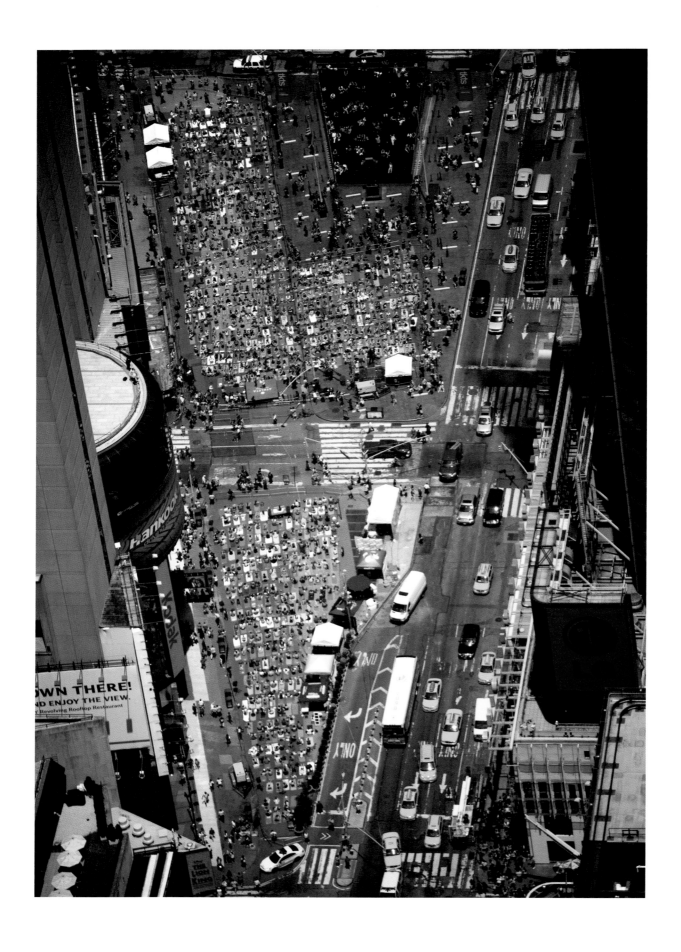

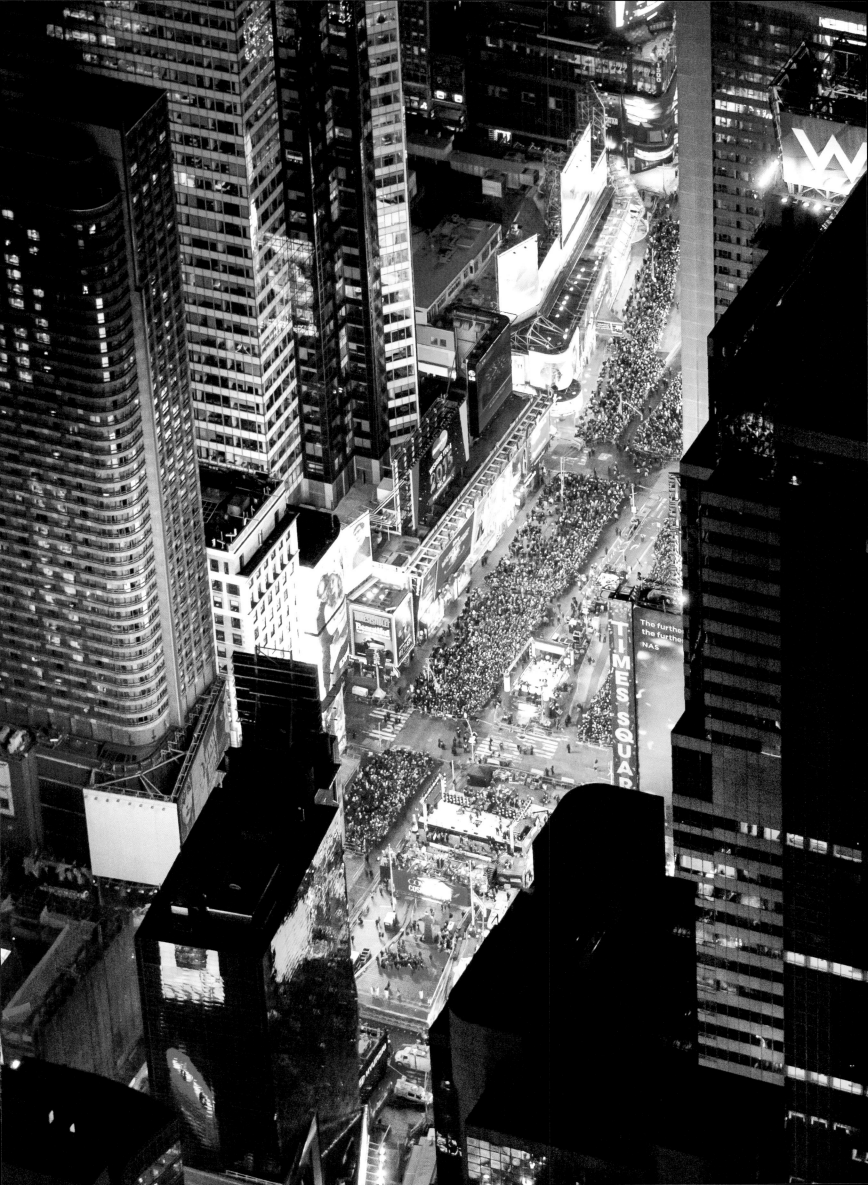

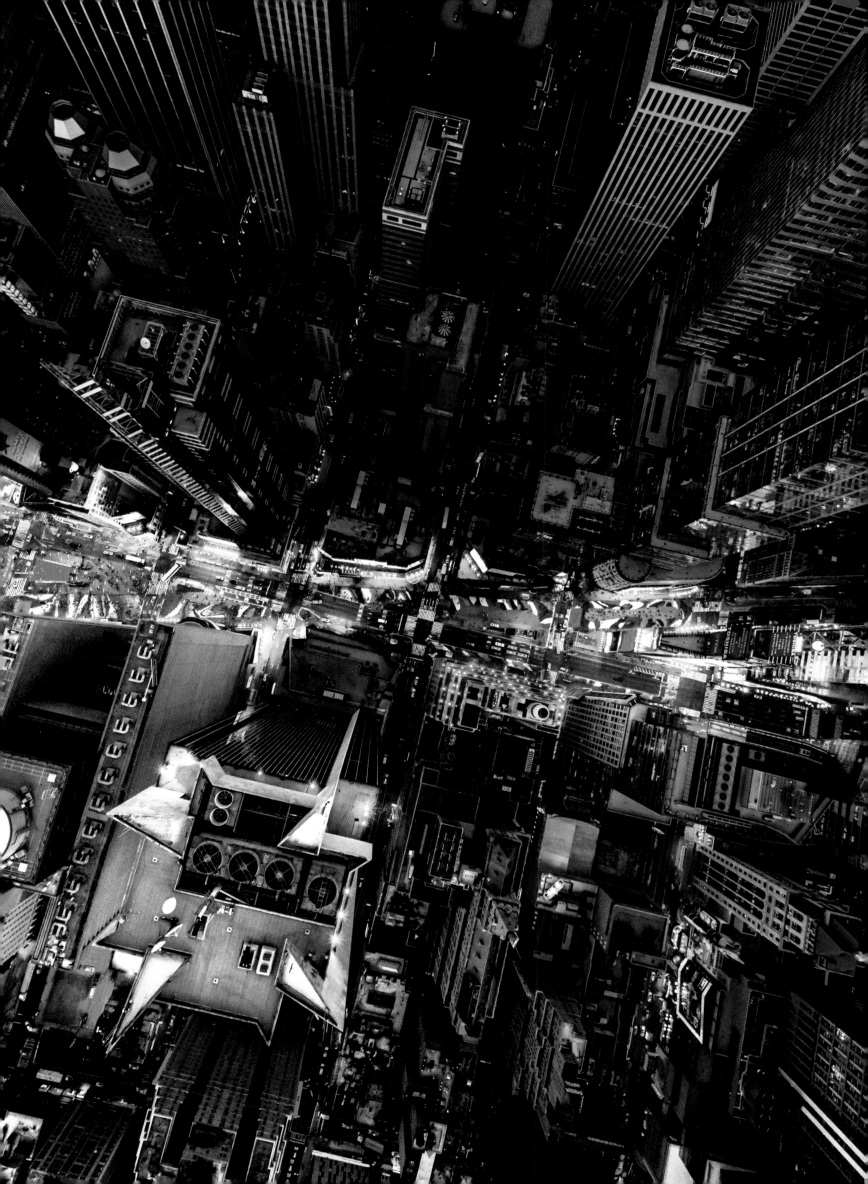

| 432 PARK AVENUE |

Topping out at 1,396 feet, this eighty-five-story high-rise at Park Avenue between 56th and 57th Streets is the world's tallest residential tower, costing over $1.5 billion to build. It contains 104 condominium apartments, most ranging in price from approximately $20 to $95 million. Residents can truly claim uninterrupted views...

202 · 203 | ROOF STYLES |

Upper right is the unmistakable sloping roof and solar panels of the Citigroup Center at Lexington Avenue and 53rd Street. Since it was completed in 1977, many newer buildings have incorporated means of generating solar energy. The image shows the great variety of cross sections in what are basically shoebox towers. Top left, at 59th Street and Fifth Avenue, is the southeast corner of Central Park. Top right is the East River, with the residential Roosevelt Island in view.

204 · 205 | THE HEART OF MIDTOWN... |

Rockefeller Center, looking from the historic Fifth Avenue frontage and classic older buildings toward Sixth Avenue (the Avenue of the Americas), marked by an impressive array of unadorned steel-and-glass post-1950s office high-rises. The tallest building is 30 Rockefeller Plaza (upper right).

206 | AT THE HEART OF THE CITY |

30 Rockefeller Plaza, with its solid verticals, gives off an aura of strength and stability that makes its steel-and-glass neighbor to the right seem somewhat fragile. In many ways, at the time of its construction during the Depression of the 1930s, the center reflected John D. Rockefeller, Jr.'s confidence in America's economic future. The architectural unity of the fourteen original buildings adds to the center's cohesion and to its projection of unity, strength, and permanence.

207 | INVITING THE PUBLIC |

Despite its powerful presence, 30 Rockefeller Plaza is far from forbidding, as this colorful and welcoming scene shows. Year-round, the colorful plantings flanking the central mall, the quality shops, and the sunken plaza draw visitors, providing a retreat from expensive shopping on busy Fifth Avenue. In winter, the sunken plaza becomes a skating rink, and the great Christmas tree a site for carolers. Nearby stores vie in brilliant window displays during the holiday season.

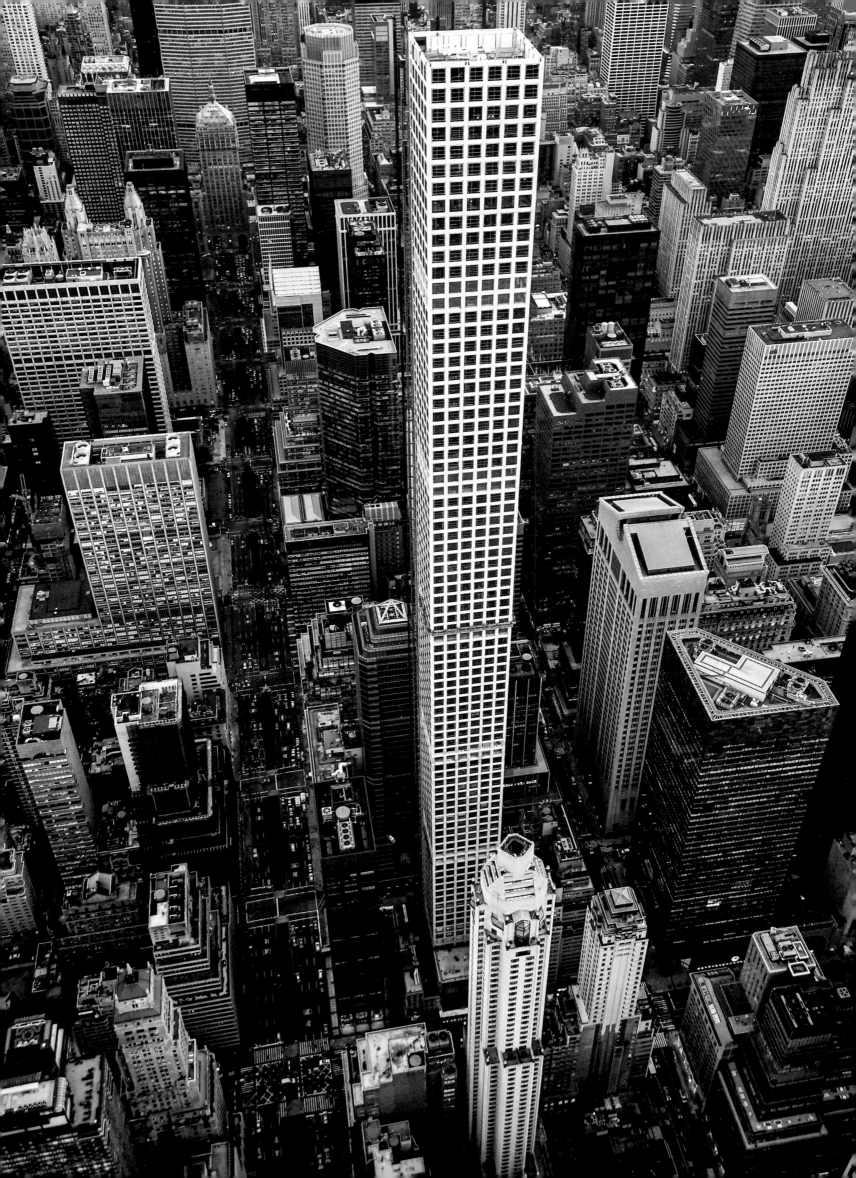

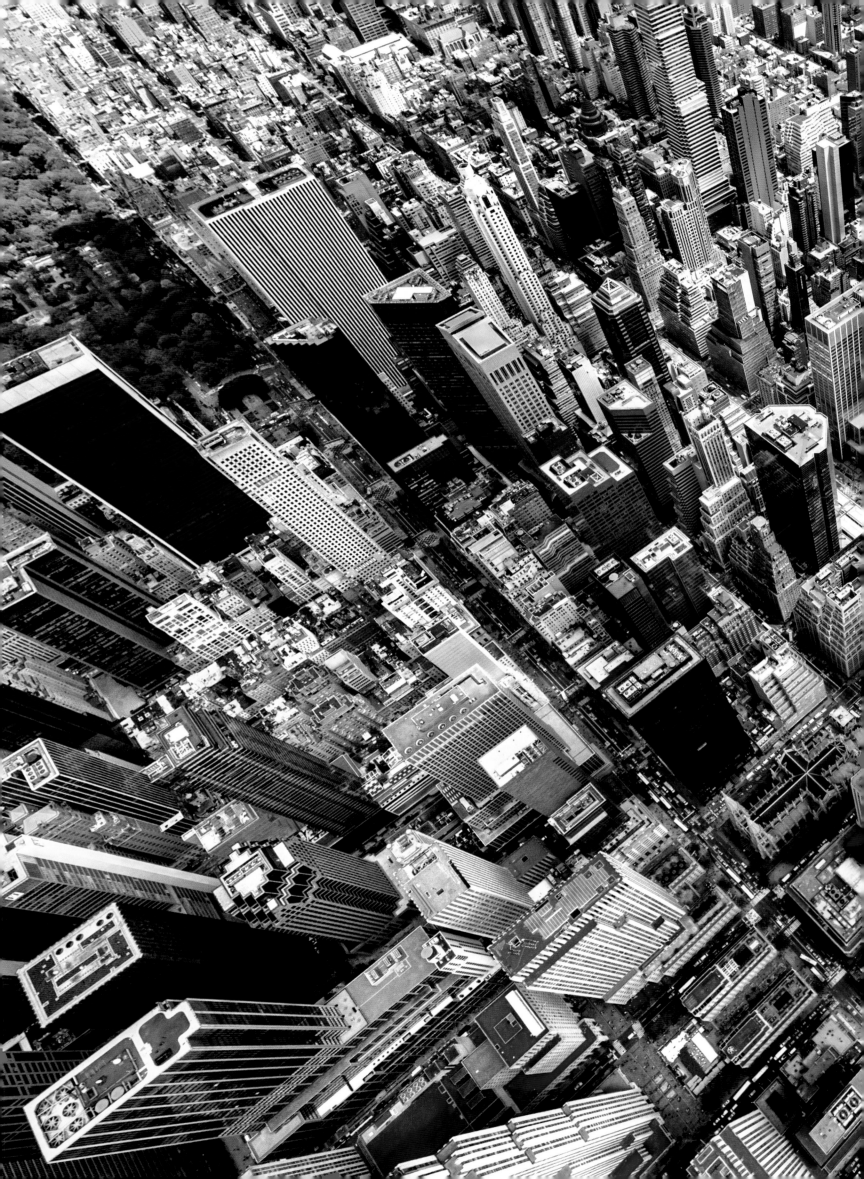

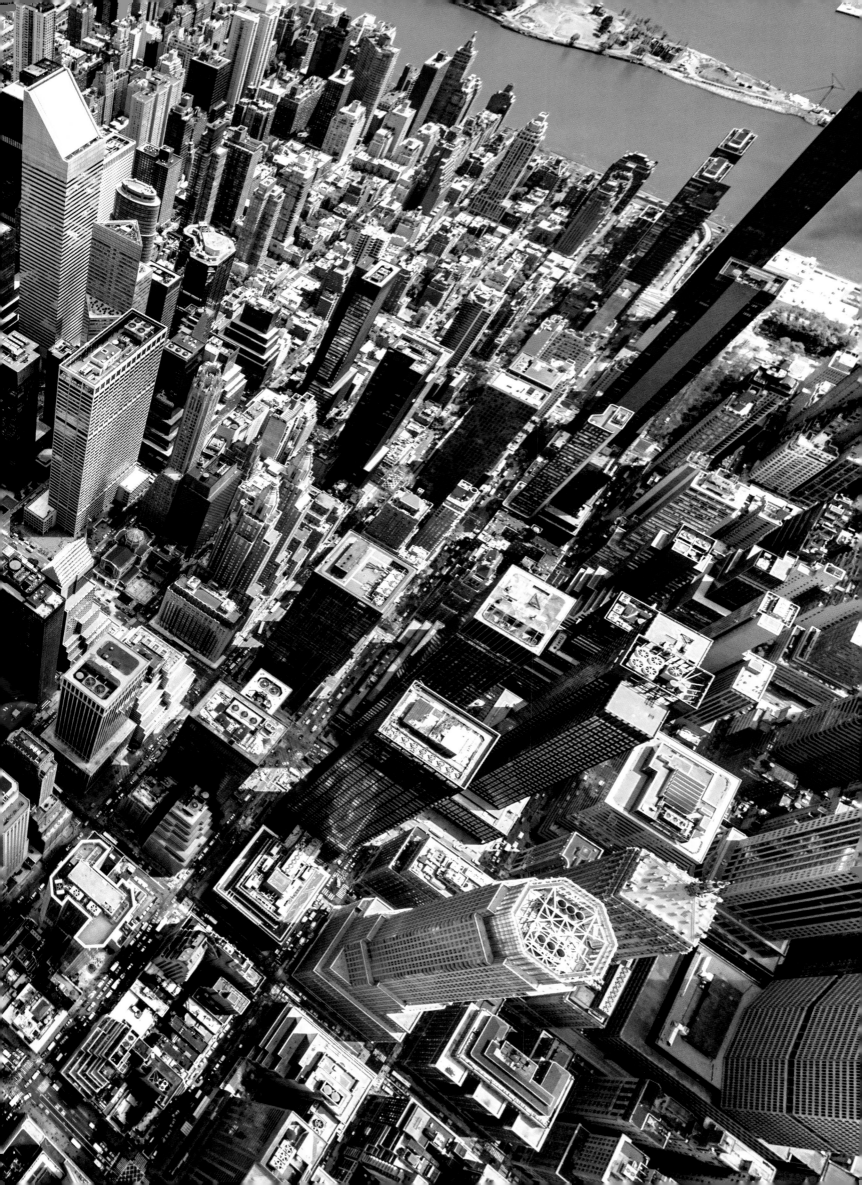

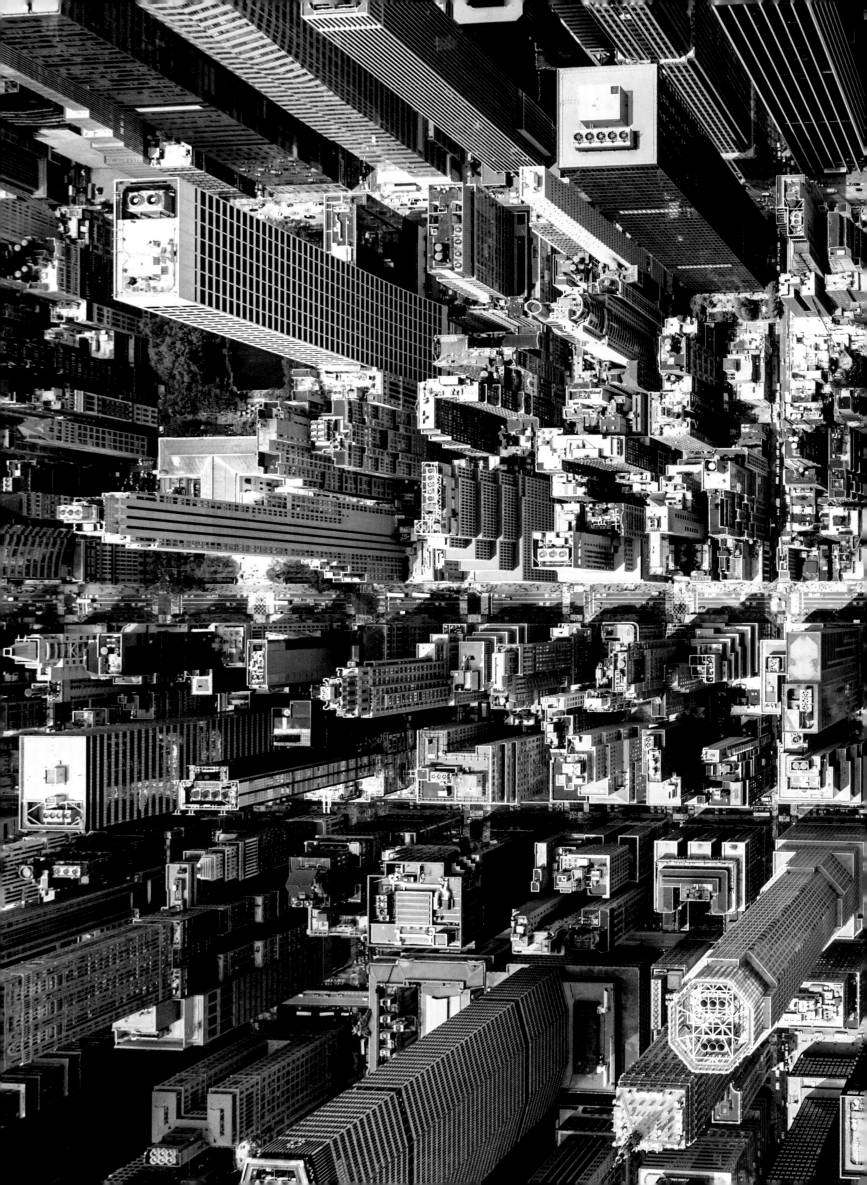

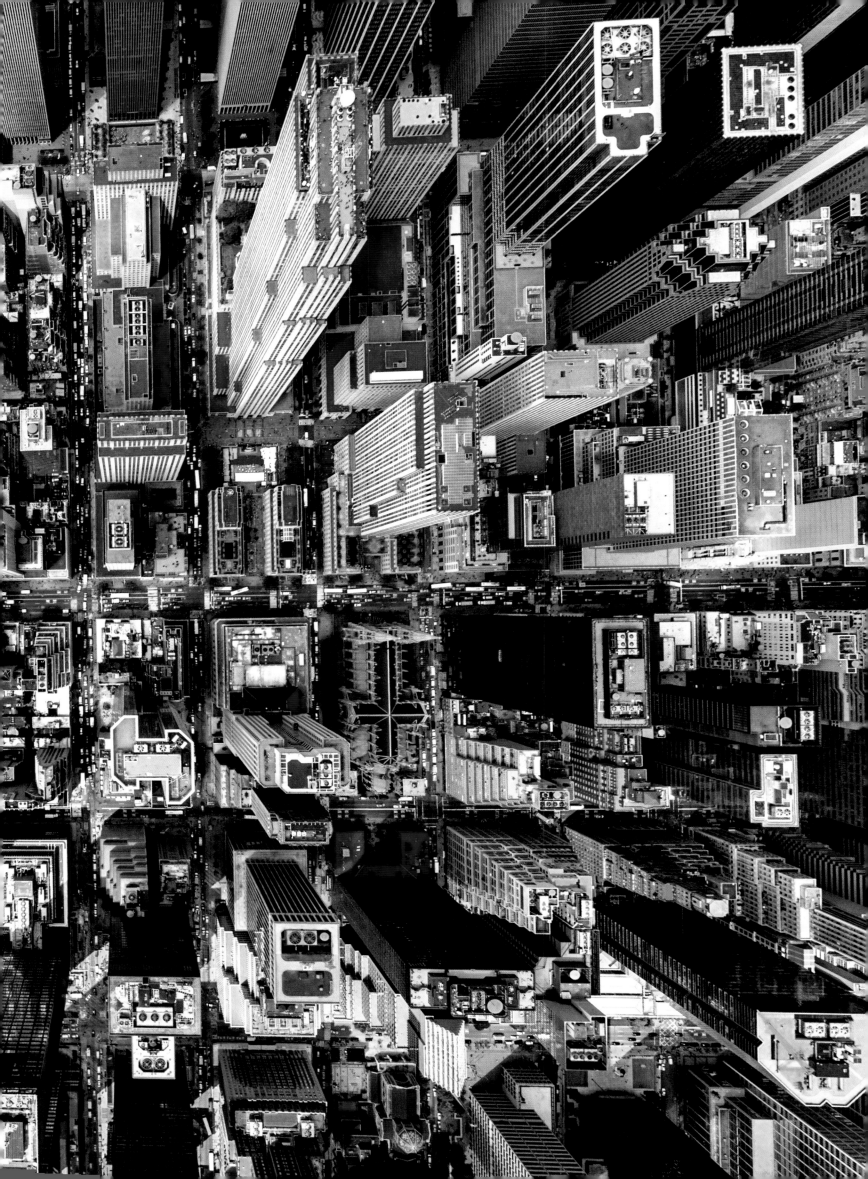

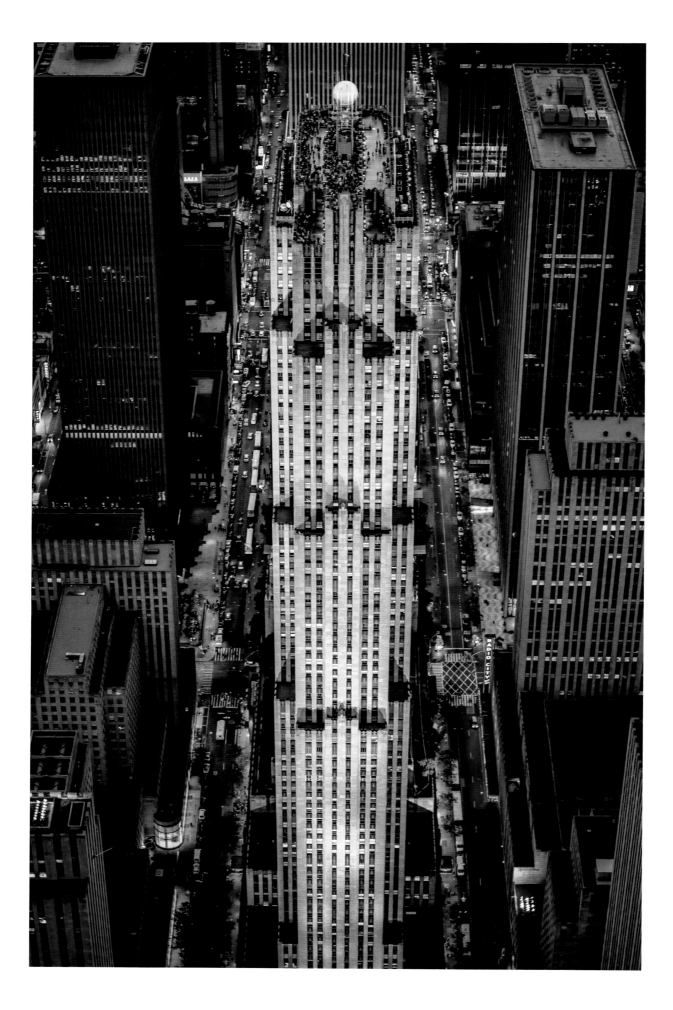

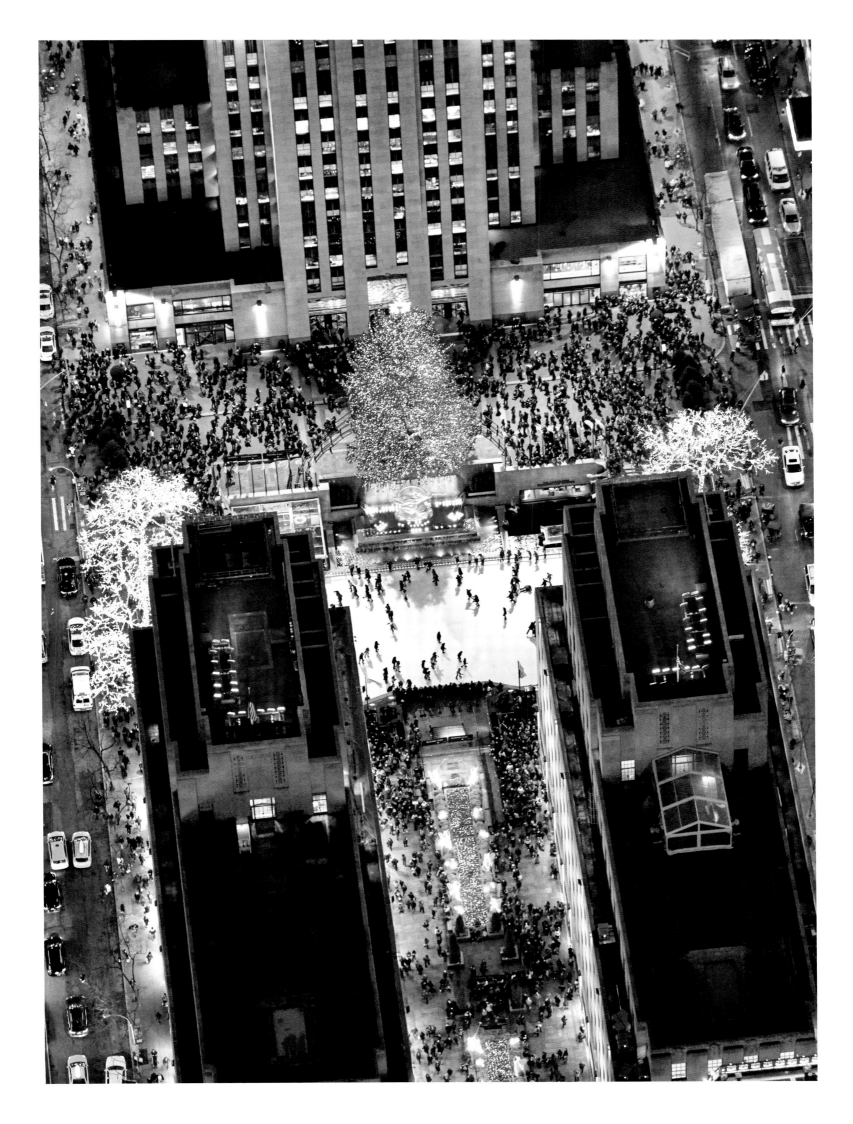

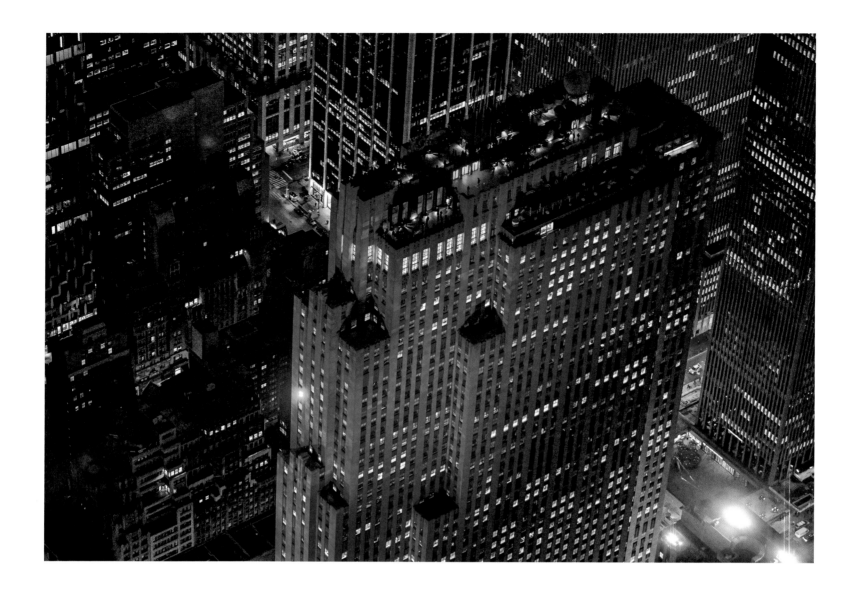

| QUEEN OF THE NIGHT I |

The upper levels of 30 Rockefeller Plaza brilliantly
illuminated with blue light. The building's elegant
entry mall from Fifth Avenue and relatively nar-
row façade, together with its vertical lines and
setbacks, carry the eye upward. It is easy to miss
the building's significant rearward depth.

| QUEEN OF THE NIGHT II |

This image of the totally blue-lit Helmsley Build-
ing (1929) clearly shows the twin elegantly arched
tunnels at street level; these accommodate the
northward and southward traffic lanes of Park
Avenue. Behind rises the MetLife Building (1963),
whose great breadth blocks the once-classic view
along Park Avenue.

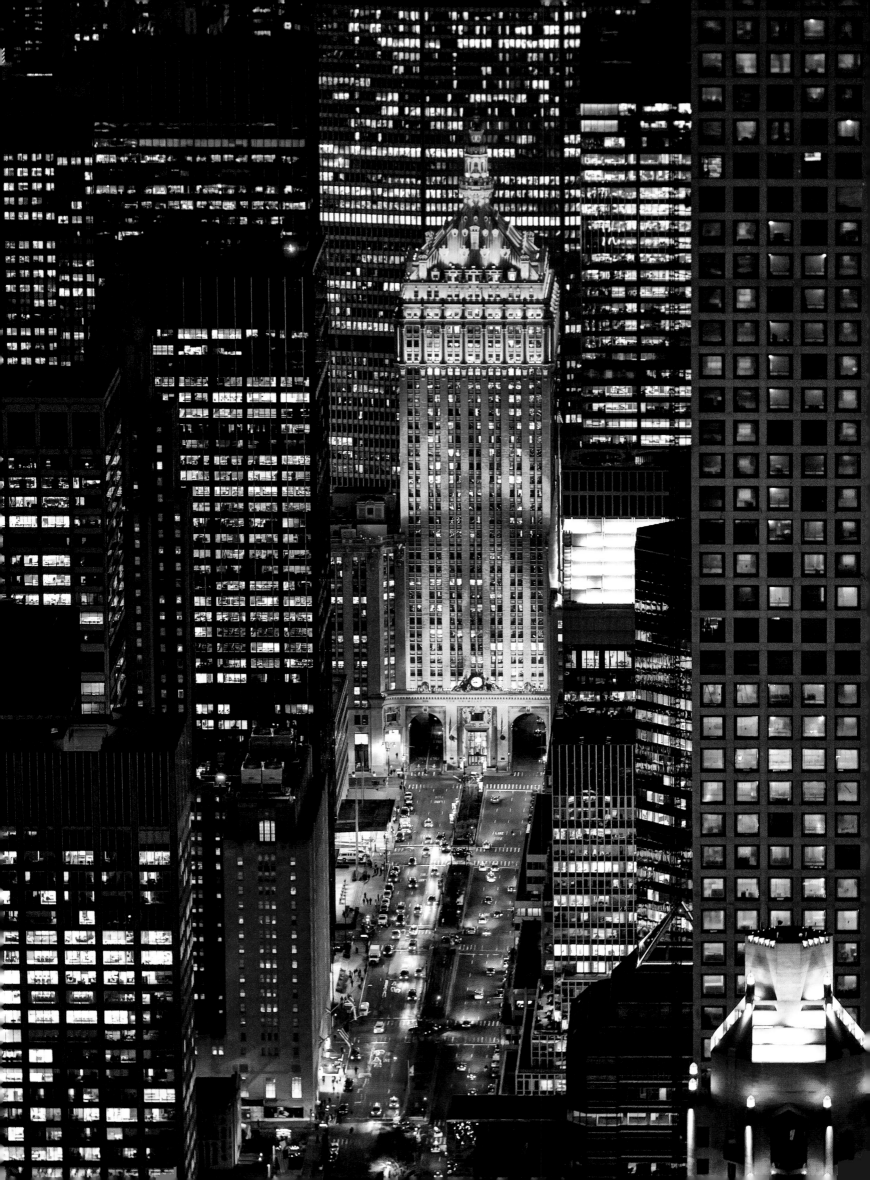

The *New York Times* spent from 1904 to 1913 head-quartered in Times Square, before moving to West 43rd Street, from where it moved in 2007 to its present building.

"All the news that's fit to print" has long been a proud claim of the newspaper. The paper has always been a worldwide leader in in-depth reporting, but is also reinventing itself not only with additional comprehensive reporting but also in offering "behind the news" access and many other digital sites and services.

The Hearst Tower won a U.S. Green Building Council Gold certification rating for its pro-environment features. New technologies resulted in savings of about 20 percent in the tonnage of steel used, while new technologies and materials in ventilating and air conditioning resulted in great energy savings. Overall, the building's energy use is more than 25 percent less than the city's required limit. The building is a hybrid in that a new tower stands on a six-story base "mothballed" in 1930.

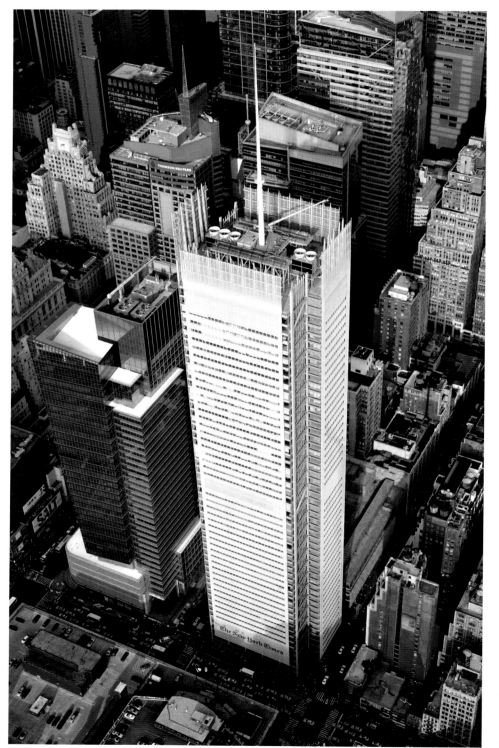

212 · 213 | CONGESTION AND CALM |

Columbus Circle, where Broadway and Eighth Avenue converge, marks the southwest corner of Central Park, with its grand entry plaza. Visible top right is the former Gulf and Western building (now a hotel); in the center is the silvery-gray façade of the Time Warner Center, and a slender new high-rise is to its left. The small trapezoidal building in front, once termed "Venetian pastiche" in design, escaped demolition and was remodeled to become the Museum of Arts and Design.

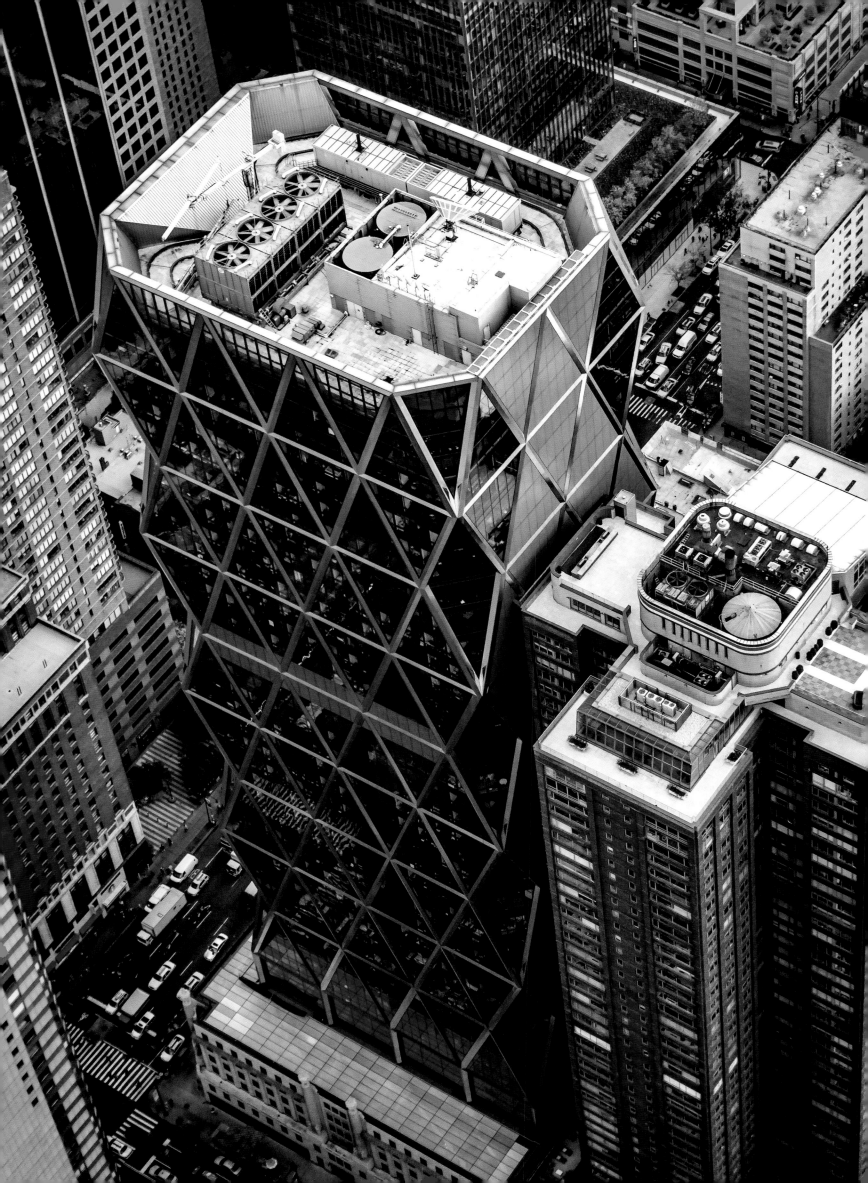

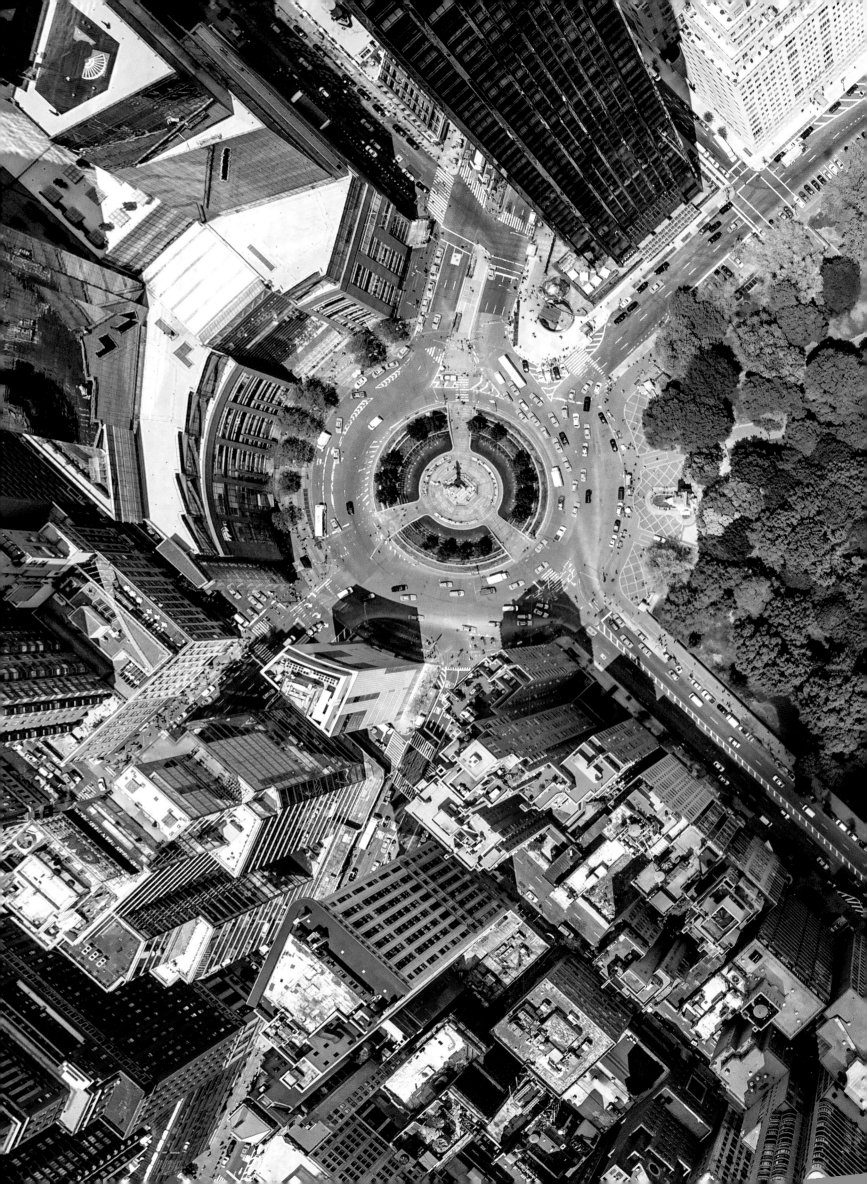

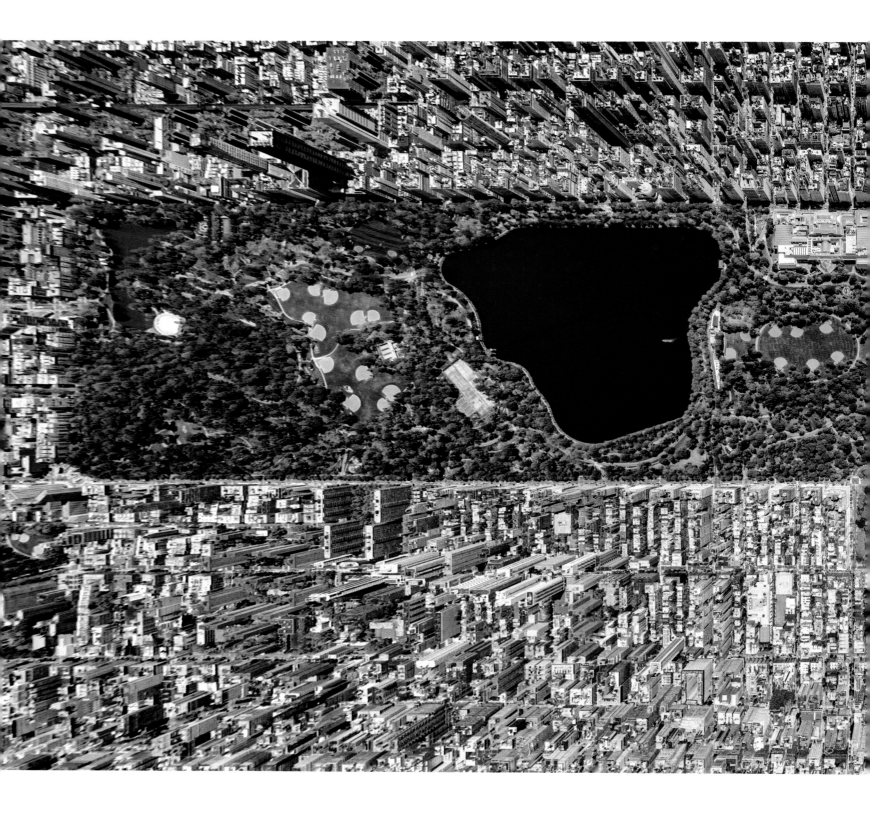

| A MIGHTY GREEN LUNG… |

Central Park, a much-loved and widely admired world-class oasis of verdant calm, extends from 59th Street (to the right) up to 110th Street and from Fifth Avenue over to Central Park West (Eighth Avenue). Harlem Meer, the Reservoir (center), and the Lake are all flanked by popular tree-shaded walks.

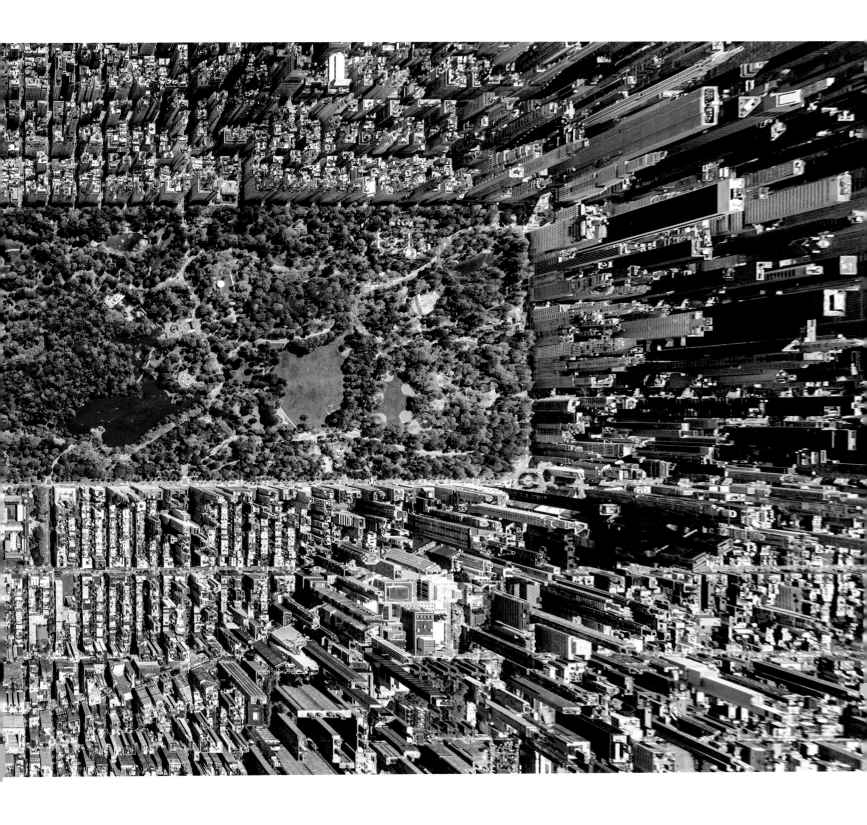

The Metropolitan Museum of Art is the largest structure within Central Park, and its massive size—boosted by extensions to increase gallery and exhibition space—make for an extensive footprint. The buff-colored baseball courts maintained for public use make a striking contrast with the surrounding green turf, as does the dark blue of the Reservoir. Those fortunate enough to live in the grand Fifth Avenue apartment buildings enjoy unrivaled natural amenities.

218 · 219 | LEAVING MANHATTAN… |

An unusual highly foreshortened view of Central Park looking northeast from the Harlem Meer (bottom right) toward Harlem (left). At the top can be seen the Triborough Bridge complex, linking Manhattan via Randalls and Wards Islands to Queens and to the Bronx (upper left). Both islands offer popular sports facilities.

220 · 221 | WINTER SCENE |

This view is looking south, with Fifth Avenue at the left, and at the far left the East River. On the right is Central Park West, with the Hudson River visible at the extreme right. The building center top is one of the new super-slender apartment towers, constructed on small but available building lots. The upper floors offer superb views for those not afraid of heights. The straight-line Mall and the Bethesda Fountain can be made out; what shows more clearly is the extensive network of smaller paths.

222 · 223 | METLIFE STADIUM |

The MetLife Stadium, located not in New York City but in the Meadowlands, East Rutherford, New Jersey, is home to the New York Jets and New York Giants of the National Football League. It opened in 2010 and cost $1.6 billion—the most expensive stadium ever built. Most New York supporters of either team have to cross the Hudson River to get to the stadium. Most drive, thus the immense parking lots. MetLife Insurance Company paid a large sum to secure the "naming rights" to the stadium.

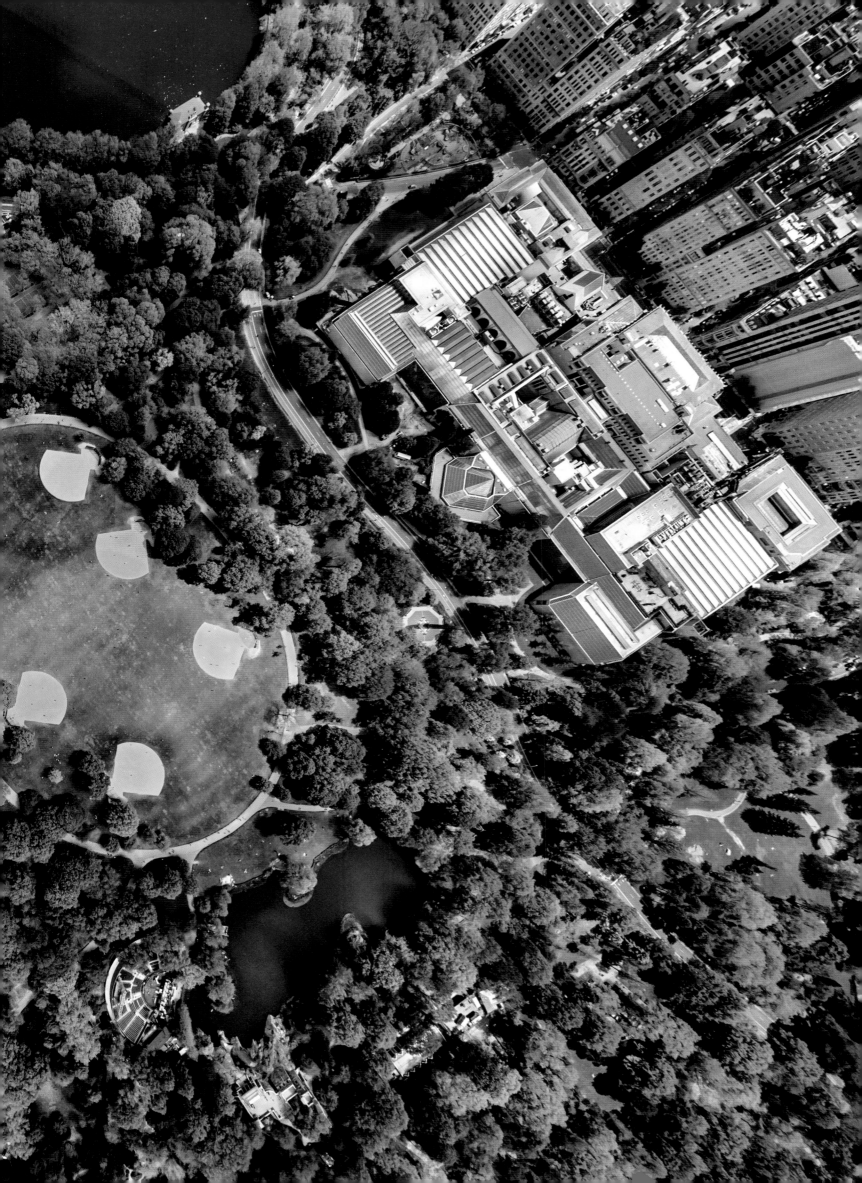

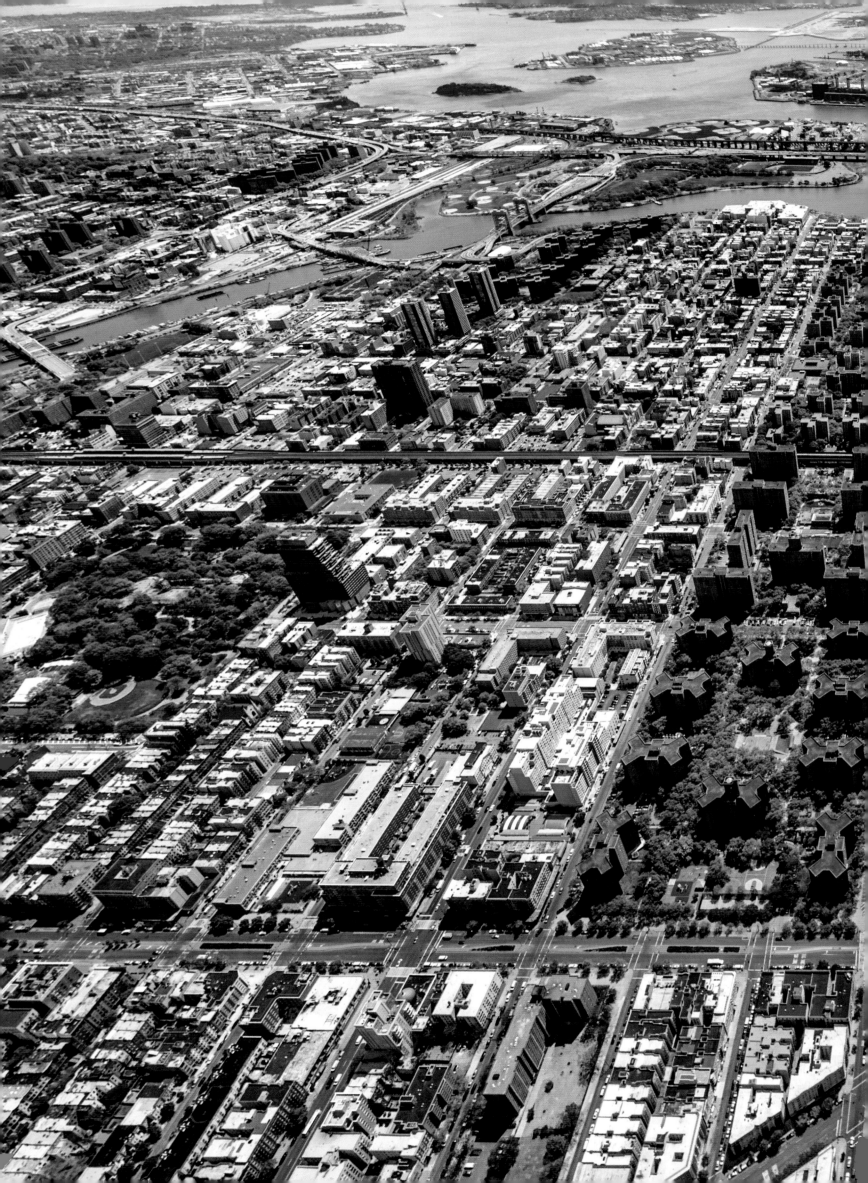

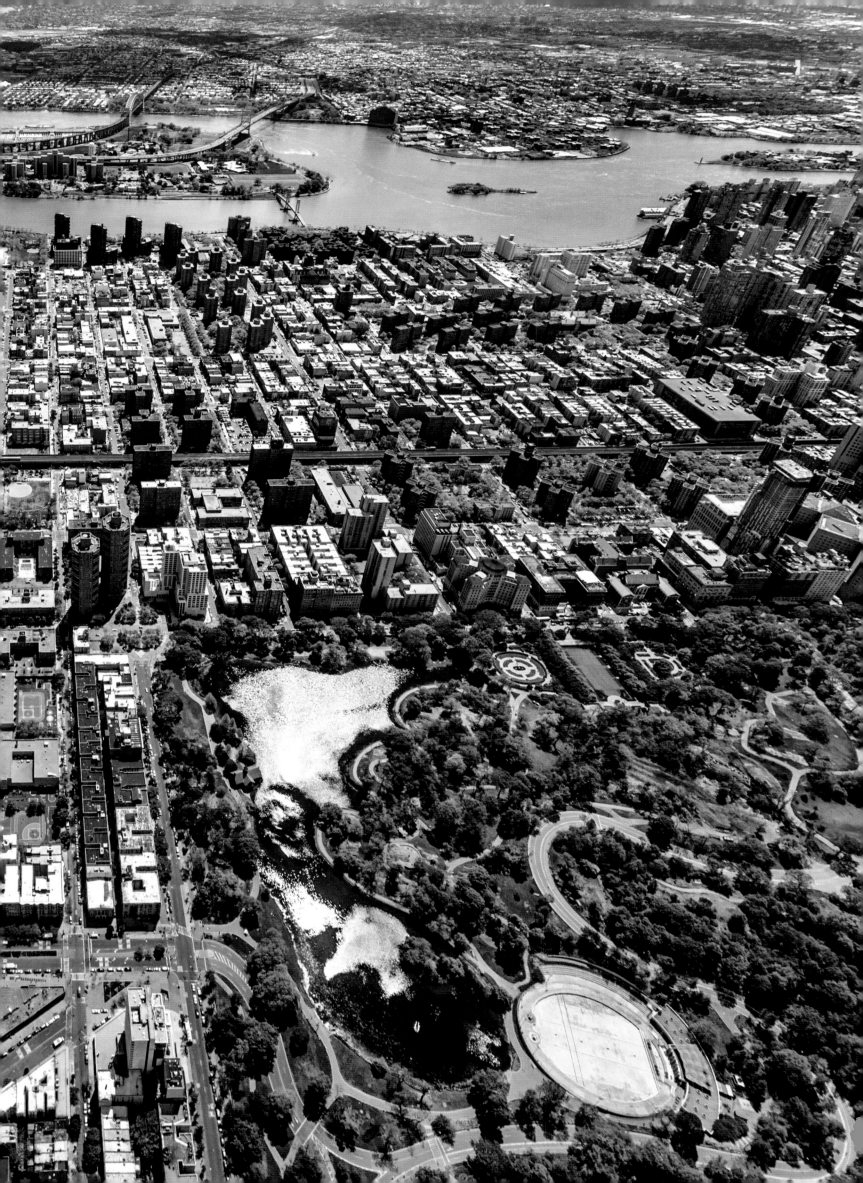

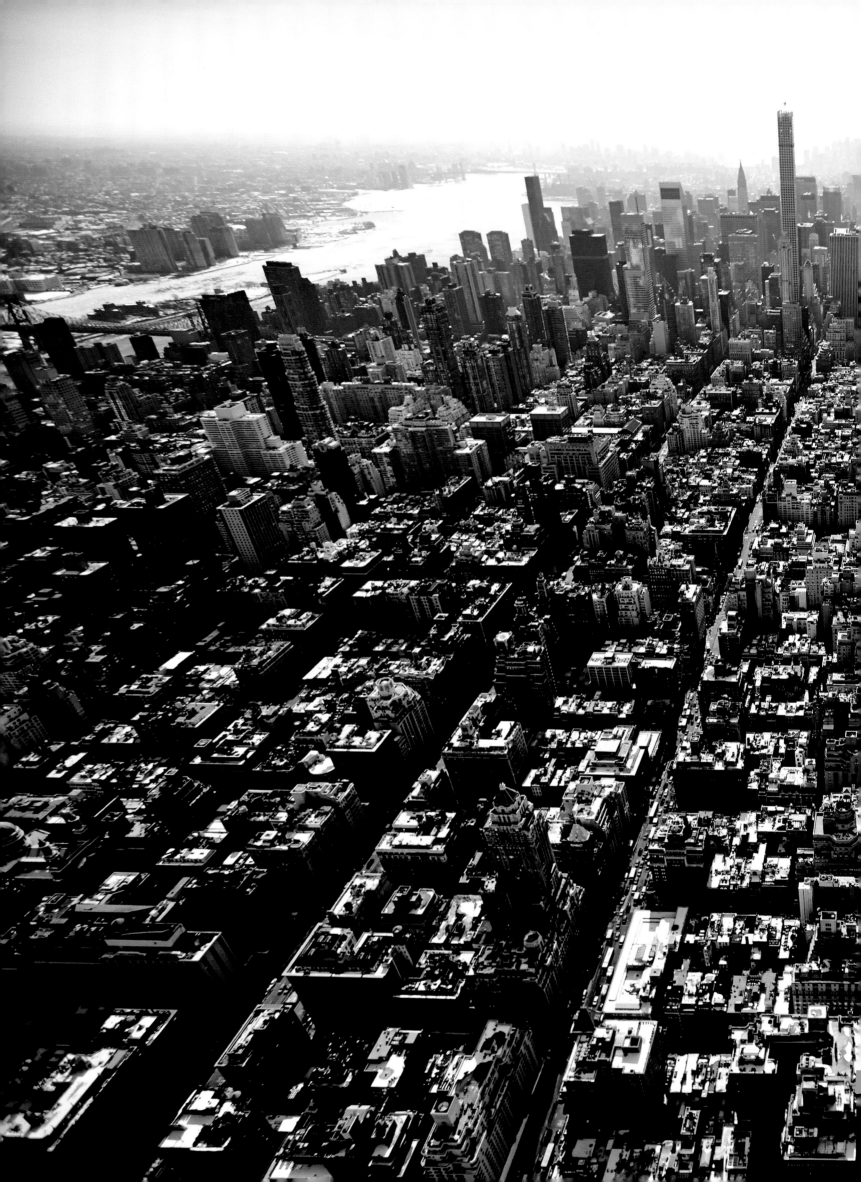

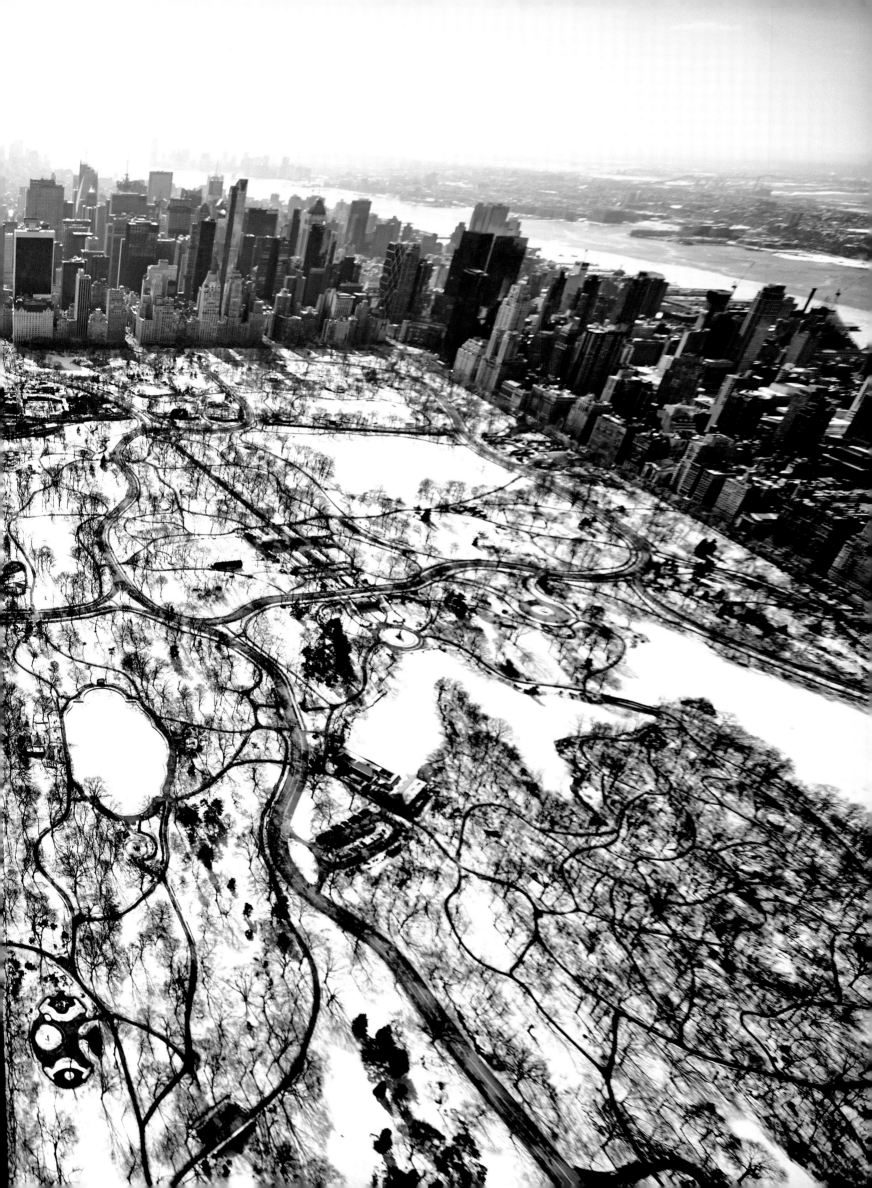

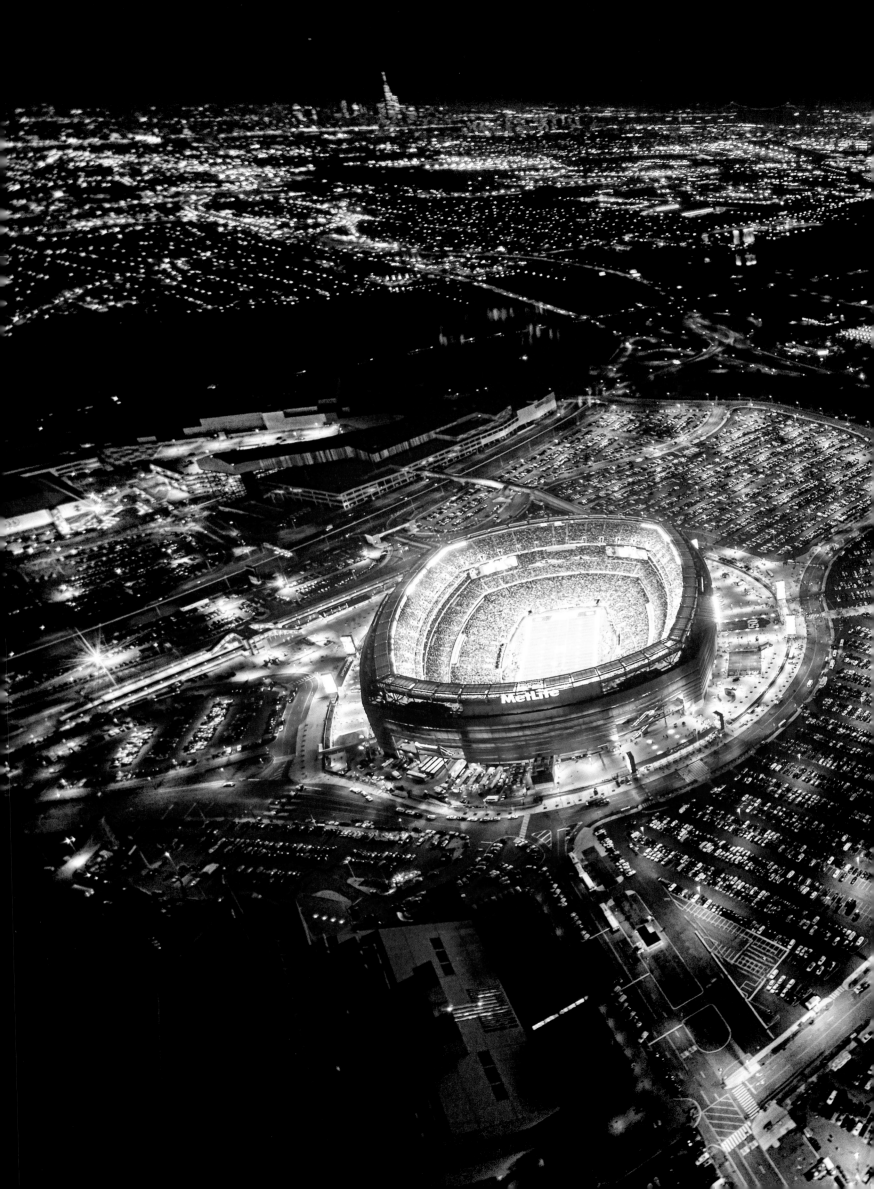

This handsome clean-lined bridge, opened in 1964, is New York's largest (followed by the George Washington Bridge), and spans the Narrows, the waterway between New York's Upper and Lower Bays, connecting Staten Island and Brooklyn. Its total length is 13,700 feet, with a central section of 4,260 feet, which is 693 feet above the water. The bridge's annual "day in the sun" is the first Sunday in November, Marathon Day, when over 52,000 marathoners stream over it.

226 | THE FIRST EAST RIVER BRIDGE |

The Brooklyn Bridge, looking west from Brooklyn toward Manhattan's Financial District. The bridge crosses (and connects with) the Franklin D. Roosevelt East River Drive (FDR Drive), which then follows Manhattan's East River boundary. The New Jersey shoreline can be seen at the top of the image.

227 | PILLARS AND PANELS |

The design of the Manhattan Bridge towers delights the eye. The contrasts between solid steel and lattice panels, the finials atop the tower, and the slender suspension cables result in an overall look of airy elegance. The towers rise 336 feet, and the bridge span is 6,855 feet. On the Manhattan side, inland of the towers, is a handsome, classical-style grand entry to the bridge that would have well suited a triumph-celebrating site in Italy at the height of the Roman Empire.

228 · 229 | THE FLOW OF GOODS… |

As these massive waterfront warehouses on the Brooklyn side of the Brooklyn Bridge suggest, the borough is heavily involved in shipping and distributing merchandise, but with less maritime activity. The area remains a vibrant and fast-developing mixed-use one, with residential and office buildings in evidence.

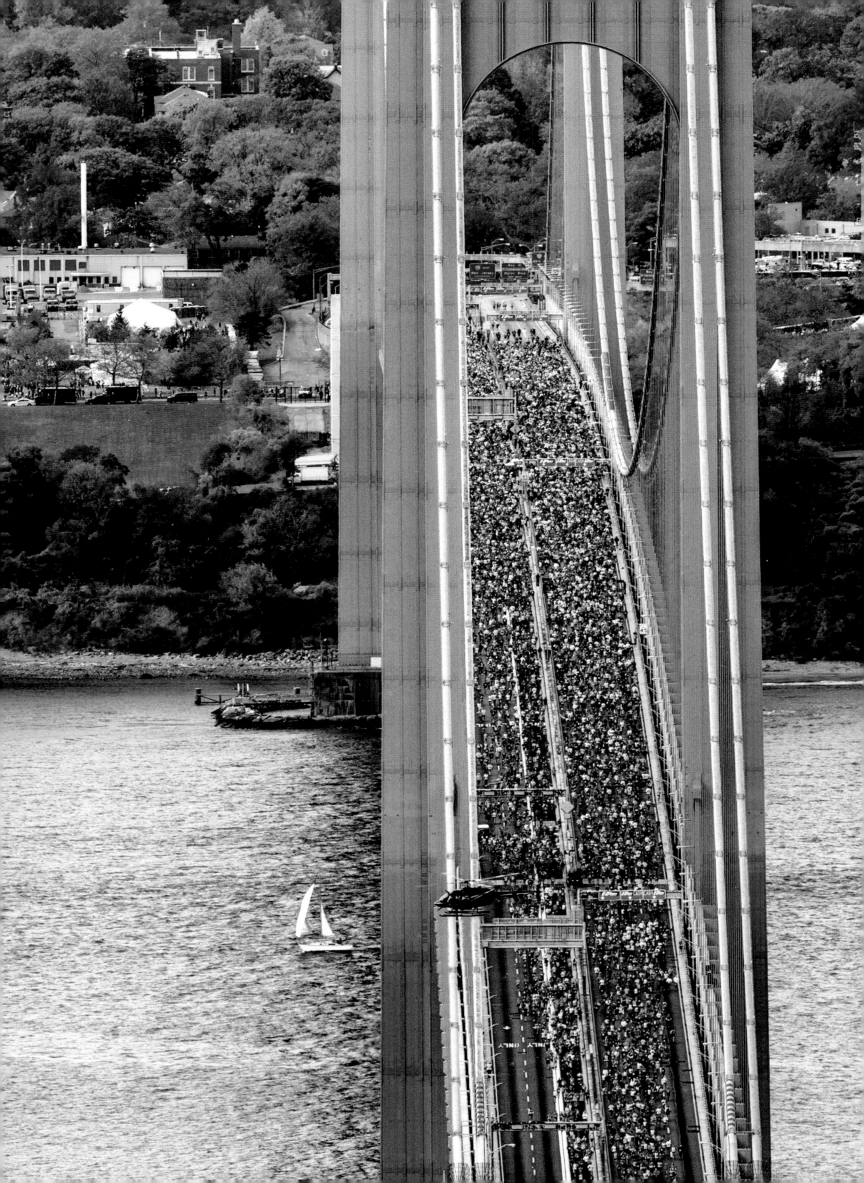

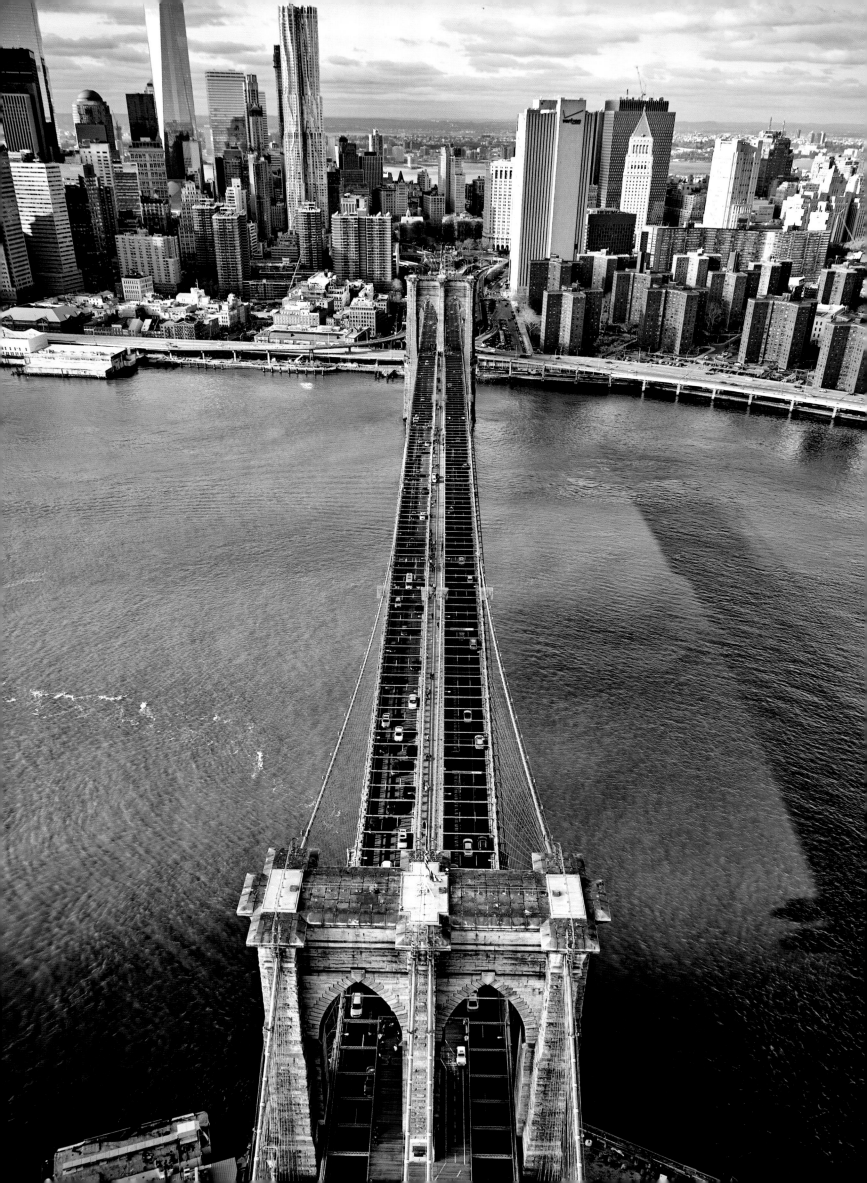

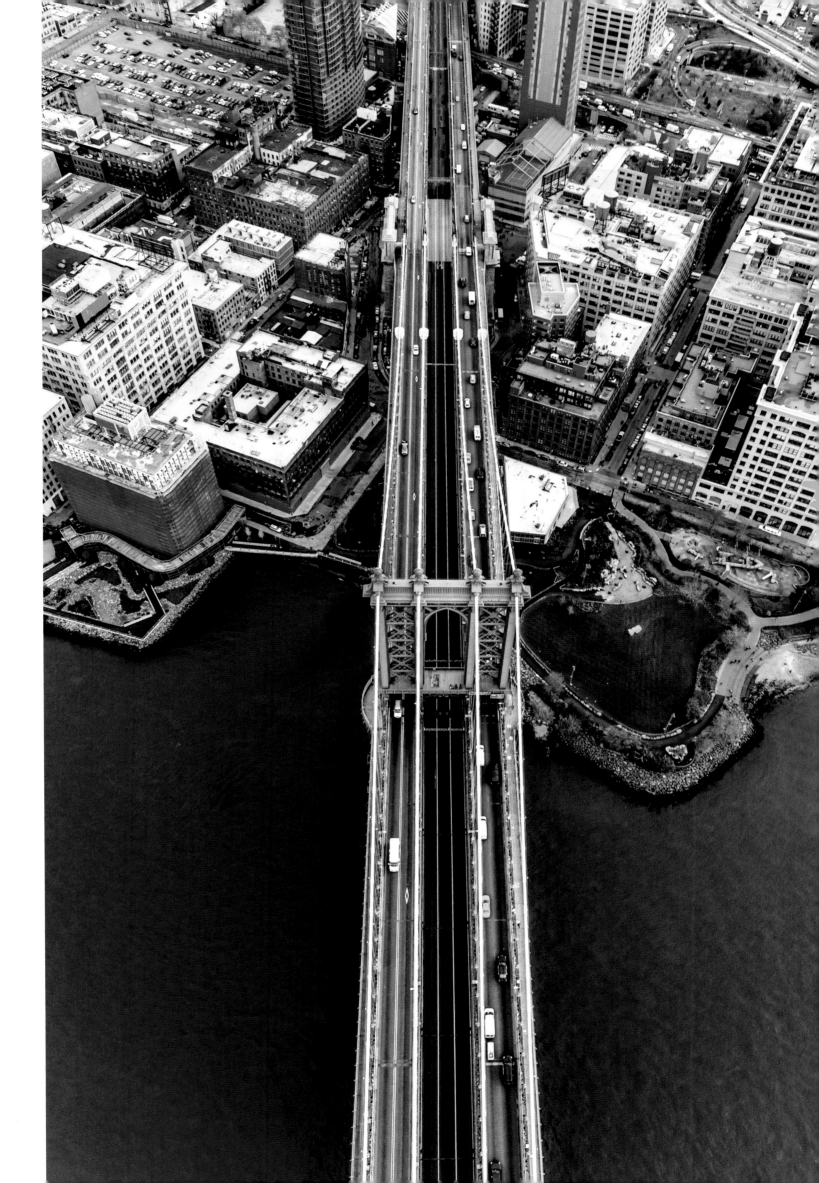

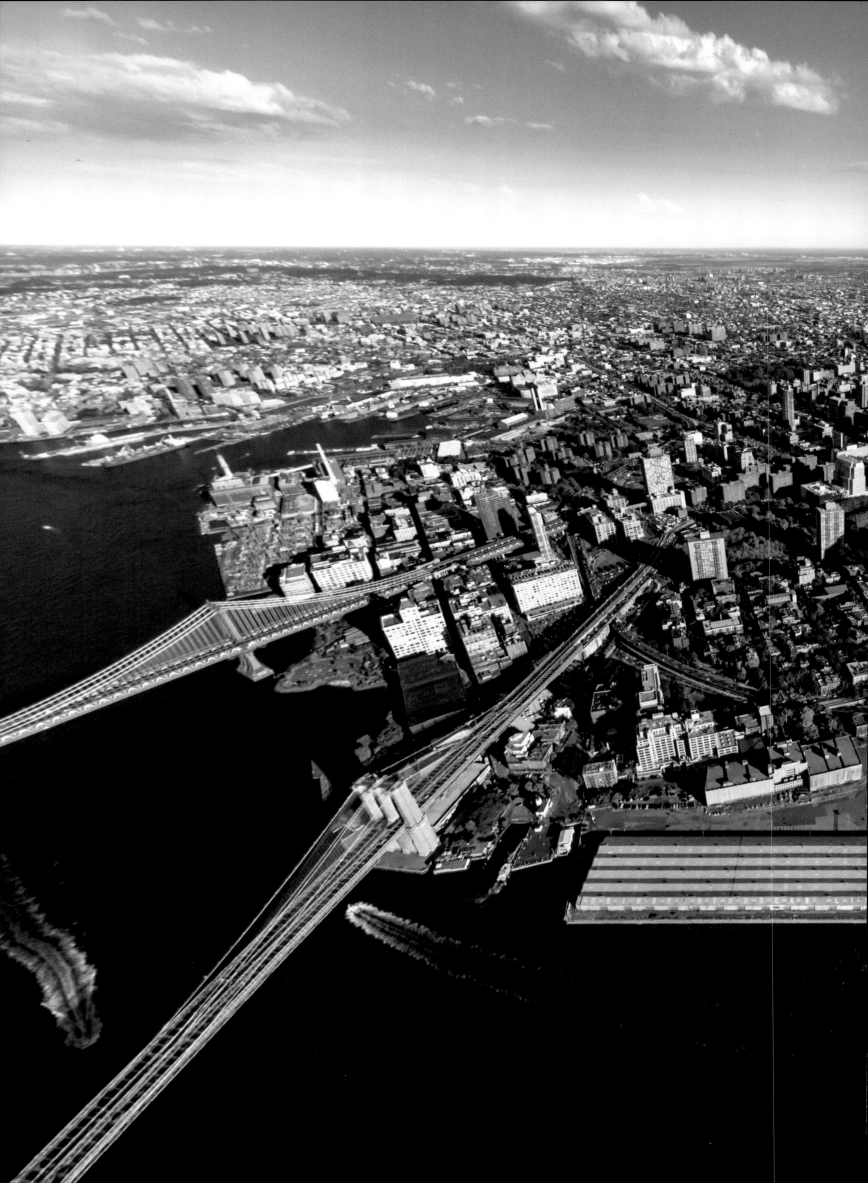

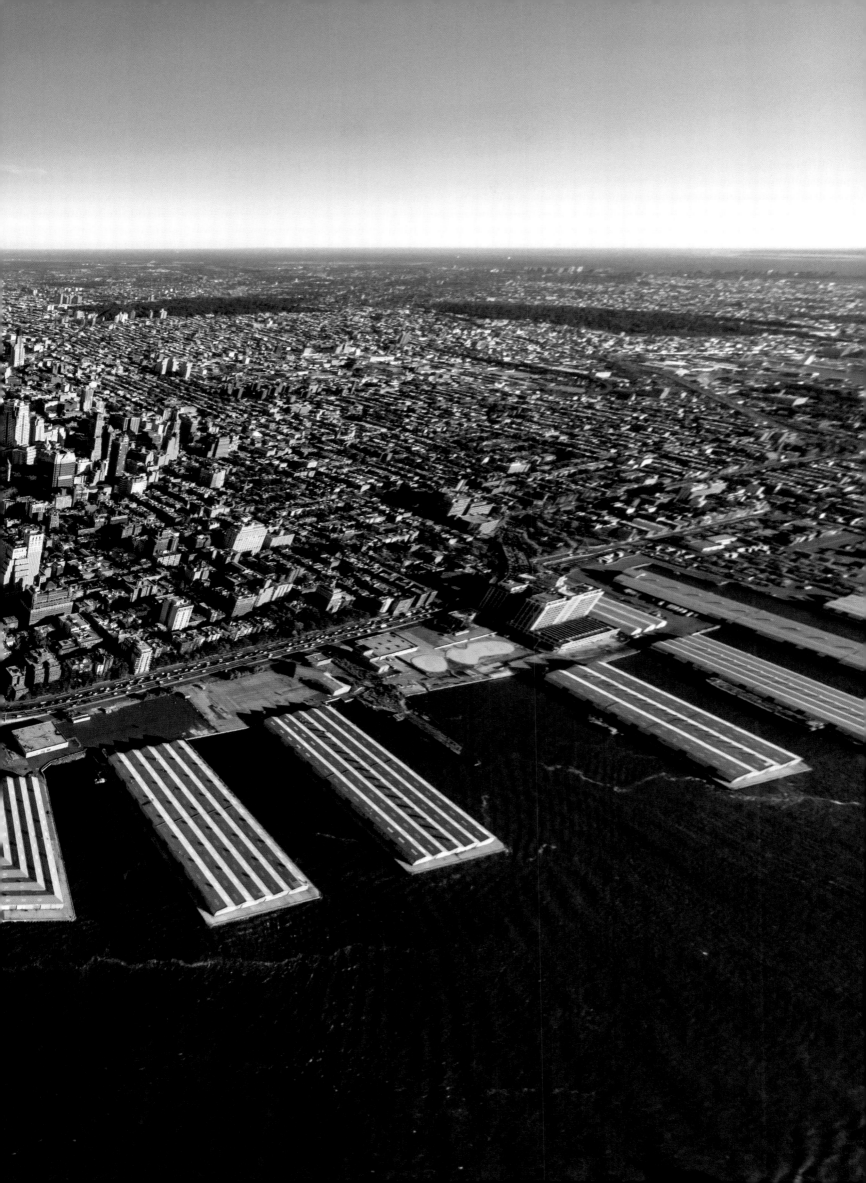

The new state-of-the-art Barclays Center is a multipurpose sports arena and business and residential complex. Though built above rail yards in downtown Brooklyn, some residential and business buildings had to be demolished. The approximately $5-billion project, still under development, is already benefiting the local economy.

232 · 233 | THREADS OF LIGHT |

This nighttime image of Manhattan is anchored by the newly built and dedicated One World Trade Center (Freedom Tower). At its foot is Battery Park City, an upscale residential development favored by many Financial District employees. To its north is the marina and a sports deck. Farther north the parallel avenues required by New York City's grid plan of 1811 extend to the far distance. To the lower right are the Brooklyn, Manhattan, and Williamsburg Bridges.

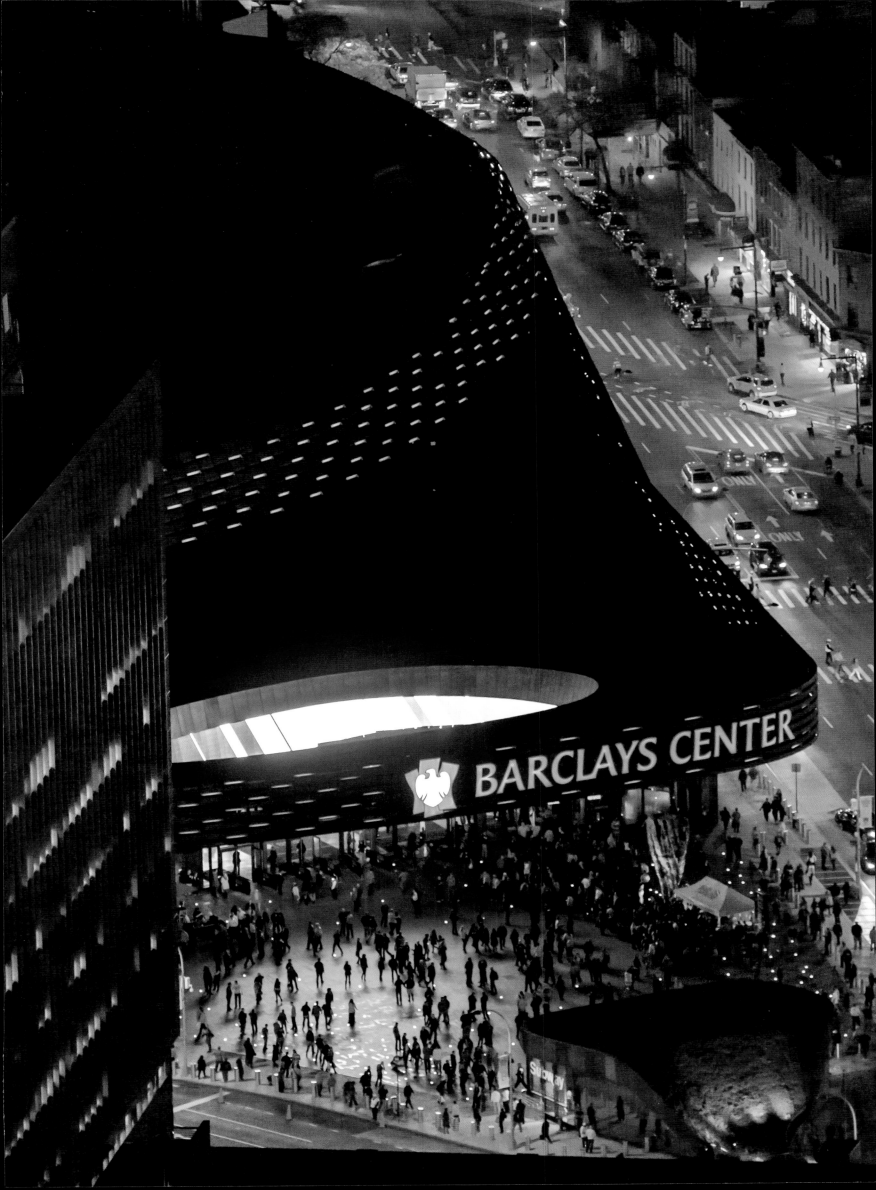

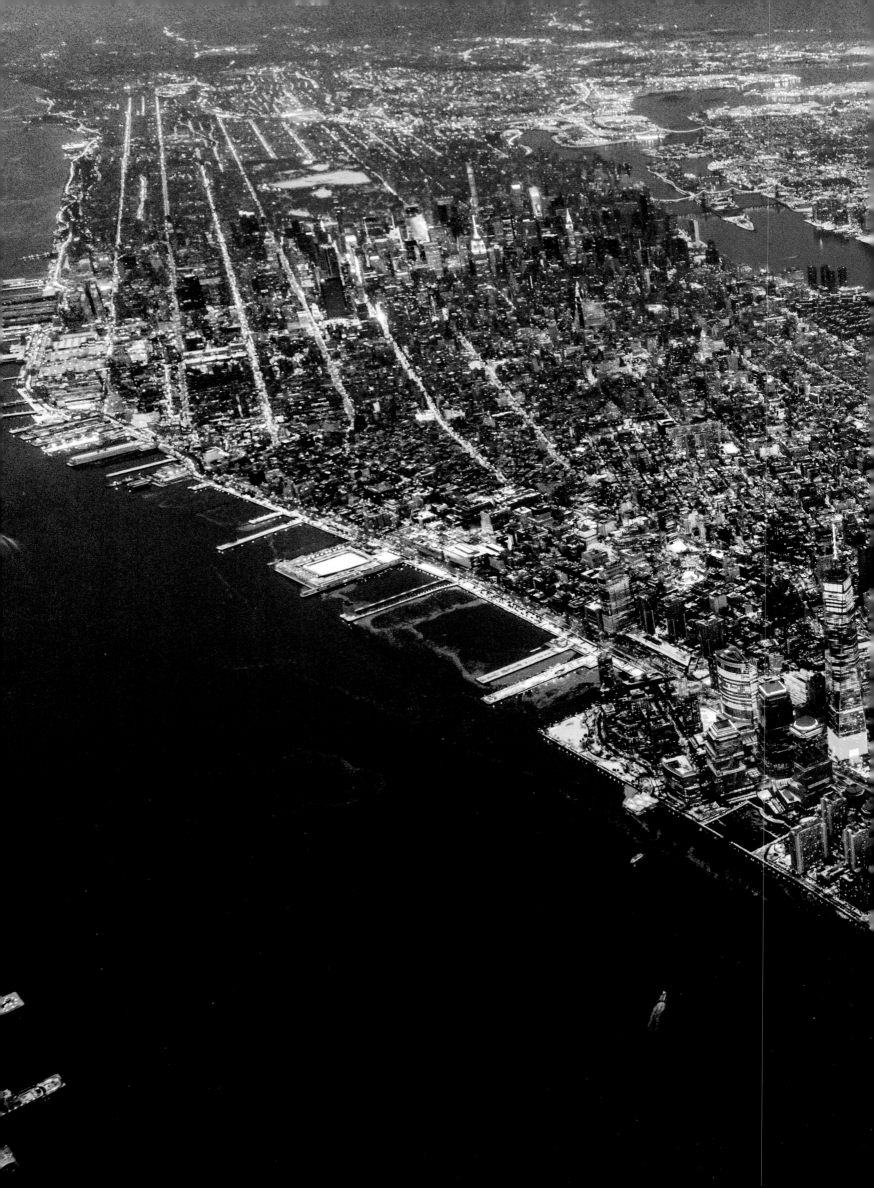

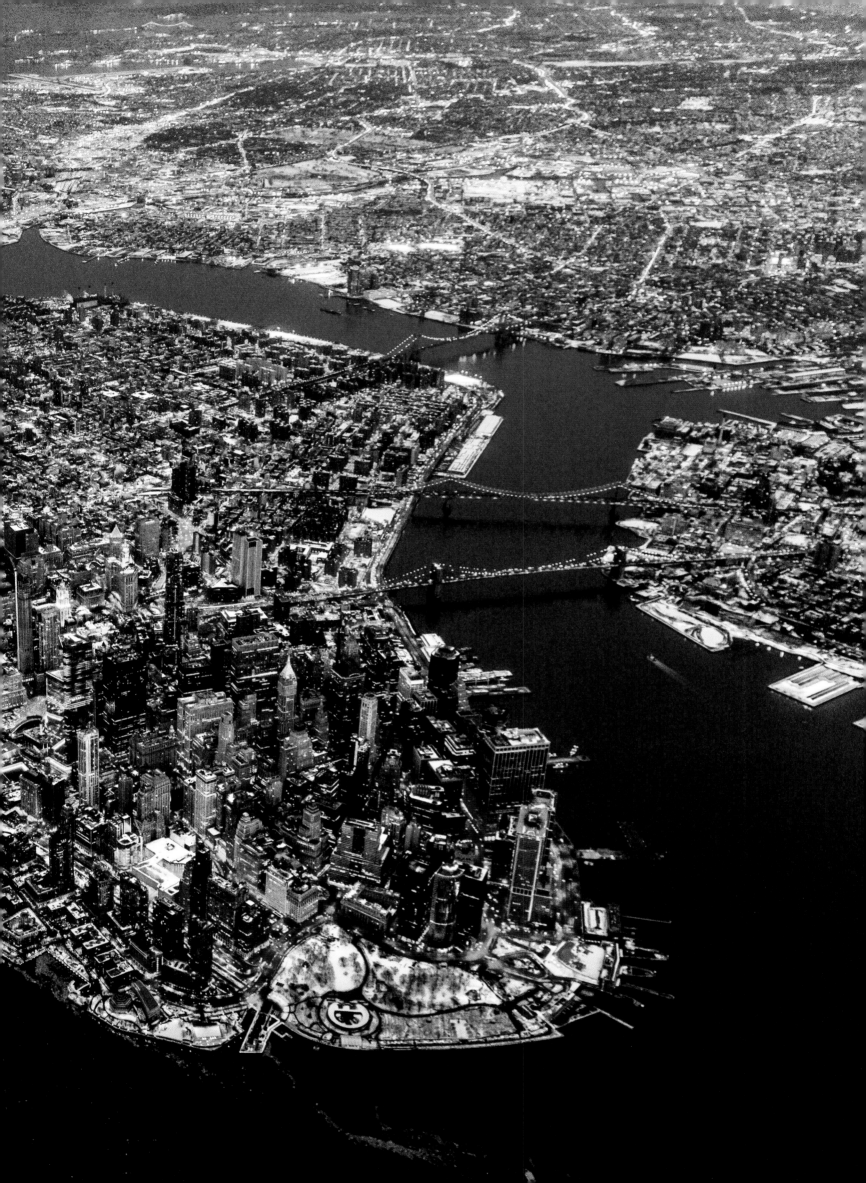

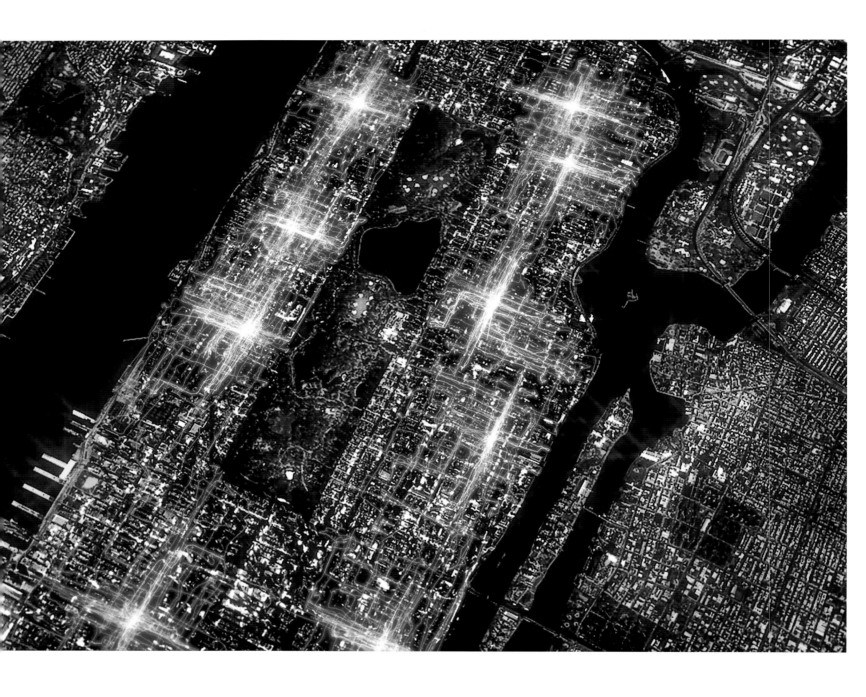

| BY DAY AND BY NIGHT... |

This image capturing from approximately 42nd to 110th Street depicts the routes of bicycle-riding pizza delivery men on a Friday night. Typically, they deliver thirty to forty pizzas in an eight-to-nine-hour shift. For the sociologist, variations in the density of delivery traffic are likely to reveal interesting socioeconomic-ethnic data.

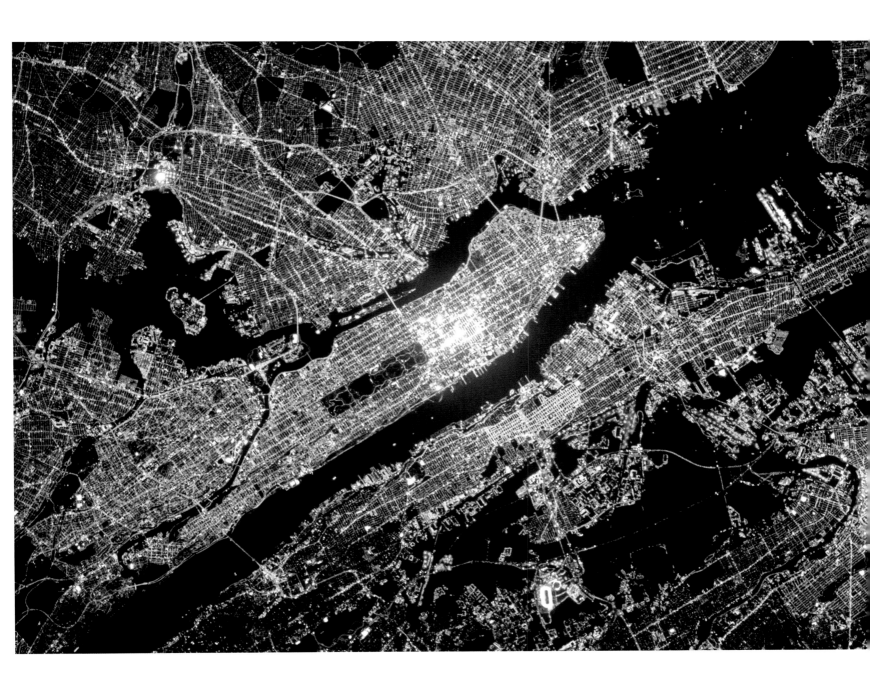

| PATTERNS OF LIGHT |

This striking image, shot in March 2013 by a crew member aboard the Earth-orbiting International Space Station, unites breadth of focus with clarity of depiction. The mid-Manhattan business section is brilliantly lit—and clearly people on Wall Street are also working late... Both the floodlit Metropolitan Museum of Art and the Museum of Natural History can be seen, facing each other, in Central Park. The gleaming "stretched-circle" structure bottom center is the MetLife Stadium, in East Rutherford, New Jersey.

In these twin special-effects summer-and-winter images of New York, north is toward the lower left and south toward the upper right. The broader Hudson River and the narrower East River and Roosevelt Island are clearly shown, as are Fifth Avenue (left of the park) and Central Park West (right of Central Park). Broadway and also the Harlem River, separating the Bronx from Manhattan, are visible. Times Square shows up as a blaze of light, upper right; to the left is the Queensboro Bridge.

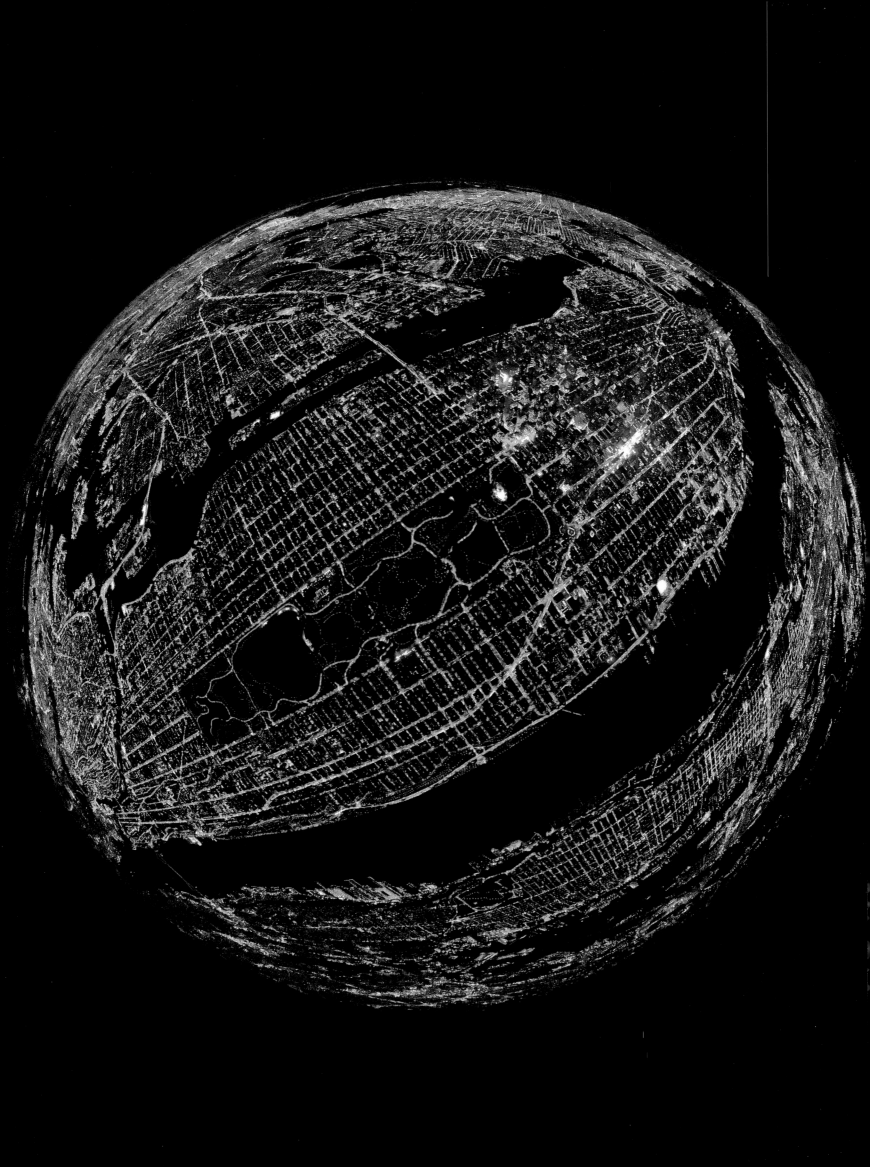

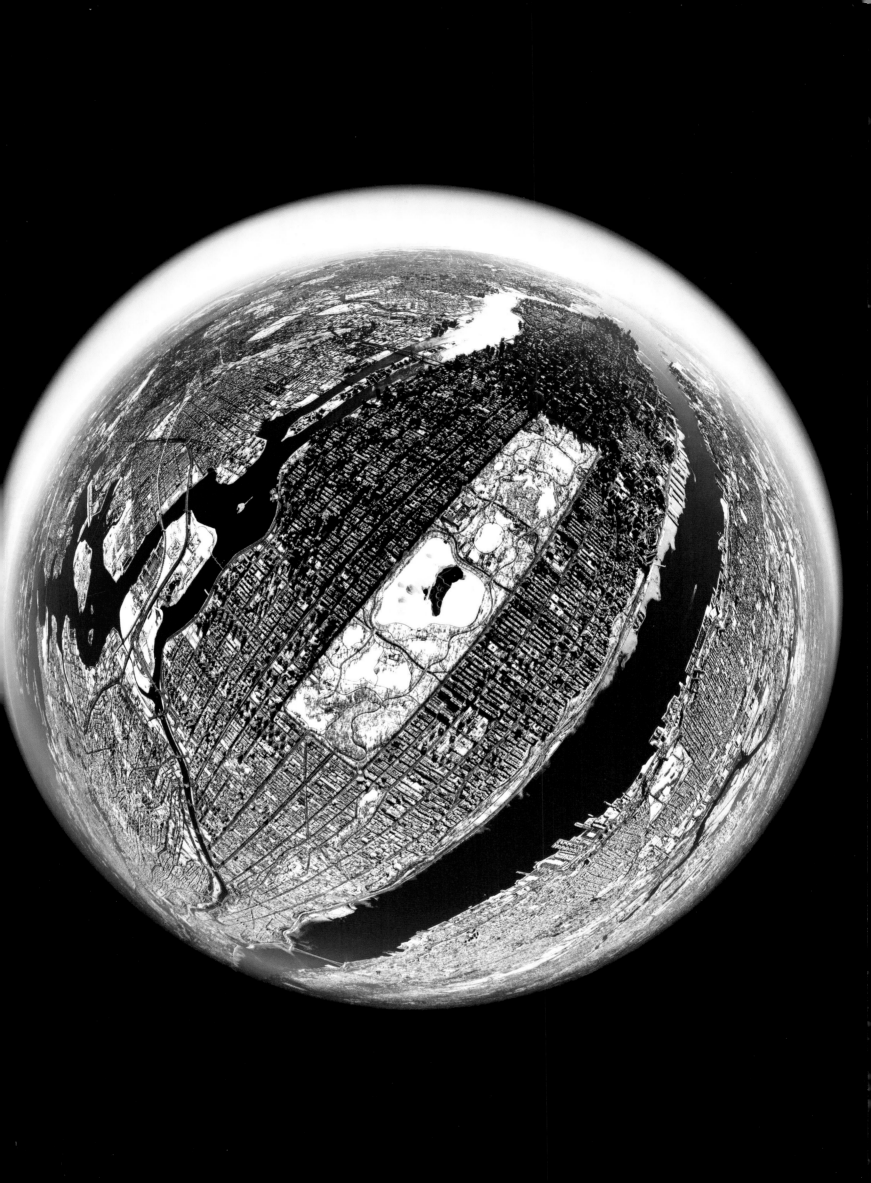

BIOGRAPHY

PETER F. SKINNER, born in the United Kingdom, has been a resident of Greenwich Village for over half a century. He has remained a keen observer of change and development—architectural, economic, human—in his adopted city. Peter Skinner is the author of *World Trade Center* (2002), which has been translated into numerous languages.

ACKNOWLEDGMENTS

The Publisher would like to thank for their important contribution:

Steven Beaucher of WardMaps
Diana Bertinetti
Cécile Breffort
Susan Cooke and Emma Murie of Lion TV
Andy Davies-Coward of 422 South
Denise Diedering of Getty Images
Alfredo Guaraldo of EdiText
Kate Hald of NYONAir®
Enrico Lavagno of Aliter Officina Editoriale
Valeria Manferto de Fabianis of White Star
Gina Martin of National Geographic Creative
Varvara Panina of AirPano
Renzo Parini (president and founder) and Marco Mosso of Fotomec, Turin
Barbara Verduci of Contrasto

A special word of gratitude goes to NYONAir® (http://nyonair.com/) for their cooperation and the important photographic reportage realized for this book.

PICTURE CREDITS

For the English edition © Prestel Verlag,
Munich · London · New York, 2016,
A member of Verlagsgruppe Random House GmbH,
Neumarkter Strasse 28, 81673 Munich

World copyright for *New York. Un siècle de photographies
aériennes* © 2016 Snake SA, Switzerland

© for the texts by the authors, 2016
© for the images by the photographers, 2016

Front Cover: Aerial view of Manhattan, AirPano.com
Back Cover: Margaret Bourke-White, 1951
Frontispiece: Margaret Bourke-White, 1951

Prestel Publishing Ltd.
14-17 Wells Street
London W1T 3PD

Prestel Publishing
900 Broadway, Suite 603
New York, NY 10003

Editorial direction: Curt Holtz, Stella Sämann
Copyediting: Jonathan Fox
Layout modification (pp. 1, 3, 16–19, 44–47, 90–93, 146–149):
Benjamin Wolbergs
Cover design: Sofarobotnik; Benjamin Wolbergs
Production Management: Astrid Wedemeyer
Typesetting: Hilde Knauer
Printing and binding: Druk-Intro S.A. Drukarnia, Poland
Paper: Arctic Silk

Verlagsgruppe Random House FSC® N001967

Printed in Poland

ISBN 978-3-7913-8293-7

www.prestel.com